James Rondeau and Sheena Wagstaff

With contributions by Clare Bell, Yve-Alain Bois, Iria Candela, Harry Cooper, Sara Doris, Chrissie Iles, James Lawrence and Stephen Little

NSTEIN
A Retrospective

TATE PUBLISHING

IN ASSOCIATION WITH
The Art Institute of Chicago

First published in the United Kingdom 2012
by order of the Tate Trustees
by Tate Publishing, a division of Tate Enterprises Ltd,
Millbank, London SW1P 4RG
www.tate.org.uk/publishing

First published in the United States of America in 2012
by The Art Institute of Chicago

A catalogue record for this book is available from the
British Library
ISBN 978 1 84976 106 2 (hardcover)
ISBN 978 1 84976 009 6 (softcover)

Designed and typeset in Gotham and Utopia by Roy Brooks,
Fold Four, Inc., Milwaukee, Wisconsin
Colour reproduction by Professional Graphics, Inc., Rockford,
Illinois
Printed in Italy by Conti Tipocolor
Printed on paper certified by the Forest Stewardship Council
Front cover: Roy Lichtenstein, *Seascape*, c. 1965 (detail of cat. 56)
Back cover: Dennis Hopper, *Roy Lichtenstein (in Studio with Paintings)*, 1964

Measurements of artworks are given in centimetres, height
before width, followed by inches in brackets.

Roy Lichtenstein: A Retrospective

THE ART INSTITUTE OF CHICAGO
16 May – 3 September 2012

NATIONAL GALLERY OF ART, WASHINGTON
14 October 2012 – 6 January 2013

TATE MODERN, LONDON
21 February – 27 May 2013

CENTRE POMPIDOU, PARIS
3 July – 4 November 2013

Sponsored by:

Bank of America
Merrill Lynch

Supported by:

TERRA
FOUNDATION FOR AMERICAN ART

LUCE
HENRY LUCE
FOUNDATION

Maryam and Edward Eisler

The Lichtenstein Exhibition Supporters Group

American Patrons of Tate

This exhibition has been made possible by the provision of
insurance through the Government Indemnity Scheme. The Tate
would like to thank H M Government for providing Government
Indemnity and the Department for Culture, Media and Sport and
the Arts Council England for arranging the indemnity.

CONTENTS

GLOBAL SPONSOR 7

CATALOGUE SPONSORS 9

LENDERS TO THE EXHIBITION 11

DIRECTORS' FOREWORD 13

ACKNOWLEDGMENTS 14

CATALOGUE AUTHORS 17

NOTE TO THE READER 18

JAMES RONDEAU
AND SHEENA WAGSTAFF INTRODUCTION 19

HARRY COOPER ON THE DOT 26

IRIA CANDELA PICASSO IN TWO ACTS 36

SARA DORIS MISSING MODERNISM 46

CHRISSIE ILES SEE-SICKNESS: 52
ROY LICHTENSTEIN'S MOVING PICTURES

YVE-ALAIN BOIS TWO BIRDS WITH ONE STONE 62

JAMES LAWRENCE STUDIO ARTIST 72

JAMES RONDEAU POP GEOMETRIES 78

STEPHEN LITTLE LANDSCAPES IN THE CHINESE STYLE 88

SHEENA WAGSTAFF LATE NUDES 94

PLATES 105

CLARE BELL CHRONOLOGY 340

INDEX 362

PHOTOGRAPHY CREDITS 368

Bank of America

Continuing our long tradition of support for the arts, Bank of America is pleased to be the Global Sponsor of *Roy Lichtenstein: A Retrospective* in Chicago, Washington, and London. We look forward to working once again with three leading arts institutions—the Art Institute of Chicago and the National Gallery of Art in the United States and Tate Modern in London—and to being part of one of the most comprehensive examinations of Lichtenstein's work in recent years. Each of these institutions is a world-class organization that consistently delivers incredible, groundbreaking exhibitions, as well as programming for the public, which is always an important consideration for us as we choose arts organizations and programs to support.

Bank of America supports more than 5,000 arts institutions around the world each year. This element of our Corporate Social Responsibility program remains a key focus, and includes financial support so that programs and institutions may flourish, including several innovative signature initiatives that have become synonymous with our company. The program is designed to engage individuals, organizations, communities, and cultures in creative ways to build mutual respect and understanding; to strengthen institutions that contribute to local economies; to engage and provide benefits to our employees; and to fulfill our responsibilities as a major corporation with global reach and an impact on economies and societies throughout the world.

We hope you are inspired by *Roy Lichtenstein: A Retrospective* to consider how art can transcend time and place to create meaningful human connections, and that you are able to share this special experience with family and friends. We also hope that you will value the opportunity to share a rich cultural experience with hundreds of thousands of people from around the globe.

Brian T. Moynihan
Chief Executive Officer
Bank of America

7

CATALOGUE SPONSORS

Major funding for the exhibition catalogue
is generously provided by

Kenneth and Anne Griffin
Cari and Michael J. Sacks

LENDERS TO THE EXHIBITION

The Art Institute of Chicago
The Blavatnik Family
Neil G. Bluhm
Irving Blum
Jason Blum ·
Irma and Norman Braman
The Broad Art Foundation
The Eli and Edythe L. Broad Collection
Courtesy Christie's
Collection Kenneth and Judy Dayton
Detroit Institute of Arts
Janet and Craig Duchossois
Stefan T. Edlis Collection
The Doris and Donald Fisher Collection
Aaron I. Fleischman
Agnes Gund Collection
The Helman Collection
Courtesy Gagosian Gallery
Barbara Bluhm-Kaul and Don Kaul
Kravis Collection
Anstiss and Ronald Krueck
Kunstmuseum Basel
Collection Viktor and Marianne Langen
Lenhardt Collection
The Roy Lichtenstein Foundation Collection
Jeffrey H. Loria
Los Angeles County Museum of Art
Nancy and Robert Magoon
Courtesy Matthew Marks Gallery
Robert B. Mayer Family Collection
Courtesy Mitchell-Innes & Nash
Museum Abteiberg Mönchengladbach
Museum of Contemporary Art, Los Angeles
Museum Ludwig Köln
The Museum of Modern Art, New York
Museum für Moderne Kunst, Frankfurt am Main
Raymond and Patsy Nasher Collection, Nasher Sculpture Center
National Gallery of Art, Washington
The Pace Gallery
The Ruben Family
Ryobi Foundation
Cari and Michael J. Sacks
Saint Louis Art Museum
San Francisco Museum of Modern Art
Collection Simonyi
Staatsgalerie Stuttgart
Stedelijk Museum
Tate
Fondation Louis Vuitton pour la Création
Walker Art Center
Frederick R. Weisman Art Foundation
Whitney Museum of American Art
Wolverhampton Arts and Heritage, Wolverhampton Art Gallery
Yale University Art Gallery

And other private collectors who wish to remain anonymous

DIRECTORS' FOREWORD

On the occasion of this momentous, retrospective exhibition, we are exceedingly proud that both our museums were early supporters of Roy Lichtenstein. The Art Institute of Chicago purchased *Brushstroke with Spatter* (cat. 49) from Leo Castelli in 1966. The first Lichtenstein to come to the museum, this painting entered the collection the same year it was made—at the time, an uncommon distinction. When Tate bought *Whaam!* (cat. 36) the same year, the acquisition generated sensational public interest. In 1968 Tate hosted a major solo exhibition of Lichtenstein's work. Since that time, our respective institutions have substantially advanced our commitments to the artist's oeuvre.

Given that the art of Roy Lichtenstein fundamentally altered the possibilities of painting in the second half of the twentieth century, a complete assessment of his full career seemed overdue. We are honored to collaborate in the organization of the present retrospective exhibition and catalogue. Both James Rondeau, Frances and Thomas Dittmer Chair and Curator, Department of Contemporary Art, the Art Institute of Chicago, and Sheena Wagstaff, who was until early 2012 Chief Curator at Tate Modern and is now Chairman of the Department of Modern and Contemporary Art at the Metropolitan Museum of Art, New York, are to be commended for their efforts, over nearly five years, in bringing this exhibition to fruition. We are further indebted to Jack Cowart, Executive Director, and the staff of the Roy Lichtenstein Foundation and to the staff of the Estate of Roy Lichtenstein for their complete cooperation. The present endeavor has benefited immeasurably in every respect from the gracious and invaluable support of Dorothy Lichtenstein, and we express our sincere appreciation to her. In addition, we gratefully acknowledge all of the lenders who have generously entrusted us with their works.

Bank of America is the Global Sponsor of *Roy Lichtenstein: A Retrospective*; simply put, such an exhibition as this would not exist without its substantial underwriting. For their enthusiastic interest in taking this exhibition and extending its national and international impact, we are grateful to Earl A. Powell III, Director of the National Gallery of Art, Washington, and to Alfred Pacquement, Director of the Musée national d'art moderne, Centre Pompidou, Paris.

Major funding for the exhibition catalogue was generously provided by Kenneth and Anne Griffin and Cari and Michael J. Sacks. Major support for the exhibition in Chicago was provided by the Bette and Neison Harris Exhibitions Fund. Additional exhibition support was received from the Terra Foundation for American Art, the Henry Luce Foundation, and the Exhibitions Trust of the Art Institute of Chicago: Goldman Sachs, Kenneth and Anne Griffin, Thomas and Margot Pritzker, the Earl and Brenda Shapiro Foundation, the Trott Family Foundation, and the Woman's Board of the Art Institute of Chicago. In London, the exhibition is generously supported by Maryam and Edward Eisler, the Terra Foundation for American Art, and the Henry Luce Foundation, with additional support from Christopher Eykyn and Nicholas Maclean, the Lichtenstein Exhibition Supporters Group, and the American Patrons of Tate.

Until just weeks before his unexpected death in 1997 at the age of seventy-three, Roy Lichtenstein remained a vital creative force: dedicated to the studio, preparing canvases for new paintings, always planning the next great series. What remains is an extraordinary body of work—monumental in its achievement—for us to contemplate, study, and enjoy. We are honored to share and, in turn, celebrate with our wide audiences his enduring accomplishments.

Douglas Druick
President and Eloise W. Martin Director
The Art Institute of Chicago

Chris Dercon
Director
Tate Modern

13

ACKNOWLEDGMENTS

Although the thought of a small, thematic exhibition of Lichtenstein's work initially took shape in Chicago, those involved quickly realized both the limitations of that concept and the real need for a major posthumous overview. To this end, the Art Institute of Chicago and Tate Modern joined forces in 2007. In a large, temporary workspace a year or so later, we undertook to review images of every documented object—nearly two thousand strong—that Lichtenstein produced over the course of some six decades. While confronting the cumulative volume of his output was overwhelming, grappling with the force, clarity, and beauty of his entire oeuvre was energizing. We began with the totality of Lichtenstein's work and focused all our subsequent efforts from this starting point. The process has been rich and rewarding. In this most basic regard, we owe our first acknowledgment to the artist, whom both of us were fortunate to have met at different stages of his career.

Since the first suggestion of a full retrospective, Dorothy Lichtenstein has offered with characteristic grace and intelligence her invaluable support, enthusiasm, and trust. We are profoundly grateful to her. From the outset, Roy Lichtenstein Foundation Executive Director Jack Cowart generously opened the foundation's doors to us and to our colleagues, sharing his expertise as well as scholarly resources. For those of us who have had the good fortune to spend time at the foundation's offices, housed, in part, in the artist's former studio, it is clear that Lichtenstein's legacy continues through the diligence of those entrusted with its preservation: the foundation staff. Along with Jack, Managing Director Cassandra Lozano has been an incomparable source of information, advice, and anecdote. For their able and patient assistance throughout the course of our planning and implementation, we also thank Clare Bell, Justin Brancato, Larry Levine, Evan Ryer, Andrea C. Theil, and Saskia Verlaan. In addition, we are grateful to the staff of the Estate of Roy Lichtenstein: Shelley Lee, Larry Levine, and Cassandra Lozano. We extend special thanks to Natasha Sigmund, Registrar for the Estate of Roy Lichtenstein, for her skillful organization and oversight of loans and related installation details.

An exhibition of this size is only possible with the generosity of private collectors and public institutions. We are wholly indebted to these lenders for sharing their prized objects for our research and exhibition purposes and entrusting us with their safekeeping. Our hope is that this exhibition and the present catalogue will elucidate and extend understanding of the artist's work in meaningful ways.

There are many individuals and institutional colleagues who have provided assistance with research, loan procurement, and coordination, and in so doing made possible an exhibition of this ambition and scope. Thus, we are especially grateful to Stephanie Barron, Stefano Basilico, Claudia Bautista, Neal Benezra, Daniel Birnbaum, Emily Braun, James Keith Brown, Bernhard Mendes Bürgi, Andrea Caratsch, Arielle Caruso, Pamela Caserta, Paula Cooper, Nicole Cosgrove, Jeffrey Deitch, Lisa Dennison, James DePasquale, Stephan Diederich, Susan Dunne, Mark Francis, Peter Frei, Jodi Furlong, Susanne Gaensheimer, Larry Gagosian, Nicole Gallo, Vicki Gambill, Gary Garrels, Chloé Geary, Lily Goldberg, Helyn Goldenberg, Ann Goldstein, Michael Govan, Marla Hand, Rebecca Hart, Matt Heffernan, Sandy Heller, Joanne Heyler, Sheila Johnson, Ellsworth Kelly, Christine Kim, Sandi Knakal, Melinda Knapp, Kasper König, Mario Kramer, Robin Lamb, Cyndy Liewehr, Jamie Loso, Matthew Marks, Kate McGrath, Cheryl Miller, Dana Miller, Lucy Mitchell-Innes, Bob Monk, Jed Morse, Rysia Murphy, Maria Naula, Suzanne Page, Beatrice Parent, Laura Paulson, Jeffrey Peabody, Chelsea Peters, Mary Phelps, Mary-Ellen Powell, Emily Rauh Pulitzer, Suzanne Quigley, Stefan Ratibor, Jock Reynolds, Jennifer Ritchie, Ashley Robinson, Cora Rosevear, Laura Satersmoen, Paul Schimmel, Richard Sigmund, Loren Smith, Jeremy Strick, Ann Temkin, Olga Viso, Adam Weinberg, Amy Wright, Keli Zaloudek, and John Zarobell.

It has been our privilege to work with and learn from the distinguished scholars who contributed to our catalogue, including Yve-Alain Bois, Professor, Institute for Advanced Study, Princeton; Iria Candela, Assistant Curator, Tate Modern; Harry Cooper, Department Head and Curator, Modern and Contemporary Art, National Gallery of Art, Washington; Sara Doris, Assistant Professor of Contemporary Art History, Department of Art and Design, Northeastern University; Chrissie Iles, Anne and Joel Ehrankranz Curator, Whitney Museum of American Art; James Lawrence, independent scholar; and Stephen Little, Department Head and Curator, Chinese and Korean Art, Los Angeles County Museum of Art. Clare Bell, Program Manager and Researcher, Catalogue Raisonné, Roy Lichtenstein Foundation, expanded and shared her authoritative chronology of the artist's life specifically for our publication.

We take this opportunity to acknowledge early support from the Terra Foundation for American Art,

which provided us with funds to plan and host a scholars' day workshop at the Art Institute in October 2010. The goal of the roundtable was to examine our thesis for the exhibition, test attendant selections of works of art, and consider aspects of the artist's career that the exhibition catalogue might address. The result was a lively and productive discussion among peers, an opportunity too often missed in the planning stages of an exhibition, but here enabled by the perspicacity of the Terra Foundation. We are grateful to Elizabeth Glassman, President and Chief Executive Officer, and Carrie Haslett, Program Officer, Exhibition and Academic Programs, for their advice throughout. We are indebted to our colleagues who traveled to Chicago that day, willing to indulge us by thinking aloud and graciously sharing their own work, critical observations, and new ideas: Graham Bader, Mellon Assistant Professor of Art History, Rice University; Tracey Bashkoff, Curator of Collections and Exhibitions, Solomon R. Guggenheim Museum; Thomas Crow, Rosalie Solow Professor, Institute of Fine Arts, New York University; Isabelle Dervaux, Curator of Modern and Contemporary Drawings, the Morgan Library and Museum; Hal Foster, Townsend Martin '17 Professor of Art and Archaeology, Princeton University; and Gianni Mercurio, independent curator, Rome; in addition to Clare Bell, Iria Candela, Harry Cooper, and James Lawrence, already named above.

For other support in the course of our research and exhibition development, we acknowledge Avis Berman, Marisa Bourgoin, Leslie Cade, Barbara Bertozzi Castelli, Anita Douthat, Jessica Duffett, Ken Fernandez, Mark Golden, Jeannine Guido, Jenny Guo, Robert Lancefield, James Mayor, Cesare Misserotti, Kate Montlack, Xan Price, Stephanie Spika, Gail Stavitsky, Kenneth E. Tyler, Bill Van Niekerken, Kathy Vodicka, and Queenie Wong. For its financial support of our research efforts, we would like to thank the Aaron I. Fleischman Foundation.

This exhibition was coorganized by the Art Institute of Chicago and Tate Modern, but it was undoubtedly made stronger through our association with the National Gallery of Art, Washington, and Centre Pompidou, Paris. In addition to Director Earl A. Powell III and Curator Harry Cooper, at the National Gallery we would like to thank D. Dodge Thompson, Chief of Exhibitions; Mark Leithauser, Chief of Design; Naomi Remes, Exhibition Officer; as well as Jamé Anderson, Nina O'Neil, Paige Rozanski, and Melissa Stegeman, for their expert and congenial partnership. At the Centre Pompidou, in addition to Director Alfred Pacquement, we acknowledge Didier Ottinger, Deputy Director; Camille Morineau, Curator of Contemporary Collections; Yvon Figueras, Head of Exhibitions Management; and Hervé Derouault, Production Manager.

This project was conceived under the leadership of James Cuno, former director of the Art Institute. Jim is a great Lichtenstein enthusiast, and he championed with his distinctive energy and passion our earliest aspirations to expand and travel the exhibition. Douglas Druick, whose curatorial voice continues to edify our exhibition program, has supported the project in key regards since his appointment in August 2011 as the museum's President and Eloise W. Martin Director. We also acknowledge the important contributions of Dorothy Schroeder, Vice President for Exhibitions and Museum Administration. Our gratitude is due as well to Julie Getzels, Elizabeth Hurley, Jeanne Ladd, Maria Simon, and David Thurm.

In the Art Institute's Department of Contemporary Art, Exhibitions Manager Maureen Pskowski merits particular recognition. She has overseen every aspect of this complex project with rigorous dedication, clarity, and calm—all trademarks of her professionalism. Maureen's contributions have been immeasurable. Jay Dandy has been instrumental to our research efforts; we have benefited from his knowledge, always informed by an inexhaustible, contagious zeal for all things Lichtenstein. Nicholas Barron oversaw the installation of the exhibition at the Art Institute with his usual excellence, guided by skill and care. Jason Stec, in addition to being second in command for installation, is now, much to our advantage, an expert model maker and film/video technician, two skill sets that have been irreplaceable in the course of our planning and installation. Michelle West and Tracy Parker ably assisted with the early stages of checklist preparation and the scholars' day, as well as with general research and administration. Numerous interns and volunteers have contributed their time over the course of five years. Among them we are especially grateful to Faye Gleisser, Sarah Jorgenson, Courtney Wheaton, and Katie Beth White. Our sincere thanks go as well to Charles Campbell, Lisa Dorin, and Nora Riccio.

This volume exemplifies the consistently extraordinary quality of scholarly catalogues produced by the Art Institute's Department of Publications, headed by Robert V. Sharp. We are very grateful to Maia Rigas for her adept editing and thoughtful and sensitive suggestions, which benefited our essays and the book as a whole. As always, Sarah Guernsey,

15

assisted by Joseph Mohan and Lauren Makholm, has produced an incomparably handsome and, we hope, useful volume. The form of this publication owes much to Sarah's unerring eye and unwavering commitment to distinction. This book's beautiful design is the work of the very talented Roy Brooks of Fold Four, Inc., Milwaukee, Wisconsin.

Curator Mark Pascale of the Art Institute's Department of Prints and Drawings provided his insights into process and materials, and his assistance with the final selection of works on paper was invaluable. Close attention from the Art Institute's Department of Conservation, headed by Frank Zuccari, has served us well, as always. We express our appreciation to all of the conservators who worked diligently to research, examine, and protect the works of art under our care, including Kelly Keegan, Kristin Lister, Sara Moy, Kimberly Nichols, Christine Conniff-O'Shea, Charles Pietraszewski, Suzie Schnepp, Mardy Sears, Harriet Stratis, and Kirk Vuillemot. For the superb exhibition design and construction in Chicago, we thank Bernice Chu and William Caddick together with their adept and always willing staff, especially Yaumu Huang and Tom Barnes. Under the leadership of Patricia Loiko, the Art Institute's registrarial team has managed myriad scheduling and organizational details—a Herculean feat to be sure. For this we thank Susanna Hedlom and her predecessor, Angie Morrow, as well as their packing and installation crews. Communications, graphics, and other outreach efforts were ably executed by Gordon Montgomery, Erin Hogan, Paul Jones, Chai Lee, Tricia Patterson, Lauren Schultz, Gary Stoppelman, and Jeff Wonderland.

Other Chicago colleagues deserving special acknowledgment are Susan Augustine, Jack Brown, Celeste Diaz, Melanie Emerson, Linsey Foster, Kimberly Frezados, Mary Sue Glosser, Michelle Lehrman Jenness, Brice Kanzer, Dawn Koster, George Martin, Suzanne Folds McCullagh, Allison Muscolino, Jennifer Oatess, Janet Oh, Mary Lou Perkins, Sam Quigley, Maureen Ryan, David Stark, Jennifer Stec, Jann Trujillo, Susan Weidemeyer, Patricia White, Amy Zavaleta, and Emily Vokt Ziemba.

At Tate Modern, an exhibition of this scale and complexity could not have been organized without the expertise of many individuals. Foremost among these has been Iria Candela, Assistant Curator, whose curatorial intelligence and quiet tenacity has made a vital contribution to every aspect of this project. Sir Nicholas Serota, Director of Tate, has been a perceptive advocate of our vision since the initiation of the project, offering sage advice at key moments during its development. Vicente Todolí was also an enthusiastic supporter of this endeavor during his years at Tate Modern.

Special appreciation goes to Tate colleagues who have worked to bring this retrospective to fruition in London. Sincere thanks are due to Helen Sainsbury, Head of Exhibitions Programme Manager, for her organizational flair and logistical counsel. Rachel Kent, Exhibitions Touring Manager, has ably dealt with the contractual aspects of the exhibition and its tour, ensuring smooth communication with our partner venues. Caroline McCarthy, Exhibitions Registrar, has skillfully orchestrated the transport and care of large precious works. Tate's team of painting, sculpture, and paper conservators has ensured the correct conservation of the works with attention to detail, led by Patricia Smithsen, Head of Conservation Programme. Phil Monk and Kerstin Doble, along with their art-handling colleagues, have coordinated the installation of the show at Tate with their usual professional rigor and efficiency. Curatorial interns Rebecca Davies, Stephanie Hirsch, Barbara J. Scheuermann, Susie Stirling, and Wenny Teo each provided much-appreciated assistance and initial research. For her calm efficiency and assistance in all administrative matters in connection with both exhibition and catalogue, Stephanie Busson also deserves many thanks.

In developing the Lichtenstein retrospective, a number of Tate colleagues have proffered welcome advice or collaborated on complementary interpretative and learning aspects of the exhibition, in particular Marko Daniel, Matthew Gale, Mark Godfrey, and Emily Pringle. Special thanks are also extended to Stuart Comer and Kate Vogel for their respective film projects that contribute new understanding about the work of Roy Lichtenstein.

Finally, we join Douglas Druick and Chris Dercon in expressing our deepest gratitude for the support of Bank of America, which has generously underwritten the tour of this exhibition.

James Rondeau
Frances and Thomas Dittmer Chair and Curator
Department of Contemporary Art
The Art Institute of Chicago

Sheena Wagstaff
Chairman of the Department of Modern and Contemporary Art
The Metropolitan Museum of Art, New York

CATALOGUE AUTHORS

CLARE BELL is Program Manager and Researcher, Catalogue Raisonné, Roy Lichtenstein Foundation.

YVE-ALAIN BOIS is Professor, Institute for Advanced Study.

IRIA CANDELA is Assistant Curator, Tate Modern, London.

HARRY COOPER is Department Head and Curator, Modern and Contemporary Art, National Gallery of Art, Washington.

SARA DORIS is Assistant Professor of Contemporary Art History, Department of Art and Design, Northeastern University, Boston.

CHRISSIE ILES is the Anne and Joel Ehrankranz Curator, Whitney Museum of American Art.

JAMES LAWRENCE is a critic and historian of modern and contemporary art.

STEPHEN LITTLE is Department Head and Curator, Chinese and Korean Art, Los Angeles County Museum of Art.

JAMES RONDEAU is the Frances and Thomas Dittmer Chair and Curator, Department of Contemporary Art, the Art Institute of Chicago.

SHEENA WAGSTAFF is Chairman, Department of Modern and Contemporary Art, the Metropolitan Museum of Art, New York.

17

NOTE TO THE READER

Measurements of artworks are given in centimeters, height before width, followed by inches in parentheses.

Works are grouped thematically; within each section, works appear, with some exceptions, in chronological order. Exceptions to chronology have been made for the sake of clarity of design.

The dates listed for series (e.g., Landscapes, Mirrors) in the Plates are intended to act as a tool for the reader. They refer to the full span of years in which the artist actively explored the imagery or theme as series, and are inclusive of a full range of media (including prints) even though the selections are limited to a subset of the chronology and do not include the full range of media. The exceptions to this rule are Art History and Works on Paper, which are organizing principles of the exhibition rather than series per se and therefore reflect only the dates of works in each section.

In the publication history of Roy Lichtenstein's art, there has been great variance in the color reproduction of his paintings, sculptures, and works on paper. Our attempts to accurately reproduce his paintings were greatly aided by the use of select Magna paint chips of the exact type the artist used, provided by the Roy Lichtenstein Foundation. While we were unable to compare the samples against every painting represented here, we used our best judgment based on the chips, Foundation guidance, and other research with the hope of reproducing them more accurately than ever before.

Lichtenstein began using Magna paints in 1962; thereafter it appears in media descriptions for the majority of his painted canvases. Magna, a brand-name acrylic paint soluble in turpentine or mineral spirits, was developed by Leonard Bocour and nephew Sam Golden and released in 1947. The paint consisted of pigments in n-butyl methacrylate resins dissolved in solvent that could be diluted with turpentine and mixed with oils. Bocour Artist Colors, Inc., producer of Magna, was sold in 1982 to Zipatone, based in Hillside, Illinois. Production of Magna declined or ceased altogether after Zipatone acquired the company. In 1988, Lichtenstein began to stockpile Magna from New York Central Art Supply, storing it near his Washington Street studio. In September 1990 Mark Golden of Golden Artist Colors, Inc., met with Lichtenstein in his studio about color matching as well as finding a replacement for Magna, as it was becoming scarce and difficult to locate. Throughout 1991–92 Lichtenstein experimented with Golden brand alternatives. At the same time Golden MSA (Mineral Spirit Acrylic) Colors, now called MSA Conservation Paints, appeared on the market. Lichtenstein began using MSA paints in his paintings sporadically in 1994 and fully in place of Magna in 1997 when his stock ran out.

Media descriptions for Lichtenstein's paintings are, in some cases, still in question. What is published here does not always reflect previously published media descriptions but rather is reflective of the latest research with the close cooperation of the Roy Lichtenstein Foundation.

Titles and/or dates for some works have recently changed. In some cases, what is published here does not reflect previously published titles and dates but rather reflects the latest research. All changes or amendments to titles and dates of Lichtenstein artworks were made by the Roy Lichtenstein Foundation in anticipation of a forthcoming catalogue raisonné.

At the time of printing, the following works will appear only in the exhibition at the Art Institute of Chicago: cats. 9, 33, 60, and 157. The following works will not appear at the Art Institute of Chicago: cats. 13, 17, 31, 73, 101, 113, 118, 125, and 135.

INTRODUCTION

JAMES RONDEAU AND SHEENA WAGSTAFF

To understate, that is the quiet beauty of the work.
— Frederic Tuten on Roy Lichtenstein, 2001

The present exhibition surveying the art of Roy Lichtenstein (1923–1997) includes over 160 works made between 1950 and 1997. The show focuses on the artist's achievements in painting, sculpture, and drawing—excluding for reasons of space many compelling objects as well as his prodigious efforts across a much wider spectrum of mediums, notably prints and multiples. This is the first major retrospective to broadly examine his art since his death. Over the course of his long, uncommonly successful career, Lichtenstein's work has been the subject of over 240 solo exhibitions, the last full survey organized by the Solomon R. Guggenheim Museum in 1993.[1] To be sure, his art has enjoyed tremendous exposure, although arguably lacking at times commensurate critical scrutiny. Inscrutability and equivocation are, in fact, defining characteristics of both the artist and his creative venture.

Lichtenstein's singular contribution, predicated on the elegant resolution of an uneasy, still potent collision of commercial and fine art, defined the enduring legacy of Pop. Interest in Lichtenstein seems more durable than ever, his reputation as one of the great American artists of the twentieth century unassailably assured. Aside from the obvious enthusiasm of the marketplace, there is an imperative—fifteen years since the artist's passing and nearly twenty years after the last major survey—to view his career from beginning to end. With this endeavor there is a further intent, based on an expansive approach to the chronology, to introduce lesser-known works alongside established masterpieces.

One understands today—without need for critical theory but rather on an intuitive level, corroborated on a daily basis—that access to lived experience is entirely mediated by signs and symbols endlessly replicated by an omnipresent mass media. This is an old chestnut, to be sure,

but one whose essential truth has been widely amplified in recent years by the onslaught of social networking technology, highly portable points of access, and proliferating global connectivity. More than fifty years after his opening salvo—and with the diminution of the viability of print media rendering his now obscure sources ever more remote—Lichtenstein's work seems wiser than ever in its insistence on the authority of the artificial. In 1968 artist Richard Hamilton quipped, "[R]eproducing a Lichtenstein is like throwing a fish back into water."[2] At the time this was both clever and true, yet the comment retains its pertinence even as the waters have changed. The tactile sites from which Lichtenstein's art emerged are growing progressively extinct. Provoking nostalgia by means of a deliberate historicism was often an inducement to the artist; many of his sources were purposely chosen because they were dated and had passed into the realm of cliché. Today, however, what was once ubiquitous now carries more complex layers of remove, set amid an increasingly immaterial, dispersive referential field.

A common misperception about Pop art, firmly rooted in orthodox accounts, is that it embraced "reality." In fact, the opposite is true—and Lichtenstein took pains to emphasize the schism. Pop artists in general, and Lichtenstein in particular, subsumed already distilled, counterfeited representations. The effect of the greater part of his work, based on reproductions of reproductions, is to concurrently falsify and reify the mass-produced image. The site of this engagement is conventional easel painting; Lichtenstein opened up a parodic space between highly stylized appropriation ("low art" subject matter and an apparently commercial art technique) and the syntax of a very traditional artistic genre. In other words, he seized the power of an imagery—used within the broader culture but disesteemed and actively derided within a fine art context—while simultaneously capitalizing on venerated paint on canvas to inscribe a putatively superseding jurisdiction, thereby holding two competing authorities in tension. Never fully reconciled, the critical strength of his art emerges out of this unresolved duality.[3]

Indeed Lichtenstein remains an artist of absorbing contradictions. His inventiveness is rooted in imitation; he transformed the very idea of borrowing into a profoundly generative, conceptual position, one that alters the trajectory of Modernism, and beyond. His ephemeral sources are reformed as enduring, precious objects. The works on canvas often look convincingly machine-made, but they are entirely dependent on drawn studies and painted by hand.[4] Impersonal in their collective provenance, they are counterintuitively autographic in their finish. Satires of style, they assert their own stylistic authority; mockeries of taste are themselves now imminently tasteful. What seemed ironic issued from a character of inexorable sincerity. By midcareer Lichtenstein was a bona fide celebrity and man of means, yet he remained a modest creature of habit, spending most waking hours in the studio, living above the shop, always shunning the limelight. He was the first artist to systematically dismantle—through appropriation, repetition, stylization, and parody—the history of modern art, and he himself is now an inviolable fixture in that very canon. By rendering reproductions of paintings plucked from a familiar litany of Modernist art history, Lichtenstein conflated disparate genre subjects and styles, though not without deference and respect. ("The things that I have apparently parodied I actually admire," he told Bruce Glaser in 1964.[5] Or as David Sylvester perceptively noted in 1966, "It's another case of degrading the thing and then building it back up again."[6]) To look mindfully at a Lichtenstein painting today is to become suspended in a loop of conflicting, simultaneous responses: crass/elegant, cheap/expensive, subversive/establishment, familiar/strange, degraded/elevated,

20

funny/serious, formulaic/inventive, ugly/beautiful. These incongruities—remarkably present at the beginning and still formidable—animate the staying power of the artist.

Lichtenstein was one of the most consistent—one might even say conceptually programmatic—painters of the twentieth century. Yet there is a persistent compulsion to distinguish between "Pop" and "post-Pop" work, in effect, to proclaim early favorites more classically "Pop." This is, in fact, a wholly spurious—one might even hazard market-driven—divide that fails to recognize the centrality of the artist's tenacious conceptual regularity. Even Lichtenstein's work before 1961 occupies a place on the continuum. For over ten years he had been exhibiting paintings that played with unfashionable derivations of such scenarios as medieval jousting and American folklore (see cats. 62, 128, 129); thus engaged with the outré, it was not a big leap to the "first" Pop experiments (see cats. 130, 131), and then to *Look Mickey* (1961; cat. 8).[7] In terms of what is regarded generally as "classic Pop" in the early 1960s, one understands there is a clear sense of a liberating movement with other adherents, an electric convergence of intellectual concerns, an urgent set of reactions—all of it powerfully clarifying in an identifiable historical moment. Lichtenstein was arguably its first, principal, and most loyal architect, and while his art necessarily evolved, he remained true to its core philosophy. The solidification of a defined Pop idiom in 1961—when the artist was almost forty—was for Lichtenstein a radical confluence of a new style with a new subject rather than a methodological breakthrough.

The first phase of his mature art announces the inimitable "cartoon" mode. The artist typically began with a two-dimensional source, often a comic image or another readily redactional form of printed mass communication; he would sketch the image and, in the process, recompose it to suit narrative clarity or strictly formal ends; subsequently, he would trace the drawing onto canvas with the aid of an opaque projector, continuing to make necessary compositional adjustments (later, collages were also used as intermediate studies), and then paint, often with the aid of assistants. Many observers were, and still are, fixated on the palpably cartoon-derived paintings; when the comics supposedly disappear in 1966, Pop art is pronounced dead. Such logic is hollow. (One might recall that he was already parodying Pablo Picasso and Piet Mondrian as early as 1962, the heyday of the comic-book period.) When the infamously troubled heroines and virile fighter pilots (neither of which were ever shown as a coherent group at the time they were made) recede from view, cartoon sources persist, albeit less conspicuously. After 1966 Lichtenstein applied the comic style to a broad range of found imagery. Still, Landscapes (1964–67), Brushstrokes (1965–71), and perhaps, the Perfect/Imperfect abstractions (1978–89) were sparked by steadfast comic sources. Even his late Nudes (1994–97) derive directly from his archive of 1960s comic-book clippings—the same romantic stories from which his cartoon stereotype of the love-anguished female was plucked—though now they are rendered naked, lost in erotic, narcissistic contemplation.

Throughout Lichtenstein was a classic Pop artist, categorically and definitively. His art is characterized not only by what is depicted but equally by how it is made; the confluence of transposable subjects and indelible style is paramount, and in this, Lichtenstein never wavered. His disparate, and daringly indiscriminate, sources—an illustrated children's story, comic strips, product packaging, newspaper advertisements, mail-order catalogues, museum postcards of art objects, yellow pages—are equalized by Lichtenstein's singular point of view. Inspiration, as well as convictions regarding process, remains largely unchanged from the beginning to the end of his career—there is refinement, but no rupture. The

core of his practice is to drain the particularity of an object or an image and impose his own affect.

Playing on an epithet applied to Jackson Pollock in 1949, the title of a January 1964 *Life* magazine article on Lichtenstein posed the converse question—"Is He the Worst Artist in the U.S.?"[8] Especially early on Lichtenstein was the target of intense enmity and rancor. Exhibitions were pilloried, as by Dore Ashton in a 1962 review:

> **I am interested in Lichtenstein as I would be interested in a man who builds palaces with match sticks, or makes scrapbooks of cigar wrappers. His "art" has the same folk originality, the same doggedness, the same uniformity.[9]**

The radical upstart of Pop art sensationalism was, in fact, the most conservative stylist of his generation. In a 1997 conversation with his friend David Sylvester, Lichtenstein was reminded of the latter's charge in 1963 that he was a classical artist, the heir to Jean-Baptiste-Siméon Chardin and Nicolas Poussin. Thirty-four years later, Lichtenstein readily agreed: "Both of them seem static, set in stone, the same sort of thing that I'm trying to do in my style. And artificial. It's probably true. I wish it were true."[10] Lichtenstein was rigorous in his pursuit of a purely distilled aesthetic philosophy; his commitment was based on a devout faith in the principles of pictorial order. A time-honored easel painter, he worked on a device, which he customized himself in 1950, that allowed him to spin a canvas in any direction. Turning a work upside down or sideways, as well as studying the inverse image in a mirror, minimized its referential function and aided in his abstracting assessment of pictorial structure. Meticulous in his execution, Lichtenstein took pains to mask his fastidiousness. After 1962, he worked with Magna paints, which dissolve entirely in turpentine, thus enabling him to make corrections seamlessly, without scraping or over-painting. Materials and method furthered his goal: "I want to hide the records of my hand."[11] Flat, unmodulated, fiercely resistant surfaces belie the labor; they look elegantly easy.[12] Today Lichtenstein's pictures—he himself referred to his depictions as "crystallized symbol[s]"[13]—have the icy cool authority of sacred icons.

The idea of compositional unity was central to Lichtenstein's thinking.[14] As Hamilton succinctly described, Lichtenstein's "major concern appears to be with the task of depicting a figurative subject in such a way as to adhere to the two dimensional integrity of the canvas."[15] Plastic values—beauty, balance, and the internal relationships of individual parts to one another and the whole—were of primary importance. To this end the recomposition of found imagery was an essential part of Lichtenstein's process.[16] (As early as 1965, the National Periodical Publications meeting pronounced that his work was definitively not a copy of current comic styles.)[17] Always the artist rephrased a source, restating it in his own language of line, pattern, and volume. (Or as one bewildered critic writing in the Cleveland *Plain Dealer* in 1963 surmised, "It's all supposed to have something to do with imposing poetic order on the mass-produced world.")[18] Drawing was the first transformative act, enlargement the second. In the process Lichtenstein tightened composition by eliminating extraneous details, brightening colors, heightening contrasts, balancing positive and negative spaces, and, in general, emphasizing the pictorial clichés and graphic codes of commercially printed imagery, itself a sophisticated visual language. Emphatically planar, most of Lichtenstein's setups rely upon the effective elimination of the spatial

22

distinctions between figure and ground. (Often he complicated the juxta-position of the two by radically simplifying spatial conundrums.) Forms appear to be locked in place by hard contour lines. Sturdily reliable formal tropes—outlines, as well as his trademark imitations of Benday and half-tone dots and, importantly, solid diagonals—are the building blocks of nearly every composition.

At times the dots themselves become the ostensible purpose of the representation, in small works like *Magnifying Glass* (1963; cat. 25) or, more ironically if obviously, in works such as the Rouen Cathedral paint-ings (1968–69; see cat. 69). In his later years, Lichtenstein went further in blurring the distinction between the function of his characteristic formal elements: "I've been using gradated dots or colours that go from one form to another, but the idea is that the lines could act like that to make areas or localities of the things that are independent . . . I don't think I've ever done anything like this before . . . So I'm trying to do something like that, putting colour with subject matter. If you did it without the subject matter you wouldn't know this was being done, so the subject matter helps because there's a reference to reality."[19]

Lichtenstein's first Pop paintings were initially declaimed for their vulgar-ity and are now wildly coveted for their iconic populism, yet their commer-cial sources are in some sense red herrings.[20] This dialogue has been taking shape for decades. Speaking in 1962 about Lichtenstein at a sympo-sium on Pop art at the Museum of Modern Art in New York, critic Leo Steinberg, skeptical if unresolved, stated, "I do not feel competent to judge them as paintings because the pressure of subject matter is too intense."[21] A few years later, on the occasion of Lichtenstein's first New York museum survey in 1969, curator Diane Waldman issued a retort: "To assume that the power and originality of Lichtenstein's work depends primarily on its subject is to misunderstand the intent of the work."[22] The colloquy was not limited to such exchanges. Reviewing the Sonnabend Paris show of Modern sculpture in 1970, one critic wrote, "No sculptor has ever succeeded as well in creating work so devoid of meaning."[23] What was seen as an insistent privileging of form over content led one reviewer to observe, "The lack of content . . . is amazing." He went on declare Lichtenstein's objects "magnificently blank things,"[24] an opinion sometimes wittingly corroborated by Lichtenstein's own often gnomic statements.

In Lichtenstein's formal lexicon neither a coffee cup nor a hillside scene—nor any other scenario—appears to signify anything; his images are bereft of, or more accurately, freed from, the operations of metaphor and symbol. All the objects he depicted, with few early exceptions, lack even the specificity of brand. The connotative charge was too excessive. Everything is generic, including people. Subject matter, then, is deemed apparently meaningless, leveled by the brutally consistent application of unified style. From the very beginning the artist himself admonished against interpreting his work at a deeper level: "Don't look for ideas," he stated in 1952. "My purpose in painting is to create an integrated organi-zation of visual elements."[25]

In 1962, with the first flush of success, the conviction was being distilled almost as shtick. A reporter visiting Leo Castelli described the artist's dealer (delivering what the reporter describes as "his Lichtenstein lecture") exclaiming, "Look at that picture! There is not an idea in it! But it is a painting. And Lichtenstein is a painter!"[26] The same sentiment was expressed many years later from a different, if complementary, side of Lichtenstein's operation. Longtime studio assistant Carlene Meeker observed, "The idea of a painting was always more important than the subject matter . . . There are some artists where the subject matter is the

absolute, most important thing they are doing . . . But Lichtenstein didn't want his art to be viewed that way. He wanted his work to be viewed as an idea."[27]

Lichtenstein's content is this explicit visualization of an "idea"—to look for content or subject matter independent of this insight would be to miss the key to his practice. He suppressed rather than eliminated the meaning of subject matter. Again, the intellectual velocity of his work is achieved through paradox: subject and form are fixed in delicate equipoise. It is this "idea" to which Meeker referred, one that Lichtenstein underplayed but which is central to his work. While subjects served as interchangeable decoys for the plastic operations required to translate image to canvas, Lichtenstein always privileged the potent historic trope on which his parodic enterprise depends—painting itself.

Mural with Blue Brushstroke (1986), the third-largest and among his most ambitious statements, is a veritable catalogue of Lichtenstein's formal preoccupations in terms of motifs, specific paintings, series, and favored artists. The pivotal protagonist here is the hand holding a sponge, itself recalling two earlier paintings of the same action (*Sponge* [1962; cat. 13]; *Sponge II* [1962; private collection]) staging a pictorial drama of self-erasing. Lichtenstein described the mural: "I tried to construct it in a way I would if I were saying something important. It has no theme whatsoever, but it seems to be saying something . . . the other mural in the building, the Benton, is saying something. Benton has a definite social point of view. I have an ambivalent point of view, which I'm getting across. I can't make out the world, and it shows."[28] Such characteristic protestations again somewhat belie the seriousness of his endeavor.

The notion of erasure, embodied by Lichtenstein's sponge, extended to his presentation of self. Rarely has there been so copious a body of work that so rigorously expunged any trace of disclosure. He did not convincingly succeed as an Abstract Expressionist painter, perhaps, because the idea of turgid release was inimical to his constitution. His War and Romance (1961–66) paintings famously dramatize extreme emotional states in opposition to both technique and self. Lichtenstein's few self-portraits all purport to render his absence.[29] Yet by replacing his physiognomy with a depicted mirror, one "self-portrait" becomes a representation of erasure transformed by, and into, a picture (cat. 101). As art historian Michael Lobel succinctly describes, Lichtenstein "oscillates between an erasure of self and an attempt—however conflicted or provisional—to reconstitute a semblance of authorial presence."[30] In this respect, Lichtenstein's concession to "an ambivalent point of view" plays with the identity of the artist—not by erasing the subject or self but instead by picturing both literally and formally his equivocation.

Ultimately there is a profound radicality in Lichtenstein's project, enduringly more extreme than the initially transgressive embrace, heralded and decried as it was, of Pop culture. Impeccable sleight of hand is Lichtenstein's revolutionary stance. In restating the mass-produced image by means of an insistently handmade, painterly process, Lichtenstein confounded the notion of the ready-made, establishing the central paradox of Pop. As such, his art has had a convulsive effect on the history of twentieth-century art. Marcel Duchamp, upon first seeing Lichtenstein's work, is said to have knowingly remarked, "That's what I meant. That's what I mean."[31]

1. Diane Waldman, *Roy Lichtenstein*, exh. cat. (Solomon R. Guggenheim Museum, New York, 1993). The show started in New York (Oct. 7, 1993–Jan. 16, 1994), then traveled to Museum of Contemporary Art, Los Angeles (Jan. 26–Apr. 3, 1994); Montreal Museum of Fine Arts, Montreal (May 26–Sept. 5, 1994); Haus der Kunst, Munich (Oct. 13, 1994–Jan. 9, 1995); Deichtorhallen, Hamburg (Feb. 8–Apr. 10, 1995); Paleis voor Schone Kunsten/Palais des Beaux-Arts, Brussels (June 2–Sept. 3, 1995); and Wexner Center for the Arts, Ohio State University, Columbus (Sept. 21, 1995–Jan. 7, 1996).

2. Richard Hamilton, "Roy Lichtenstein," *Studio International* 175, 896 (Jan. 1968), p. 23.

3. See Hal Foster, *The First Pop Age: Painting and Subjectivity in the Art of Hamilton, Lichtenstein, Warhol, Richter, and Ruscha* (Princeton University Press, 2011), chap. 2, "Roy Lichtenstein, or The Cliché Image."

4. Many mistake the process as one indebted to mechanical reproduction. Art historian John Wilmerding made this false assumption: "For his part, Lichtenstein had rapidly risen to fame with the now-familiar comic-book paintings, first hand-painted and *later silkscreened*, their Benday-dot patterns appropriated from magazine and newspaper images." Wilmerding, "Roy Lichtenstein's Still Lifes: Conversations with Art History," in *Roy Lichtenstein: Still Lifes*, exh. cat. (Gagosian Gallery, New York, 2010), p. 9; emphasis added. Rather than making use of the photomechanical silk-screen process (typical, for example, of Andy Warhol's work), Lichtenstein and assistants used perforated templates to transfer the ersatz Benday dots by hand.

5. Bruce Glaser, "Oldenburg, Lichtenstein, Warhol: A Discussion," *Artforum* 4, 6 (Feb. 1966), p. 23.

6. Sylvester, in "New York, January 1966," *Some Kind of Reality: Roy Lichtenstein Interviewed by David Sylvester in 1966 and 1997*, exh. cat., published in conjunction with *Roy Lichtenstein: New Painting*, Oct. 23–Nov. 27, 1997 (Anthony d'Offay Gallery, London), p. 16.

7. For "big leap," see Michael Kimmelman, *Portraits: Talking with Artists at the Met, the Modern, the Louvre and Elsewhere* (Random House, 1998), p. 84, quoted in Gail Stavitsky and Twig Johnson, *Roy Lichtenstein: American Indian Encounters*, exh. cat. (Montclair Art Museum, 2005), p. 22.

8. Dorothy Sieberling, "Is He the Worst Artist in the U.S.?" *Life*, Jan. 31, 1964, pp. 79–81, 83.

9. Dore Ashton, "New York Report," *Das Kunstwerk* 16, 4 (Oct. 1962), p. 27.

10. From "New York, April 1997," in *Some Kind of Reality*, p. 37.

11. John Coplans, "Talking with Roy Lichtenstein," *Artforum* 5, 9 (May 1967), p. 34.

12. Curator Jane Livingston once observed that Lichtenstein's paintings are so well made they are aggressive. "Roy's craftsmanship and his dedication to a kind of almost hostile perfection, in terms of execution, it was so dangerous." Jane Livingston, oral history, conducted by Avis Berman, Dec. 17, 2009, transcript, p. 17. The Roy Lichtenstein Foundation Archives.

13. "I'm never drawing the object myself, I'm only drawing a depiction of the object—a kind of crystallized symbol of it." Lichtenstein, from an interview with Bici Hendricks, Dec. 7, 1962, quoted in *Roy Lichtenstein: Beginning to End*, ed. Jack Cowart (Fundación Juan March, Madrid, 2007), p. 119.

14. Lichtenstein acknowledged his debt to his mentor at Ohio State University, Hoyt Sherman, in an early interview with Gene Swenson: "He taught me how to go about learning how to look." When asked by Swenson to clarify, Lichtenstein responded, "At what doesn't have anything to do with it. It is a process. It has nothing to do with any external form the painting takes, it has to do with a way of building a unified pattern of seeing." In G. R. Swenson, "What Is Pop Art? Answers from Eight Painters, Part I: Jim Dine, Robert Indiana, Roy Lichtenstein, Andy Warhol," *Artnews* 62 (Nov. 1963), pp. 24–27, 60–64, quotation at p. 62. Michael Lobel treats this issue extensively in *Image Duplicator: Roy Lichtenstein and the Emergence of Pop Art* (Yale University Press, 2002).

15. Hamilton, "Roy Lichtenstein," p. 20.

16. "The closer my work is to the original, the more threatening . . . the content. I take a cliché and try to organize its forms to make it monumental . . . The difference is not often great but it is crucial." Lichtenstein, quoted in Sieberling, "Is He the Worst Artist in the U.S.?" p. 83. A relevant quotation from Waldman in 1969: "This ability to alter reality enables him to confer on the most common of subjects an esthetic orientation entirely foreign to its condition. Then, too, the very methods of transformation entail an adjustment of visual images and confirm the subsidiary role of subject matter in relation to formal ideas." Diane Waldman, *Roy Lichtenstein*, exh. cat. (Solomon R. Guggenheim Museum, New York, 1969), pp. 14–15.

17. See Mario Amaya, *Pop as Art* (London, 1965), p. 91. National Periodical Publications was formed in the 1940s after a series of mergers and consolidations in the comic-book industry. It was more widely known by the name of one of its publications, Detective Comics, or DC, and later officially changed its name. DC and its affiliate publications were responsible for well-known titles like *Superman*, *Batman*, and the *Flash* as well as lesser-known titles such as *Girls' Romances*, *Our Fighting Forces*, and *Secret Hearts*, from which Lichtenstein appropriated many of his images of War and Romance.

18. Helen Borsick, "Roy Lichtenstein Makes Splash as Pop Artist," *Plain Dealer* (Cleveland), Apr. 28, 1963, p. 2G.

19. "New York, April 1997," p. 38.

20. On the subject of his sources, Lichtenstein said, "I use them for purely formal reasons . . . Once I have established what the subject matter is going to be I'm not interested in it anymore." Cited in Jennifer Ollie, "London," *Art and Artists* 9, 3 (June 1974), p. 41. In another context the artist stated, "I don't know what the value is, if any, of having a subject outside of keeping myself awake." From *Roy Lichtenstein: Meditations on Art*, directed by Christina Clausen, in collaboration with the Roy Lichtenstein Foundation Archives and the Estate of Roy Lichtenstein (La Trieannale di Milano and Alphaomega Art, 2010), DVD.

21. Leo Steinberg, quoted in Erle Loran, "Pop Artists or Copy Cats?" *Artnews* 62, 5 (Sept. 1963), p. 48. In the April 1963 *Arts Magazine* reprint of the Pop Art Symposium, Leo Steinberg repeated this: "The subject matter exists for me so intensely that I have been unable to get through to whatever painterly qualities there may be." *Arts Magazine* (Apr. 1963), p. 40.

22. Waldman, *Roy Lichtenstein* (1969), p. 13. See also Sieberling, "Is He the Worst Artist in the U.S.?" "Eventually, Lichtenstein and his admirers expect, the repulsiveness of his subject matter will wear off and viewers will become more aware, and perhaps appreciative, of the esthetic qualities of his paintings. Right now, however, his subject matter dominates." Lichtenstein took the long view as he acknowledged this aspect of the reception of his work: "Pop Art has very immediate and of-the-moment meanings which will vanish—that kind of thing is ephemeral—and Pop takes advantage of this 'meaning,' which is not supposed to last, to divert you from its formal content. I think the formal statement in my work will become clearer in time." Swenson, "What Is Pop Art?" p. 63.

23. Bernard Borgeaud, "Exhibitions in Paris," *Arts Magazine* 44, 7 (May 1970), p. 53.

24. Jeff Schlanger, "Ceramics and Pop—Roy Lichtenstein," *Craft Horizons* 26, 1 (Jan.–Feb. 1966), pp. 42–43.

25. Roy Lichtenstein, quoted in *Cleveland News*, March 13, 1952, Home Magazine, p. 19.

26. Leo Castelli, quoted in "Everything Clear Now?" *Newsweek* 59, 9 (Feb. 26, 1962), p. 87. The artist echoed his dealer, saying in 1969, "I think all artists destroy literal meaning." Roy Lichtenstein, interviewed by Frederic Tuten, New York City, 1969, in *Lichtenstein at Gemini* (Gemini G.E.L., 1969).

27. Carlene Meeker, quoted in Cowart, *Roy Lichtenstein*, p. 132. From Carlene Meeker, oral history, conducted by Avis Berman, Aug. 14, 2003. The Roy Lichtenstein Foundation Archives.

28. Quoted in Calvin Tomkins and Bob Adelman, *Roy Lichtenstein: Mural with Blue Brushstroke* (Abrams, 1988), pp. 10, 41.

29. Examples of this include *Self-Portrait* (1976; private collection), *Self-Portrait II* (1976; Eli and Edythe L. Broad Collection, Los Angeles), *Self-Portrait* (1978; cat. 101), and *Coup de Chapeau (Self-Portrait)* (1996; private collection). This gesture culminates in *Coup de Chapeau I* (1996; edition of six), and *Coup de Chapeau II* (1996; edition of six), in which only his hat remains.

30. Lobel, *Image Duplicator*, p. 73.

31. Leo Castelli secretary Connie Trimble recounts this undated visit: "Who came in [to Leo Castelli] was Teeny and Marcel Duchamp, and they sat down and chatted . . . So they dropped in on Saturday morning, and we brought the things out, the Lichtensteins out, and Duchamp sat there and looked at them for a minute, and he said, 'That's what I meant. That's what I mean.' He absolutely endorsed them one-hundred percent, without any prodding." Trimble, oral history, conducted by Avis Berman, Feb. 17, 2004, transcript, p. 18. The Roy Lichtenstein Foundation Archives.

ON THE DOT

HARRY COOPER

Let's start with the work that the artist considered his first Pop painting, *Look Mickey* (1961; cat. 8).[1] I know it pretty well, and throughout the acquaintance I have been bothered by a nagging thought: Mickey is blushing (fig. 1).

"Blushing is the most peculiar and most human of all expressions."[2] So Charles Darwin begins his renowned chapter on blushing, adding that it is unknown among animals (perfect for a human mouse!). He observes that it occurs only when our attention is directed to how we appear to others, so that even when we blush in private, it is because we are thinking about how we have been in public. And it is focused in the face, that part of the body most scrutinized by others. Blushing is thus a uniquely complex socio-psychosomatic phenomenon, an "intimate sympathy" of excitations in the brain and the face where *face* is taken in its fully social sense as that which we present to the world.[3]

Of course there are other readings of the red dots that spread over Mickey's face right up to the whites of his eyes. They may indicate a healthy glow: Mickey has skin, not fur, and since the 1940 movie *Fantasia* it has been consistently treated as Caucasian-white rather than snow-white.[4] Or they may simply indicate his skin as such, just as the blue dots that tone the whites of Donald's eyes do not mean that they are actually blue. In the three-color printing process that the painting emulates, and of which we are all practiced consumers and automatic decoders, color can signify either hue or tone: yes, Donald wears a blue coat, but no, the inside of his mouth is not blue, it is just dark. So it is hard to say whether we are meant to see Mickey's face as slightly toned or slightly red, and if the latter, whether that is normal for him or not.

Graham Bader, who has studied *Look Mickey* closely, refers to Mickey's "red face." Still, this is not necessarily to say he is *red-faced*, or

Fig. 1. Roy Lichtenstein. *Look Mickey*, detail (1961; cat. 8).

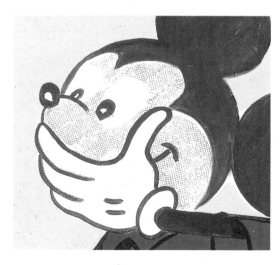

embarrassed. Not every flush is a blush. Such facial coloring can also indicate anger or (as Bader sees it) exertion, Mickey's effort of "containing a certain howl—or at least a squeak—of laughter" at Donald's ludicrous position.[5] This reading is supported by the original source for the painting, which Bader discovered with the help of Michael Kades, a color illustration (not a cartoon: a fairly nuanced wash drawing) from the 1960 book *Donald Duck Lost and Found* (fig. 2). The illustrated text goes like this: "'Look, Mickey,' cried Donald. 'I've hooked a big one.' 'Land it,' laughed Mickey, 'and you can have it fried for lunch.'"[6] In the illustration, Mickey's forward-bending pose implies laughter contained by the clap of glove over mouth, threatening to erupt. He will deliver the punch line as soon as he recovers.

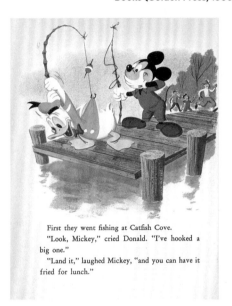

First they went fishing at Catfish Cove.
"Look, Mickey," cried Donald. "I've hooked a big one."
"Land it," laughed Mickey, "and you can have it fried for lunch."

For Bader, Mickey's amused superiority, indeed the whole narrative, functions in the painting on a higher level as well, as an allegory of Lichtenstein's "predicament" as an artist saddled with realist instincts and training (Hoyt Sherman's drawing lab at Ohio State University) in the heyday of Abstract Expressionism. Donald leaning over the water is a self-portrait of Lichtenstein as a Narcissus-like realist vainly trying to capture his reflection (the initials "rfl" float beneath him). Mickey, a figure of self-control, represents the "art historical superego looming over Lichtenstein at the moment of *Look Mickey*'s creation," namely, the vanguard modernist (a paintlike white spill under his left foot recalls Jackson Pollock's pours) who can only laugh at the exertions of the retrograde realist. The painting pits Donald's "thwarted object attachments and slapstick textual exuberance" against Mickey's "position of epistemological and symbolic authority."[7]

This brilliant reading overlooks little, but it does skip the fact that Mickey's forward lean is less pronounced in the painting than in the illustration. Conversely, Donald is more bent over in the painting. At the same time, Lichtenstein's Mickey seems more flushed than in the original, thanks to the dots. (Ironically, the handmade painting gives its slightly classy source the look of a cheaper, more mechanical reproduction.) Taken together, these facts suggest that Mickey, rather than bursting (as Bader sees him), is a slightly embarrassed mouse, self-split by schadenfreude.[8] Ashamed of his delight at his pal's misfortune, he blushes as if for Donald himself, who is all unblushing immediacy. Perhaps Mickey has already hatched his off-color retort about the frying of Donald's "big one" (his "substantial backside," as Walt Disney himself called it, nicely exposed to Mickey's view) and is trying to contain the remark as well as a laugh with his hand.[9]

Covering the mouth and blushing are often linked: in Marcel Proust's *The Captive*, Albertine lets slip the first half of an obscene wish, one also concerning a backside (her own): "At once her face flushed . . . [and] she put her hand over her mouth as though she could have thrust back the words which she had just uttered."[10] But perhaps, as this example may betray, my reading of the painting is too nineteenth-century, too ready to find what Roland Barthes called "these idiotic blushes" that deface so many moments of pleasure in texts by Honoré de Balzac, Émile Zola, Gustave Flaubert, and Marcel Proust ("Only Mallarmé, perhaps, is master of his skin").[11] And yet we cannot underestimate the Victorianism of the late-1950s American context of *Look Mickey*, the repression of instinct and channeling of pleasure that the Disney Corporation, as Bader points out, was busily enforcing. Indeed, by 1960 Mickey had shed his original "roguish antihero" identity and had been rebranded as "an ever cheerful yet shy role model," one capable of bashful and contrite poses if not (to my knowledge) outright blushing.[12]

But enough Pop psychology. A guilty-Mickey theory is, admittedly, something of a fantasy projected onto a generally happy, almost blank persona.[13] Whether it might have been Lichtenstein's fantasy as well is

impossible to say. In any case, it was not primarily narrative, character, or pose that suggested the blush to me, but paint. The red dots of Mickey's face are imperfectly distributed and varied in strength. They *spread*, as I wrote at the start, unevenly, in subtle blotches, into a blush. This has generally been dismissed as the result of a still-primitive technique, for Lichtenstein made the dots by using "a plastic-bristle dog-grooming brush dipped in oil paint."[14] Once he perfected the use of a screen with cut-out holes (also referred to as a stencil, or *pochoir*) in 1963, so the familiar account goes, he was able to deploy the dots with flat uniformity and realize the trademark tension of his mature mid-1960s work between cold, mechanical means and emotive, melodramatic content.

I propose an alternate reading of the dot (as well as of Lichtenstein's work), one that regards it, even in its mature state, as connected rather than opposed to matters of flesh and feeling, seeing and being seen—located, in short, right on that mind/body, private/public cusp that is the blush. Indeed, the very action of pressing liquid through a dot screen onto a canvas is not unlike the mechanics of blushing, in which blood moves through dilated vessels to the skin's surface, where it leaves its color, its mark. (Might that have overdetermined Lichtenstein's preference for the method?) Seen in this light, the imperfection in *Look Mickey* is not an anomaly but rather an inaugural moment, the first blush of a visual unevenness or optical shiver that will persist in Lichtenstein's regular and mechanical applications of dots, carrying with it all the sensitivity of a skin. With apologies to Willem de Kooning, I am tempted to exaggerate and suggest that flesh is the reason the dot was invented.[15]

Let us briefly recall the evolution of Lichtenstein's dot-making in the wake of *Look Mickey*. In *Popeye*, also of 1961 (and the work that Lichtenstein showed right after *Look Mickey* in a 1995 slide lecture),[16] he dragged red pigment over the canvas to depict skin, enlisting the weave of the fabric itself as a fine dot pattern (fig. 3). This was a clever subversion of the canvas as fine-art material, but it was too subtle to evoke commercial printing. The breakthrough invention arrived later the same year: a "small, thin strip of aluminum, measuring approximately 2 × 16 inches, through which he drilled holes, using a piece of graph paper as a guide."[17] Mechanical means produced mechanical results; but still, as many of the paintings from 1961–62 testify, the dots were imperfectly formed and arrayed, reflecting the homemade nature of the device. Lichtenstein experimented with another method in many of his 1962 drawings, placing a textured surface under the page and rubbing pencil over it. Although this frottage produced regular dots, it proved difficult to suppress the pencil strokes, and in any case the technique was not applicable to paint on canvas. In the same year, Lichtenstein greatly improved his stencil technique, abandoning the homemade device in favor of a large metal screen with staggered rows of circular holes from the Beckley Perforating Company in Garwood, New Jersey (fig. 4).[18]

The first painting to employ the store-bought screen might well have been (fittingly for a founding work) *George Washington* (1962; cat. 62). In the study for this painting (fig. 5), Lichtenstein stuck to frottage, placing the Beckley screen underneath the sheet, which he then rubbed with pencil to yield an image of the screen as white dots (the paper) on a dark ground (the graphite). But he soon realized that the screen would do better as a stencil placed over the support, resulting in the "positive" dots of the painting as opposed to the "negative" dots of the drawing.[19] Once again, as with *Look Mickey* and *Popeye*, the occasion for a new dotting technique was the depiction of skin.

Of course, Lichtenstein neither invented the dot nor stole it; he reinvented it. To be brief, the use of black dots of varying sizes to give the

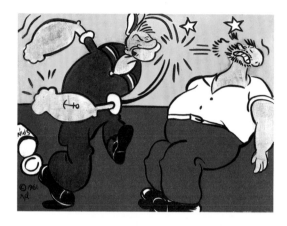

Fig. 3. Roy Lichtenstein. *Popeye*, 1961. Oil on canvas; 106.7 × 142.2 cm (42 × 56 in.). Private collection.

Fig. 4. Annotated and cut pages 10–11 from *Beckley Perforations Catalog C*, n.d. Beckley Perforating Company, Garwood, N.J. Courtesy The Roy Lichtenstein Foundation Archives.

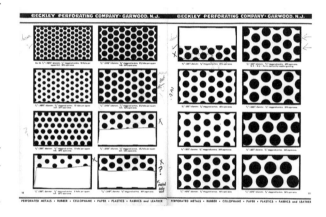

Fig. 5. Roy Lichtenstein. *George Washington (Study)*, 1962. Graphite pencil and frottage on paper; 47 × 36.8 cm (18 ½ × 14 ½ in.). Private collection.

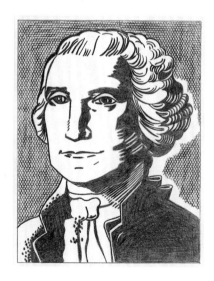

28

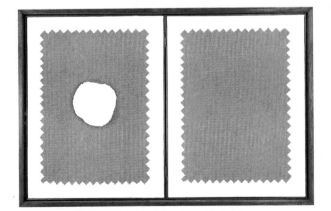

impression of gray tones, or halftones, had been pursued since the 1850s. As for color, in 1879 Benjamin Day, Jr., developed an inexpensive way to apply patterns of colored dots to plates prior to printing. By the 1880s, halftone and Benday processes were in commercial use for newspaper pictures, book illustrations, and all kinds of mass-produced images. (Not surprisingly, this was also the decade of Georges Seurat's Divisionism, dubbed "pointillism" by its critics.) The Benday dot became especially popular in the twentieth century for comic books and the Sunday funny pages.

For a close look at the operation of colored dots in comics, let us examine a detail of Wonderworld Comics's November 1939 issue of *The Flame* (fig. 6). Blue dots are used to indicate the force of the blow, where they stand alone, and for skin, where they are overlaid with flat yellow to produce a greenish tinge, while flat applications of yellow, blue, and red account for the other color areas, including a green cloak produced by a yellow-blue overlay. This simultaneous use of dots and flat areas of color within a single frame is standard in comic books, and Lichtenstein took it on board from the start. However, as *Look Mickey* also demonstrates, he tended to keep his colors (whether dots or flat areas) separate rather than mingling them, thus electing *not* to exploit the great commercial advantage of the Benday dot, its economical production of extra hues.[20]

Another standard feature of comic books exemplified by the detail from *The Flame* is the misalignment of various printing plates: neither the flat fields nor the dots of color stay in their proper places, resulting in multiple contours and haloing where imperfectly overlaid colors and textures separate out. Lichtenstein was a connoisseur of such imperfections, carefully soliciting the look of poor registration throughout *Look Mickey*, for example, in the way that the cups and points of the blue waves fail to mesh with the yellow sky, allowing the white ground to peek through.[21]

A literal if unintentional instance of poor registration enters Lichtenstein's oeuvre just after *Look Mickey* in the paintings made with the narrow, homemade screen. These all reveal slight hiccups in the dot pattern whenever he would shift the narrow stencil to a new location: "To use this stencil in areas exceeding its dimensions, Lichtenstein would move it . . . in regular intervals, matching up the dot distribution pattern to the extent possible."[22] The results are easy to spot, for example, in *Step-on Can with Leg* (1961; cat. 10), especially in the leg on the right, whose horizontal lines recall the unevenness of linen. As soon as Lichtenstein started using the larger Beckley stencils, the problem disappeared.

An amusingly self-reflexive example of the new and improved stencil technique is *Like New* (fig. 7), a hinged diptych likely based on a before-and-after advertisement for screen-door repair.[23] The screen depicted at left has a gaping, roughly circular hole, its curling edge carefully suggested by denser dots. The hole has been seamlessly mended in the image at right: no matter how closely we look, which is just what the diptych asks us to do, we cannot find a trace of the circular absence. However, all is not perfect. Uneven "inking" (the medium is actually oil paint), especially in the right panel, conveys the slightly rippled surface of the depicted screen. In addition to this intended and controlled effect, both images seem traversed by subtle white bands, difficult to pin down, moving in many directions.

The same banding is evident in another painting whose subject is close looking, especially within a central, foveal area: *Magnifying Glass* (fig. 8). Here the dots are still more regular, and indeed the painting seems to celebrate its own achievement in this regard, saying to the beholder, Go ahead, take a close look! And yet the field as a whole seems more traversed by irregularities that shift and swarm before our eyes. This optical

29

phenomenon, not unlike the white patterns that flash out of a dense field of newspaper type, is the result of retinal overstimulation coupled with an intermittent figure-ground reversal by which we interpret the white background of the staggered dot pattern as bands running in three different directions, one horizontal and two diagonal. (In *Like New*, the stencil was positioned to produce one vertical and two diagonals: Lichtenstein went back and forth over the course of his career, with some preference for the vertical orientation.) That these effects are truly optical illusions rather than actually in the paint is confirmed by the fact that they are far less present in the "magnified" portion of the dots, where the pattern is less tight and stimulating. Indeed, one could read the painting as a demonstration of the dependence of optical effects on dot density.

The staggering of the dot pattern (the diagonal offsetting of its rows with respect to one another) was crucial to producing this optical phenomenon. A rare example of unstaggered dots in Lichtenstein's oeuvre, the *Lincoln Center Poster* (1966), demonstrates just how visually static his work would have been if he had arranged his dots in a simple grid.[24] The fact that Benday dots are not offset but rather horizontally and vertically aligned testifies to Lichtenstein's deliberate solicitation of this optical excitement.

Strangely, all of this has rarely if ever been discussed in the Lichtenstein literature, as if by tacit agreement to keep the categories of Pop and "Op" nicely separate, despite or perhaps because of the fact that they developed at the same time. *Like New* and *Magnifying Glass* demonstrate a kind of marriage of the two, given that both paintings find optical effects in the simple domestic products of Pop. The fact that these products (screen and glass) both involve looking—indeed, looking through—and that Lichtenstein probably used both as instruments in his own work, completes the circle.[25]

Earlier, narrow-stencil paintings such as *Step-on Can with Leg* do not exhibit this banding effect. The material hiccups in dot facture noted above serve to prevent its emergence; they operate, whether intentionally or not, as "dither" (to use the wonderful term from digital processing), that is, signal noise introduced as a means of "preventing large-scale patterns such as 'banding' in images."[26] Thus the irregularities of these early Pop paintings, once eliminated, found dialectical fulfillment in the more striking and uncontrollable optical shiver of Lichtenstein's mature dot technique. In short, making the dots perfect brought new imperfections. *Magnifying Glass* is arguably *about* this development, about how the newly regular dots on proud display in the "magnified" portion lay behind (so to speak—they pretend to lie in front of) the optical effects most visible in the "unmagnified" portion. The new technique, to put it another way, was only *like* new.

"The advantages of a white frame are certainly evident. Thus Monsieur Seurat, far from adopting a fully colored frame, simply notes on his white frame the reactions of neighboring colors. If he stops there, all is well." So wrote the brilliant critic Félix Fénéon of Georges Seurat's submission to the 1888 Salon des Indépendants. But Seurat did not stop there: he sometimes went on to imagine that the frame itself was part of the scene and colored it accordingly, in obedience to the type and direction of light within the depiction, and this, for Fénéon, was a fatal mistake. "The frame leaves its neutrality behind, and takes on an existence of its own. Herein resides the inconvenience of this polychromy."[27]

Framing and cropping are central to the language of the comics, and equally central to Lichtenstein's art. Although his paintings themselves never bear more than a strip frame, framed art often figures in his work, whether on the walls of the Artist's Studios (1973–74; see cats. 105–08)

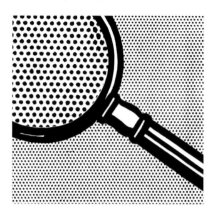

Fig. 8. Roy Lichtenstein. *Magnifying Glass*, detail (1963; cat. 25).

30

or in the Interiors (1989–97), such as *Still Life with Reclining Nude (Study)* (1997; cat. 171). In two other series, Lichtenstein explicitly raised the issue of the relationship between color or pattern within images and on their frames by painting what might be called mock trompe l'oeil frames just inside the canvas edge: the Mirrors (1969–72; see cats. 95–102) and the Reflections (1989–93), such as *Reflections on "Interior with Girl Drawing"* (1990; cat. 85). In this last work, black diagonal stripes and flat areas of white, yellow, and blue circulate around the "frame," sometimes with seemingly little relationship to what lies inside. At upper center, however, the diagonal bars extend from image onto frame seamlessly. And at upper right, a pale yellow on the frame complements a pale blue-green within: Seurat could not have done better.[28]

Did Lichtenstein intuit the problem that Fénéon put his finger on with the phrase "If he stops there, all is well"—namely, that the logic of complementary-color neighboring at the base of Seurat's "polychromy" would *not* stop, had to continue into the frame (and beyond)? Is that to some extent what the Mirrors and Reflections are about? One might object that this logic did not threaten Lichtenstein's work, given that he generally avoided the Seurat problem, that is, the pitfalls and possibilities of color juxtaposition and optical mixing—but perhaps that is precisely *why* he avoided it. In any case, Lichtenstein's dots had their own inclination to spread, their own tropism toward the edge; this was a result of their mechanical nature, far more mechanical than Seurat's touches, so mechanical that starting in 1963 he hired assistants to execute them.[29]

Where does pure repetition stop? (The fact that the repetition sets up uncontrollable optical effects does not help.) Nor was it just the repetitive nature of Lichtenstein's dots that suggested endlessness. The staggered dot pattern, with its three directions of dots, could never quite settle into the four-square rectangle of the canvas. No matter how the screen was positioned, some dots would fall short and others would get cropped. Seen in this light, the rickrack edge of the two screens depicted in *Like New* does not simply depict the screen sample in some lost advertisement; it attempts to bring the marching dots to a logical standstill by creating an edge, a kind of selvage, that at least roughly reflects their internal pattern. And yet the wide margin that Lichtenstein left between this edge and that of the canvas is an admission of defeat.

The oft-noted, surprisingly traditional aesthetic and pictorial ideals that Lichtenstein inherited from his mentor, Sherman, are relevant here. The former's concern for unity is almost Diderotian: he looked hard for cartoon frames that would "sum up" a narrative (the so-called pregnant moment of eighteenth-century aesthetic theory) rather than be "in transition," and he wanted frames that were "in some way able to be pulled together" in formal terms as well.[30] No doubt this pulling together had something to do with his tendency, starting as early as *Look Mickey*, to crop the source image (here sacrificing part of Mickey's ear), thereby creating a tighter relation between image and edge and bringing the viewer closer to the scene than in the original.

This cropping of sources soon became part of Lichtenstein's playbook, but it was not a foregone conclusion. In what I will call his Object series (1962–63), the item featured in each work, be it a hot dog, tire, or piece of gaudy jewelry (see cats. 19, 21), floats easily in its field. The opposite of cropped, each is "islanded," as Lichtenstein nicely put it.[31] In a subgroup of the Object series, he experimented with a technique between cropping and islanding, a mutual adequation of image and field "where the size and shape of the subject and the size and shape of the painting are the same."[32] In the work *Portable Radio* (1962; cat. 18), an actual leather strap hangs the painting/radio on the wall, and in three paintings titled

Compositions (all from 1964; see cat. 26), the entire surface is devoted to the rendering of a classic black-and-white school composition book.[33]

These four cases of adequation are notable for their almost total absence of dots. Could it be that Lichtenstein, attempting to create a painting-object, naturally avoided a technique that was obviously reproductive rather than realistic? No, for *Radio* employs obvious graphic conventions for the dials, nothing like trompe l'oeil. I would suggest, rather, that Lichtenstein avoided using dots here because their principle of spreading was anathema to the logic of the painting-object. (Where he does use stenciled dots in *Radio*, they have a representational excuse: the tin screen of the radio's speaker.)[34] A corollary to this can be found in the rest of the Object series, where dots, if they are used at all, most often appear in the background, the part of the image that goes out to the edge, and rarely in the objects themselves, which are strongly centered and contained.[35]

It was only after exploring these two alternatives, islanding and adequation, that Lichtenstein accepted cropping/spreading as the "fate" of his dots, the pictorial strategy they demanded. With its attendant magnification of the scene and enlargement of the dots themselves, this approach reached an apogee in a series of paintings of isolated female heads, including *Hopeless* (1963; cat. 31), *Drowning Girl* (1963; cat. 32), *Oh, Jeff . . . I Love You, Too . . . But . . .* (1964; cat. 38), and *Ohhh . . . Alright . . .* (1964; cat. 37).

These paintings, as their titles amply indicate, bring us back to the charged territory of desire and emotion with which we began. For Bader, the exclusion of any male presence in these scenes, as compared to the earlier, more fully narrative paintings in which men and women interact, such as *The Kiss* (1961; private collection) or *Masterpiece* (1962; cat. 29), suggests that "the object of these figures' attentions . . . is none other than Lichtenstein himself," and that the Pygmalion-like artist in turn longs to meet his model, somehow, on the dotted surface of the canvas to which they both draw close.[36] As Lichtenstein's girlfriend at the time recalled, "Roy wanted some beautiful Breck Girl to love him the way these women loved their men."[37]

It is here that my debt to Bader, and my differences with him, become clear. He writes of *We Rose Up Slowly* (1964; cat. 39) and similar works:

> **And just as these characters are repeatedly shown in the midst of being "swept away" . . . by flows and sensations emerging within the flattened Benday world they inhabit, so Lichtenstein's own early-'60s production is driven by the mining of new creative possibilities — or really, libidinal channels — within the increasingly "antiseptic" forms of his pop idiom.[38]**

While I share his sense that an erotics of surface is at work, I differ in the description of the dot field itself, which for Bader is a "flattened" world essentially hostile to the "flows and sensations" crossing it. He finds these flows and sensations in the nondotted abstract patterns, primarily of hair or explosions, that oppose the dotted and regulated flesh in such paintings as *Girl With Ball* (fig. 9). Taking a page from *A Thousand Plateaus: Capitalism and Schizophrenia* by Gilles Deleuze and Félix Guattari, he suggests that it is in these passages, rife with hidden images, that an uncontrolled libidinal urge can manifest itself against internalized social controls — that the "subversive force of the tic" can challenge "the rigid order of the face."[39]

While this is a compelling avenue of interpretation (which might be historicized even more by reference to the subliminal advertising scandals of the time),[40] I would argue that the dot field itself is the matrix of optical

Fig. 9. Roy Lichtenstein. *Girl With Ball*, 1961. Oil on canvas; 153.7 × 92.7 cm (60 ½ × 36 ½ in.). Museum of Modern Art, New York, gift of Philip Johnson, 421.81.

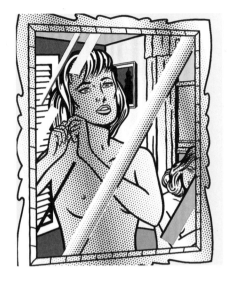

Fig. 10. Roy Lichtenstein. *Nudes in Mirror*, 1994. Oil and Magna on canvas; 254 × 213.4 cm (100 × 84 in.). Rush Family Collection, New York.

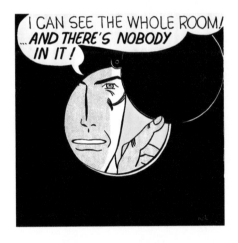

Fig. 11. Roy Lichtenstein. *I Can See the Whole Room! . . . And There's Nobody in It!*, 1961. Oil and graphite pencil on canvas; 121.9 × 121.9 cm (48 × 48 in.). Private collection.

excitement and (or as) erotic investment—and of the blush that it might engender. (And lest we deny it, Lichtenstein's *Nudes in Mirror* [fig. 10], one of his most frankly voyeuristic works, provides the perfect rhyme of a dot with a nipple, recalling other sensual rhymes of the dot in his work: with the dimples on a golf ball, the pores in a sponge, the circle of a ring about to be enfingered, a peephole.) Bader too acknowledges "the artist's own conflicted libidinal connection to his practice—to precisely the surface of painting with which, over the course of their production, these women are increasingly equated."[41] In the simplest terms, the dot pattern, not in spite of but because of its mechanical nature, gives Lichtenstein's paintings an optic-erotic vibration without which they would, and (I think) do, wither.[42]

Like New and *Magnifying Glass* can both be seen as images of blindness. One presents a circle ripped from the screen of vision (and invisibly repaired); the other, a circle of useless scrutiny, bringing us too close to see the opticality that is really there. There is a third painting from those years about focal vision and blindness: *I Can See the Whole Room! . . . And There's Nobody in It!* (fig. 11), taken quite directly from a Steve Roper comic-strip panel of the same year. In the middle of a black field, within a circle of yellow light, a finger pushes aside a peephole and a man's face looks straight into a room.

For Michael Lobel, this painting is as much a self-portrait as *Look Mickey* is for Bader: "*I Can See the Whole Room* is, after all, an image of a male figure pushing an extended digit through a circular opening—one much like the perforations in the dot-screen stencils the artist had just begun to use in his work." In an interpretive tour de force, Lobel takes this single peephole/dot to stand for the monocular, mechanical exercises of Sherman's teaching,[43] and the painting itself as representing Lichtenstein's conflicted relationship to that teaching, his sense that in the end it might sacrifice corporeality, subjectivity, even vision itself.[44] But corporeality is there (I would argue), and not just in the over-the-top phallicism of the image (which Lobel appears to miss) but in the fine red dots on a tan ground that spread over the face, warming it in contrast to the cold white of the teeth and highlights, the hard yellow background, and the black surround. Is this a blush? Is it the blush of the artist's voyeurism, projected through his dot? No, not yet.

In 1967, in a mural for the U.S. Pavilion at Expo '67 in Montreal, Lichtenstein used a custom-made Beckley metal screen with graduated dots for the first time.[45] With this innovation, the optical flows that coursed through the regular dot pattern were resorbed into the dots themselves, made explicit and channeled. Lichtenstein used the new dots to spectacular effect in the Mirror series (1969–72), but they found an equally powerful, if far less recognized, application in the Nudes of 1994–97. In this daring return to the human figure, Lichtenstein employed the dots to depict the flush—not the blush—of female flesh. The paintings are almost hard to look at in their frank admission that such schematic, blandly idealized bodies in clichéd poses could be objects, and subjects, of desire.

But wait: the waves of dots exceed the outlines of the figures, continuing into other objects or into the background (fig. 12). The figure has been overtaken, abducted. Dots course through the scene and settle here or there, their action difficult to understand, obscuring bodies and crossing boundaries, like a cataract in the sense of both *waterfall* and *obstruction of vision*. As these dots, following their own formal and psychic logic, spread beyond the body, they escape narrative and depiction to become identified instead with the surface of painting, the plane where subject and object, artist/beholder and model, would meet, the intersubjective space of the blush. This is the blush of painting that lowers its eyes, loath

33

to imagine itself seen in all of its show. (Lichtenstein's paintings are nothing if not showy.) It is not easy to simultaneously blush and look: to blush is to turn inward and downward in the face of actual or imagined exposure.

By the time of his 1970 interview with John Coplans, Lichtenstein had had almost a decade to think about his dots, and he seemed to have it all figured out. "The dots can have a purely decorative meaning, or they can mean an industrial way of extending the color, or data information, or that the image is a fake." In other words, they could be considered formal elements, or they could refer to Benday dots, or they could suggest TV and computer screens, or they could indicate a cheap imitation. Little of what I have proposed above is in his list. But Lichtenstein was not talking about the meanings he intended, only the meanings that had accrued over time: "I think those are the meanings the dots have taken on, but I'm not really sure if I haven't made all this up."[46] This abdication of any position of interpretive authority is striking and seems more than a matter of modesty. The dots are not his: he can only watch them spread.

Fig. 12. Roy Lichtenstein. *Nude with Yellow Pillow*, 1994. Sixteen-color relief print; 133.7 × 109.2 cm (52 ⅝ × 43 in.); edition of sixty.

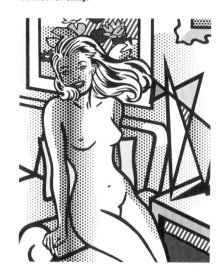

34 NOTES

My thanks to Sarah Boxer and Yve-Alain Bois for their valuable comments.

1. Lichtenstein makes the assertion in "A Review of My Work Since 1961—A Slide Presentation" (1995), in *Roy Lichtenstein*, ed. Graham Bader, October Files 7 (MIT Press, 2009), p. 57.
2. Charles Darwin, *The Expression of the Emotions in Man and Animals* (D. Appleton and Co., 1886), p. 310.
3. Ibid., p. 326. As for the big question— "Why should the thought that others are thinking about us affect our capillary action?" (p. 337)—Darwin rejects the "sexual ornament" theory, and blushing has resisted evolutionary explanation ever since. He offers only the observation that we can increase blood flow to the parts of our body by thinking intently about them: we blush when we think about our face.
4. On the history of Mickey Mouse, see http://en.wikipedia.org/wiki/Mickey_Mouse, accessed Sept. 12, 2011. For a pre-*Fantasia* example of Mickey with more realistic skin color, see Earl Duvall's drawing for the cover of the 1931 children's book *Mickey Mouse: Pictures to Paint*, reproduced in Floyd Gottfredson, *Walt Disney's Mickey Mouse: "Race to Death Valley"* (Fantagraphics Books, 2011), p. 273.
5. Graham Bader, *Hall of Mirrors: Roy Lichtenstein and the Face of Painting in the 1960s* (MIT Press, 2010), pp. 62, 66.
6. Ibid., p. 210 n. 20.
7. Ibid., pp. 68–69.
8. For Bader, Donald is the one who is self-divided, between visual acuity (his wide eyes) and tactile numbness (his apparently insensate backside),

although I would question the acuity, since he sees a fish that is not there. Bader takes this aspect of Donald as a critique of the aesthetic program of Lichtenstein's mentor at Ohio State University, Hoyt Sherman, whose flash lab was a training program in perceptual drawing. Involving images flashed in a darkened art studio, it was meant to integrate visual and tactile modalities (just what is *dis*-integrated in Donald) in the production of aesthetic wholes. Bader sees the use of text in the painting, especially on the theme of looking, as a further critique, although not a rejection, of Sherman, who hoped to eliminate cognitive and verbal preconceptions in the act of drawing. Given Lichtenstein's lifelong attachment to Sherman's teachings, Bader concludes that the painting marks a realization that "the pursuit of Shermanesque aesthetic integration necessitated an embrace of precisely the everyday commercial detritus, mechanized forms, and corrupting 'verbalisms' to which the program of perceptual unity was ostensibly opposed" (p. 56). Although Bader does not quite say it, Lichtenstein's painting proposes a third way between the perceptual realism he had been taught in the 1940s and the abstracting modernism he tried out in the 1950s, a way that would be called "Pop."
9. Bader, *Hall of Mirrors*, p. 74. Quoted from Jack Alexander, "The Amazing Story of Walt Disney," *Saturday Evening Post* 226, 19 (Nov. 7, 1953), p. 28.
10. Marcel Proust, *The Captive*, vol. 5 of *Remembrance of Things Past*, trans. C. K. Scott Moncrieff (Random House, 1927), vol. 2, p. 618.

11. Roland Barthes, *The Pleasure of the Text*, trans. Richard Miller (Hill and Wang, 1975), p. 31.
12. See note 4. The release of Epic Mickey for the Nintendo Wii video-game console in 2010 was seen as a return to earlier, naughtier aspects of the character.
13. Ward Kimball, one of Mickey's most devoted animators, said, "We could never figure out what to do with him. Who is Mickey? What does he like? Is he mean? Is he happy? Is he a Boy Scout? Does he play with himself? No one knew. And so, he finally became a symbol." Kimball, interview with Richard Shale, cited in John Canemaker, *Walt Disney's Nine Old Men and the Art of Animation* (Disney Editions, 2001), p. 114.
14. Clare Bell, chronology in this catalogue, p. 346.
15. De Kooning wrote, "Flesh is the reason oil paint was invented." Willem de Kooning, "The Renaissance and Order" (talk delivered at Studio 35, New York, Feb. 1950), reprinted in *trans/formation* 1, 2 (Feb. 1951), pp. 85–87; quotation at p. 86.
16. Lichtenstein, "A Review of My Work Since 1961," p. 69.
17. Margaret Holben Ellis and Lindsey Tyne, "'Mechanical' Drawings in the Age of Mechanical Reproduction," in *Roy Lichtenstein: The Black-and-White Drawings, 1961–1968*, exh. cat. (Morgan Library and Museum, New York, 2010), p. 55. Lichtenstein made the stencil with his former Ohio State University student Tom Doyle. Tom Doyle oral history, conducted by Avis Berman, Jan. 2, 2002, transcript, pp. 66–67. The Roy Lichtenstein Foundation Archives.

18. Ellis and Tyne, "'Mechanical' Drawings," p. 56, citing a chronology made by Clare Bell in 2007 for the Lichtenstein Foundation website. Ellis and Tyne (p. 57) note that Lichtenstein purchased two screens at about the same time, one with 4 mm holes and another with 2 mm holes, and used them until 1968, sometimes both in the same work. However, due to the weight of these screens, "in 1964 Lichtenstein commissioned Beckley to fabricate disposable perforated screens made from heavy, nonabsobent paper" (p. 58).

19. "Judging from the numerous corrected areas of frottage, especially above Washington's head, Lichtenstein quickly realized that his Beckley screen would be far more effective if used over the paper rather than under it." Ellis and Tyne, "'Mechanical' Drawings," p. 57. He placed the resulting dots, appropriately, in Washington's face, rather than confining them, as in the negative-dot drawing, to the background.

20. I think this may be part of what Ellis and Tyne (ibid., p. 62 n. 16) mean when they write, "Lichtenstein's dots are not genuine Benday dots." Lichtenstein mixed colors of dots in the mid-1960s Landscapes, the late-1960s Rouen Cathedral paintings, and *Reflections: Whaam!* (1990; Doris and Donald Fisher Collection, San Francisco), among others. More often, he placed colored dots on colored grounds to achieve mixing.

21. In his 1995 slide lecture, Lichtenstein notes that the thick black lines of cartoons "hid the difficulty printers had in registering different colors, which were printed one after the other." Lichtenstein, "A Review of My Work Since 1961," p. 59.

22. Ellis and Tyne, "'Mechanical' Drawings," p. 56.

23. The source is proposed in Michael Lobel, *Image Duplicator: Roy Lichtenstein and the Emergence of Pop Art* (Yale University Press, 2002), p. 105.

24. Reproduced in Diane Waldman, *Roy Lichtenstein*, exh. cat. (Solomon R. Guggenheim Museum, New York, 1993), p. 166. Several other prints demonstrate the same nonstaggered dot pattern. The dots of the homemade screen Lichtenstein used in 1961–62 are not staggered, nor are those of *Look Mickey*. There is also the anomaly of *I . . . I'll Think about It* (1965; Robert and Jane Meyerhoff Collection), a collage that employs a preprinted sheet of (nonstaggered) dots as background.

25. "It has been suggested that Lichtenstein used window screening as the raised surface for his frottage." Ellis and Tyne, "'Mechanical' Drawings," p. 56. The use of a magnifying glass seems likely given Lichtenstein's close attention to such "errors" as poor registration. Lichtenstein's most obviously Op-related works are the ones employing the dazzling Rowlux material (see cats. 57–58).

26. For an explanation of dither, see http://en.wikipedia.org/wiki/Dither, accessed Sept. 19, 2011.

27. Félix Fénéon, *Oeuvres plus que complètes: Tome I, Chroniques d'art* (Librarie Droz, 1970), p. 84 (my translation). My thanks to Yve-Alain Bois for bringing this passage to my attention twenty years ago.

28. Much broader parallels between Lichtenstein and Seurat are proposed by Robert Rosenblum in "Roy Lichtenstein: Past, Present, Future," *Artstudio* 20 (Spring 1991), pp. 34–43.

29. Bell, chronology, p. 348.

30. John Jones, "Tape-recorded Interview with Roy Lichtenstein, October 5, 1965, 11:00 A.M.," in Bader, *Roy Lichtenstein*, p. 25.

31. Ibid., p. 26.

32. Lichtenstein, "A Review of My Work Since 1961," p. 60.

33. There are also apparent cases of image-field adequacy in some of the War and Romance paintings, where the text boxes fit perfectly within the canvas, but these are not full-blown examples since the image part is precropped, as it were, in the source, with guns or bodies extending beyond the edge, and Lichtenstein crops it still more in the painting. Truer cases of adequacy in the later work are the Mirror and Reflections series.

34. *Stretcher Frame* (1968; fig. 14, p. 68), a canvas-filling view of a stretched canvas with keys seen from the rear, is a similar case: here the pattern of black dots has the excuse of figuring the canvas texture.

35. One exception is *Sock* (1962; private collection), in which the dots are confined to the object, but this may be because they serve nicely to depict the actual fabric, just as they depict the screen of the speaker in *Portable Radio*.

36. Bader, *Hall of Mirrors*, p. 117.

37. Letty Lou Eisenhauer in conversation with Bradford Collins, in Collins, "Modern Romance: Lichtenstein's Comic Book Paintings," *American Art* 17, 2 (Summer 2003), cited in Bader, *Hall of Mirrors*, p. 123.

38. Bader, *Hall of Mirrors*, p. 127.

39. Ibid., p. 91.

40. Bader mentions Vance Packard's *Hidden Persuaders* (1957) but does not seem aware that his own detection of bodies, limbs, and faces within Lichtenstein's patterns of hair and water is not unlike the decoding of subliminal messages.

41. Bader, *Hall of Mirrors*, p. 117.

42. To my eye, one of the few successful series of non-dot paintings is the Plus and Minus series of 1988 (see cat. 83), in which Lichtenstein developed an equivalent to the staggered dot pattern consisting of alternating horizontal and vertical blocks.

43. See note 8.

44. Lobel, *Image Duplicator*, pp. 102–03.

45. Bell, chronology, p. 352.

46. John Coplans, "Interview: Roy Lichtenstein" (1970), in Bader, *Roy Lichtenstein*, p. 36.

PICASSO IN TWO ACTS

IRIA CANDELA

Roy Lichtenstein's career demonstrates that there are indeed second acts in American lives. If he had stopped painting in 1961, as he was approaching middle age, most likely he would be unknown today. Although he painted profusely during the 1940s and 1950s, Lichtenstein is celebrated as one of the leading figures of Pop art—a style he practiced only after he turned thirty-seven. Even art historian Ernst Busche, who has a profound knowledge and admiration for Lichtenstein's early work, admits that his post-1961 trajectory is, without a doubt, "his greatest achievement."[1] Nevertheless, the artistic production of his early years offers a unique perspective on his subsequent work, as many of the aesthetic and thematic interests of the mature Lichtenstein—in particular, his relationship to the work of Pablo Picasso—gestated during his pre-Pop period.

Lichtenstein openly acknowledged Picasso as his main artistic influence. In an interview with John Jones in 1965, he announced, "I think really the painter I like best is Picasso, just because of the variation and the insistence of his images."[2] In 1988, he commented, "I think Picasso is the greatest artist of the twentieth century by far. Is there any real doubt about that? I think he had just more magic, more insanity, more images, more styles, greater production than many others."[3] And in 1996, one year before his death, he succinctly declared, "The big influence is Picasso."[4]

But Lichtenstein's artistic relationship with the Spanish master was neither rigid nor uniform: it evolved from early admiration to critical engagement, radically changing after his "discovery" of Pop art in 1961. While the early Lichtenstein painted under the strong influence of Picasso, the late Lichtenstein was able to sustain a stimulating dialogue with him on equal terms. This played an essential role in Lichtenstein's intellectual

development as an artist who tirelessly sought to revise the aesthetic notions of authorship, originality, and commodification.

ACT 1

Richard B. Baker: How many times were you interviewed before 1961?
Roy Lichtenstein: Just about never.[5]

Lichtenstein was attracted to Picasso's work from the very beginning. In 1937, at age fourteen, he read his first book on art history, Thomas Craven's *Modern Art: The Men, the Movements, the Meaning*. Years later he could recall that it included a reproduction of Picasso's *Girl before a Mirror* (1932; fig. 9, p. 98).[6] During a visit to the Museum of Modern Art with his mother and sister in May 1939, Lichtenstein saw *Guernica* (1937; Museo Nacional Centro de Arte Reina Sofía, Madrid) for the first time and was greatly impressed by it. When Picasso's masterpiece was exhibited in 1941 in Columbus, Ohio, he openly shared his admiration with classmate Charles Batterman.[7]

While studying fine art at Ohio State University, Lichtenstein refined his appreciation for Picasso. College professor and mentor Hoyt Sherman encouraged him to explore how Picasso created a unified space through the dialectical interaction of figure and background. Sherman's theories were the foundation for his understanding and emulation of Picasso's "perceptual unity."[8] One of Lichtenstein's first paintings, *Untitled (Portrait of a Man)* (fig. 1), openly references Picasso's *Gertrude Stein* (1905–06; Metropolitan Museum of Art, New York). The pictures share the posture of the subject, the oval shape of head and eyes, and the palette of warm ochres. Likewise, some of Lichtenstein's paintings from the early 1940s, such as *Reclining Woman* (1942; private collection), were inspired by Picasso's Blue and Pink periods.[9]

Lichtenstein was inducted into the U.S. Army in 1943, and his combat tour took him to England, Belgium, and Germany. In October 1945 he arrived in a liberated Paris. He visited the Louvre Museum and, following the footsteps of other young soldiers, writers, and artists, decided to visit Picasso's studio:

> I remember I always wanted to meet Picasso and I found out he had a studio in — was it — Rue des Grands Augustins or something and went there . . . but I was actually afraid to go in. There was a big gate and there was a paper mill or something on part of it, it was very closed off. I think actually at that time Picasso was not seeing GIs any longer.[10]

Any other attempt to meet Picasso at that time was thwarted in December 1945, when Lichtenstein had to return to America due to his father's illness.

After finishing his undergraduate degree in June 1946, Lichtenstein stayed on at Ohio State as an art instructor. That same year he made *Head* (private collection), a carved stone sculpture whose rounded and primitivist forms recall the female busts created by Picasso in 1931. Two years later, Lichtenstein finished *The Musician* (fig. 2), a direct allusion to the clarinetist of *Three Musicians* (1921; Museum of Modern Art, New York), the major work painted by Picasso in Fontainebleau. In his canvas Lichtenstein captured the humor of the Cubist Pierrot through a geometrical deconstruction of the figure observed from multiple viewpoints. Picasso's shadow is discernible in many other early Lichtenstein works: from prints such as *To Battle* (1951; edition of ten), where he paid tribute to Picasso's

37

Fig. 1. Roy Lichtenstein. *Untitled (Portrait of a Man)*, 1943. Oil on canvas; 80.6 × 60.3 cm (31 ¾ × 23 ¾ in.). Private collection.

Fig. 2. Roy Lichtenstein. *The Musician*, 1948. Oil and graphite pencil (possibly charcoal) on canvas; 45.5 × 40.5 cm (18 × 16 ¼ in.). The Roy Lichtenstein Foundation Collection.

Minotauromachy (1935; Museo Nacional Centro de Arte Reina Sofía, Madrid), to drawings, pastels, and even found objects such as *The Warrior* (1951; National Gallery of Art, Washington), which clearly evokes Picasso's *Head of a Bull* (1942; Musée National Picasso, Paris).[11] The lithograph series David and Bathsheba (1947) heavily influenced Lichtenstein's oil paintings *Beauty and the Beast I* (private collection) and *Beauty and the Beast II* (location unknown), signed only two years later, and demonstrates "how closely he followed the work of the master."[12]

An early formulation of Lichtenstein's philosophy of art can be found in his master of fine arts thesis, submitted in 1949.[13] His artwork was complemented by nine poems, in which he reflected with humor and irony on the process and meaning of art. A section of the second poem reads, "In awe, then, you must sing/An Ode to the Wonderful Wizards of Art:/Sing of Klee's secret glee,/And of Picasso's electric expression."[14] Referencing artists from Vincent van Gogh and Paul Gaugin to Henri Rousseau and Georges Braque, Lichtenstein conceived painting not as a method of self-expression or re-creation of natural beauty, but instead as an intellectual exercise of dialogue between artists. This understanding undoubtedly represented a crucial prelude to his Pop period: both before and after 1961, Lichtenstein painted not from life directly, but from borrowed images taken from comics, advertisements, or art history books. "Art," he would sententiously declare, "relates to perception, not nature."[15]

In 1951 Lichtenstein moved to Cleveland, where he worked intermittently as an industrial designer and engineering draftsman. While there, he began a series of works based on history paintings by American artists such as Charles Willson Peale and Frederic Remington. Images of American history, Native Americans, and the Old West were transfigured by his Cubist and Expressionist style. From an iconographic perspective, the American history paintings quoted by Lichtenstein were easily recognizable; however, from a stylistic point of view, the main influence remained Picasso. As Lichtenstein himself later pointed out, "They were of American scenes but they were seen more through Picasso's eyes, I think, than mine."[16] *Indian with Pipe* (1953; private collection), for instance, deconstructed the subject in a Picassoesque way, linking the pipe to Parisian Cubist paintings rather than to Native American spiritual iconography.

Abstract Expressionism was the prevailing style in Lichtenstein's work from the period 1957–1960, when he was teaching at the State University of New York, Oswego. Paintings such as *23* (private collection) and *Composition* (private collection), both dated 1959, epitomize a new stage in his career. But this simply consisted of substituting one influence for another; since Lichtenstein conceived painting as an intellectual rather than an emotional quest, Abstract Expressionism represented an obstacle more than a liberation. In other words, it was the right step in the wrong direction: Lichtenstein needed to break with Picasso's influence, but simply replacing it with the style of Jackson Pollock and Willem de Kooning was not the solution. And even then, traces of Picasso remained, as Lichtenstein later admitted: "Abstract Expressionism almost as a movement was an effort to get away from Picasso [because] any hint of subject matter they ever put in looked so much like Picasso, I think even de Kooning's *Women*, as soon as there was an eye or a mouth or something in it, it took on a Picasso quality, at least to me."[17]

"Act 1" of Lichtenstein's career ended in 1961 with his move to New Jersey to teach at Douglass College, Rutgers University. He had spent two decades in search of a personal style with which to respond to a fundamental question raised at the very beginning of his career:

It was very obvious to me that there was some underlying,
difficult-to-grasp principle about art; that if two things can
be very much alike to me and one can be of great value, the other
be aesthetically valueless, that there must be some very subtle
thing that has to do with painting. And I was very much interested
in finding out what that underlying principle is.[18]

ACT 2

Richard B. Baker: I just wanted to bring out the fact that you have
 become a "name" artist now. Do you find this burdensome?
Roy Lichtenstein: No, I find it delightful.
RB: Well, it might become burdensome after another twenty years if you
 get to be as famous as Picasso or something.
RL: It's the best kind of burden I think to labor under.[19]

Fig. 3. Roy Lichtenstein. *Femme au chapeau*, 1962. Oil and Magna on canvas; 172.7 × 142.2 cm (68 × 56 in.). Private collection.

In 1962 Lichtenstein painted *Femme au chapeau* (fig. 3), his first direct appropriation of a work by Picasso. Only a year had passed since he had adopted the Pop style that would bring him international acclaim. In fact, Robert Rosenblum recalled that "for most of the world, Lichtenstein was born at the Leo Castelli Gallery in February–March 1962, at an exhibition that dumbfounded with horror or delight everybody who saw it and that can still jolt the memory."[20] But how did Lichtenstein transform his style in this second act of his career? In exactly what way did his relationship to Picasso change?

In his first Pop paintings, from *Look Mickey* (1961; cat. 8) and *Girl With Ball* (1961; fig. 9, p. 32) through *Drowning Girl* (1963; cat. 32) and *Whaam!* (1963; cat. 36), Lichtenstein featured an entirely new style, mimicking the compositional techniques of comics and advertisements: a palette of primary colors, flat backgrounds, heavy black lines for outlining, and Benday dots that artificially simulated shadows and tonalities. Imitating industrial and mechanical forms of representation, this style enabled him to paint a varied range of topics—from a comic superhero to a golf ball. In fact, this pictorial method was so broad that by 1965 his subject matter included brushstrokes, landscapes, sunsets, and pyramids.

Lichtenstein quickly understood that the artificial and parodical practice of duplicating already existing images could also be employed to create variations of artworks—not only by Picasso, but also by Piet Mondrian and Claude Monet. In *Femme au chapeau*, the use of Picasso's *Woman in Gray* (1942; Brooklyn Museum, New York) is completely transparent, for Lichtenstein re-creates the original in a straightforward manner. The same female figure appears in the identical position and with the same shape of eyes, neck, and hat. The structure of the Cubist image, with its unequivocally Picassoesque face, remains intact. Yet at the same time, everything has changed. Where Picasso used grays and ochres, Lichtenstein chooses instead pure yellow and two tones of cool and chemical blue. The volumes and sensations conveyed by the texture of Picasso's brushstrokes have been annulled by a geometrical composition that flattens space. This industrial effect eliminates any signs of organic life from the canvas. The image has been reduced to its essence as a code or minimum unit of meaning, and yet, with its extreme reduction, it moves us.[21]

Femme au chapeau dramatically illustrates the changed relationship of Lichtenstein to Picasso. His personal vision no longer depends on the gaze of Picasso: only by discovering the Pop style can he finally confront the master. In this sense, *Femme au chapeau* declares, in a personal and public way, his emancipation from Picasso. As Lichtenstein himself

39

recognized years later, "I was always I guess trying to hide [Picasso's] influence in a way . . . and suddenly to do one that really looked like Picasso seemed very liberating. It was very liberating to know I could do something with the Picasso and it would be *me*."[22]

In 1963 Lichtenstein produced three other works that, with *Femme au chapeau*, constitute what Henry Geldzahler has designated "Lichtenstein's Picasso Women Series":[23] *Femme dans un fauteuil* (Nationalgalerie, Berlin) was based on *Woman Seated in an Armchair* (1941; Zervos 11:343); *Woman with Flowered Hat* (fig. 4), on Picasso's *Woman with Flowered Hat* (1939–40; Morton G. Neuman Family Collection); and *Femme d'Alger* (cat. 64), on a female figure from Picasso's Women of Algiers series (1954–55). Lichtenstein employed the same method of simplifying the original pictures through a graphic codification of forms and pictorial tones. In *Femme d'Alger* the play of references became more intricate, since Picasso's work was already a variation on Eugène Delacroix's *Women of Algiers in Their Apartment* (1834; Musée du Louvre, Paris).[24] It was precisely this metadiscursive quality that motivated Lichtenstein to choose that painting—as he explained, he painted his *Femme d'Alger* "for that reason, because [Picasso] did it from Delacroix."[25]

Lichtenstein's first Pop exhibition of 1962 generated ambivalence within the art world, as his work was viewed as an assault on the prevailing understanding of originality in art.[26] "Copying" Picassos was seen not only as an illicit way to "kill" the master of modern painting, but also as an attempt to supplant him and assume the "burden" of his fame. Yet those flawed interpretations missed Lichtenstein's own announcement of the death of the author. As Roland Barthes and Michel Foucault would soon argue, there is no such thing as an original text, for every work is a complex combination of previous ideas, a polysemic discourse without a single author.[27] In this sense, *Femme d'Alger* should be understood as an amalgam of signatures flowing together onto the same canvas—a Lichtenstein, a Picasso, and a Delacroix all at once. According to Barthes, the understanding of the work of art as a palimpsest leads not only to the death of the painter/author, but also to the birth of the spectator/reader:

> However much Pop art has depersonalized the world, platitudinized objects, dehumanized images, replaced traditional craftsmanship of the canvas by machinery, some "subject" remains. What subject? The one who looks, in the absence of the one who makes. We can fabricate a machine, but someone who looks at it is not a machine—he desires, he fears, he delights, he is bored, etc. This is what happens with Pop art.[28]

This transformation of the artistic subject can be sensed in Lichtenstein's well-known pronouncement, "But my work isn't *about* form. It's about seeing."[29] If, according to Foucault, "the author is the ideological figure by which one marks the manner in which we fear the proliferation of meaning,"[30] then Lichtenstein, by removing his signature from the canvas, was creating new meanings of Picasso's legacy.[31] Paraphrasing the Foucauldian twist, one could argue that Lichtenstein's Picassos force the viewer to abandon outdated questions like Who paints? and With what originality? and focus instead on issues such as the modes of existence of a discourse, where it has been used, how it circulates, and who can appropriate it.[32]

Lichtenstein returned to Picasso over the years, in numerous metapaintings that document an ongoing dialogue. With *Still Life after Picasso* (fig. 5), Lichtenstein painted not Picasso's still life, but rather its cheap, mechanical reproduction, just as it appeared in a book or a magazine. He did not copy the "real" Picasso—*Guitar, Glass, Fruit Dish with Fruit*

Fig. 4. Roy Lichtenstein. *Woman with Flowered Hat*, 1963. Oil and Magna on canvas; 127 × 101.6 cm (50 × 40 in.). Private collection.

40

Fig. 5. Roy Lichtenstein. *Still Life after Picasso*, 1964. Magna on Plexiglas; 121.9 × 152.4 cm (48 × 60 in.). Collection of Barbara Bertozzi Castelli.

Fig. 6. Roy Lichtenstein. *Still Life with Picasso*, 1973. Screen print on Arches 88 paper; 72.2 × 53.2 cm (30 × 22 in.); edition of ninety.

(1924; Zervos 5:252)—but its mystified appearance as advertisement, fetish, or cultural myth.[33] On several occasions Lichtenstein expressed an interest in portraying the "anti-sensibility"[34] that pervaded society during the 1960s. For that purpose he cleverly chose the very "insensible" style of commercial art. *Still Life after Picasso* translates a low-quality reproduction of a high-art painting "into another high-art medium that *pretends* to be low art."[35] Such suggestion of mechanical reproduction obscures the fact that the transposition is not automatic. On the contrary, Lichtenstein paints the mechanical, but he does it manually. As Otto Hahn commented, "Lichtenstein's work seems so obvious that we generally miss the obvious";[36] perhaps one of the most overlooked features of his oeuvre is precisely this *faking* of the industrial.[37]

Between 1973 and 1975 Lichtenstein made a dozen works—from *Flowers* (1973; edition of 380) to *Le Journal* (1975; private collection, Zollikon)—that re-created the spatial complexity of Cubist *natures mortes*. Here Lichtenstein engaged Picasso as an equal, and, as the title of *Still Life with Picasso* (fig. 6) suggests, he was no longer working *after* the Spanish artist, but *with* him. This work juxtaposes the traditional iconography of a still life with a Picassoesque head; on this occasion, there is no direct reference to Picasso's oeuvre. Rather than an object of appropriation, the Spanish master is summoned to enter the Pop canvas. The female face that appears next to a vase with brushes and a few bananas does not present a parody of a cheap Picasso reproduction, but a festive blending of both painters' imaginaries. In fact, *Still Life with Picasso* is a reminder of how the Spanish artist himself established a dialogue with the Old Masters during his late career.

For their jovial and irreverent approach, Picasso's variations, like Lichtenstein's, provoked discomfort among many critics.[38] In his multiple re-creations, Picasso paid an informal—even mocking—homage to artists such as Diego Velázquez and Rembrandt. The way in which, for example, *Portrait of a Painter, after El Greco* (1950; Museum Sammlung Rosengart, Luzern) reformulated the famed El Greco painting *Portrait of Jorge Manuel* (1605; Museo de Bellas Artes, Seville), confirms how variation for Picasso was "a form of free play or *jeux d'esprit*, in which he attempt[ed] to work his way out of the paintings that entrap him, and to construct new meaning from the old signs, freighted with historical and personal significance."[39] As for Lichtenstein, art history became an endless source of renewal through which Picasso could satiate his voracity—a creative process that John Richardson has described with the Freudian term "psychic cannibalism."[40] The fact that he signed his painting *Musketeer* (1967; Ludwig Múzeum, Budapest) as "Domenico Theotocopoulos van Rijn da Silva" shows to what extent Picasso could consume El Greco, Rembrandt, and Velázquez in a single bite. The late Lichtenstein was equally a master of iconophagy, who also appropriated Matisse, Fernand Léger, Theo van Doesburg, and by extension, a large part of the art movements of the twentieth century—from Surrealism and German Expressionism to Futurism, Art Deco, and beyond.[41]

Lichtenstein's desire to invoke Picasso in his paintings became more evident during the 1980s, as he discarded some basic Pop strategies in search of new paths.[42] One innovation was self-reference. Lichtenstein started to reproduce his earlier works within his new paintings, adding another twist to the genre of metapainting. For example, *Two Paintings with Dado* (1983; private collection) simulates a wall space with, on one hand, the top section of Lichtenstein's *Woman with Flowered Hat* duly presented in a yellow frame, and on the other, the lower section of another framed painting, a "Jasper Johns' flagstone pattern."[43] The detailed representation of the frame moldings emphasizes the idea of a painting within

a painting and, at the same time, reflects upon the illusive character of painting itself as an artistic medium. In *Paintings: Picasso Head* (1984; private collection), a Picassoesque face hangs next to an Abstract Expressionist painting with its idiosyncratic brushstrokes.[44] Lichtenstein increases spatial illusion with a blue sky background . . . or is it perhaps wallpaper simulating a landscape?

Another 1980s innovation, intimately related to Picasso and self-reference, treats the painting as a museum. Lichtenstein conceived the canvas as an imaginary space where pictures of art history could coexist. This is no longer the artist's studio, but a space inside his mind: a repository of memories in which all the images of Lichtenstein's universe vibrate, forming a controlled and astonishing chaos. For this, he needed to conquer the mural size, first in the *Greene Street Mural* (1983; destroyed), 18 by 96 feet, in which the woman of *Still Life with Picasso* reappears on the right side of the composition, and later, in the *Tel Aviv Mural* (fig. 7), where Lichtenstein painted again his first Picasso, *Femme au chapeau*.

Fig. 7. Roy Lichtenstein. *Tel Aviv Mural*, 1989. Oil and Magna on canvas; 700 × 1700 cm (275 9/16 × 669 5/16 in.). Tel Aviv Museum of Art, gift of Roy Lichtenstein.

In both murals the Picassos live side by side with the panoply of renowned Lichtenstein motifs. Picasso's image is reactivated here through a process of disillusion and dereification. As Hal Foster has pointed out, Lichtenstein "provides an illusionistic image and tricks the eye, but he also breaks the illusion and exposes the trick."[45] The disillusion is articulated as a direct critique of the way the art institution commercializes culture and dismantles its emancipatory power. By emphasizing the process by which the political value of artworks is assimilated and disarmed by the culture industry, Lichtenstein "implies that no language, verbal or visual, is immune to this process."[46] Perhaps Lichtenstein's decision to destroy the *Greene Street Mural* after its presentation at Leo Castelli reflected a wish to save the painting from this fate (even at the cost of sacrificing its existence). In this regard, as Dorothy Lichtenstein has explained, "He wanted to do this as an impermanent piece of work that would be the exhibition, but not an object. His work was becoming very costly, and he loved the idea of doing something that couldn't be sold—just erased."[47]

In his 1980s works, Lichtenstein's choice of the Picasso image implies "a way of making clichés that occur in Picasso more clichéd," but also, according to Lichtenstein, "a way of re-establishing them," of "making them not a cliché."[48] Picasso comes back to life, transfigured: he is no longer the ghost who haunts "living artists" nor a "threatening presence to be annihilated, exorcised or worshipped."[49] The Spanish master has been invited to a real *fiesta* of painting, a celebration in which his legacy can confront with renewed energy the process of reification that once imprisoned it. In this sense, according to Michael Lobel, Lichtenstein's approach "is reminiscent of those medical treatments in which the patient is given small doses of a poison in order to build up immunity."[50]

CODA

The painter takes whatever it is and destroys it. At the same time, he gives it another life. For himself. Later for other people. But he must pierce through what the others see—the reality of it. He must destroy. He must demolish the framework itself.

 —Pablo Picasso, quoted in André Malraux, *Picasso's Mask*

Two acts, two Lichtensteins, two modes of engagement with Picasso's influence. Dividing them, a Copernican turn: the discovery of Pop. In 1961, Lichtenstein destroyed one way of making (and understanding) art in order to build another. Through a combination of high and low art, his Pop style blew up a canonical and exclusivist idea of artistic practice. "You could say my work is a vulgar version of Picasso," Lichtenstein affirmed on one occasion, "[but] I don't really think I'm vulgarizing Picasso any more than Picasso vulgarized his subjects . . . Everywhere through modern history, art has always been vulgarized. By that, I don't mean to put it down, what I mean is that art *demystifies*."[51]

No analysis of Lichtenstein's aesthetics can ignore either this demystifying quality or his complex relationship to the history of art. According to Barthes,

> **Pop art as we know it is the permanent theater of this tension: on one hand, the mass culture of the period is present in it as a revolutionary force which contests art; and on the other, art is present in it as a very old force which irresistibly returns in the economy of societies. There are two voices, as in a fugue — one says: "This is not Art"; the other says, at the same time: "I am Art."[52]**

To study Lichtenstein's Picassos is to acknowledge the two voices of the fugue, to recognize the subversion of pictorial conventions, to follow the journey of art to the land of anti-art where every cultural illusion is criticized and the traditional aesthetic framework is disregarded. Lichtenstein referred to this process when he declared, "I think all artists destroy literal meaning."[53] Only through the rejection of the mythical and normative character of painting could his art survive its own reification.

Perhaps none of Lichtenstein's appropriations formulates a greater critique of illusion than one of his last Picasso variations, *Reflections on "Interior with Girl Drawing"* (1990; cat. 85). The re-created work by Picasso — *Deux femmes* (*Two Women*) (1935; Museum of Modern Art, New York) — appears now as a framed painting under glass that produces reflections and prevents the spectator from viewing the whole picture.[54] Just as in his Mirror series (1969–72), Lichtenstein creates an image that questions not only the relationship between painter and spectator, but also the notion of the image itself. Is the ultimate meaning of Picasso's oeuvre unattainable? Is painting always a delusion, an indecipherable enigma? Lichtenstein seems to join Picasso in a dialogue with Velázquez's *Las Meninas* and, by extension, with a long tradition in art history that undermines the materiality of the world by highlighting the phantasmagoric, ephemeral, and evanescent qualities of the real.

Unlike the early Lichtenstein — unable to escape Picasso's tutelage — the late Lichtenstein acquired a personal style; paradoxically, as Thomas Crow has indicated, "his own attainment of a distinctive fine-art personality required his suppressing the one that he already had."[55] In the second act of his career, Lichtenstein was able to engage Picasso without complexes and, along the way, to criticize the process through which Picasso's masterworks had become reified signs. But, as we have seen, Lichtenstein did not simply condemn the trivialization of Picasso. His appropriations should not be misunderstood as a mere antipatriarchal impulse; in fact, his paintings revitalized the legacy of the father of modern art. In his Picassos, Lichtenstein was carrying out "a sort of sly, ironically aristocratic game for salvaging a language which was and still is in danger of being lost."[56] Beyond this rescue of the language of painting and the critique of signs, a third social function of his work emerges: the

revitalization of the very act of seeing. As he confronted the mythical notion of the "author" and the capitalist fetishization of images, Lichtenstein fought the regressive gaze of the spectator and encouraged viewers to develop a truly critical appreciation of art.

In April 1997, in what would be his last published interview, Lichtenstein spoke again of his vital relationship with Picasso's "electric expression," and admitted, "I don't think that I'm over his influence."[57] So . . . Picasso in three acts? A drawing and a collage created shortly before his death show that Lichtenstein was preparing a painting titled *Mickasso* (fig. 8), a work that would resume not only his connection with the Spanish master but also his entire trajectory. Returning to the theme of *The Musician*, painted by Lichtenstein almost forty years earlier, and following Picasso's Cubist style—specifically, his *Harlequin with a Guitar* (1918; Collection Jacqueline Picasso, Mougins)—*Mickasso* again presented the character of commedia dell'arte, this time with a Mickey Mouse hand playing the guitar, and established the ultimate combination of high and low culture, art and comics, gravity and humor. What would Picasso have thought of Lichtenstein's irreverent variations? When asked this question, Lichtenstein answered, "I think Picasso would have thrown up if he'd seen my versions. Maybe not, though. Maybe he would have fallen in love with them and then destroyed all his other work."[58]

Fig. 8. Roy Lichtenstein. *Mickasso (Study)*, 1996. Tape, cut-and-pasted painted and printed paper on board; 77.8 × 65.1 cm (30 ⅝ × 25 ⅝ in). Private collection.

NOTES

1. Ernst Busche, *Roy Lichtenstein: Das Frühwerk, 1942–1960* (Gebr. Mann Verlag, 1988), p. 262. Subsequent quotations of this book come from the unpublished English translation by Russell Stockman, *Roy Lichtenstein: The Early Work, 1942–1960*, courtesy of the Roy Lichtenstein Foundation. Thanks to Clare Bell and the foundation's staff for their invaluable help during my research. Needless to say, Lichtenstein's style went through multiple "scenes" as well, but this two-act division still offers valuable insight into his relationship with Picasso's oeuvre.
2. John Jones, "Tape-recorded Interview with Roy Lichtenstein, October 5, 1965, 11:00 A.M.," in *Roy Lichtenstein*, ed. Graham Bader, October Files 7 (MIT Press, 2009), p. 24.
3. Matthew Diehl, "Conversation with Roy Lichtenstein," July 1988, transcript, [p. 5]. The Roy Lichtenstein Foundation Archives. Part of this conversation was published as "Picasso Was Here: Five Contemporary Artists Mine the Master," *Art and Antiques* 6, 2 (Feb. 1989), pp. 37–38. See also Barbaralee Diamonstein, "Caro, de Kooning, Indiana, Lichtenstein, Motherwell, and Nevelson on Picasso's Influence," *Artnews* 73, 4 (Apr. 1974), pp. 44–46.
4. Joan Marter, "Interview with Roy Lichtenstein," Mar. 27, 1996, transcript, [p. 3]. The Roy Lichtenstein Foundation Archives.
5. Richard B. Baker, "Tape-recorded Interview with Roy Lichtenstein," Nov. 1963–Jan. 1964, tape 1, transcript, p. 10. Archives of American Art, Smithsonian Institution, Washington, D.C.
6. Ibid., p. 78.

7. Charles Batterman, oral history, conducted by Avis Berman, Aug. 15, 2002, Hancock, N.H., transcript, pp. 19–20. The Roy Lichtenstein Foundation Archives.
8. On Sherman's influence, see Michael Lobel, *Image Duplicator: Roy Lichtenstein and the Emergence of Pop Art* (Yale University Press, 2002), chap. 3.
9. Baker, "Tape-recorded Interview with Roy Lichtenstein," tape 2, transcript, p. 73. Lichtenstein subsequently destroyed most of these paintings.
10. Ibid., p. 6. Indeed, around that time Picasso was focused on creating lithographs in Fernand Mourlot's studio. As Françoise Gilot wrote, Picasso "was being more and more distracted from his work by an increasing flow of visitors, English and American, as well as old French friends . . . the chance to get out of the atelier of the Rue des Grands-Augustins and into the relative seclusion of Mourlot's print-shop seemed a good idea." In Françoise Gilot and Carlton Lake, *Life with Picasso* (Virago Press, 1990), p. 85.
11. In his personal library, Lichtenstein kept a first edition of Paul Éluard's *À Pablo Picasso* (Éditions des Trois Collines, 1944), in which he sketched three portraits— dated 1947—following the style of Picasso.
12. Busche, *Roy Lichtenstein*, p. 54.
13. Roy Lichtenstein, "Paintings, Drawings, and Pastels" (1949), p. 1. The Roy Lichtenstein Foundation Archives. Published as *Paintings, Drawings, and Pastels: A Thesis by Roy Fox Lichtenstein* (Fundación Juan March, 2007).
14. Lichtenstein, "Paintings, Drawings, and Pastels," pp. 2–3.
15. Quoted in Michael Kimmelman, "At the

Met with: Roy Lichtenstein; Disciple of Color and Line, Master of Irony," *New York Times*, Mar. 31, 1995, p. C27.
16. Baker, "Tape-recorded Interview with Roy Lichtenstein," tape 2, p. 3.
17. Ibid., p. 4.
18. Ibid., tape 1, p. 76.
19. Ibid., p. 13.
20. Robert Rosenblum, "Roy Lichtenstein: Past, Present, Future," in *Roy Lichtenstein*, exh. cat. (Tate Gallery, Liverpool, 1993), p. 9.
21. Otto Hahn, "Roy Lichtenstein" (1966), in *Roy Lichtenstein*, ed. John Coplans (Praeger, 1972), p. 139.
22. Diehl, "Conversation with Roy Lichtenstein," [p. 1]; emphasis added.
23. Henry Geldzahler, *Lichtenstein's Picassos, 1962–1964*, exh. cat. (Gagosian Gallery, New York, 1988), n.pag.
24. Picasso created fifteen canvases after the French master, which he designated as versions A through O. In his painting Lichtenstein primarily referred to version L and the female figure located on the left side of version K.
25. Baker, "Tape-recorded Interview with Roy Lichtenstein," tape 2, p. 3.
26. As early as 1962, art writers and artists such as Dore Ashton, Clement Greenberg, and Robert Motherwell dismissed Lichtenstein's methods: "In fact, it is hard to imagine now the degree of absolute scorn and creeping anxiety Lichtenstein's work could generate in the 1960s." Rosenblum, "Roy Lichtenstein," p. 10.
27. Roland Barthes, "The Death of the Author" (1968), in *Image, Music, Text*, trans. Stephen Heath (Hill and Wang, 1977), pp. 142–48; and Michel Foucault, "What Is an

Author?" (1969), in *Language, Counter-Memory, Practice: Selected Essays and Interviews*, trans. Donald F. Bouchard and Sherry Simon (Cornell University Press, 1977), pp. 113–38.

28. Barthes, "That Old Thing, Art . . ." (1980), in *The Responsibilty of Forms: Critical Essays on Music, Art, and Representation*, trans. Richard Howard (Basil Blackwell, 1986), pp. 204–05.

29. John Coplans, "Interview: Roy Lichtenstein" (1970), in Bader, *Roy Lichtenstein*, p. 48.

30. Foucault, "What Is an Author?" p. 119.

31. In this respect, Lobel has written that "it has gone unremarked in the critical literature that, among the substantive changes Lichtenstein made in the process of appropriation, he deleted the signatures that those earlier artists had consistently applied to their paintings." Lobel, *Image Duplicator*, p. 60.

32. Foucault, "What Is an Author?" p. 120.

33. Lichtenstein said once that he re-created not a "real" but a "fake" Matisse. In Jean-Claude Lebensztejn, "Roy Lichtenstein in Conversation on Matisse" (1975), in Bader, *Roy Lichtenstein*, pp. 49–50. Picasso's still life is reproduced in *Picasso's Paintings, Watercolors, Drawings and Sculpture: A Comprehensive Illustrated Catalogue, 1885–1973; Neoclassicism II, 1922–1924* (Alan Wofsy Fine Arts, 1996), p. 217.

34. See, for example, Alan Solomon, "Conversation with Lichtenstein," in "Lichtenstein," ed. Alberto Boatto and Giordano Falzoni, special issue, *Fantazaria: Rivista Bimestrale di Arte e Cultura* 1, 2 (July–Aug. 1966), p. 36.

35. Diehl, "Conversation with Roy Lichtenstein," [p. 4]; emphasis added.

36. Hahn, "Roy Lichtenstein," p. 136.

37. Lichtenstein voiced this goal explicitly: "I want my painting to look *as if* it has been programmed. I want to hide the record of my hand." John Coplans, "Talking with Roy Lichtenstein" (1967), in Coplans, *Roy Lichtenstein*, p. 86; emphasis added. But such programming of the work is only a simulation: "I really don't think that art can be gross and over-simplified and remain art. I mean it must have subtleties and it must yield to aesthetic unity, otherwise it's not art." In Solomon, "Conversation with Lichtenstein," p. 36.

38. For more information on the reception of Picasso's variations, see John Richardson, "L'epoque Jacqueline," in *Late Picasso*, exh. cat. (Tate Gallery, London, 1988), pp. 26, 36. Concerning Picasso's variations in general, see Susan G. Galassi, *Picasso's Variations on the Masters: Confrontations with the Past* (Harry N. Abrams, 1996); *Picasso: Tradición y van-guardia*, exh. cat. (Museo del Prado, Madrid, 2006); and *Picasso et les maîtres*, exh. cat. (Réunion des Musées nationaux, Paris, 2008).

39. Galassi, *Picasso's Variations on the Masters*, p. 16.

40. Richardson, "L'epoque Jacqueline," p. 31.

41. See *Roy Lichtenstein: Meditations on Art*, exh. cat. (Skira, 2010); Markus Brüderlin, "Roy Lichtenstein und das Kunstzitat," in *Roy Lichtenstein*, exh. cat. (Kunstforum, Vienna, 2003), pp. 17–25; and Lawrence Alloway, *Roy Lichtenstein* (Abbeville Press, 1983), pp. 37–61.

42. As early as 1976, Lichtenstein admitted, "I think maybe the Pop idea has run its course. It's understood. I think everyone sees it . . . [M]ost movements are finished almost as soon as they're understood . . . I don't feel locked into a Pop notion . . . I feel I could go anywhere." Audio transcript from a Michael Blackwood Productions film on Lichtenstein, 1976, p. 26. The Roy Lichtenstein Foundation Archives.

43. Ernst Busche, "Lichtenstein," in *Lichtenstein*, exh. cat. (Leo Castelli, New York, 1983).

44. Lichtenstein's first self-referential painting with a link to Picasso is *Artist's Studio* (1973; fig. 1, p. 72), where he painted again, among other canvases, a section of *Still Life after Picasso*.

45. Hal Foster, "Pop Pygmalion," in *Roy Lichtenstein: Sculpture*, exh. cat. (Gagosian Gallery, New York, 2005), p. 11.

46. Ibid., p. 16.

47. Dorothy Lichtenstein, quoted in Avis Berman, "In a New Times Square, a Wink at Futures Past," *New York Times*, Sept. 1, 2002, p. 25.

48. Quoted in "New York, January 1966," in *Some Kind of Reality: Roy Lichtenstein Interviewed by David Sylvester in 1966 and 1997*, exh. cat. (Anthony d'Offay Gallery, London, 1997), p. 15.

49. Robert Rosenblum, "Adventures in Picassoland," in *Picasso: A Contemporary Dialogue*, exh. cat. (Galerie Thaddaeus Ropac, Salzburg and Paris, 1996), p. 18.

50. Lobel, *Image Duplicator*, p. 159.

51. Diehl, "Conversation with Roy Lichtenstein," [pp. 1–4]; emphasis added.

52. Barthes, "That Old Thing, Art . . . ," p. 198. To which he added: "For meaning is cunning: drive it away and it gallops back. Pop art seeks to destroy art (or at least to do without it), but art rejoins it: art is the counter-subject of our fugue," p. 202.

53. Quoted by Frederic Tuten, "Lichtenstein at Gemini" (1969), in Coplans, *Roy Lichtenstein*, p. 99.

54. In 1990 Lichtenstein also painted *Reflections on "Painter and Model"* (fig. 12, p. 100), based on Picasso's *Painter and Model* (1928; fig. 11, p. 100). For an analysis of the reflections in Lichtenstein's work, see Graham Bader, *Hall of Mirrors: Roy Lichtenstein and the Face of Painting in the 1960s* (MIT Press, 2010), pp. 164–90.

55. Thomas Crow, "For and Against the Funnies: Roy Lichtenstein's Drawings in the Inception of Pop Art, 1961–1962," in *Roy Lichtenstein: The Black-and-White Drawings, 1961–1968*, exh. cat. (Morgan Library/Hatje Cantz, New York, 2010), p. 36.

56. Filiberto Menna, "The Organised Perception of Lichtenstein," in Boatto and Falzoni, "Lichtenstein," p. 64.

57. *Some Kind of Reality*, p. 33.

58. Diehl, "Conversation with Roy Lichtenstein," [p. 5].

MISSING MODERNISM
SARA DORIS

In the early 1960s, Roy Lichtenstein began the series of paintings for which he remains best known: large-scale appropriations of the weeping young women and daring young men featured in romance and war comics. His earliest critics—who were generally hostile ones—believed they understood the significance of that gesture. Lichtenstein and his fellow Pop artists had mounted an "invasion" of the sanctum of the art world, making a mockery of Modernism by supplanting it with "the pin-headed and contemptible style of gum chewers, bobby soxers, and worse, delinquents."[1]

Lichtenstein's own words seemed to support the claim that he was engaged in a form of anti-Modernist iconoclasm. Two years after creating his first Pop painting *Look Mickey* (1961; cat. 8), he asserted that Modernism had become superannuated. "Art since Cézanne," he noted, "has become extremely romantic and unrealistic . . . it is utopian . . . It has less and less to do with the world."[2] His remarks suggested skepticism about the relevance of Modernist aesthetic strategies for an artist living in the mid-twentieth century: how could they be used to depict a world filled with "gas pump[s] . . . signs and comic strips"? In contrast to the introspective tradition of Cézanne, Lichtenstein insisted, his Pop art looked "out into the world."[3] As he viewed the matter, it was Modernism's irrelevance that justified his radical break with its tenets.

To understand Lichtenstein as motivated by simple antipathy, however, would be to underestimate the complexity of his relationship to Modernism; until the end of his career he remained haunted by it. Within a year of producing his first comic-book paintings, he embarked on another series of works appropriating the imagery of Modernist masters ranging from Pablo Picasso (see fig. 1) to Jackson Pollock. Plundering images from opposite ends of the cultural spectrum, these works have

Fig. 1. Roy Lichtenstein with *It Is . . . With Me!* (1963; private collection), 1963. Photograph by John Loengard.

most often been regarded as two discrete series. Yet their simultaneous production and stylistic unity argue instead for their consideration as a single series, one whose larger thematic concern was a meditation on the increasing interrelationship between Modernism and mass culture.[4] As Hal Foster recently noted, the "critical edge" of Lichtenstein's work resides in its unreconciled "collision of high and low modes."[5] Catalyzing that collision was a simultaneous embrace and repudiation of Modernism.

HIGH AND LOW

Lichtenstein did not part with Modernism easily—or completely; he later described the process as "traumatic."[6] Throughout his career, he explained his work in language that had a curiously Modernist cast. Picasso was the subject of superlative praise, and Lichtenstein repeatedly underscored his interest in the formal qualities of his paintings—his fascination with the challenges of texture, color, and composition.[7] Further, he defended his own work in terms that evoked the political idealism of the Modernist avant-gardes. In contrast to the cynicism attributed to him by Pop art's critics, Lichtenstein presented a principled ground for his use of commercial subject matter and style. Employing those means, he argued, "*is* an involvement with what I think to be the most brazen and threatening characteristics of our culture, things we hate, but which are also powerful in their impingement on us . . . America was hit by industrialism and capitalism harder and sooner [than the rest of the world] and its values seem more askew."[8] More than a quarter century after his initial forays into Pop, Lichtenstein reiterated that involvement, observing that the purpose of his work was to "show . . . the capitalist system in an ironic way."[9]

Lichtenstein began his comic-book/Modernist series at a time when debates about high and low culture were rampant in the American popular and intellectual press.[10] The terms of that discussion had been signally dictated by the writings of Clement Greenberg, whose 1939 essay "Avant-Garde and Kitsch" had defined that relationship as fundamentally antithetical. In his account, the interval between Modernism and mass culture was "too great to be closed by all the infinite gradations of popularized 'modernism' and 'modernistic' kitsch."[11] Avant-garde art constituted the sole genuine form of modern culture, one that was increasingly threatened by the proliferation of mass culture. Greenberg's thesis enjoyed a renewed influence with its republication in his 1961 *Art and Culture*—the year Lichtenstein began making works that appropriated comic-book imagery. In this context, Lichtenstein's broad comic-book/Modernist series can be seen as a visual challenge to Greenberg's claims about the incommensurability of avant-garde and kitsch.[12]

While Lichtenstein was ambivalent toward Modernism, he was more troubled by mass culture and could be quite critical of the media's trivialization of experience.[13] At the same time, the comics' verbal and visual distillations of the most intimate aspects of our psychic lives had for him a certain ironic appeal: "We all at times talk like comic books to people and, you know, they're really the most potent situations of our lives but they're also laughable if you're not really in it."[14] Lichtenstein savored the accidental Modernism of their visual style—the flattening of space, the simplification and abstraction of form. While he acknowledged that those formal affinities were a consequence of the economic and technical constraints imposed by mass reproduction, Lichtenstein felt it brought the comics into a proximity with Modernist style that Greenberg would never have admitted. "There is a relationship between cartooning and people like Miró and Picasso which may not be understood by the cartoonist, but

it definitely is related even in the early Disney."[15] Likewise, Modernist style had, in turn, been affected by the economies of mass-reproduced imagery. His own work increasingly emphasized the interchange between different cultural levels. Lichtenstein suggested that the comic-book panel (fig. 2) that inspired his *Drowning Girl* (1963; cat. 32) bore visual resonances with Katsushika Hokusai's Edo period *The Great Wave off Kanagawa* (fig. 3); *Drowning Girl* became the middle term that linked the two in a cultural continuum.

POP MODERNISM

It was Lichtenstein's recognition of an increasingly intimate relationship between avant-garde and kitsch that inspired him to begin a series of works that served as a counterargument to Greenberg's dialectic. With *Portrait of Madame Cézanne* (1962; cat. 63)—a Pop rendition of the "extremely romantic" Cézanne's tribute to his wife—he began his artistic appropriations of the canonical works of Modernism. But Lichtenstein's painting failed entirely to convey the romanticism of his predecessor's. It was based not on the painting itself, but on art historian Erle Loran's diagram of the painting in *Cézanne's Composition: Analysis of His Form with Diagrams and Photographs of His Motifs*.[16] Loran's book, originally published in 1943, proved to be one of the most durable art historical accounts of Cézanne's work: when Lichtenstein appropriated the diagram in 1962, the book was being prepared for a third edition (and nearly seventy years after its first publication, a fourth edition is still in print).

Loran's illustration exemplified a type of mid-twentieth-century artistic analysis that gave primacy to what he termed "plastic form." Privileging the role of composition and abstraction, the diagram reduced the portrait to a harsh black outline and a series of arrows indicating compositional axes, thus eliminating the texture and expressiveness of Cézanne's original. "No doubt," Loran remarked, "this diagrammatic approach may seem coldly analytical to those who like vagueness and poetry in art criticism."[17] He further underscored the chilliness of his analysis by likening the work's composition to that of the artist's landscapes, approvingly noting that "in this portrait there is a majestic and monumental quality having little if anything to do with the human character of the sitter."[18] Loran's emptied Cézanne inadvertently provided Lichtenstein with a means of marking the distance between a hot modern and a cool postmodern sensibility. "Cézanne talked about losing himself" in his art, Lichtenstein noted, whereas he, in contrast, evoked detachment by making his "work . . . look programmed or impersonal."[19]

Lichtenstein was struck less by Loran's coldness (a charge also leveled at his own work) than by its unintentional absurdity: "The Cézanne is such a complex painting. Taking an outline and calling it 'Madame Cézanne' is in itself humorous, particularly the idea of diagramming a Cézanne when Cézanne said, 'the outline escaped me.'"[20] Loran's was a form of simplification reminiscent, he felt, of cartoons. In Lichtenstein's reading, Loran himself had turned the Cézanne into a comic; his own painting merely underscored that fact.

In the following year, Lichtenstein began a series of paintings based on Modernist works that literalized the cartoonish implications he had discerned in Loran's diagram. In *Femme d'Alger* (1963; cat. 64), Lichtenstein created a version of Picasso's 1955 painting of the same name (fig. 4). The earlier work likely had a particular resonance for Lichtenstein, as it was itself based on a work by the Romantic painter Eugène Delacroix, making Lichtenstein's work a copy of a copy.

Fig. 2. Opening panel, Tony Abruzzo, "Run for Love!" *Secret Hearts* 83 (Nov. 1962). © DC Comics. Used with permission.

Fig. 3. Katsushika Hokusai. *The Great Wave off Kanagawa* (*Kanagawa oki nami ura*), from the series Thirty-Six Views of Mount Fuji (Fugaku sanjurokkei), c. 1830–32. Color woodblock print; oban 5.7 × 7.2 cm (10 ⅛ × 14 ⅝ in.). The Art Institute of Chicago, Clarence Buckingham Collection.

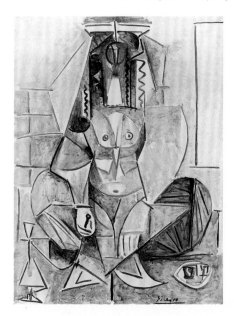

Fig. 4. Pablo Picasso. *Femme d'Alger*, version L, 1955. Oil on canvas; 130 × 97 cm (51 × 38¼ in.). Formerly private collection; Christie's, New York, May 4, 2011, lot 32.

Fig. 5. Piet Mondrian. *Composition (No. 1) Gray-Red*, 1935. Oil on canvas; 57.5 × 55.6 cm (22 ⅝ × 21 ⅞ in.). The Art Institute of Chicago, gift of Mrs. Gilbert W. Chapman, 1949.518. © 2012 Mondrian/Holtzman Trust c/o HCR International, Washington, D.C.

The style of Lichtenstein's replication was such, however, that it could never be mistaken for the original—he described it as a deliberate "misconstrual" of Picasso's forms.[21] Rather than using the muted earth tones of Picasso's late Cubist work, Lichtenstein's rendition featured the gaudy primary colors of his own comic-book paintings. The unity of the two genres of his work—comic-book and Modernist—was further underscored by his replacement of painterly brushwork with hard, precise outlines and enlarged Benday dots: the traits that signaled, in his comic works, the cheaply mass-reproduced image. Lichtenstein asserted that those dots carried a particular semantic freight: "[T]he Benday dots were blown up, and they meant at first, of course, reproduced material, but I think they also may mean the image is ersatz or fake."[22] Thus the dots highlight an uneasy affinity between the comics and Picasso's Modernism. As Lichtenstein noted, his sources were not the originals, but rather *mass reproductions* of Picassos.[23]

Lichtenstein continued to pilfer images from various modernisms throughout the rest of the decade, creating ersatz versions of De Stijl, Abstract Expressionism, Art Deco, and Impressionism in his comics-inflected style. His *Non-Objective I* (1964; cat. 65) emulates (without precisely copying) Piet Mondrian's *Composition* grids of the 1920s–30s (see fig. 5). While Mondrian's paintings shared formal similarities with Lichtenstein's work—flat paint application, hard-edged lines, and a palette limited to black, white, and primary colors—the affinity between them ended there. The apparently mass-reproduced nature of *Non-Objective I* belies the spiritual and utopian motives of the originals, while its static composition conveys the feel of a rote, paint-by-numbers modernism.

The titles of Lichtenstein's Compositions paintings, begun in 1964, link them to his Mondrian series, although their source was thoroughly pedestrian and mass cultural. *Compositions I* (1964; cat. 26) depicts an ordinary school composition notebook in grossly inflated facsimile. Nearly six feet tall, the painting's scale seems hyperbolic given the physical and aesthetic slightness of its source. Once again, Lichtenstein was playing with the convergences of Modernism and mass-produced design. The title recalls both the Modernist fetishizing of the formal elements of painting as well as the titles of so many nonobjective works. The abstract pattern of white swirls that sprawls across the "printed" surface of the book evokes, when seen in an artistic context, the all-over compositions of Abstract Expressionist Jackson Pollock's drip paintings—their once-ecstatic outpourings reduced to a rote form of decoration adorning a low-end commodity.

OBSOLETE MODERNISM

By the early 1960s Lichtenstein, like many younger artists, felt that Abstract Expressionism had lost its avant-garde status. As fellow Pop artist Robert Indiana remarked in 1963, Pop had now succeeded it "in the eternal What-Is-New-in-American-Painting shows" and in the affections of avant-garde collectors.[24] Far from continuing to shock the bourgeoisie, Abstract Expressionism had made its way into the average American home: "Once the hurdle of its non-objectivity is overcome, A-E is as prone to be decorative as French Impressionism." Shortly thereafter, Lichtenstein featured in a *Life* pictorial in which he was portrayed as an anti-Pollock, his mechanical style of reproducing his comic-book sources implicitly contrasted with Pollock's frenzied creativity.[25]

By mid-decade, the superannuation of Abstract Expressionism was evident even to its most avid supporters. In 1965 Lichtenstein embarked

on his Brushstokes (1965–71); the following year, he stopped painting comic-book panels.[26] His first painting in the new series, *Brushstrokes* (cat. 47), embodied that transition. Derived from a heavily cropped comic-book panel, the composition is dominated by three massive, dripping brushstrokes; in the lower level a partial view of a hand gripping a paint brush is truncated by the edge of the canvas.[27] In later works such as *Little Big Painting* (1965; cat. 48) and *Brushstroke with Spatter* (1966; cat. 49), all residue of the original narrative is eliminated from the heroically scaled paintings; "gestural" brushwork is rendered with the schematic outlines and Benday dots of the comic-book paintings. Seen up close, the gigantic brushstrokes are revealed to be composed of small, mechanically applied strokes of paint. Lichtenstein noted of these works, "[I]t's taking something that originally was supposed to mean immediacy and I'm tediously drawing something that looks like a brushstroke . . . I want it to look as though it were painstaking. It's a picture of a picture really and it's a misconstrued picture of a picture. Something like the feeling in those Picassos I did, you know . . . It looks more like an idiot painting of Picasso."[28] Like Lichtenstein's rendering of earlier modernisms, the Brushstroke series called Abstract Expressionism into question by suggesting that its primary sign of authenticity—the painterly trace of the painter's gesture—was as reproducible as a comic strip.

Despite his ironic approach to Modernism, Lichtenstein denied any intention to demean it: "The things that I have apparently parodied I actually admire and I really don't know what the implication of that is."[29] Apparently, then, Lichtenstein's borrowings were not motivated by an attempt to bowdlerize his sources—although his uncertainty is suggestive. Perhaps irony inevitably inflected his "copies" because he was unable to respond in earnest to the utopianism their originals embodied: art and kitsch were equally susceptible to obsolescence.

OBSOLETE POP

Lichtenstein's consciousness of Modernism's accelerating cycles of innovation and superannuation made him keenly aware that his own art would eventually succumb to the same process. In the year he began his Brushstrokes—four years after he produced his first Pop paintings—he announced that "no one can become a Pop artist now."[30] By the time he began work on his Artist's Studio series in 1973, Lichtenstein seemed resigned to the irretrievable pastness of Pop. Inspired by Henri Matisse's depictions of his own studio in the early twentieth century, works such as *Artist's Studio "Look Mickey"* (1973; cat. 104) conflated early Modernism with emergent postmodernism. Juxtaposed about the studio were flowers and fruit from Matisse's still lifes as well as works comprising a retrospective of Lichtenstein's work over the last dozen years—including, of course, one of the paintings that started it all: *Look Mickey.* The image carries a dual portent: if Lichtenstein seems to assert he can be considered the peer of Matisse, he simultaneously relegates his Pop art to a historical—rather than to a contemporary—status.

Lichtenstein had matured artistically during the heyday of American Modernism, and it had shaped his expectations of both aesthetics and artistic practice: "I was brought up on Abstract Expressionism."[31] Nonetheless, by the early sixties Lichtenstein had become convinced that tradition was exhausted, no longer relevant to the contemporary world—Modernism had, in fact, ceased to be modern. In response to this obsolescence, what Lichtenstein insisted on was not merely the proximity of avant-garde and kitsch, but instead the active and mutual exchange

between them: culture was ultimately not dichotomous, but a continuum. In rendering masterpieces as the equivalents of comic books, the collapse of that dichotomy was doubly determined: yesterday's kitsch would become tomorrow's avant-garde, just as yesterday's avant-garde would become tomorrow's kitsch.

NOTES

1. Max Kozloff, "'Pop' Culture, Metaphysical Disgust, and the New Vulgarians," *Art International* 6 (Mar. 1962), p. 36.
2. G. R. Swenson, "What Is Pop Art? Part I," in *Pop Art: A Critical History*, ed. Stephen Henry Madoff (University of California Press, 1997), p. 107. Originally published as "What Is Pop Art? Answers from Eight Painters, Part I: Jim Dine, Robert Indiana, Roy Lichtenstein, Andy Warhol," *Artnews* 62 (Nov. 1963), pp. 24–27, 60–64.
3. Quoted in Lucy Lippard, *Pop Art* (Praeger, 1966), pp. 85–86.
4. See Lawrence Alloway, *Roy Lichtenstein* (Abbeville Press, 1983); and Diane Waldman, *Roy Lichtenstein*, exh. cat. (Solomon R. Guggenheim Museum, New York, 1993).
5. Hal Foster, "Pop Pygmalion" (2005), in *Roy Lichtenstein*, ed. Graham Bader, October Files 7 (MIT Press, 2009), p. 147. See also David Deitcher, "Unsentimental Education: The Professionalization of the American Artist," in *Hand-Painted Pop: American Art in Transition, 1955–62*, ed. Russell Ferguson, exh. cat. (Museum of Contemporary Art, Los Angeles; and Rizzoli, 1992), pp. 114–15.
6. John Jones, "Tape-recorded Interview with Roy Lichtenstein, October 5, 1965, 11:00 A.M.," in Bader, *Roy Lichtenstein*, p. 67.
7. Lichtenstein's praise of Picasso is quoted in Milton Esterow, "Roy Lichtenstein: How Could You Be Much Luckier Than I Am?" *Artnews* 90, 5 (May 1991), p. 87. His interest in formal issues is asserted in Swenson, "What Is Pop Art?" p. 109; and Alloway, *Roy Lichtenstein*, p. 105.
8. Quoted in Swenson, "What Is Pop Art?" pp. 107, 109.
9. Paul Taylor, "Roy Lichtenstein," *Flash Art*, no. 148 (1989), p. 90.
10. See Sara Doris, *Pop Art and the Contest over American Culture* (Cambridge University Press, 2007), chap. 2.
11. Clement Greenberg, "Avant-Garde and Kitsch," *Partisan Review* 6, 5 (Autumn 1939), p. 44.
12. Lichtenstein acknowledged familiarity with Greenberg's work. See Bradford Collins, "Modern Romance: Lichtenstein's Comic Book Paintings," *American Art* 17, 2 (Summer 2003), p. 84 n. 7. In 1965, at the height of Pop's fame, he remarked that the critic "might say that innovation has taken over and the art bit is minimal in the scene now." See Jones, "Tape-recorded Interview," p. 31.
13. Alan Solomon, "Conversation with Lichtenstein" (1966), in *Roy Lichtenstein*, ed. John Coplans (Praeger, 1972), pp. 66–67. Originally published in *Fantazaria* 1, 2 (July–Aug. 1966).
14. Jones, "Tape-recorded Interview," p. 25.
15. Lichtenstein, quoted in John Coplans, "Talking with Roy Lichtenstein" (1967), in Coplans, *Roy Lichtenstein*, p. 90.
16. For a contrast of the attitudes of Lichtenstein and Loran toward the repetition and reproduction of images, see Michael Lobel, *Image Duplicator: Roy Lichtenstein and the Emergence of Pop Art* (Yale University Press, 2002), pp. 109–12.
17. Erle Loran, *Cézanne's Composition: Analysis of His Form with Diagrams and Photographs of His Motifs*, 2nd ed. (University of California Press, 1944), p. 1.
18. Ibid., p. 85.
19. Bruce Glaser, "Oldenburg, Lichtenstein, Warhol: A Discussion," in Coplans, *Roy Lichtenstein*, p. 145. Originally published in *Artforum* 4, 6 (Feb. 1966), pp. 20–24.
20. Quoted in Coplans, "Talking with Roy Lichtenstein," p. 89. It is likely that Lichtenstein was influenced by the criticism of Loran's analysis articulated by his former professor, Hoyt Sherman, in his book *Drawing by Seeing: A New Development in the Teaching of the Visual Arts through the Training of Perception* (Hinds, Hayden, & Eldregde, Inc., 1947), pp. 75–77. Many thanks to Maia M. Rigas for calling this to my attention.
21. Coplans, "Talking with Roy Lichtenstein," p. 90.
22. Jeanne Siegel, "Thoughts on the 'Modern' Period," in Coplans, *Roy Lichtenstein*, p. 94.
23. For Lichtenstein's observation that mass reproduction had made Picasso a "popular object," see Coplans, "Talking with Roy Lichtenstein," p. 89.
24. Swenson, "What Is Pop Art?" p. 106.
25. Dorothy Sieberling, "Is He the Worst Artist in the U.S.?" *Life,* Jan. 31, 1964, pp. 79–81, 83. The article's title deliberately invoked—and inverted—that of "Jackson Pollock: Is He the Greatest Living Painter in the United States?" *Life,* Aug. 8, 1949, pp. 42–43, 45.
26. Discussion of the disappearance of dialogue balloons from Lichtenstein's paintings in 1966 (and their brief reappearance in the following decade) can be found in the chronology by Clare Bell in this catalogue.
27. The most comprehensive discussion of Lichtenstein's early Brushstrokes can be found in Lobel, *Image Duplicator*, chap. 6.
28. Jones, "Tape-recorded Interview," pp. 21–22.
29. Glaser, "Oldenburg, Lichtenstein, Warhol," p. 145.
30. Grace Glueck, "Warhol's Pad Is Scene of Blast Launching 'Pop Art,' New Book," *New York Times*, June 30, 1965, p. 43.
31. Glaser, "Oldenburg, Lichtenstein, Warhol," p. 145.

SEE-SICKNESS:
ROY LICHTENSTEIN'S MOVING PICTURES

CHRISSIE ILES

Everything that we call substance is nothing but movement.
—Kazimir Malevich

All art is optics.
—Paul Cézanne

At its core, the experience of both making and looking at painting is inescapably defined by optical, somatic processes. Since Aristotle and Plato, this process has evolved through the use of projection, light, and, from at least the sixteenth century, technological aids extending out from the eye that have transformed the viewer's perception of the image in space. From the camera obscura to the film camera, optical apparatuses have exerted a powerful influence on the construction and meaning of painting through common techniques: magnification, projection, reflection, tracing, cropping, and copying. In considering Roy Lichtenstein's three-screen 35 mm film loop installation *Three Landscapes* (c. 1970–71; fig. 1, cat. 60), therefore, the question is not so much why Lichtenstein chose to engage with film, as how he used film to test his radical experiments of the 1960s.

From the moment that film entered popular culture in the early 1920s it became both material and subject matter for artists, whose engagement with it followed three directions that continue to this day: the extension of the optical and synesthetic ideas of painting into film by Oskar Fischinger, Hans Richter, Mary Ellen Bute, and Láslzó Moholy-Nagy, among others; the exploration of the conceptual potential of film through its material and optical characteristics and those of its accompanying apparatus, by artists such as Marcel Duchamp and Francis Picabia; and the invention of an alternative narrative cinematic language by Salvador Dalí, Man Ray, and Fernand Léger. *Three Landscapes* is important because it contains elements of the first two approaches, yet does not resemble them or share their intentions. It is unique, both within Lichtenstein's oeuvre and in the history of art and film. In the pure, disembodied state of viewing it proposes, it firmly roots itself within the Greenbergian tradition of Modernist painting, while its internal structure and external appearance are pure Pop.

Fig. 1. Installation view of *Three Landscapes: A Film Installation by Roy Lichtenstein* at the Whitney Museum of American Art, New York, Oct. 6, 2011–Feb. 12, 2012.

Three Landscapes, which premiered in *Art and Technology* at the Los Angeles County Museum of Art (LACMA) on May 10, 1971, audaciously manages to turn the medium of film to its own advantage, distancing it from any of its previous painterly associations and transforming it into a mesmerizing hybrid of painting, billboard, comic strip, cartoon, and kinetic spectacle. Lichtenstein divides the three films that compose the installation into contrasting images of stillness and movement. The bottom half of each film shows the ocean rippling in the sunlight (and, in the center screen, its symbolic equivalent in footage of fish swimming in a fish tank), while the top half depicts the sky in three still images: large blue Benday dots, a still of a blue sky with billowing clouds, and a seagull frozen in flight against a Kodachrome blue sky. The two halves of each film are separated from each other by a black horizon line that rocks back and forth, introducing a third element of movement and rendering impossible a singular reading of the image as either still or moving. The films are back-projected onto a triptych of hanging translucent screens enclosed by a thick black frame, like three moving pictures. The photographic aspect of each film, suggested by the still images of the sky and the thick black frames, evocative of 35 mm slides or 1950s 3D View-Master slides, delineates the edge of the otherwise endlessness of the ocean and sky, and contains the destabilizing rocking motion of each film's horizon line, in a counterpoint of stable rectilinearity.

The bold singularity of *Three Landscapes* confirms in filmic terms Lichtenstein's radical transformation of the viewer's optical perception of the representational subject. Lichtenstein was among a new generation of artists at the beginning of the 1960s who sensed that "the vanishing point had vanished,"[1] and his engagement with the picture plane was, from the first, an inquiry into the corporeal experience of seeing, played out through surface, texture, flatness, color, exaggerations of scale, and the tension between apparent mechanical perfection and the hand of the artist. This formal inquiry is used to turn the material, perceptual, and cinematic qualities of film inside out in *Three Landscapes,* which, like all encounters with Lichtenstein images, confronts the viewer with the transformation of a subject—in this case, three seascapes—through the mechanized techniques of advertising, popular culture, and the mass media, into a stereotyped referent of itself from which, as Diane Waldman argues, we instinctively attempt to recall the original.[2] In *Three Landscapes,* we watch a film of fish swimming back and forth in an aquarium knowing that it is standing in, tongue-in-cheek, for the ocean, just as we know that the large swath of blue Benday dots above a film of an ocean at sunset represents the sky.

Lichtenstein's engagement of the viewer with the mechanics by which the image has been constructed in order to find its meaning underlines his closeness with the pictorial concepts of Georges Seurat, who, as Graham Bader argues, "industrialized not only his technique but also his viewers, by applying small strokes of color that were to be actively 'rebuilt and synthesized artificially' by his audience, according to scientific theories of optical mixture."[3] Lichtenstein triggers a similar reaction in the viewer, creating meaning by depicting exaggerated technological effects (the Benday dot from printing, the hard black outlines of the comic strip) with visible traces of the artist's own hand, thus rendering the mechanistic process symbolic. The paradoxical result, Bader concludes, "suggests a grand form of perceptual experience, only to reveal something calculated . . . the promise of subjective visual experience is undercut by the rationalizing systems of objective control."[4]

The corporealized artifice of the works that appeared during the intensely experimental period of Lichtenstein's career in the 1960s seems, in retrospect, to have led inevitably to an engagement with the medium of

film. His incorporation of the spectator's gaze into his work was already cinematic, as were many of his formal techniques—highly zoomed close-up surfaces of Benday dots, projection of sketched imagery onto canvas, and cropping, framing, and freezing actions, exclamations, and objects to capture moments of high drama.

Lichtenstein's choice of landscape as the subject for his film installation is significant for its optical perceptual structure. Of all the genres that Lichtenstein employed throughout his career, landscape was one of the earliest, and one to which he returned consistently. Unfashionable with artists, it joined Impressionism, School of Paris, and other retro art historical movements that were entering popular culture in the 1960s as subjects that could be borrowed back as clichés. The genre had the added appeal of having already been rendered kitsch by its thorough absorption into popular culture, from postcards of sunsets to picture windows in suburban houses. As Clare Bell points out, Lichtenstein explicitly stated that he wanted his landscapes to look "vulgar,"[5] and as Bader has observed, he spoke of wanting to create "the kind of sky that would stop you as you went by a store." To Lichtenstein, landscape seemed, above all, "to be made up of . . . a desire to sell products," full as it was of "billboards and neon signs." Lichtenstein's landscapes are therefore not so much pictures of landscapes "as of advertising's saturation of both landscape and painting. Lichtenstein's landscapes stand as the very picture of the automatism of immediate experience."[6]

Landscape painting was thus the perfect vehicle for Lichtenstein's exploration of the corporeality of vision, first in a series of kinetic painted seascapes and, later, in his films. The picture surface becomes "a material object to be sensed . . . disporting itself with impudent immediacy within the observer's own space."[7] Lichtenstein's landscapes of the 1960s stand apart as a genre in their ability to assert this materiality through the use of collaged materials whose visual and textural properties mimic those evoked by the landscape itself (see fig. 2). Studies for unrealized films reflect his interest in transposing this from his kinetic works into his film project. As he remarked, "You use an optical material to make a sky because the sky has no actual position—it's best represented by optical effects."[8]

The optical effects that Lichtenstein selected were a result of a combination of his signature Benday dots, areas of painted color, and the shimmering surface of Rowlux, a lenticular plastic sheet whose "microscopic spherical lenses"[9] cast a pearly sheen. The effect "den[ies] the viewer any ground on which to stand" and triggers, as Barbara Rose describes, the "bizarre sensation that either the 'landscape' is floating through [while] we stand still, or . . . it is standing still and we are passing by" (see fig. 3).[10] This optical dislocation anticipates *Three Landscapes*, whose split images create a similar perceptual ambiguity. The reflective three-dimensional moiré patterns in the sheets of Rowlux that Lichtenstein used in his Rowlux Landscapes throughout the 1960s achieved this sensation precisely because they evoked, even more literally than his Benday dots, the actual surfaces of the sky and the sea that they depicted. As Bader points out, Lichtenstein considered Rowlux "a sort of ready-made nature . . . [its] brilliant reflections . . . like real water reflecting real sunlight,"[11] rendering it the perfect material with which to articulate the tension between two- and three-dimensional space.

In 1966 Lichtenstein further heightened this tension by attaching a Synchron motor to the back of a series of Kinetic Seascapes (1966), setting the water depicted in the bottom half of the picture rocking in perpetual motion (fig. 4). In most seascapes in this series, the sky is represented by a flat, static surface of Benday dots of varying sizes and shapes, while the water moving below it is rendered in Rowlux, whose glistening prisms

54

Fig. 2. Roy Lichtenstein. *Fish and Sky*, **1964. Screen print, photographic print, and lithograph on composition board; 60.4 × 50.8 cm (23 ¾ × 20 in.); edition of two hundred.**

Fig. 3. Roy Lichtenstein. *Kinetic Seascape #3*, **1966. Rowlux and tape on board and electric motor; 67.3 × 57.2 cm (26 ½ × 22 ½ in.). Ryobi Foundation.**

Fig. 4. Roy Lichtenstein. *Ocean Motion*, 1966. Rowlux, cut-and-pasted printed paper, and plastic on board and electric motor; 57.2 × 66.7 cm (22 ½ × 26 ¼ in). Private collection.

catch the light as the surface moves back and forth. Each composition consists of two halves, their demarcation represented by a thick black horizon line that will reappear in *Three Landscapes*, which asserts the flatness of the work as its relentless movement confirms its identity as a three-dimensional, kinetic form.

Lichtenstein took his interest in the most clichéd form of landscape—the sun rising or setting over the ocean—to its kitsch extreme in his Electric Seascapes (1966–67), for which he had specially designed picture lamps made, with rotating sleeves placed over the inner bulbs, onto whose surface he applied thin strips of colored gel paints. As the sleeve over the lit bulb rotated, a changing sequence of colored light washed over the seascape, evoking the shifting tones of a sunrise or sunset as it played across the water—at least, as it might be seen in the window display of a cheap store on 42nd Street.

In 1968 Lichtenstein accepted an invitation from Maurice Tuchman, chief curator at LACMA, to participate in a residency at Universal Film Studios as part of the museum's Art and Technology Program. Tuchman's ambitious four-year plan paired artists with high-tech corporations based mostly in Southern California, with the intention that the artworks resulting from each collaboration would be shown in a large exhibition. *Three Landscapes* derives from Lichtenstein's participation in the Art and Technology Program.

The natural association of Lichtenstein's comic-strip heroes and heroines with Hollywood cinema inspired the LACMA team to pair Lichtenstein with Universal Film Studios. Lichtenstein agreed to the match and flew to Los Angeles to tour Universal's facilities in the San Fernando Valley on September 12, 1968. An internal LACMA memo records that "several department heads explained the capacities of the film laboratories, including optics, cutting, editing and special effects. There was a visit to the set of *Topaz* . . . and a behind-the-scenes look at the mechanical set-ups for the public tour of the studios."[12]

Lichtenstein first envisioned "a sequence of shots of a woman's face with contrasting lighting (for example, green light on the left, red on the right), or tattooed with dots, or with varieties of make-up," but reconsidered, finding this idea "too 'zippy' or slick."[13] He then proposed a series of seascapes projected as large, "fairly phony"–looking moving pictures. Returning to Los Angeles on February 3, 1969, for a two-week residency, Lichtenstein took over comedian Jack Benny's old dressing room as his studio and began work on the seascapes. He consulted with Universal Film Studios technicians on how to back-project the films so that they would appear as pristine, autonomous images, able to hang in a gallery space like paintings. For logistical reasons Lichtenstein decided to collaborate with Joel Freedman, an independent filmmaker and friend also based in New York.[14] Lichtenstein and Freedman initially filmed the ocean on the beach at Southampton in Long Island during the day and at night along with Robert Fiore, Chuck Levy, and Peter Kolsky. Freedman tried mounting an Arriflex 35 mm silent film camera to the bow of a boat to film the water at sunset and attaching a high-powered telescope on top of the camera to make a time-lapse film of the sun. At one point he called NASA for advice; the cost of NASA's computerized technique proved to be prohibitive.

On the beach, assistants "held a four-by-six-foot wooden board, painted with blue dots on a white field, suspended over the water. The camera was rocked back and forth to simulate the motion of a boat."[15] This approach was quickly abandoned due to the impossibility of reconciling the variations in depth of field, focus, and light exposure. Instead, Freedman filmed separately the sea, the sky, a fish tank, and a large

55

Benday-dot surface, and later pieced together the various elements, step-printing the water and working on an optical bench using an Oxberry animation stand in an optical laboratory.

Lichtenstein's sketches and notes reveal that he hoped to make a variety of films, fifteen in total (fig. 5). (Due to time and money constraints, only three were realized.) Many of the films were to be accompanied by sound—mood music, a heroic, stirring composition, or the sound of lapping water. In one, a time-lapse film would show a sunrise, daylight, sunset, and the night sky above a never-changing ocean. In another the sun was to rise out of the frame, giving way to a blue sky, then a sunset, and finally a starry night. In a third, the bottom portion, depicting the sea, was to be made of black opaque dots on frosted Plexiglas, while in another, a quilted, stainless steel sheet depicting a sunset was to occupy the top portion of the film. Screens of Benday dots are cast in some of these sketches as the sky, and in others as the sea; they also stand in for another kind of surface—a close-up of the film grain—and appear as either a filmed or physical element placed above or below the filmed half of the screen.

The most complex film sketch (sketch no. 3 in fig. 5) incorporates a freestanding black-velvet theater rope on stanchions positioned in front of a screen, which is divided in two, like all the others, by a thick black horizon line, which is obscured from view by the rope. As the images of sky and water were to rock from side to side, the horizon line would have tipped at a diagonal angle, separating itself from its echo in the physical line of the velvet rope and splitting the horizon into two, definitively revealing its artifice. The screen would have had to have been positioned quite low to the ground for the velvet rope to bisect it. The contrast between depicted and material form that defined his kinetic seascapes is, here, made even more literal. Filmic space becomes engaged in a dialogue with an element that not only is three-dimensional and real but, in addition, has climbed out of the picture plane and inserted itself directly into the space of the viewer, as though keeping back an imaginary audience. The complex three-dimensional elements of this particular film sketch relate to Andy Warhol's *Rain Machine (Daisy Waterfall)* (fig. 6), which consists of a large grid of lenticular color photographs of daisies, in front of which a sheet of water falls into a large horizontal tank. The extra layer of water augments the lenticular effects of the daisies, creating a three-dimensional aspect to the flowers' two-dimensional form.

A year before the Art and Technology Program exhibition at LACMA in May 1971, Tuchman was invited to organize artists from the project for the U.S. Pavilion for Expo '70, a world's fair held in Osaka, Japan. Lichtenstein and Freedman completed two of the three films in *Three Landscapes* for this exhibition: the one with a Benday-dot sky and a film of the sea at sunset, the other a still photographic image of a Kodachrome blue sky with a seagull in flight above an ocean sunset. In each case, a thick black horizon line delineated the boundary between the sky and the sea as the images rocked back and forth. Both films were back-projected side by side in a one-minute-long 35 mm film loop in one of the pavilion's specially constructed galleries.

The third film, showing a still image of a blue sky with white clouds above footage of an aquarium full of tropical fish swimming back and forth, joined the first two films as *Three Landscapes*, transferred to 16 mm film for practical reasons, when *Art and Technology* opened at LACMA a year later. In a sketch of the installation, Lichtenstein indicated that the middle screen should be hung facing the viewer like a painting, flanked by the other two, identically sized screens, which were to be tilted slightly inward like the open panels of a medieval triptych. The split screens collage each seascape into two parts in a way that evokes the animation techniques of

Fig. 5. Roy Lichtenstein. *Three Landscapes (Studies)*, 1969. Marker, ballpoint pen, and graphite pencil on paper; two sheets; each 27.7 × 21.3 cm (10 ⅞ × 8 ⅜ in.). Private collection.

56

Fig. 6. Andy Warhol. *Rain Machine (Daisy Waterfall)*, 1971. Mixed media and xographic prints; 271.8 × 629.9 × 175.3 cm (107 × 248 × 69 in.). The Andy Warhol Museum, Pittsburgh, Anonymous gift.

hand-drawn cartoons. The construction of both the collages and the endless rocking movement of the loop was achieved in a similar way to the animation process, in laborious optical bench work undertaken by Freedman.

The context that gave rise to *Three Landscapes*—a major exhibition showcasing collaborations between artists and high-tech industries—underlined the extent to which art had internalized the mechanized processes of technology. As Jack Burnham has pointed out, *Art and Technology* was one of several exhibition projects addressing the relationship between technology and visual culture that appeared at the end of the 1960s.[16] This proliferation of exhibitions on the subject of technology's relationship to art appeared at a utopian moment, when it was felt that artists were demonstrating a capability to resist, and thereby transform, the stifling mechanized structures of postwar American life. As Willoughby Sharp noted in 1967, a new generation of artists turned to the idea of a total integration of the self with others: "We are in the process of moving away from the physical view of reality as that which exists, to a kinetic view of reality as that which seems to happen—a shift from being to becoming."[17]

The hypnotic quality of *Three Landscapes* belongs to this new kinetic reality, one that proved to be a transitional moment between older mechanized forms of technology and our current dematerialized, globally interconnected world. As with Seurat, Lichtenstein's own quotation of the mechanistic techniques of industrialized popular culture at that pivotal moment at the end of the 1960s was a form of resistance to its supposed rendering of painting as anachronistic. It is significant that Lichtenstein turned his attention to film at a moment of crisis in the history of cinema, when television (to whose boxlike form the square screens of *Three Landscapes* bears a subtle but important resemblance) began both to challenge cinema's hegemonic hold over moving-image popular entertainment, and to threaten to render it obsolete. For Lichtenstein, it was this whiff of potential obsolescence that made cinema a potent material for his transformative strategy.

Lichtenstein's approach is rooted in the painterly experiments of the nineteenth century, conducted in an era of profound technological change, when film appeared to be challenging established perceptions of time and reality and photography was challenging the purpose of painting if not threatening its very existence. Lichtenstein's embrace of the trivial, the banal, and the mechanical beats technology at its own game. His use of all three in *Three Landscapes* to expose the seamy side of both the seascape genre and of cinema in general evokes critic August Wilhelm Schlegel's horror at the consequences of exposing landscape painting to the vulgar clutches of technology: "[T]he use of a mechanical aid . . . would be questionable and tend to encourage a flat, unimaginative style."[18]

The "flat, unimaginative style" that so perturbed Schlegel was exactly the effect that Lichtenstein sought. The deadpan kitsch of the ocean in *Three Landscapes* is underlined by the gentle mechanical rocking of each image back and forth, in an absurd exaggeration of the motion of the sea and the horizon line as they might be seen from the porthole of a ship. Viewers are suspended somewhere between this imaginary nautical viewpoint, in which they are encouraged to picture themselves, and the actual space of the gallery within which the three seascapes undulate. His insistence on the back-projection of the films onto three screens and that the gallery should be dimly lit rather than completely dark, maneuvers the viewer into an ambivalent viewing position—brought to a halt in the gallery yet prevented from sliding into cinematic mode by being obliged to remain standing, as Lichtenstein insisted on no seating. As a result, we become caught between two states of seeing: the ambulatory beholding of art, and the static, hypnotic dream state of watching a movie.

This constructed tension between reading the films in *Three Landscapes* as either three-dimensional and material, or two-dimensional and temporal, suggests the importance of Lichtenstein's training with Hoyt Sherman, professor of fine arts at Ohio State University, in the 1940s. Sherman believed that "the eyes must be trained to see with perceptual unity" in order to grasp what he considered to be the compositional basis necessary for all art.[19] To this end, he constructed what he termed a "flash lab," a seventy-foot-long, completely dark chamber within which a small group of art students undertook an intensive training course in visual perception.

During the first weeks, students worked in complete darkness, sitting first for ten minutes while they became acclimated to the dark. Images were then flashed on a screen in front of the students for a tenth of a second, after which they had to draw what they had just seen.[20] The images were generated by lantern slides projected as nine-by-twelve-foot images—almost identical in size to the film images in *Three Landscapes*—onto a large screen fifty-five feet from the students. Music was played throughout the process.

As the weeks progressed, the images evolved from simple abstract shapes to recognizable everyday objects—a wastepaper basket, a chair—as projected two-dimensional images and then as three-dimensional objects suspended from the ceiling, as well as live models (fig. 7, top). In each session, the students were brought progressively closer to the screen until they were fifteen feet away from it, shifting their field of vision to twelve times the area that they were asked to draw at the beginning. Whereas the first sessions were conducted in total darkness, by the end of the training sessions the students worked in daylight.

Significantly for *Three Landscapes*, three weeks into the flash lab course, two additional screens were added parallel to either side of the front screen, five feet in front of it, so that the projected image spilled over onto all three screens, on different planes, creating a perception of three dimensions (fig. 7, bottom). Sherman considered the ability to translate between these two registers to be a primary goal of the flash lab: "Seeing with perceptual unity must . . . become a skill not only in seeing all points in relation to a focal point, but also in converting multi-dimensional relations among these points into two-dimensional terms."[21] Lichtenstein's tilting of the two side screens toward the center screen in *Three Landscapes* creates a similar slippage in the cognitive relationship between two- and three-dimensional space.

Sherman's insistence on the somatic experience of drawing and painting encouraged an approach that, like the hypnotic effect of *Three Landscapes*, evokes the performative and psychedelic environment of the 1960s in which *Three Landscapes* was made. Sherman encouraged the students to listen to music throughout, and to move freely in the space and become aware of their bodies: "Keep relaxed . . . try to keep the whole period of drawing in rhythmic sequence; draw with big movements, feel the movements throughout your whole body; draw vigorously and with conviction. Ready!"[22]

The space of *Three Landscapes* clearly echoes the principles, if not the conditions, of Sherman's flash lab, and Lichtenstein's absorption of Sherman's radical ideas goes some way toward explaining the unique character of his moving-image installation. *Three Landscapes* incorporates Lichtenstein's distinctive Pop grammar (Benday dots, deadpan flat surface, thick black lines) to force the viewer to negotiate the boundary between two and three dimensions, and between stillness and movement, much as Sherman's flash lab had done. *Three Landscapes* recalibrates our understanding of this boundary through a series of binary relationships.

Fig. 7. Hoyt Sherman's flash lab. *Top*, diagram of objects suspended from the ceiling; *bottom*, arrangement of the three screens. Hoyt L. Sherman with Ross L. Mooney and Glenn A. Fry, *Drawing by Seeing: A New Development in the Teaching of the Visual Arts through the Training of Perception* (Hinds, Hayden & Eldredge, 1947), p. 10, fig. 4; p. 18, fig. 6.

The framing of *Three Landscapes* evokes a range of complex, interwoven associations, from the matting of a cinema image to a porthole of a listing ship through which the sea can be observed, or the exaggerated contours of a fish tank being tipped backward and forward. As always, Lichtenstein plays with scale to underline the absurdity of the image as a realistic representation, in this case distorting the natural relationship between the sky and the sea. In the left-hand screen, Benday dots, enlarged as though seen through a magnifying glass (or, in cinematic terms, in close-up) are rendered as a flat, vertical plane, in contrast to the ocean, which is also filmed in close-up but at a slightly greater distance, and from above, looking down onto the water. The right-hand screen, by contrast, shows the ocean at a much greater distance, just as the sun has set over the horizon. The film's one-minute loop sustains the magic moment of sunset over the ocean in perpetuity, shimmering like a moving postcard, the vanishing point of its long perspective abruptly obscured by the thick horizon line and the flat sky blue above it, whose flat, garish artificiality erases any suggestion of naturalistic composition. In the center screen, the image of exotic fish swimming back and forth in a small aquarium becomes a metaphor for the ocean through its juxtaposition with a still photograph of a vast summer sky overhead.

The artifice of each film is heightened by their black frames, which render the images both painterly and evocative of demonstration slides, returning us once again to Sherman's flash lab and his desire to encourage in his students what Kent Minturn describes as an "unmediated 'aesthetic vision,' through an emphasis on retention, reproduction, and speed . . . [This] attempt to turn the artist into a machine . . . led to an indissoluble paradox—action painting married to the ready-made."[23]

Sherman's goal is realized in *Three Landscapes*. There is barely evidence of the artist's hand in Lichtenstein's blue Benday dot screen, unlike the self-consciously painterly mark-making of filmmakers such as Stan Brakhage or Robert Breer. The stroboscopic structural film installations of Paul Sharits are closer to *Three Landscapes* and Sherman's techniques in their corporeal, mechanized reading of film's optical properties, but Lichtenstein aimed to erase all traces of film's celluloid reality—the frame, the grain, the surface, the sprockets—not to draw attention to it. A trace of cinema can be detected, however, in the quotation of one of its most classic techniques: the "Dutch angle," in which the horizon line is tilted at a diagonal, to depict psychological instability, disorientation, or, as in Charlie Chaplin's films, a comedic loss of control. Once again Sherman's influence can be felt, here in an echo of his engagement with forced perspective as a teaching tool, including the effect of a diagonal line on perspective. Most famously used in films such as *The Third Man* and Dziga Vertov's *Man with a Movie Camera*, the Dutch angle appears in *Three Landscapes* not as a symbol of instability, but as a tool with which to induce it.

Lichtenstein's appropriation of a cinematic trope to effect a disruption of the body's orientation in space evokes Bader's observation that "the 'physical clarity and openness' described by Greenberg in 1964 as central to properly advanced '60s painting . . . are primary to both the look and the desired effect of these landscape projections . . . [which] are characterized by precisely the interplay of surface declaration and perceived depth that was the very essence of 'optical' art for the critic."[24] *Three Landscapes* epitomizes the paradoxical relationship between painting and technology that finds its roots in Franz Kline's use of projection in 1948, at the suggestion of Willem de Kooning, to expand his painterly gestures into what amounts to a close-up.

Three Landscapes achieves a similar effect, using projection to draw the eye right up to the painterly surface, but the film footage of sea and sky

pushes the eye away again. This paradoxical optical experience demonstrates David Deitcher's argument that, while "Kline and de Kooning produced copies that looked like originals . . . Pop artists produced originals that masqueraded as copies."[25] *Three Landscapes* internalizes this paradox, executing the considerable feat of existing as a modernist film work constructed entirely outside the language of avant-garde cinema.

One of the distinctive features of this achievement is Lichtenstein's recalibration of time through the optical experience of a film loop, which creates an object rather than a perceptible narrative. The endlessness of each loop demonstrates Willoughby Sharp's assertion that "time is now measured as the spectator's perception of the duration of a witnessed activity."[26] Andy Warhol's eight-hour film *Empire* (1964) affords a similar experience of extended temporality, as it traces the gradual changes in light from dusk to evening and, eventually, dawn, against the otherwise static image of the iconic building. To screen *Empire*, theaters are obliged to take on the hours of a gallery rather than those of the cinema, further underlining the film's subject as an object to be observed over time. While the Empire State Building in Warhol's epic film remains static as the light changes, in *Three Landscapes* the simultaneous experience of stillness and movement is built in on a material as well as a pictorial level, achieved through collage as well as duration. The split screens, juxtaposing still images with moving film, are semi-static, semi-moving images, set in motion as a single, larger image by the exaggeratedly animated horizon line.

Lichtenstein's embrace of the sea as a subject is defined by the way he uses the horizon line. Discussing Goethe's account of discovering the horizon in a boat, Stephan Oettermann argues that "at sea it becomes possible to experience a previously abstract notion in a concrete way. In the line where sky and water meet, the mathematical horizon and the natural limits of sight become fused." By the end of the eighteenth century "the word *horizon* denoted not so much a particular kind of line in art or mathematics as a sensory experience" that people sought out, hoping to feel "various sensations of giddiness [that were] less true seasickness than 'see-sickness.'"[27]

The sensation of sea/see-sickness engendered by the rocking sensation of Lichtenstein's kinetic works, the liquid light effects of the Electric Seascapes, and the hypnotic undulating expanse of *Three Landscapes* evokes this curiously sought-after phenomenon, which occurred during the nineteenth century, at a transformational moment similar to that of the 1960s, as part of a newly corporealized visual experience of discovering where the limits of the world lay. The horizon became a tourist attraction, and therefore became prone, like the horizons and sunsets in Lichtenstein's films, to associations of kitsch.

Another historical precedent for the corporeal opticality of *Three Landscapes* appeared in 1900, at the Universal Exposition in Paris, a predecessor of the world's fair, whose iteration in Osaka as Expo '70 showcased the partial version of Lichtenstein's film installation. The Universal Exposition of 1900 featured two panoramic spectacles in which the audience could experience the illusion of watching a moving seascape.[28] The panoramic experiments presented at the Universal Exposition, one of the final moments in the history of the panorama, which had proliferated in European and American cities throughout the nineteenth century, were, as Oettermann has observed, "a medium of instruction on how to see"[29]—a direct precursor, perhaps, to the principles of Sherman's flash lab. Their circular format introduced a democratic experience of viewing, in which the single perspectival composition of traditional painting was replaced by a broad horizon incorporating multiple perspectives. As Oettermann points out, this large-scale format fostered a new kind of

subject matter in painting: a kind of protocinematic spectacle in which landscapes, seascapes, battles, and urban vistas were rendered topographically rather than allegorically or ideally. The new, broad audiences for this populist art form were attracted to it more for its corporeal, sensory effects than its aesthetic efficacy. This collision of art and entertainment, and the accompanying shift away from the rarified aesthetic principles of classical painting to a more pragmatic approach to the construction of a detail from the larger landscape, with the evident assistance of mechanical aids such as the camera obscura and the Claude Lorraine glass, prefigure the dramatic formal and perceptual shifts that occurred in painting during the early 1960s with the advent of Pop art.

By the 1960s, the world's fair had extended its engagement with popular culture to include contemporary art, culminating in Expo '70, where the Art and Technology Project was presented. It is significant that the three giants of Pop art—Warhol, Lichtenstein, and Claes Oldenburg— participated in this vehicle of popular, educational entertainment, showing the results of their engagement with technology in pieces that made evident the mechanistic underpinnings of their work and their corporeal effect on the viewer. In Lichtenstein's case, the hypnotic experience of *Three Landscapes* marked a watershed in the inquiry into the optics of spectatorship that had defined his work of the 1960s. Its mesmerizing effect articulated the extent to which his role in the mechanization of the gaze had thoroughly penetrated the viewer's consciousness, using the optical and kinetic properties of cinema to rewrite the relationship between the body and the machine.

NOTES

1. Willoughby Sharp, "Luminism and Kineticism," in *Minimal Art: A Critical Anthology*, ed. Gregory Battcock (University of California Press, 1967), p. 344.
2. Diane Waldman, *Roy Lichtenstein: Reflections* (Electa, 1999), p. 10.
3. Graham Bader, *Hall of Mirrors: Roy Lichtenstein and the Face of Painting in the 1960s* (MIT Press, 2010), p. 145.
4. Ibid., p. 145.
5. Clare Bell, "From Sea to Shining Sea: Roy Lichtenstein's Rowlux Works and the Luminist Tradition in American Art," Roy Lichtenstein Scholar's Day, Art Institute of Chicago, Oct. 1, 2010, typescript, p. 8.
6. Bader, *Hall of Mirrors*, p. 137.
7. Ibid., p. 133.
8. Lichtenstein, in John Coplans, "Roy Lichtenstein: An Interview," in *Roy Lichtenstein* (Pasadena Art Museum, 1967), p. 15.
9. Rowland Devt. Corp. employee Joseph "Butch" Wandy, oral history, conducted by Clare Bell, Apr. 15, 2008, transcript, p. 22. The Roy Lichtenstein Foundation Archives.
10. Quoted in Bader, *Hall of Mirrors*, p. 135.
11. Ibid., p. 146.
12. Quoted in Maurice Tuchman, *Art and Technology: A Report on the Art and Technology Program of the Los Angeles County Museum of Art, 1967–1971* (Viking, 1971), p. 194.
13. Quoted in ibid.
14. See also Clare Bell, chronology in this catalogue, p. 354.
15. Tuchman, *Art and Technology*, p. 196.

16. Others included the Experiments in Art and Technology program (E.A.T.); the "post-machine" *Cybernetic Serendipity* exhibition, Institute of Contemporary Art, London, and *The Machine*, MoMA (both 1968); *Software*, Jewish Museum, New York (1969); and *Information*, also at MoMA (1970). Jack Burnham, "Art and Technology: The Panacea That Failed," in *The Myths of Information: Technology and Postindustrial Culture*, ed. Kathleen Woodward (Coda Press, 1980).
17. Sharp, "Luminism and Kineticism," p. 344.
18. Quoted in Stephan Oettermann, *The Panorama: History of a Mass Medium* (MIT Press, 1997), p. 28.
19. Hoyt L. Sherman with Ross L. Mooney and Glenn A. Fry, *Drawing by Seeing: A New Development in the Teaching of the Visual Arts through the Training of Perception* (Hinds, Hayden & Eldredge, 1947), pp. 2, 5. While he never experienced the flash lab as a student, Lichtenstein worked in the lab as an undergraduate and graduate student; once a university instructor in his own right, he tried to replicate the conditions of the flash lab for his own students. See Michael Lobel, *Image Duplicator: Roy Lichtenstein and the Emergence of Pop Art* (Yale University Press, 2002).
20. For more on Sherman's flash lab, see Lobel, *Image Duplicator*; and David Dietcher, "Unsentimental Education: The Professionalization of the American Artist," in *Hand-Painted Pop: American Art in Transition, 1955–62*, ed. Russell Ferguson, exh. cat. (Museum of Contemporary Art, Los Angeles; and Rizzoli, 1992).

21. Sherman et al., *Drawing by Seeing*, p. 7.
22. Ibid., p. 19.
23. Kent Minturn, review of Michael Lobel, *Image Duplicator: Roy Lichtenstein and the Emergence of Pop Art*, Archives of American Art Journal 4, 1–2 (2004), p. 49.
24. Bader, *Hall of Mirrors*, p. 152.
25. Deitcher, "Unsentimental Education," p. 109.
26. Sharp, "Luminism and Kineticism," p. 334.
27. Oettermann, *The Panorama*, p. 8.
28. Ibid., pp. 177–81.
29. Ibid., p. 22.

TWO BIRDS WITH ONE STONE
YVE-ALAIN BOIS

A few months before Roy Lichtenstein died, David Sylvester asked him this question: "Have you produced any art which seems to you not to have an element of humor or wit or irony?" The artist replied:

> **Well I'm trying to think. Even the *Entablatures* are meant to be humorous in a way, because they don't seem to be funny but they mean imperial power or something like that. That's the work I can think of that's maybe the most humorless, but it's still meant to be humorous in some way.[1]**

He added: "It's hard to talk about humor without making it very unfunny." He was right, of course, but there is no way to avoid such a booby trap when writing about his works. In order to fully appreciate their humor (among other qualities), one has to identify the target of the jokes, the context to which they respond.

In the present case, there are two disparate contexts to be summoned (and it's in part on their unexpected intermingling that Lichtenstein builds his tongue-in-cheek joke). He directly alluded to the first when he named "imperial power" as the prime signified of his Entablatures (1971–76). He was even more precise in his extraordinary Kyoto lecture of 1995: "This series can also be seen to represent, in a humorous way, the *establishment*. By establishment I mean that the reference in these *Entablature* paintings was to the Greco-Roman tradition, which permeates our art and culture."[2] The other context (to avoid suspense on your behalf, dear reader) is Minimalism—but more on that below.

Figs. 1–3. Roy Lichtenstein. Photographs of architectural details. The Roy Lichtenstein Foundation Archives.

Fig. 4. Roy Lichtenstein. *Temple of Apollo*, 1964. Oil and Magna on canvas; 238.8 × 325.1 cm (94 × 128 in.). Private collection, Saint Louis.

As is well documented, the visual source of the Entablature series was a photo shoot in the Wall Street area of New York City (and in Lower Manhattan, where Lichtenstein had his studio at the time) (see figs. 1–3).[3] Going straight for the geographical jugular of Empire, Lichtenstein photographed building fragments at a time of day when the shadows would be the least distorted and convey the maximum information about their referent (what they are a shadow of). These architectural morsels look crisp in the photographs but unimposing despite having been shot from below, at street level. The cool, mineral detachment in the sharp dark/light contrast of these exclusively frontal images recalls the very early attempts at recording architectural monuments by Edouard Baldus, Gustave Le Gray, and their colleagues of the 1851 Mission Héliographique, but there is a major difference between the work of these pioneers and Lichtenstein's snapshots: for all their attentiveness to detail, the latters' purpose is not documentary, strictly speaking. Or rather, what they document with a certain laissez-faire (they are casually framed) is the routine use of classical motifs by architects of institutional buildings (banks, above all) at the end of the nineteenth and the beginning of the twentieth century. In other words, they record not particular monuments but the pervasiveness of a handful of architectural traits in our culture.

A couple of sessions were enough for Lichtenstein to gather all the shots he needed for concocting a kind of statistical average, a generic look. As the many preparatory drawings for the series reveal (from doodles in a sketchbook to finished studies), his main concern was finding the minimum information required for a vertical piling of horizontal bands to be read as a classical entablature—that is, the architrave, which rests directly on the capital; the cornice, which supports the pediment; and, between these two, the frieze. One or two ornamental bars were enough, Lichtenstein found out, and many sketches endeavor to simplify the decorative models he had photographed. To simplify, but to tweak as well. The traditional bead-and-reel pattern one sees in many of the Entablature paintings, for example, has been slanted to the right, so that it looks like a torsade and thus suggests movement (this never happens in antiquity, and it is doubtful that it occurred in any of the buildings the painter photographed).[4] Yet although no particular New York building would ever be recognized as the source for any one painting, there could not be any doubt that Greco-Roman architecture, or rather the imitation by American architects of its imitation by French Beaux-Arts architects of the nineteenth century, was the model.

While Lichtenstein's Entablatures are often linked to his formidable *Temple of Apollo* (fig. 4) and other works of the same ilk (such as *Three Pyramids* [1969; private location]), the target of the painter's irony is slightly different here. The previous works were playing with icons of mass tourism (*Temple of Apollo* is based on a postcard of a Corinthian ruin, barely transformed), but the debasement to which the Entablatures allude is of another kind—it is that of the devolution into vernacular of the "classical language of architecture," to use John Summerson's phrase.[5] While in 1857 a Karl Marx could ponder the charm that Greek art still exerts on us, despite the fact that our world differs so much from that of its makers, by 1871 a César Daly—then the leading modernist critic of architecture in France—would declare that the idiom of classical architecture had become meaningless.[6] And by 1912, it was the vapidness and fraudulence of its imitation that Roger Fry lamented, as Lawrence Alloway perspicaciously reminded us in his commentary on Lichtenstein's Entablatures.[7]

This explains perhaps why Lichtenstein had recourse to photographs—and not, say, to books about classical architecture (none are to be found in his library, although a clipping pasted in one of his notebooks

reproduces the plate of a Renaissance architectural treatise representing a Doric entablature [fig. 5]).[8] To learn the language of fraudulence, to be able to speak it with the proper accent, one must resist the temptation of consulting the original—one must instead start from its degeneration into a hackneyed cliché, which is the strategy Lichtenstein adopted each time he took "high art" (be it Piet Mondrian, Pablo Picasso, or Paul Cézanne) as his ostensible point of departure.[9] Speaking about his early use of cartoons and comic strips, he told Alloway, "It's really the art we have around us; we're not living in the world of Impressionist painting . . . Our architecture is not van der Rohe, it's really McDonald's, or little boxes."[10] He could have added: it's not the Temple of Apollo at Corinth, it's the facade of the New York Stock Exchange. And if the cliché is not legible enough qua cliché, he'll make one up: he'll hatch up an "idiot Picasso," for example, as he declared to John Jones in 1965,[11] or a brain-dead Mondrian.

Was Lichtenstein aware of the gallons of ink that had been spilled in debates, since the rediscovery of Vitruvius's treatise in the Renaissance, on the exact proportions and placement of every architectural element in the Greco-Roman tradition he was invoking, albeit through several degrees of separation? From his student years he might have remembered the respective merits of the five "orders" (Doric, Ionic, Corinthian, Tuscan, and Composite), but for his purpose he did not need to, for the debates had mostly raged around the morphology of the column or the capital (hard to believe today, but the main issue was which best imitates nature). The *table* (en*tabl*ature, es*tabl*ishment) resting on these noble components (and on which, in turn, rested the noblest of all, the pediment) had remained more or less the stuff of specialists, and there is a good reason for that: to the noninitiate, a classical entablature is bland, a quasi-mute interval—all the more since the frieze, that is, the most potentially decorative element of the entablature, was usually conceived (except for its Doric variant) as a wall space eventually destined to be adorned by sculptures (but most often left blank in the version distilled by Beaux-Arts architects). So not only would the fuss about the orders have been utterly superfluous for Lichtenstein, but he also chose to zero in on the least demonstrative, most mute element of the Greco-Roman architectural inheritance.

What is remarkable (and no doubt fortuitous) is that Lichtenstein's travels in "antiquity" landed him not far from other critiques of Beaux-Arts academism, addressing the system from within a century and a half earlier. I am thinking in particular of Henri Labrouste, whose exquisite 1828 drawings for his imaginary restoration of Paestum (fig. 6) earned him the opprobrium of none other than Antoine Quatremère de Quincy, the powerful chief of the Académie des Beaux-Arts ("an aberration") and the accolades of the romantic and Gothic revivalist Eugène Viollet-le-Duc ("purely and simply a revolution, on a few sheets of double-elephant paper").[12] But even closer to Lichtenstein's Entablatures is the restoration project of the Rome Colosseum by Louis Duc, submitted a year after Labrouste's Paestum: one of his most beautiful and austere drawings (fig. 7) adorns the cover of Arthur Drexler's *The Architecture of the École des Beaux-Arts*, the 1977 catalogue of a 1975–76 exhibition of the same title at the Museum of Modern Art, New York (to which we will turn again below). I wager that if this book had *preceded* (instead of followed) Lichtenstein's series, Duc's sheets would have been declared its source.[13] In both we see the same absolute frontality, same cropping, same vertical piling of horizontal bands of various tonality, same regular shadows. In fact, already in his photographs but above all in the finished drawings related to the series (as opposed to the small sketches), Lichtenstein seems to be emulating—to a T— Duc and Labrouste's overkill (so extreme as to become unorthodox) in obeying the rules of the Académie for architectural drawing competitions

Fig. 5. Roy Lichtenstein. Page from the Jericho Compositions notebook, with cut-and-pasted printed image of a classical architectural study. Private collection.

Fig. 6. Henri Labrouste. Restored facade, Temple of Neptune, Paestum, 1828. École nationale supérieure des Beaux-Arts, Paris.

Fig. 7. Louis Duc. Colosseum, Rome, elevation and capital study, 1830. École nationale supérieure des Beaux-Arts, Paris.

(no perspective rendering, only orthogonal projections; so, aside from plans, any information regarding space and volume was to be conveyed solely by the play of shadows on elevation renderings).[14] The only difference between Lichtenstein's and Duc's rendering of an entablature is that Duc anchors his cropped fragment on the capital upon which the entablature rests and whose marble curves he depicts with a mixture of distant cool and caressing sensuality, while Lichtenstein utterly omits it.

It is hard today to understand why those highly polished drawings were so severely judged by the members of the Académie, to whom they were sent from Rome (the fourth-year *envoi* of a Villa Medici *pensionnaire* was to include both the precise record of a ruined monument and a detailed project of its restoration). The pretext of the fury unleashed at Labrouste was that he had chosen a Greek site instead of the traditional Roman one (Paestum, originally named Poseidonia, was founded by Greek colonists at the end of the seventh century B.C.). But the real reason was that the young and brilliant architect had discarded the sacrosanct text of Vitruvius and had chosen instead to rely solely on his own observations and measurements in situ for the recording part of his *envoi*, and on a constructive approach (basically that of an engineer) for his restoration project. As a result, he documented the anomalous (and, to the Academicians, scandalous) superposition of two orders of columns in the cella of the second Temple of Hera, and explained this patently non-Roman feature, to quote Neil Levine's superb analysis of this episode, as "a mere structural exigency."[15] In short, he paid less attention to the various orders with regard to their stylistic characteristics and prescribed use than to their rational, constructive role, and he insisted on the inventiveness of Greek architects, their willingness to depart from fixed rules. It does not sound like much, but "this was heresy," notes Levine, who adds: "Labrouste's restoration of Paestum sounded the death knell of Neoclassicism in France."[16] It would not take long for the message to be heard—Duc's Colosseum already echoes Labrouste's audacity in faithfully recording the simplified orders he discovered in this ruin.[17] As for Labrouste, he would become more and more rebellious until he stunned the architectural world with his Sainte-Geneviève Library in 1850, "the first French building to discard the Order, or any of its surrogate forms, as the means for ordering a building."[18]

A final note about the Entablatures and the history of architecture. If Drexler's formidable exhibition could not have had any role in the artist's sudden turn to the Greco-Roman model and its avatars, it did have a major impact on the production of architecture, for a massive return to classicism took place in the years following the show, taking off immediately after it closed its doors. This was the last turn of the eclectic movement branded "Postmodernism," a turn whose initial spark had probably been Robert Venturi and Co.'s *Learning from Las Vegas* (MIT Press, 1972), with its populist and disingenuous plea for an architecture of the "decorated shed." It took a while for Venturi's pamphlet to trickle down to architectural practice, and for his misty-eyed defense of the Caesar's Palace sign to be hailed as having presaged a revolution and launched a victorious repudiation of Modernist architecture (just as in the 1920s the infamous "return to order" in painting had been celebrated as a cutting-edge rebuttal of Cubism and abstract art). Drexler's show came at exactly the right time for this particular "return" to take off, and by the late seventies and early eighties, architecture worldwide was deep into a lovefest with the mediocre pastiches of the likes of Michael Graves and Ricardo Bofill, which were imitated everywhere and for every possible kind of building, from the crassest strip mall to the most luxurious skyscraper.

The first Entablature painting dates from 1971 (JP Morgan Chase Collection, New York), the last ones from 1976 (the last drawings and prints

also date from that year)—which is to say that Lichtenstein stopped working on the series shortly before the neo-Neoclassicist rage struck. There are only thirty paintings, divided into two series (the first, from 1971–72, is exclusively in black and white [see fig. 8]; in the second, from 1974–76, Lichtenstein added color and texture [see figs. 9, 12]); a handful of drawings; and eleven prints: a relatively small number of works, done in a relatively short period of time—in comparison, say, to the artist's several decades of involvement with the theme of the brushstroke. My guess is that it is not coincidental that Lichtenstein lost interest in the entablature just as the architectural world was suddenly rediscovering the Greco-Roman patois, this time inflected with the heroism of novelty (a Postmodernist David against the tyrannical Goliath of Modernism), as opposed to the dusty smell of the Beaux-Arts tradition. Had he gone on with this series, it would have ended up looking either as if he belonged to the same club as the Postmodern pasticheurs, or as if their work was the butt of his joke. Neither of those possibilities could have appealed to him much: first, because his manipulation of the classical codes is far more subtle than that of the neo-Neo architects (whose pediments, columns, arches, and the like were so poorly detailed that they did not offer much to dwell on, and whose resolutely conservative stance, particularly with regard to contemporary art, would not have made them very desirable company);[19] and second, because it is practically impossible to parody a pastiche. (Art Deco is not a pastiche of Cubism, for example, but one of its "derivatives," as Lichtenstein notes, adding, it's "Cubism for the Home," which is why he could base a whole series of parodic works on it—the Modern paintings and sculptures of 1966–71.)[20] "The things that I have apparently parodied I actually admire," Lichtenstein said in 1964; I doubt he felt the same "perverse admiration" for Graves and Co. that he felt for their Beaux-Arts models.[21]

One thing is certain, in any event: in his investigation of the entablature as a motif, he did exactly what the neo-Neoclassicists did not do when they decided to pilfer anew the Greco-Roman cornucopia: not only did he discard, as mentioned above, the most recognizable elements of the decorative apparel (the capital), but he did not even consider alluding to the cardinal rule of symmetry, so dear to classical architecture. Rather, he chose to concentrate, as Labrouste and his friends had done before him, on what is perhaps the favorite feature in any building for any painter, the wall, and highlighted above all its lateral expanse.

After mentioning the 1968 Stretcher Frame series and his Mirror series (1969–72) in his Kyoto lecture, Lichtenstein said of the Entablatures, "Once again these paintings can be seen as objects (rather than as pictures with objects in them), in that the entablature itself constitutes the whole painting."[22] But this is not quite the case. That is: only the cropped fragment of an entablature is depicted (as opposed to Lichtenstein's mirrors, or his stretcher, given whole), and the elongated horizontal format suggests a potential extension (the elongation is often carried to the absurd, as in *Entablature #8* [1972; cat. 102], included in the present exhibition, which measures 30 by 240 inches!). In framing a fragment of an edifice and representing it flush with the picture

Fig. 8. Roy Lichtenstein. *Entablature #4*, 1971. Oil and Magna on canvas; 66 × 548.6 cm (26 × 216 in.). Private collection.

Fig. 9. Roy Lichtenstein. *Entablature*, 1975. Oil and Magna on canvas; 177.8 × 284.5 cm (70 × 112 in.). Musée d'art moderne de Saint-Étienne Métropole.

66

Fig. 10. Donald Judd. *Untitled (Progression)*, 1979. Galvanized steel and anodized aluminum; 12.7 × 191.1 × 12.7 cm (5 × 75 ¼ × 5 in.). Museum of Modern Art, New York, the Riklis Collection of McCrory Corporation. © Judd Foundation. Licensed by VAGA, New York, NY.

Fig. 11. Kenneth Noland. *Grecian Dream*, 1969. Acrylic on canvas; 58.4 × 304.8 cm (23 × 120 in.). The Art Institute of Chicago, bequest of Solomon B. Smith. © Estate of Kenneth Noland / Licensed by VAGA, New York, NY.

Fig. 12. Roy Lichtenstein. *Entablature*, 1975. Oil, Magna, and sand with aluminum powder and Magna medium on canvas; 91.4 × 121.9 cm (36 × 48 in.). Private collection.

plane, Lichtenstein eliminated any subjective point of view and underlined the planarity of classical architecture, ignoring its rightfully celebrated play of volumes. "You say that composition was all for Greco-Roman architects and their multitudinous progeny," these works announce (or so I imagine) to the arch-conservative champions of the Academy, as well as to the art historians satisfied with this cliché, "but I'll show you otherwise: this architecture is about flatness and repetition." The Entablature series, in Lichtenstein's own words (words he applied to the Office Furniture series that immediately followed, but which are equally if not more applicable here), is "interesting in its uninterestingness."[23]

Which is to say something like: "This architecture is akin to Minimal art." After all, Lichtenstein's formulation recalls Donald Judd's famous declaration that "a work needs only to be *interesting*" (see fig. 10).[24] Indeed, it even ups the ante of the statement, calling not merely for an interestingness but for an *uninteresting* one. But Lichtenstein's wit goes deeper than that. As he said in the Kyoto lecture: "The *Entablatures* represent my response to Minimalism and the art of Donald Judd and Kenneth Noland. It's my way of saying that the Greeks did repeated motifs very early on, and I am showing, in a humorous way, that Minimalism has a long history . . . It was essentially a way of making a Minimalist painting that has a Classical reference."[25] So much for any avant-gardist claim of radical novelty: always take such claims with a grain of salt, Lichtenstein tells us.[26] Hard to know whether Judd felt a sting (after all, he had been one of the earliest and most eloquent defenders of Lichtenstein, brilliantly comparing his work to "metalinguistics"),[27] but the Pop painter's elegant whack could be regarded as tit for tat. In both his 1962 and 1963 reviews Judd had deemed Lichtenstein's paintings compositional (in 1962, this was seen as a flaw; in 1963 as a necessity: "Something has clearly to be art—that is, already developed and recognizable").[28] Whatever the case, Lichtenstein's take was prescient: today very few things look as classical as Judd's art, in every sense of the term.

Things go a bit differently with regard to Noland, for here the visual quote is direct, and the critical strategy more flagrant: in addition to the one or two decorative stripes mentioned above, what distinguishes an Entablature most from the series of elongated horizontal canvases that Noland painted between 1966 and 1970 (see fig. 11) is the thickly textured band of metallic paint (a mix of Magna and sand) that Lichtenstein conspicuously trowels in, adding one more marker in favor of the signified "wallness" (see fig. 12). In the second series of Entablatures, Lichtenstein even adds the clue of color (in case we missed the allusion to Noland in the predella format): the chromatic range is close to Noland's, with its saturated hues of juxtaposed blue, green, red, or yellow, sometimes alternating with flesh tones.

"Noland's pictures of the late sixties are the fastest I know," Leo Steinberg wrote in 1972, just as Lichtenstein was beginning his first Entablature series.[29] The fastest? What about all the commercial imagery

vaunted by Pop artists? What about the WHAAMs and the POWs? Wasn't immediate recognition part of the allure of Pop art?[30] Lichtenstein's retort was to show how little it takes to decelerate a Noland picture: a regular row or two of meandering shadows, a stuccolike application of metallic paint, and the race car of painting slows to a walking pace. Duchamp used a mustache to act out his vandalistic penchant; Lichtenstein's irreverence is less acerbic, one could even say it is more generous: by forcing us to take on his Entablatures in slow motion (and to come close in order to enjoy the granular tactility of their metallic bands), he also invites us to go have a second look at Noland's work. Call it constructive deconstruction or just plain tact, Lichtenstein's winks are always eye-opening.

As far as I know, the Entablature series is the last group of works in which Lichtenstein explicitly *toys* with the possibility of abstraction, transforming a figurative motive into something nearly abstract, as opposed, say, to producing abstract paintings directly, which he had done with his Brushstroke series and would do again with the Perfect/Imperfect series (1978–89), or the Plus and Minus series (1988), all of which you could call his own versions of the "idiot" abstraction.[31] And it is the last series, as well, in which congruence (between image and field) is clearly posited as a trope of noncomposition (there are a few works after that, such as *Painting with Detail [Blue]* [fig. 13] and *Painting with Detail [Black]* [1987; Robert and Jane Meyerhoff Collection], but those are exceptions).[32] Congruence had been a strategy Lichtenstein had adopted since his early Pop years and brought to a pinnacle with the Mirror series, which is roughly contemporary with the Entablatures (they are often shown together). As opposed to the congruence of the Mirrors, though (or to *Stretcher Frame* [fig. 14] and a few other works, including of course the three canvases that bear the most ironic title of his entire output, the 1964–65 Compositions based on the marbleized cover of notebooks [see cat. 26]), the congruence of field and image is not easily perceived in Lichtenstein's Entablatures. This is because, although the picture plane is congruent with the surface of the wall that is depicted, the image, as noted before, represents only a fragment of that wall rather than coinciding fully with the totality of the object (as, does, say, a Jasper Johns *Flag* or, several years before that, Ellsworth Kelly's *Window, Museum of Modern Art, Paris* [fig. 15]).

In his Kyoto lecture, a chronological commentary on his life's work, Lichtenstein situates his interest in congruence as something that followed (perhaps stemmed from) his *Golf Ball* (1962; cat. 20):

> **Then I was interested in doing works where the painting itself can be thought of as an object, where the size and shape of the subject and the size and shape of the painting are the same. This phenomenon happens in various stages of my work where the subject of the painting is rectangular and occupies the entire canvas, so you can consider the painting to be an object. This was being done in the abstract painting of other artists as well, and in *shaped canvas* paintings, where the shape was not rectangular, like certain Frank Stella paintings of the period, where the canvases were filled with concentric bands of color.[33]**

Reflecting on those comments, one soon realizes that Lichtenstein's paintings based on comic strips and cartoons were in fact the first works in which such a congruence took place—but there, too, it is difficult to spot. And this time for a different reason: the image is so powerful that we are oblivious to the fact that the painting is a picture of a picture.[34] For us to acknowledge that fact, the picture of the picture has to be "misconstructed" (as he realized later on when he used Picasso or Mondrian as grist for his

Fig. 13. Roy Lichtenstein. *Painting with Detail (Blue)*, 1987. Oil on canvas; left, 152.4 × 121.9 cm (60 × 48 in.); right, 43.8 × 43.5 cm (17 ¼ × 17 ⅛ in.). Private collection.

Fig. 14. Roy Lichtenstein. *Stretcher Frame*, 1968. Oil and Magna on canvas; 91.4 × 91.4 cm (36 × 36 in.). Private collection.

Fig. 15. Ellsworth Kelly. *Window, Museum of Modern Art, Paris*, 1949. Oil on wood and canvas, two joined panels; 128.3 × 49.5 cm (50 ½ × 19 ½ in.). Collection of the artist.

mill).[35] To be sure, Lichtenstein always transforms his source images, but only an avid reader of comic books (or the rare academic specializing in their history) could have detected the misconstruction—thus the common belief that in his comic-strip paintings he merely "duplicated" his found material, a misconception that he never ceased to lament. This is perhaps the reason why, rather than painting strictly congruent images, Lichtenstein preferred for a while to depict an object isolated in the middle of an empty white field (as in his *Golf Ball*), a stylistic device he called "islanding."[36]

The fact that congruence returned in force in Lichtenstein's work as he tackled abstraction should not be surprising, for within abstraction there are very few tropes that can exhale the kind of impersonal look he had always been striving for. "I think the only innovation in Pop plastically is that the painting doesn't have to be symbolic of the organizing act," he declared in 1965.[37] All too true, but apart from the modular grid and the monochrome (which he will combine in *Painting with Detail [Blue]*), or chance (a version of which he depicts with a supreme irony in his painstakingly elaborate Brushstroke series), congruence is about the only other strategy one can use when wanting to free painting from the romantic pathos of the organizing mimicry. And it is perhaps the best at producing the meaninglessness he always wanted to obtain, his Grail.

A much shorter version of this essay appeared in the catalogue of the exhibition *Roy Lichtenstein: Entablature Paintings*, Paula Cooper Gallery, New York, September–October 2011. My thanks to Harry Cooper for his invaluable editorial comments, to Joan Breton Connelly for the information she gave me regarding Greco-Roman entablatures, and to Cassandra Lozano and Clare Bell of the Roy Lichtenstein Foundation for their generosity in answering my questions and giving me access to their documentation.

1. Lichtenstein, quoted in "New York, April 1997," in *Some Kind of Reality: Roy Lichtenstein interviewed by David Sylvester in 1966 and 1997*, exh. cat. (Anthony d'Offay Gallery, London, 1997), p. 33. Available on the Roy Lichtenstein Foundation website.

2. Roy Lichtenstein, "A Review of My Work Since 1961—A Slide Presentation," in *Roy Lichtenstein*, ed. Graham Bader, October Files 7 (MIT Press, 2009), p. 66. This lecture was delivered by Lichtenstein on November 11, 1995, on the occasion of being awarded the Kyoto Prize that year.

3. See Diane Waldman, *Roy Lichtenstein*, exh. cat. (Solomon R. Guggenheim Museum, 1993), p. 195; and Jack Cowart, "Entablatures, 1971–72," in Cowart, *Roy Lichtenstein, 1970–1980*, exh. cat. (Hudson Hills/Saint Louis Art Museum, 1981), pp. 31–32.

4. Here are some other examples (among many) of slight transformations by Lichtenstein: in *Entablature #4* (fig. 8), he places small decorative circles in the metopes (the blank spaces between triglyphs on the frieze), which is unheard of—these spaces were highly valued by ancient Greeks and were regularly adorned with figurative scenes, as on the Parthenon, and, sometimes, with enemy shields displayed as trophies after battle. In an *Entablature* dating from 1975 (private collection), he repeated this scheme but replaced the triglyphs with an invention of his own: diglyphs. In another *Entablature* from the same year, besides denoting marble via a pattern that seems more appropriate for wood (as indeed he concurred in several works of other series), Lichtenstein transforms the "beads" of his slanted "bead and reel" into horizontal triglyphs (fig. 9). (These works appear as checklist nos. 22 and 19, respectively, in *Roy Lichtenstein: Entablature Paintings*, exh. cat. [Paula Cooper Gallery, 2011].) In each case the alteration must seem minimal to a nonspecialist (if perceived at all), but represents a major violation of the classical code. My thanks to Joan Breton Connelly for enlightening me on all this.

5. See John Summerson, *The Classical Language of Architecture* (MIT Press, 1965).

6. Here is Marx's celebrated passage in his "Introduction to a Contribution to the Critique of Political Economy": "Is Achilles possible when powder and shot have been invented? And is the Iliad possible at all when the printing press and even printing machines exist? Is it not inevitable that with the emergence of the press bar the singing and the telling and the muse cease, that is the conditions necessary for epic poetry disappear? The difficulty we are confronted with is not, however, that of understanding how Greek art and epic poetry are associated with certain forms of social development. The difficulty is that they still give us aesthetic pleasure and are in certain respects regarded as a standard and unattainable ideal." In Karl Marx and Friedrich Engels, *A Contribution to the Critique of Political Economy*, trans. S. W. Ryazanskaya (Lawrence and Wishart, 1971), p. 216. For César Daly, see Neil Levine, "The Romantic Idea of Architectural Legibility: Henri Labrouste and the Neo-Grec," in *The Architecture of the École des Beaux-Arts*, ed. Arthur Drexler, exh. cat. (Museum of Modern Art, New York, 1977), p. 328.

7. "Roger Fry, a formalist, a modernist, and a snob, sitting in a railroad waiting room made contemptuous notes on the democratic ornament that surrounded him. The room included 'a moulding but an inch wide and yet creeping throughout its whole width a degenerate descendant of a Graeco-Roman carved guilloche pattern: this has evidently been cut out of the wood by machine.' (A guilloche is an ornamental band of interlaced curves.) Lichtenstein's Greek keys and dentils are subject to the same degeneration when repeated by machine production. He starts, as his photos show, with the mechanization of ornament as a fact, and includes it in his art, which is slyly hand-done." Lawrence Alloway, *Roy Lichtenstein* (Abbeville Press, 1983), p. 69.

8. The notebook is referred to as the Jericho Compositions notebook (private collection), from the label on its cover. The clipping seems to come from a glossy magazine; the image seems to be from a seventeenth- or eighteenth-century edition of a Renaissance architecture treatise, most probably Giacomo Barozzi da Vignola's *On the Five Orders of Architecture*.

9. The words "hackneyed" and "cliché" are recurrent in Lichtenstein's interviews. For "hackneyed," see, for example, his 1965 interview with Coplans in Bader, *Roy Lichtenstein*, p. 33; as for "cliché," the interview with David Sylvester of the same year is almost entirely devoted to it ("Roy Lichtenstein," in Sylvester, *Interviews with American Artists* [Yale University Press, 2001], pp. 222–34). The best analysis of Lichtenstein's use of visual clichés is found in Hal Foster, *The First Pop Age: Painting and Subjectivity in the Art of Hamilton, Lichtenstein, Warhol, Richter, and Ruscha* (Princeton University Press, 2011), chap. 2, "Roy Lichtenstein, or The Cliché Image."

10. Alloway, *Roy Lichtenstein*, p. 106.

11. John Jones, "Tape-recorded Interview with Roy Lichtenstein, October 5, 1965, 11:00 A.M.," in Bader, *Roy Lichtenstein*, p. 22.

12. Quoted in Levine, "The Romantic Idea of Architectural Legibility," p. 365.

13. By the time the exhibition opened (Oct. 29, 1975), Lichtenstein had already painted most of his Entablatures.

14. Gaspard Monge theorized the auxiliary use of shadows in orthogonal projections as early as 1799 in his *Géométrie descriptive*. By the time of the new edition of this book (1820), his method had become a staple of the architecture curriculum at the École des Beaux-Arts.

15. Levine, "The Romantic Idea of Architectural Legibility," p. 375.

16. Ibid., pp. 386–88.

17. See the entry on Duc's Colosseum project in Drexler, *The Architecture of the École des Beaux-Arts*, p. 166.

18. Levine, "The Romantic Idea of Architectural Legibility," p. 349.

19. An episode illustrates the reactionary and populist opposition of the neo-Neo architects to contemporary art: for its celebratory exhibition *200 Years of American Sculpture*, in the spring of 1976, the Whitney Museum had hired Robert Venturi and his team as architect/installer, promising him total freedom. Venturi's antimodernist input dominated the show, starting with the posting of a twenty-nine-foot billboard of Hiram Powers's *Greek Slave* outside the museum (resting on the entrance canopy), and continuing inside with a deliberate sabotaging of the works of Dan Flavin, Carl Andre, and many others. Andre withdrew one of the two pieces of his in the show, *Twelfth Copper Corner*, and asked that the other one, *29th Copper Cardinal*, which the museum had recently

purchased, be removed (he even offered to buy it back)—a request that was not granted. The artist then exhibited (at the John Weber Gallery) the first piece with the subtitle "Rescued from Mutilation at the Whitney Museum of American Art" and a new version of the second piece with the subtitle "Liberated from Property Bondage at the Whitney Museum of American Art's '200 Years of American Sculpture.'" On this episode, see T. B. Hess, "Carl Andre Has the Floor," *New York Magazine,* June 7, 1976, pp. 70–71; and Rosalind Krauss, "Las Vegas Comes to the Whitney," in *Partisan Review* 3 (1976), pp. 467–71.

20. Lichtenstein lumps together Art Deco, Purism, Vorticism, and Futurism: "I am interested in the quirky results of those derivatives of Cubism and like to push this quirkiness further toward the absurd." Lichtenstein, "A Review of My Work Since 1961," p. 66; for the "Cubism for the Home" tag, see p. 62.

21. See Foster, *The First Pop Age*, p. 106. Foster's essay is particularly brilliant in pointing out the double movement that pervades Lichtenstein's work and gives it its dialectical tension (a dialectic that, as he shows at every turn, never resolves in a reconciliation). As mentioned above, it is Lichtenstein's use of the cliché that Foster sees as the clearest implementation of his dual strategy: "on the one hand, the cliché is reproduced to the point of utter familiarity, and therefore, as Lichtenstein comments, it is 'completely antithetical to art'; on the other, its 'visual shorthand' suggests 'a kind of universal language,' one that can possess a 'startling quality,' in which case it involves 'an esthetic element' that can be developed. It is this doubling within the cliché that Lichtenstein exploits" (p. 90).

22. Lichtenstein, "A Review of My Work Since 1961," p. 66.

23. Ibid., p. 67.

24. Donald Judd, "Specific Objects" (1963), in Judd, *Complete Writings, 1959–1975* (Press of the Nova Scotia College of Art and Design/New York University Press, 1975), p. 184.

25. Lichtenstein, "A Review of My Work Since 1961," p. 66.

26. Interestingly enough, Lichtenstein's strategy is not dissimilar to that of Rosalind Krauss in her early essay "Allusion and Illusion in the Art of Donald Judd"— although the aesthetics to which she was tying Judd's art, against his declared program, was that of his nemesis Clement Greenberg and not that of classical architecture. This essay, initially published in the May 1966 issue of *Artforum*, is reprinted in Krauss, *Perpetual Inventory* (MIT Press, 2010). Judd told me that he was particularly incensed by the suggestion that some illusionism could be detected in his work (which would thus be more in keeping with Greenberg's credo than he ever suspected).

27. Donald Judd, "Reviews, 1962–64 (1962, 1963, 1964)," in Bader, *Roy Lichtenstein*, p. 4. Originally published in *Arts Magazine* (Nov. 1963).

28. Judd, "Reviews, 1962–64," p. 4. The most relevant of Judd's reviews, with regard to the Entablatures, is that of Lichtenstein's third show at Leo Castelli in 1964 (pp. 4–5), which included various sunsets and seascapes as well as the large *Temple of Apollo* (fig. 4): "Lots of people hang up pictures of sunsets, the sea, noble buildings and other supposedly admirable subjects. These things are thought laudable, agreeable, without much thought. No one pays much attention to them; probably no one is enthusiastic about one; there isn't anything there to dislike. They are pleasant, bland, and empty. A lot of visible things are like this . . . The stuff just exists, not objectionably to many people, slightly agreeably to many. Basically, again, no one has thought about it. It's in limbo . . . No one knows anything about Greek temples and everyone agrees they're great. Lichtenstein is working with this passive appreciation and opinion" (p. 4).

29. Leo Steinberg, "Other Criteria," in Steinberg, *Other Criteria: Confrontations with Twentieth-Century Art* (Oxford University Press, 1972), p. 81.

30. The neo-Kantian ideal that "the whole of a picture should be taken in at a glance" was a staple of Clement Greenberg's aesthetics, and of his defense, as well as that of Michael Fried, of an artist like Noland—and it is a major target of the vigorous attack against their position by artists such as Robert Morris and Robert Smithson, or critics like Rosalind Krauss (whose book *The Optical Unconscious* [MIT Press, 1993] is for the most part a refutation of this ideal). But as Hal Foster shows, Pop art, and particularly the work of Lichtenstein (as well as that of Richard Hamilton), deaestheticizes the ideal and deflates its transcendentalist loftiness in relating it to commodity branding and to marketing strategies (see *The First Pop Age*, pp. 58–60, 72, 102).

31. On the Perfect/Imperfect series, see the essay by James Rondeau in this catalogue, and my own preface for the catalogue of their exhibition at Gagosian Gallery in 2002. In this text, I proposed that the Imperfect paintings were a parodic response to Frank Stella's shaped canvases, and I developed an idea voiced by Lichtenstein in his Kyoto lecture—that in these works he was seeking "the most meaningless way to make an abstraction."

There is yet another series of abstract works, the Forms in Space series of 1985 and 1987. The first batch clearly belongs to the mimicking category (a figurative motive made nearly abstract), as they stem from *American Flag* from 1980 (location unknown); in the second batch, of a square format, the reference to the flag is gone and the paintings look closer to a Sol LeWitt grid. Finally, there are some isolated works in the 1990s that exploit what I call the mimicking strategy, for example *Venetian Blinds* (1994; private collection) and *Venetian School I* and *II* (1996; private collection).

32. We can also add the two Venetian blind paintings as well as the Forms in Space series mentioned in the previous note, although the case is more complicated for the latter.

33. Lichtenstein, "A Review of My Work Since 1961," p. 60.

34. As Harry Cooper points out in his essay in this catalogue, Lichtenstein most often cropped his comic-strip source images, but unlike what happens with the Entablatures, we are not made aware of this, since *framing* is in itself one of the most important devices of the medium of comics.

35. Jones, "Tape-recorded Interview with Roy Lichtenstein," p. 22.

36. Lichtenstein uses the term "islanded" to describe his isolation of an object in the middle of an empty field in paintings from the early sixties. Curiously, he does not differentiate between the perfect adequation between field and image and his "islanding" technique which he compares, not too accurately, to the practice of Noland. See Jones, "Tape-recorded Interview with Roy Lichtenstein," p. 26. On "islanding" and adequation (or congruence), see the essay by Harry Cooper in this catalogue.

37. Jones, "Tape-recorded Interview with Roy Lichtenstein," p. 31.

STUDIO ARTIST

JAMES LAWRENCE

It's a case of building something that looks completely without thought, or senseless, and then of course trying to make it work. I mean, that's the hope.

—Roy Lichtenstein, interviewed by Jean-Claude Lebensztejn, 1975

Ten years after *Baseball Manager* (1963; The Helman Collection) appeared in Roy Lichtenstein's second solo exhibition at Leo Castelli in New York, a corner of it reappeared in his painting *Artist's Studio* (fig. 1). The economical, graphic clarity and the telltale pattern of hexagonal background mesh make the excerpt instantly recognizable. The portrait is enclosed within an incongruous, ornate frame that lends an air of tradition to what is, after all, remarkably traditional subject matter. The horizontal band of architectural detail that reinforces this nod to heritage, however, refers to Lichtenstein's Entablatures (1971–76). To give an idea of the dizzying complexity involved when Lichtenstein incorporated his own works: the architectural detail is a representation of a type of painting that Lichtenstein based on photographs of neoclassical architecture in Manhattan. We see a depiction of a depiction of a depiction of a derivative style—at least four orders of remove from the underlying source.

The complications continue. Who can say with certainty that the abbreviated circle at the top edge of *Artist's Studio* should be understood as one of his Mirror tondi (1969–72) rather than as a mirror, or that the stack of cups in the foreground is one of the Ceramic Sculptures (1965–66) and not just a stack of ceramic tableware? The remaining two replications of Lichtenstein's earlier paintings in *Artist's Studio* are less ambiguous: *Still Life after Picasso* (1964; fig. 5, p. 41), as though nestling between *Baseball Manager* and the wall; and *Stretcher Frame* (1968; fig. 14, p. 68), which seems to be hanging on the wall. These appear in plausible locations that help to articulate the pictorial space.

In addition to these references to his own work, Lichtenstein included at the heart of *Artist's Studio* a stripped-down emulation of the table in Henri Matisse's *Red Studio* (1911; Museum of Modern Art, New

Fig. 1. Roy Lichtenstein. *Artist's Studio*, 1973. Oil and Magna on canvas; 152.4 × 188 cm (60 × 74 in.). Collection of Batsheva and Ronald Ostrow.

York). The resulting composition is contradictory, as though Matisse's distorted perspective and Lichtenstein's graphic compression were struggling to rectify each other—a striking problem of pictorial misalignment. As the four large canvases in the subsequent Artist's Studio series (cats. 104–08) would confirm, however, Lichtenstein presents the studio not as a working environment, but as an assertion of artistic identity.

When Lichtenstein began work on the Artist's Studio paintings in the autumn of 1973, he was thriving as a painter of still lifes. The genre suited him well, not only because it followed naturally from his earlier renderings of inanimate objects, but also because it represented a diverse and living artistic tradition. Among the origins for the still lifes that Lichtenstein painted between 1972 and 1976 were Cubism and Purism, American trompe l'oeil painting, vernacular motifs from the New England coast, and the pages of office-supply catalogues.[1] Lichtenstein brought these styles into accord with his own; they expanded his repertory without fundamentally changing his technique of delivery. His Cubist Still Lifes (1973–75), for example, did not make him more like Pablo Picasso; they made Picasso more like Lichtenstein. This was consistent with the underlying aesthetic hypothesis of Lichtenstein's work: an image stripped of its origins soon becomes malleable.[2] Still lifes thrive on a similar kind of malleability, which allows streams of connotation to spring forth from ostensibly inert objects.

This involvement led naturally to Matisse, whose *Goldfish and Sculpture* (1912; Museum of Modern Art, New York) directly inspired *Still Life with Goldfish* (1972; cat. 66). Lichtenstein appreciated the "peculiar" aspects of Matisse's contributions to the genre, their capacity to breathe new life into long-standing conventions.[3] Lichtenstein worked from reproductions, many of which appeared in exhibition catalogues and monographs that had made a relatively small number of Matisse's works widely recognizable. Insofar as Lichtenstein mined those sources, he was drawing from a repository of familiar images. It is not quite accurate to think of these as clichés. They were examples of the conventions that develop within the systems of commentary about art, part of a shared language that represents a step toward the common shorthand of mass recognition.

The debt that the Artist's Studio series owes to Matisse is evident in the general composition of space and in specific paraphrases of objects. The arrangement of space in *Artist's Studio "Foot Medication"* (1974; cat. 107) incorporates the same perspectival ambiguity that characterizes Matisse's *Pink Studio* (1911; Pushkin State Museum of Fine Arts, Moscow) and other scenes of his studio at Issy-les-Moulineaux. In order to confer tone on the wall and tabletop, Lichtenstein used regions of red diagonal hatching. Ten of those red lines run across both the table and the wall. The outline of the table and the overall legibility of the painting signal the difference between vertical and horizontal planes, much as the outlines and legible objects in Matisse's *Red Studio* give shape to an inchoate red field. Conventions of graphic modeling and the syntax of painterly marks elide in a subtle act of formal reconciliation.

Artist's Studio "Look Mickey" (1973; cat. 104) also takes its organizational cues from *Red Studio*. Of the four paintings in the Artist's Studio series, this presents the deepest, most plainly articulated interior space. Next to the couch (rather, Lichtenstein's 1961 drawing *Couch* [Sonnabend Collection]), we see a pewter jug after an illustration in *Henri Matisse: A Novel* by Louis Aragon.[4] The sculptor's turning table appears in numerous works by Matisse, including both versions of *Nasturtiums with the Painting "Dance"* (1912; Metropolitan Museum of Art, New York; Pushkin State Museum of Fine Arts, Moscow). A preliminary sketch for *Artist's Studio "Look Mickey"* (fig. 2) shows an arrangement of fruit on the table as well as

imperfectly erased evidence that Lichtenstein originally intended to include a plant-in-vessel arrangement. Those references to Matisse ended up on the floor; in the final version the stand supports a spatial pun—the telephone taken straightforwardly from -R-R-R-R-Ring!! (fig. 3). Again, Matisse's space and Lichtenstein's space elide. This time, however, the pun is temporal as well as spatial. In the original painting of the telephone, Lichtenstein used the comic-book convention of sound with exaggerated physicality: the angles, shadows, and emphatic radiating lines conveying motion and force all make the phone seem to ring so violently that it leaps up. Conversely, the telephone in the studio is in perfect stasis. It never rings, and so it needs no visual signs to indicate sound. The quiescent, dormant mood that characterizes the still life genre also suits interior scenes in which human presence is implicitly imminent or recent. Lichtenstein's pristine interiors suppress those implications and their connotations of mortal transience, but they do not entirely disappear. They are merely reassigned to figures held in a state of frozen action or inaction.

Artist's Studio "The Dance" (1974; cat. 106) is a comparatively direct emulation of Matisse's Still Life with Panel of "The Dance" (fig. 4), down to the way the window in Lichtenstein's partly depicted Sound of Music (1964; Collection Richard and Barbara Lane) echoes the stretcher frame in Matisse's painting. Lichtenstein expressed surprise when Jean-Claude Lebensztejn pointed out the similarity between the two compositions during an interview in 1975.[5] Perhaps this was coyness, or a lapse of memory. It might, however, simply confirm what Lichtenstein went on to say about his translations of Matisse: "I want it to have its own qualities but I don't want them to seem like qualities to anyone. I want it to seem as though I had divested it of quality. That's true, I think, of all the painting I've done—I've tried to take away anything that was beguiling."[6]

Lichtenstein's version of Matisse's dancers certainly seems evacuated. The dancers are outlines and blank spaces, even more featureless than in Matisse's original painting The Dance (1909–10; Museum of Modern Art, New York; State Hermitage Museum, Saint Petersburg).[7] This is consistent with Lichtenstein's approach to his Modernist precursors. He sought not to emulate their achievements, but to take the depleted expressions—the vulgarizations, the cheap imitations—of their results. Such echoes present idioms and styles not as they are internally, but as they appear externally, after the event: in a "senseless" form, to use Lichtenstein's term.[8] He was less concerned with the complexity of Matisse's work than with the way it had become simplified into isolated examples of striking imagery that constitute part of a cultural lexicon. That, of course, is precisely the effect that Lichtenstein embraced in his mature style, and the effect to which his style had itself become subject by the time he painted the Artist's Studio series.

In retrospect, Lichtenstein's midcareer turn toward his precursors in the history of modern art seems an entirely natural progression from his earlier forays into that realm. A spate of retrospective exhibitions in the late 1960s and early 1970s, and the publication in 1971 of the first monograph devoted to his work, confirmed his international standing as a Pop master.[9] His renown was also a burden, for his style was by then as recognizable as a trademark. It was so familiar and so closely associated with the mass culture from which it drew much of its form and content that it had become part of that culture. It is the fate of successful artists to watch as their styles slip from their grasp. Every pale imitation, every diminished reproduction, every knowing pop-cultural citation tends to accelerate the conversion of idiom into cliché. Lichtenstein, who had converted cliché into idiom, could not maintain his distance from the mass culture that had fully embraced him.

Fig. 2. Roy Lichtenstein. *Artist's Studio "Look Mickey" (Study)*, 1973. Graphite pencil and colored pencil on paper; 18.1 × 23.8 cm (7 ⅛ × 9 ⅜ in.). Private collection.

Fig. 3. Roy Lichtenstein. *-R-R-R-R-Ring!!*, 1962. Oil on canvas; 61 × 40.6 cm (24 × 16 in.). Marvin Ross Friedman, Coral Gables.

Fig. 4. Henri Matisse. *Still Life with Panel of "The Dance,"* 1909. Oil on canvas; 89.5 × 117.5 cm (13 ¼ × 46 ¼ in.). State Hermitage Museum, Saint Petersburg.

One recurring motif in the Artist's Studio paintings exemplifies that reflexive process of conversion. There is an angular geometric abstraction in *Artist's Studio "Foot Medication"*; a variation of this appears in *Artist's Studio with Model* (1974; cat. 105). Despite its resemblance to the kind of stark, purified abstraction derived from Piet Mondrian and his contemporaries, this image, which eventually suggested the form of Lichtenstein's Perfect series (1978–89), may have originated in a *Flash* comic. One can imagine the appeal to Lichtenstein of an image that concisely showed just how far the language of geometric abstraction had permeated popular culture and the conventions of visual narrative. This was the crucial insight of the Pop era: not simply that the effluvia of contemporary life lent themselves to aesthetic concentration, but that all visual signs lend themselves to open-ended reconfiguration. Nothing is immutable, nothing is sacred.

Despite the formal and conceptual innovation that marked Lichtenstein as a Pop revolutionary, his approach to subject matter was more notable for its traditional painterly values than for its implied sociological commentary. His talent for isolating, magnifying, and elevating characteristic moments of action and emotion was the talent of the history painter in an age of disposable icons. The banality of Lichtenstein's comic-book sources resides not in the situations they present but in the way they squander the profundity of those situations—mortal danger, martial triumph, erotic loss and fulfillment—in the rush to the next image. Similarly, Lichtenstein granted humble objects a dignity they lack when jostling with each other on a crowded newspaper page that might be turned at any moment. His humor, too, tacitly acknowledges his position. The self-conscious irony of *Masterpiece* (1962; cat. 29) and *M-Maybe* (1965; cat. 41), and the parodic *Brushstrokes* (1965; cat. 47), rest on the premise that there is a boundary between art and everything else, but that it is—for better or worse—a permeable membrane. That boundary is where artists traditionally took their places and decided what should pass through.

Assertive statements of artistic deliberation were, however, distinctly unfashionable by the time Lichtenstein rose to prominence. American artists were more likely to retreat from positions of authority or even to abdicate responsibility altogether. There were several ways to accomplish this. One could, for example, delegate fabrication; use materials, from paint to Plexiglas, to preserve their "given" condition as industrial products; exploit chance processes within, and beyond, the work of art; or nurture a persona as a mystery even to oneself, an unreliable narrator of one's own aesthetic attitude. Lichtenstein's response was to strive to be invisible and intangible. His technique implies anonymity, even though it is far less impersonal than it seems at first glance. The images he selected did not add up to a coherent moral argument, even though he acknowledged their implied social commentary.[10] Instead, he sought to suppress the human aspects of artistic choice: "I want my painting to look as if it has been programmed. I want to hide the record of my hand."[11] This, perhaps, is what it means for an artistic mark to be "senseless," for it to appear as though something other than a single, physical, thinking human being is responsible for choices and consequences.

All of this makes the Artist's Studio series striking in its underlying resistance to the senselessness that Lichtenstein elsewhere found so valuable when translating sources into results. On the one hand, *Artist's Studio with Model* employs the "senseless" Matisse evident in the other paintings. Lichtenstein simplified the lush foliage of Matisse's *La musique* (*Music*) (1939; Albright-Knox Art Gallery, Buffalo) almost to the point of silliness. The female figure, which is derived from a comic-book illustration of a young woman in a yellow bathing suit, now wears diaphanous garb and a veil.[12] She stands as a pastiche, a wholesome comic-book character pretending

to be an odalisque. On the other hand, the most important reference to Matisse is far from senseless. In the lower right-hand corner of *Artist's Studio with Model*, Lichtenstein shows a hand sketching the figure in pencil. Matisse used a similar view in a number of pen-and-ink drawings that he made in the mid-1930s, such as *Reclining Nude (The Painter and His Model)* (fig. 5). It was unusual for Lichtenstein to insert himself into a composition, even indirectly. In this case, the path is easy: Matisse provides the way in. One key difference, though, is that Lichtenstein avoided depicting himself. "I've never done a self-portrait," he said in 1975.[13] That would soon change, although none of his self-portraits of 1976 and 1978 looks like him. Two are generalized Futurist figures, and a third—inspired by René Magritte—features a rectangular mirror above an empty T-shirt (cat. 101). In order to locate Lichtenstein, it is worth taking into account this fugitive tendency, which continued to confirm the reticence apparent in his earlier work.

Unlike Lichtenstein, Matisse did not merely show his hand in his drawing. He also showed his face—here as a reflection in a mirror. The counterpart in *Artist's Studio with Model* is the pipe-smoking man at the right-hand edge. This could represent a painting, although there is no painted precedent in Lichtenstein's oeuvre that uses this image, which—like the geometric abstraction and the female figure—derives from a comic book.[14] That said, several of the "paintings" shown in the Artist's Studio series either never existed or did not yet exist. It is entirely reasonable, then, to interpret the figure of the pipe smoker as a painting. The composition would, however, remain coherent if he were instead a reflection of the unseen artist. In either case, the result is an indication of Lichtenstein's presence rather than a depiction of it.

The pipe smoker is one of many ambiguities in the Artist's Studio works. As such, it is part of the complicated ordering of depictions and references that places the series squarely in the clever tradition of studio interiors. Nonetheless, any reference to the act of depicting the scene before us heightens our awareness of the artist's presence, much as a breach of the fourth wall shifts the boundaries of theater. Perhaps there is more to the world of the Artist's Studio series, with its pop Matisse and tantalizing self-quotation, than meets the eye. Perhaps things are less senseless than they seem.

The barrage of references in these paintings can obscure what we see. The *Explosion* relief in *Artist's Studio with Model* is a depiction of a work of art in a studio. The Explosions (1963–68) themselves, on the other hand, are sculpted models of a graphic convention for a split-second blend of light, heat, noise, and matter—all of which the convention distills into a striking visual sign. The text shown in *Artist's Studio*—in the revived *Look Mickey* (1961; cat. 8) and in the speech bubble that refers to the gangster "Curly" Grogan—adds up to a surprising alignment of disparate stories. (Donald's words could conceivably appear in a hardboiled story without seeming incongruous.) Again, we see conventions for representing the transitory and intangible—in this case, the sounds of speech. *Artist's Studio "The Dance"* shows the drifting musical score from Lichtenstein's *Sound of Music*—another visual sign for a particular kind of fleeting, distant sound. The world of the Artist's Studio is a kind of utopia, a static field of indeterminate duration in which everything that can be sensed has—and even requires—a visual surrogate. This extends to the metaphors of tactility, pleasure, and physical expression, such as the implied relief of *Foot Medication* (1962; Menil Collection, Houston) or the joyous dancing taken from Matisse. Each of these images, metaphors, and conventions is present in the Artist's Studio series by choice. Lichtenstein selected them, and, whether or not the choices were calculated, they represent him.

Fig. 5. Henri Matisse. *Reclining Nude (The Painter and His Model)*, 1935. Pen and india ink on paper; 37.8 × 50.5 cm (14 ⅞ × 19 ⅞ in.). State Hermitage Museum, Saint Petersburg, gift of Lydia Delectorskaya, 1968.

Fig. 6. Roy Lichtenstein holding drawing for *Artist's Studio "The Dance"* (1974; Museum of Modern Art, New York) in his studio with *Glass IV (Study)* (1977; The Roy Lichtenstein Foundation Collection), Southampton, New York, 1977. Photograph by Vaughan Rachel.

The Artist's Studio paintings and the themes that Lichtenstein embraced as he entered the second decade of his public career provided a means of escaping the fierce gravitational pull of mass-cultural plethora and a trademark style. This happened at a difficult time for painting, when esteem for the medium was at a low ebb and even the idea of the private studio was losing adherents. None of this seemed to distract Lichtenstein, who was a studio artist first and last. If anything, he reasserted his authority over the content of his work. In order to accommodate new subjects, he had to venture beyond what he had already mastered. He reached beyond the habits of success, beyond his own "senseless" self, beyond the mere appearance of things. That, after all, was the best way to transcend clichés; and the personal space of the studio is the ideal environment for an artist who wishes to regain his senses.

NOTES

I wish to thank Jean-Claude Lebensztejn, Peter Milligan, Iria Candela, Clare Bell, Greg Lockhart, and, above all, Sheena Wagstaff. The Roy Lichtenstein Foundation Archives provided vital evidence of Lichtenstein's sources.

1. For a broader recent discussion of the precedents for Lichtenstein's still lifes, see John Wilmerding, "Roy Lichtenstein's Still Lifes: Conversations with Art History," in *Roy Lichtenstein: Still Lifes*, exh. cat. (Gagosian Gallery, New York, 2010), pp. 8–41.
2. This malleability also raises the question whether Lichtenstein's treatment of his sources should be regarded as indication or transformation. The extent of his modifications suggests the latter, and has become more obvious over time. For a succinct discussion of disputes over this point early in Lichtenstein's career, see David Deitcher, "Unsentimental Education: The Professionalization of the American Artist" (1992), in *Roy Lichtenstein*, ed. Graham Bader, October Files 7 (MIT Press, 2009), pp. 90–91.
3. Roy Lichtenstein interviewed by Jean-Claude Lebensztejn, "Eight Statements," *Art in America* 63, 4 (July–Aug. 1975), p. 69.
4. Louis Aragon, *Henri Matisse: A Novel*, 2 vols. (Harcourt Brace Jovanovich, 1972), vol. 1, p. 89.
5. Lebensztejn, "Eight Statements," p. 68.
6. Lichtenstein, quoted in ibid.
7. Ibid. Lebensztejn observed that Lichtenstein's composition used the second version of *The Dance*, whereas Matisse's composition shows the first version. The dancers are rendered in a darker tone in the second version, and so Lichtenstein's decision to show them as outlined blanks is even more noteworthy.

8. Lichtenstein interviewed by John Coplans, "Lichtenstein's Graphic Works," *Studio International* 180, 928 (Dec. 1970), p. 263. Lichtenstein was referring to the spread and dilution of Cubist methods during the 1920s and 1930s.
9. Diane Waldman, *Roy Lichtenstein* (Harry N. Abrams, 1972). See also *Roy Lichtenstein*, ed. John Coplans (Praeger, 1972). For exhibitions, see the chronology by Clare Bell in this catalogue.
10. John Jones, "Tape-recorded Interview with Roy Lichtenstein, October 5, 1965, 11:00 a.m.," in Bader, *Roy Lichtenstein*, pp. 26–27. The full transcript of this interview is in the Archives of American Art, Washington, D.C.
11. Lichtenstein interviewed by John Coplans, "Talking with Roy Lichtenstein," *Artforum* 5, 9 (May 1967), p. 34.
12. The comic-book illustration is in Lichtenstein's Jericho Compositions notebook. The Roy Lichtenstein Foundation Archives.
13. Lichtenstein, quoted in Lebensztejn, "Eight Statements," p. 68. In fact, Lichtenstein painted a self-portrait in 1951.
14. The comic-book illustration is in Lichtenstein's Jericho Compositions notebook. The Roy Lichtenstein Foundation Archives.

POP GEOMETRIES

JAMES RONDEAU

Despite the extensive literature on the artist, Roy Lichtenstein's Perfect/
Imperfect series (1978–89), his most sustained if intermittent foray into
total abstraction within the Pop idiom, arguably remains his most curious
and least examined body of work.[1] During a rare slide lecture in 1995 sur-
veying his career, the artist described the endeavor:

> I did both *Perfect Paintings* and *Imperfect Paintings*. In the
> *Imperfect Paintings* the line goes out beyond the rectangle of
> the painting, as though I missed the edges somehow. In the
> *Perfect Paintings* the line stops at the edge. The idea is that you
> can start with the line anywhere, and follow the line along, and
> draw all shapes in the painting and return to the beginning.
> I was interested in this idea because it seemed to be the most
> meaningless way to make an abstraction. It is another way
> to make a painting that is a *thing*, and also a play on *shaped
> canvases*, a familiar genre of the 1960s.[2]

The combined series—all based on studies drawn with one continuous
line—comprises 27 documented canvases (including 2 diptychs), about
50 drawings, 8 screen prints (including 2 diptychs), 5 collages, and 1 sculp-
ture. The great majority of the works are Imperfect; there are only 7 draw-
ings, 3 paintings, 1 collage, and 1 mixed-media experiment with collaged
fabric (a second possibly exists) belonging to the Perfect set.

There is a notable gap in the chronology of this initially provisional
undertaking. At least two "Perfect" canvases—initially called *Abstraction*
and retroactively titled *Perfect*[3]—were made in 1978, the one with fabric,
and the other using painted color blocks, black outline, and diagonal lines

Fig. 1. Roy Lichtenstein. *Abstraction (Fabric)*, 1978. Printed and woven fabrics sewn on canvas; 141 × 213.4 cm (55 ½ × 84 in.). Private collection.

Fig. 2. Panel, John Broome, *The Flash* 135 (Mar. 1963). Illustration by Carmine Infantino. © DC Comics. Used with permission.

(cat. 108). Lichtenstein, who rarely traveled, was in Ahmedabad, India, a textile center north of Mumbai, in November 1978 when he made what is defensibly the first object in the series—essentially a quilt on canvas (fig. 1).[4] Seven years later, working in Southampton, New York, Lichtenstein somewhat anomalously resumed work on a very large, closely related composition, more assuredly titled *Perfect Painting #1* (1985; Kunsthalle Weishaupt, Ulm), which combines areas of dots and lines to offset triangular and quadrilateral zones of color.[5] In 1986 the last discrete Perfect painting appeared, along with the first Imperfect foil. From that point his efforts almost exclusively involved variants of the latter formulation until the entire concatenation on canvas concluded in 1989 with the Perfect half of *Tel Aviv Mural* (see fig. 7, p. 42). In terms of the serial exploration of interdependent imagery, the hiatus between start and finish is without parallel in Lichtenstein's career.

The works debuted at Leo Castelli (420 W. Broadway, New York) from March 14 to April 4, 1987—nine years after the project was tentatively undertaken—in an exhibition featuring only one Perfect painting from 1986 (cat. 109) and ten Imperfect paintings. The critical response was negligible, attributable in part to the fact that the Castelli show overlapped with and was eclipsed by Lichtenstein's drawings retrospective at the Museum of Modern Art, New York (March 15–June 2, 1987).[6] In one of the few reviews taking on the Castelli show, critic Barry Schwabsky opined, "What is so disappointing is that the violation of the rectangle is so petty, so lacking in boldness. Perhaps it's a taboo that's too feeble at this late date to need violation in a big way, but then, why bother at all?"[7]

The inspiration for the Perfect form is likely traceable to an issue of the comic book *The Flash* (fig. 2).[8] The putative derivation of the design would have been excerpted from descriptive graphics surrounding the figurative action of the frame: the panel (in the artist's clippings archive) shows hero Kid Flash emitting a vibrating force field articulated by overlapping planes of color. (Art historian Yve-Alain Bois recognized the web of geometrical prisms "modeled on [Mikhail] Larionov's Rayonism and [László] Moholy-Nagy's overused trick of transforming superimposed color planes into an illusion of transparency." He concluded, "The cartoon is no dumber than the lame versions of modernism it is based on, but it has no pretense: just what Lichtenstein needed.")[9] Unlike other examples in this familiar but enervated game of sourcing, a generative relationship between this pattern and resultant art remains speculative; regardless, wholly independent creations ensued.

Lichtenstein's studio protocol from 1961 forward has been well rehearsed: the artist typically began with a two-dimensional source, often a comic image or similarly distillable form of printed mass communication; he would sketch the image and, in the process, recompose it to suit narrative clarity or strictly formal ends; subsequently, he would trace the drawing onto canvas with the aid of an opaque projector, continuing to make necessary compositional adjustments, and then paint, often with assistants. Perfect paintings instead evolved not from found sources precisely but from Lichtenstein's own compositions, generated with one continuous line and rendered (with the single exception of a straight vertical) at an angle and without interruption: "You start at any edge and draw a line to another edge, and then to another edge, and so forth, and that's the rule of the game."[10] For drawing purposes he turned for the first time in a sustained way to graph paper, enlisting the grid for the mechanical diagrams necessary to puzzle out various configurations. Transferred to canvas, graphite and colored pencil lines appear as painted solid bands. Elsewhere used as contour and outline, here they are a primary structural element, traversing the surface to form open webs of asymmetrical triangles, polygons,

star formations, and so on. The geometries created by the deployment and intersections of these lines are alternately filled in with Lichtenstein's imitations of halftone and Benday dots, diagonals, and sectors of flat color. Imperfect paintings are nearly identical in terms of both procedure and overall appearance, although, as the artist stated above, they are distinguished by small, grafted protuberances: angled forms of stretched canvas over wood are appended to the back edge of the primary support (see fig. 3). Concurrently there was a further alteration to the artist's methodology. For these works the artist did not rely on projection to map his designs onto canvas. As Bois has written, "projecting an '[I]mperfect' drawing would have been no great help indeed, since the out-of-the-frame area would have registered only on thin air."[11] Finally, the later paintings evince Lichtenstein's varied color palette of the 1980s—a departure from his dependency on primaries. Perfect paintings predictably relied on red and yellow, but as the Imperfect series progressed the artist embraced green, orange, and purple as well as harder-to-name shades of cream, teal, peach, pale yellow, lavender, and streaky brown. By 1985 the gray passage prominent in one 1978 Perfect painting resurfaces as silver metallic paint, which, together with gold metallic (see cat. 112), becomes a distinguishing attribute of the cycle.[12]

Perfect and Imperfect paintings, like the Landscapes (1964–67) that preceded them, are among the relatively rare works by Lichtenstein without an anchoring reference to a specific object or artist—they are inventions based on one of Lichtenstein's favored notions: impure style. This enterprise began as a vehicle to address generic geometric abstraction—sharing a related impulse of the Art Deco allusions central to the Modern series (1966–71). The Perfect paintings began as more generalized pastiches of Cubist extraction. In Lichtenstein's hands, the characteristically tilted planes of Georges Braque and Pablo Picasso are flattened, monochrome ochres and umbers give way to garish color, and complex linear networks—established in Cubism by the edges of shallow, fracturing planes—are condensed into the heavy outline of Lichtenstein's trademark pictorial scaffolding. While Braque and Picasso were assuredly influential, Lichtenstein also gravitated to lesser followers. His interest in the Italian Futurist Gino Severini is paradigmatic. Severini's paintings of 1913–14, made just after he established his mature Futurist style, are most certainly touchstones for both Perfect and Imperfect exercises.[13] With Perfect paintings Lichtenstein offered a concretized distillation of Severini's airy studies of fragmented color and light. Regarding Futurism and its allied movements, Lichtenstein said: "They all seem to be using a very important idea . . . for something a bit more trivial, only because the possibility was there to use it that way . . . I am interested in the quirky results of those derivatives of Cubism and like to push this quirkiness further toward the absurd."[14] Bois cogently mentions the precedents of Larionov and Moholy-Nagy. One might add to the index of evocative precedents Liubov' Popova, whose *Painterly Architectonic* (1917; Museum of Modern Art, New York) was readily accessible to Lichtenstein. There are other, now more obscure, points of intersection. Olle Bærtling, for example, was a prominent Swedish abstract artist of utopian leanings (he had studied with Fernand Léger in Paris) whose bright paintings are characterized by acute angles and open triangular shapes, the lines of which both touch and pretend to extend beyond the edge of the canvas (fig. 4).[15] Bærtling used black outline against color—primaries, but also less sanctioned chartreuse, purple, and cerulean blue. His are precisely the flavor of painting Lichtenstein effectively burlesqued. Closer to home, New York painter Nicholas Krushenick was among the few proponents of a style best described as Pop abstraction based on signs and symbols extracted from

Fig. 3. Roy Lichtenstein. Back of *Imperfect Painting*, detail, 1987. Oil and Magna on canvas; 76.2 × 70.7 cm (30 × 31 ⅜ in.). Private collection.

Fig. 4. Olle Bærtling. *Ogri*, 1959. Oil on canvas; 180.2 × 92.3 cm (70 ⅞ × 36 ¼ in.). Louisiana Museum of Modern Art. Donation: The Riklis Collection of McCrory Corporation.

Fig. 5. Nicholas Krushenick. *Ring-a-Ding II*, 1970. Acrylic on canvas; 182.9 × 152.4 cm (72 × 60 in.).

Fig. 6. Neil Williams. *Untitled (Paris Series)*, c. 1965. Fluorescent oil-based enamel on canvas; 243.8 × 243.8 cm (96 × 96 in.). Collection of Spanierman Modern, New York.

Fig. 7. Edward Clark. *Untitled*, 1957, recto and verso. Oil on canvas and paper on wood; 116.84 × 139.70 cm (46 × 55 in.). The Art Institute of Chicago, restricted gift of an anonymous donor, Samuel A. Max Endowment.

Fig. 8. Frank Stella. *Tuftonboro III*, 1966. Fluorescent alkyd and epoxy paints on canvas; 280 × 280.7 × 7.6 cm (110.25 × 110.5 × 3 in). Collection of the artist.

comic sources (fig. 5).[16] To be sure, Lichtenstein indefatigably absorbed and referenced the work of other artists, past and present. These conjectural examples are based largely on formal affinities attempting to frame the parameters defined by Cubo-Futurist-derived geometric abstraction in conventional square and rectangular formats—both exalted and exhausted.

The real energy in this bifurcated series derives from Lichtenstein's exploration of Imperfect form. Precedents in painting for lampooning the idea of rupture are rife. Severini is again a useful exemplar. Also around 1913, the artist extended (then retrograde pointillist) brushwork seamlessly from surface onto the frame. These canvases are not, however, irregularly shaped and therefore do not provide fully salient credentials. Imperfect paintings are a generic retort to the history of asymmetrically shaped forms in modern art. The antecedents are wide ranging. Accounts begin with the Counter-Reliefs (1913–14; now lost) by Vladimir Tatlin, although the few grainy documents that survive would have had little impact on Lichtenstein. It is conceivably more profitable to cite artists he knew personally. Ellsworth Kelly broke the orthodoxy of four-sided integrity in a collage of 1955, *Study for White Relief over Black* (collection of the artist). By 1986, Kelly, a friend of Lichtenstein's since the mid-1960s, had completed nearly two hundred irregularly shaped canvases. Other, now unsung New York painters like Charles Hinman and Neil Williams, who were exhibited prominently in the 1960s, also broke with a rectangular format (see fig. 6).[17] Edward Clark—who was, like Bærtling, likely unfamiliar to Lichtenstein—merits further elaboration. Clark, one of the first to experiment with shaped canvas,[18] worked in Paris in the early 1950s, returning to New York in 1956. *Untitled* (fig. 7), shown at the co-op gallery Brata (cofounded by Nicholas Krushenick), merges vibrant color and bravura application of paint with collaged elements that break the edge of the stretcher.[19] This Expressionist gambit was met with some acclaim at the end of 1957—the same year Lichtenstein, then residing in Cleveland, exhibited in a solo show at John Heller Gallery in New York.

The most immediate source for Lichtenstein's thinking about irregularly shaped canvas was, of course, his friend Frank Stella. The "perfection" of his austerely square canvases—which had preoccupied Lichtenstein—was modified by influential experimentations with nontraditional stretchers beginning in 1960. The eleven asymmetrical compositions (each executed with color variations in four versions) in Stella's Irregular Polygon series (1965–66) are particularly apposite. Their silhouettes depart from the regular geometries that distinguish his pre-1965 shaped canvases. More to the point, the essentially rectangular consonance of three of the eleven canvases is betrayed by a triangular extrusion (see fig. 8). Critic Michael Fried had praised Stella for "deriving or deducing pictorial structure from the literal character of the picture support."[20] Lichtenstein, indubitably aware of these works (seven were shown at Leo Castelli in spring 1966),[21] jokingly warped the polemics surrounding shape by forcing an incidental graft to accommodate the pattern on the field.

When Lichtenstein recollected Imperfect paintings in 1995, he described them as "a play on shaped canvases, a familiar genre of the 1960s."[22] By 1986 (the year of the first Imperfect painting), however, the dialogue around shaped canvas assuredly would have been dated. Why turn back to early Stella—and his lesser followers—on the topic of shape now?[23] Presumably Lichtenstein was motivated by more current developments. Indeed, 1986 was the watershed year of "Neo-Geo," short for Neo-Geometric Conceptualism, a term most readily applicable to the painter Peter Halley, whose cool geometries rendered with hot DayGlo paints (indebted to Stella's use of these materials as early as 1964) borrowed formal devices from generalized versions of Modernist abstraction.[24] Halley's

work, self-theorized under the auspices of Jean Baudrillard's ideas about simulation, spectacle, and the impossibility of authenticity, offered a version of Modernist geometries emptied of all content except nostalgia for Modernist geometries. In 1985 Halley wrote:

> Where once geometry provided a sign of stability, order, and proportion, today it offers an array of shifting signifiers and images of confinement and deterrence. The formalist project in geometry is discredited. It no longer seems possible to explore form as form (in the shape of geometry), as it did to the Constructivists and Neo-Plasticists, nor to empty geometric form of its signifying function, as the Minimalists proposed. To some extent, the viability of these formalist ideas has simply atrophied with time. They have also been distorted and bent to conform to the bourgeois idealism of generations of academically-minded geometric classicists . . . It no longer seems possible to accept geometric form as either transcendental order, detached signifier, or as the basic gestalt of visual perception . . . Why has geometric art been so widely accepted in our century, and why has geometric imagery gained an unprecedented importance in our public iconography?[25]

Lichtenstein might easily have connected Halley with Stella's 1960s precedents. But an even more engaged reaction can be posited. Central to the dialogue at this moment—advanced by artists such as Halley and in related ways by Haim Steinbach, Jeff Koons, and Ashley Bickerton—was an ambivalent critique of commodity fetish deeply indebted to Lichtenstein's early Pop art. Lichtenstein, cognizant of the discussions around Halley's devastating appraisal of geometric abstraction in general if not of this text in particular, was perhaps offering the Imperfect gag as a rejoinder to ideas about the "confinement" of "discredited" Modernist painting then under examination.

While it is necessary to concede prospective external influences—especially for an artist for whom appropriation was stock-in-trade—Lichtenstein was equally inclined to introversion. There is a distinct, unparalleled genealogy of latent Perfect and Imperfect forms within his own work. Pre-Pop compositions featuring asymmetrical triangles date to the late 1940s and early 1950s (see fig. 9), and a similar matrix resurfaces in Pop classics: early pastiches of Picasso (see cat. 64), *Keds* (1961; cat. 11), Explosions (1963–68) (see cats. 43–46), and Pyramids (1968–69) (see cat. 140). Three triptychs from the early 1970s animate the progression from figuration to abstraction: *Pitcher Triptych* (1972; private collection), *Portrait Triptych* (1974; Marvin Ross Friedman, Coral Gables), and, most obviously, *Cow Triptych (Cow Going Abstract)* (fig. 10) riff on a series of drawings (c. 1917; Museum of Modern Art, New York) by Theo van Doesburg. Other nascent Perfect compositions, indebted to the van Doesburg spoofs, appear in paintings and related 1975 drawings in which they first coexist and then merge with fragments of Entablatures (1971–76; see cat. 147), in two stand-alone drawings (fig. 11; although these schemes are not generated with one continuous line), and in a single drawing and collage (fig. 12; a painting was not completed) in which the triangular forms coalesce into a clear star amid a night sky and crescent moon (presumably sensing the qualities of a children's book illustration, the artist retreated from applying a representational trajectory to these intrinsically abstract schemes).[26]

Fig. 9. Roy Lichtenstein. *Indian*, 1951. Oil on canvas; 61 × 45.7 cm (24 × 18 in.). Private collection.

Fig. 10. Roy Lichtenstein. *Cow Triptych (Cow Going Abstract)*, 1974. Oil and Magna on canvas; three panels, each 172.7 × 208.3 cm (68 × 82 in.). Robert and Jane Meyerhoff Collection.

Fig. 11. Roy Lichtenstein. *Untitled (Abstraction)*, c. 1975. Graphite pencil and colored pencil on paper; 17.9 × 24.6 cm (7 1/16 × 9 11/16 in.), irregular. Private collection.

Fig. 12. Roy Lichtenstein. *Untitled*, 1975. Ink, tape, and painted and printed paper on board; 76.2 × 61. cm (30 × 24 in.). Private collection.

Fig. 13. Roy Lichtenstein, *Untitled*, c. 1955. Mixed media: canvas, painted, laminated wood, wood battens, screws; variable dimensions, 70.5 × 84.5 cm (27 ¾ × 33 ¼ in.). Collection of Nina Hope, Julian Solotorovsky, Peter Solotorovsky, and Emilie Lapham.

Fig. 14. Roy Lichtenstein. *Yellow and White Drip on Graph*, 1966. Magna on canvas; 91.4 × 121.9 cm (36 × 48 in.). Private collection.

Imperfect compositions have a less clear backstory. A small group of scrappily assembled painted reliefs from 1954–55 (now mostly lost)—casually dubbed by the artist the Splinter series—are notable for the irregularity of their form (see fig. 13). Lichtenstein collaged fragments of canvas and paper onto corrugated cardboard or wood supports with jagged edges, perhaps designing them to resemble faux Native American or Aboriginal artifacts.[27] When asked by interviewer Avis Berman about Lichtenstein's move to "work without a frame," Ohio State University professor Roy Harvey Pearce, a close friend at the time, undersold them as "Roy's attempt at Abstract Expressionism."[28] Two little-known canvases from 1966 expand Lichtenstein's ongoing disruption of Expressionist rhetoric (see fig. 14). These paintings set simulated paint spills—discernibly ejaculatory—against a backdrop of the gridded terrain found in graph paper, a staple of Minimal and Conceptual drawings of the period. The pictorial spatter transgresses the grid, falling, as it does, outside the lines. Here the simple, ready-made perfection of Modernist geometry is vitiated by ersatz accident and chance. In many ways, these experimental detours from the larger series of contemporaneous Brushstrokes (1965–71) might be seen as a root of the later Imperfect idea.[29]

At their core Perfects and Imperfects are blank parodies; fittingly, they begin to take shape as props within other works by Lichtenstein. A nearly Perfect Abstraction (it does not quite pass the "one continuous line" test) debuts as a stand-alone easel painting within one of the 1974 Artist's Studios (cat. 107); Imperfect arrangements (see fig. 15) appear as freestanding sculptures within a single interior and six landscapes (all 1977).[30] The Studio series marks the beginning of Lichtenstein's durable habit of furnishing his paintings with his own art.

> **A couple of years ago I started some paintings that had my own paintings in them, and which were similar to the Matisse studios. There was one difference . . . when I reproduce one of my own paintings in my painting, it's different from Matisse reproducing one of his paintings in his painting, because even though in both paintings the depicted painting is submerged for the good of the whole work, it's much more so in Matisse. I wanted my paintings to read as individual paintings within the work, so that there would be some confusion. There's no remove in my work, no modulation or subtlety of line, so the painting-of-a-painting looks exactly like the painting it's of.[31]**

In *Artist's Studio with Model* (cat. 105), the Abstraction in partial view might be a reference to the third panel of *Cow Triptych (Cow Going Abstract)*, although it is not known which of these two works, made the same year, came first. (*Pitcher Triptych* had been completed two years earlier, but its third, abstract panel bears little resemblance to the Abstract paintings on view in either *Artist's Studio "Foot Medication"* [cat. 107] or *Artist's Studio with Model*. Both of these Studios were completed in April 1974, months before the artist realized *Portrait Triptych*.) Practically every other self-quotation in these Studios mimes readily identifiable objects or previously expressed imagery; the Abstraction in *Artist's Studio "Foot Medication"* does not correspond to any then-existing, stand-alone painted work and thus seems to predict future production beyond the confines of the virtual studio.[32]

Somewhat radically, Lichtenstein insisted, over and over, on the status of Perfect/Imperfect works as décor.[33] The impulse to use them as proxies within other paintings continues well after the cycle itself concluded in 1989. Their effigies, in the form of both sculptures and paintings,

make repeated cameos over couches and on coffee tables in Interiors (1990–97) (see fig. 16).[34] They exist—there as before—as surrogates of surrogates, further eliding any logic of an original.[35] Lichtenstein referred to the depicted canvases in these pictures as "dumb paintings,"[36] the "nameless or generic abstraction you might find in the background of a sitcom—the abstraction hanging over the couch."[37] Without straining credulity they could be said to resemble pictures by Lichtenstein acquaintance Larry Zox, whose signature flatly painted diamonds, triangles, and other hard-edged shapes arranged in symmetrical and asymmetrical compositions (see fig. 17), featured in a solo exhibition at the Whitney Museum of American Art in 1973, were once characterized by critic Robert Hughes as "the most openly decorative, anxiety-free, socially indifferent canvases in the history of American art."[38] Lichtenstein seemed to be aspiring to just such a condition. Indeed, Perfect and Imperfect works—incipient as accessory within two of the Studios and ending as such within Interiors (see *Interior with Painting of Bather* [1997; Eli and Edythe L. Broad Collection, Los Angeles])—must be understood as constituent of the artist's larger embrace of the putatively disesteemed realm of interior decoration.

It is worth noting again that the initial volley in the Perfect series (fig. 1)—made in 1978 and never exhibited in the artist's lifetime—incorporates appliqué on canvas to form a "quilt." Throughout his career Lichtenstein produced dishes, furniture, jewelry, rugs, banners, tapestries, wallpaper, gift wrap, and other objects not readily classified as fine art. (He had worked briefly as a window dresser in Cleveland in the 1950s, and his first wife, Isabel Wilson, was an accomplished interior decorator.) The ostensibly first Perfect, for Lichtenstein a rare (if not the sole) use of fabric on canvas, might allude to precursors of Modernist painting—with its doctrinaire emphasis on flatness—in nineteenth-century textiles.[39] Such ideas were being restated with feminist inflection within the Pattern and Decoration movement at that exact time; Lichtenstein might have been slyly skewering its florid embrace of fabric collage on canvas, then at its brief zenith of recognition. Or he was thinking of Matisse, the muse of the Studios, who was famously inspired by his working library of textile remnants.[40] Regardless, Lichtenstein's bolts of Indian fabric—some found, others prepared for him (see fig. 18)[41]—are, in their own exceptional way, determinant.

To be sure, Lichtenstein exploited the series's symbiotic relationship to applied arts, audaciously encouraging a reading of his one sustained incursion into Pop abstraction simply as expert design. He trifled with a return to fabric in a collage study for an unrealized banner (1986; Roy Lichtenstein Foundation Collection). Pushing the envelope, even a holiday tree ornament (1987; private collection, San Diego) he made carries the Perfect schema. Scale plays a part—from that small bibelot to the third largest work in his oeuvre. The Perfect half of *Tel Aviv Mural*, the chronological apotheosis of the series proper, asserts itself as ambient backdrop—literally lobby art. Already the forms had been actualized as architecture. In the summer of 1987 the entrepreneurial Viennese polymath André Heller organized *Luna Luna* in Hamburg, Germany. The one-time event, a multimedia carnival cum *gesamtkunstwerk* set in an open field, featured commissioned works by Lichtenstein alongside those of other prominent artists such as Georg Baselitz, Jean-Michel Basquiat, Keith Haring, and David Hockney. Lichtenstein was initially asked to decorate a hexagonal pavilion; he demurred, insisting on a rectangular building but adding geometric intricacy by introducing the Imperfect device (see fig. 19). Following exacting collages, assistants realized a painted metal shed; the two long sides and back were emblazoned with Lichtenstein's abstract formula replete with colored, angular juts breaching the roofline (the entrance on

84

Fig. 15. Roy Lichtenstein. *Figures*, 1977. Oil and Magna on canvas; 111.8 × 254 cm (44 × 100 in.). Private collection.

Fig. 16. Roy Lichtenstein. *Interior with Mirrored Wall*, 1991. Oil and Magna on canvas; 320 × 406.4 (126 × 160 in.). The Solomon R. Guggenheim Museum, New York.

Fig. 17. Larry Zox. *Diamond Cut Series*, 1966 (installation view). Stephen Haller Gallery.

the front side was Perfect). For the interior Heller designed a mirrored labyrinth echoing with recorded sounds by composer Philip Glass. The container, an inadvertent elegy to Lichtenstein's Mirrors (1969–72), refracted emptiness—inside and out.

Luna Luna is an apt coda. Spanning eleven midcareer years of the artist's fitful attention, Perfect and Imperfect designs are, at their core, evolved parodies of the very idea of abstraction. One must recall that before he was "Lichtenstein," he was an arrested abstract painter; canvases between 1958 and 1960 were nonobjective. When asked, as a Pop star, about his clean break with his past, Lichtenstein quipped (with subtly disparaging irony) that it was due to "desperation. There were no spaces left between Milton Resnick and Mike Goldberg."[42] Perfect/Imperfect works are his factitious exorcism of that chapter. One might ratiocinate that he felt obliged to include then-fictional abstract talismans in his mock retrospective Studio pictures; the artist was tacitly acknowledging his own prehistory as an abstractionist and, at the same time, sardonically admitting the limitations of that undertaking.

Although Lichtenstein's relationship to art history was equal parts learned reverence and iconoclastic skepticism, his formal aspirations were profound. Following the example of Hoyt Sherman, his professor at Ohio State University, the artist expressed an abiding concern for pictorial unity.[43] Perfect paintings express this on the most facile level: no part distracts from the whole. Defective Imperfect paintings willfully shatter the gestalt. Throughout his career Lichtenstein professed aesthetic corruption through allied strategies of appropriation and technique. With Imperfect works he literalized the idea of impurity by defiling the sacrosanct integrity of the stretcher itself.[44] Purposively jejune within a broader art historical lexicon, these formal transgressions are not attacks on the history of geometric abstraction, past or then present. Lichtenstein had no propensity for, and certainly no profound investment in, an astringent critique of irregular shape.[45] Whether or not he was familiar with precedents, lauded or obscure, or motivated by current arguments within the Pattern and Decoration or Neo-Geo movements, he was a classicist who valued his own order above all else. Lichtenstein was, actually, a grand isolationist. The transgression here was largely self-directed—he offered an exegesis of his own dogma. With Imperfect works, the artist ironically broke free of the confinements of his own making, drolly introducing the semblance of accident into an otherwise highly sophisticated metaformulaic model of painting. Lichtenstein was a genius at maintaining inventiveness within the structure of formula—that was the essence of his brilliance. The Perfect idea celebrates boundaries, and the Imperfect idea, in sharp contradistinction, the breaking of boundaries. Returning to the actual paintings, those little wooden grafts are trace signifiers of subjectivity, buried metaphors for expressiveness, contained asides that counterfeit loss of control. Lichtenstein was nothing if not understated. Perfect paintings provided the excuse for discreet Imperfect misdemeanors—wry, liberating exercises in self-critique. They succeed as such and more: beautiful objects cleverly, vexingly masquerading as inconsequential all the while.

In the final analysis, this dual series invites an almost existential question: how is a star formed? In drawing terms, the answer is childishly easy: use one continuous line, allowing diagonal intersections in a closed set of simple geometries to render a potently universal symbol (Lichtenstein stumbled on and retreated from this discovery in 1975 [see fig. 12]). This series, rooted in his own simple drawings, subverts this simple act. Likely on a subconscious level, Lichtenstein, always self-effacing, haltingly devised Perfects and Imperfects to undermine, torque, explode—even deconstruct—the iconic import, and expectations, of a star.

85

The author gratefully acknowledges the research and editorial contributions of Jay Dandy.

1. For the most significant examination of the series to date, see Yve-Alain Bois, "Roy Lichtenstein: Perfect/Imperfect," in *Roy Lichtenstein: Perfect/Imperfect*, exh. cat. (Gagosian Gallery, Los Angeles, 2002). Ken Silver has argued for an understanding of the Imperfect form as an abstraction of masculinity. Ken Silver, *Roy Lichtenstein: Mostly Men*, exh. cat. (Leo Castelli, New York, 2010).

2. Roy Lichtenstein, "A Review of My Work Since 1961—A Slide Presentation" (1995), in *Roy Lichtenstein*, ed. Graham Bader, October Files 7 (MIT Press, 2009), p. 69; italic in the original.

3. The two 1978 "Perfect" works were originally registered in the Leo Castelli inventory as "Abstraction." The creation of the first Imperfect painting in 1986 seems to coincide with the renaming of the 1978-85 canvases as "Perfect." Roy Lichtenstein Estate registrar Natasha Sigmund, e-mail message to the author, Aug. 26, 2011. Both 1978 works, neither shown in the artist's lifetime, were published as *Perfect* in *Roy Lichtenstein: Perfect/Imperfect* (see note 1). In 2012, based on its research, the Roy Lichtenstein Foundation revised the title of the 1978 fabric work (fig. 1) from *Perfect Painting* to *Abstraction (Fabric)*. Despite this revision, I still regard the fabric work as the first Perfect: the drawn line is continuous and stops at the edge.

4. Concerning the order in which the two documented "Perfects" from 1978 were executed, Sigmund related the following: "I have spoken to [Lichtenstein assistant] James de Pasquale and his take would be that the fabric came first." Sigmund, e-mail message to the author, Aug. 26, 2011. Dorothy Lichtenstein concurs; D. Lichtenstein, conversation with the author, Sept. 16, 2011. The Lichtensteins went to India at Anand Sarabhai's invitation to visit his family's compound, with the idea of producing new work. A sandstone Mirror, among other works, was made during the same trip. Lichtenstein felt some pressure to finish the "first" Perfect. At the end of their stay, the group went to dinner, and when they returned several assistants had gathered to have Roy instruct them to sew the fabric onto the canvas (see fig. 18). D. Lichtenstein, conversation with the author, Sept. 16, 2011.

5. A Perfect painting appears in early studies for the Equitable Tower *Mural with Blue Brushstroke* (1984-86), but in the finished version the work is technically an Abstraction: the composition does not pass the Perfect litmus test, that is, it is not drawn with one continuous line. Notably, the image of a draftsman's triangle breaks the edge of the composition in early studies and maquettes completed by November 1984, prefiguring the Imperfect works. On *Mural with Blue Brushstroke*, see Pari Stave, "A Single Collaboration," in Calvin Tomkins and Bob Adelman, *Roy Lichtenstein: Mural with Blue Brushstroke* (Abrams, 1987), p. 33.

6. Reflecting current studio work, the artist made an Imperfect drawing specifically for the cover of the museum exhibition catalogue. (The Imperfect form breaks the rectangle of the cover by overlapping onto the inside book flap.) Among the 275 drawings in the exhibition were four Perfect/Imperfect drawings. Curator Bernice Rose, commenting on these works, writes: "In the spring of 1986, Lichtenstein returned to linear structure as continuous outline. He began making a series of eccentric geometries that paraphrase earlier abstractions, but strip away their rational and idealistic programs (as, for example, in Mondrian or van Doesburg, both of whose works he has imitated before). These new works, says Lichtenstein, are 'purposeless'—in the sense that without a program it is difficult to justify making art this way anymore. Yet that is the content of these works: the very purposelessness of making them." Bernice Rose, *The Drawings of Roy Lichtenstein*, exh. cat. (Museum of Modern Art, New York, 1987), p. 54.

7. Barry Schwabsky, "Roy Lichtenstein," *Flash Art* 135 (Summer 1987), p. 97. Subsequent exhibitions—of Perfect and Imperfect paintings, at Galerie Hans Meyer, Düsseldorf (June 12-Aug. 13, 1987); of Imperfect paintings and prints, at Galerie Heland Wetterling, Stockholm (Oct. 25-Nov. 20, 1988); of Imperfect prints alone, at Castelli Graphics, New York (Sept. 22-Oct. 22, 1988) and concurrently at Carl Solway Gallery, Cincinnati (Sept. 9-Oct. 22, 1988)—yielded little commentary. (The three earliest Perfect works, two paintings from 1978 and one from 1985, were not shown.) The series was not fully accounted for until a posthumous, nearly comprehensive, survey at Gagosian Gallery, Los Angeles (Sept. 28-Dec. 7, 2002), which included over eighty works and merited a catalogue with a short essay by Yve-Alain Bois (see note 1); this exhibition, too, received scant critical response.

8. *The Flash*, 135 (Mar. 1963). Created by writer Gardner Fox and artist Harry Lampert, the original Flash first appeared in *The Flash* 1 (Jan. 1940). See Phil Jimenez, *The DC Comics Encyclopedia: The Definitive Guide to the Characters of the DC Universe* (DK Publishing, 2004), pp. 124-27.

9. Bois, "Roy Lichtenstein," p. 18. The *Flash* source certainly seems to be the inspiration for a curious, little-known work on canvas, *Two Paintings (Alien)* (1983; private collection; Sprengel Museum Hannover, on loan).

10. Roy Lichtenstein, lecture at the 92nd Street Y, Feb. 14, 1991, transcript. The Roy Lichtenstein Foundation Archives. On the topic of Imperfect drawings: "He liked the idea that you could draw a line within the limitations of the square or rectangle without lifting the pencil. He liked the 'oops' factor of going outside the boundary making the work 'imperfect.'" D. Lichtenstein, e-mail message to the author, Aug. 24, 2011.

11. Bois, "Roy Lichtenstein," p. 15. Roy Lichtenstein Foundation program manager Clare Bell verifies: "[James de Pasquale] concurs with Yve-Alain that Roy never projected the Perfect/Imperfect graph studies onto the canvas. James told me that he, Roy, and [Lichtenstein assistant] Bob McKeever used a straight edge they would pass over to each other on either side to plot the lines out on the canvas." Bell, e-mail message to the author, Nov. 16, 2011.

12. Presumably the references here extend from Byzantine art up to Jackson Pollock's and Frank Stella's penchant for metallics. Bois further cites Clement Greenberg's "biased interpretation" of Pollock's fondness for aluminum paint as a "paean to a dematerialized opticality, as a 'Byzantine parallel,'" referring to an eponymous title of a 1958 essay by Greenberg. Bois, "Roy Lichtenstein," pp. 17, 20 n. 11.

13. Ibid., pp. 9-10. Also of note are the Lichtenstein self-portraits based on Severini: *Self-Portrait* (1976; private collection) and *Self-Portrait II* (1976; Eli and Edythe L. Broad Collection, Los Angeles).

14. Lichtenstein, "A Review of My Work Since 1961," p. 66.

15. See the review by Donald Judd (who himself collected Bærtling's prints) in *Arts* (Sept. 1964), pp. 66-67. It is certainly conceivable that Lichtenstein might have been aware of Bærtling, as he had seventeen solo shows in the United States in 1964-70, including a retrospective exhibition at Columbia University in 1964. Group presentations included the Guggenheim Annual in 1964, curated by Lawrence Alloway, and a 1967 Museum of Modern Art collection show entitled *The 1960s: A Selection from the Museum Collection*. Lichtenstein was likely unfamiliar with Bærtling: "I doubt Roy knew of Olle Bærtling, nor did he pay much attention to Galerie Denise René." D. Lichtenstein, e-mail message to the author, Aug. 24, 2011.

16. Lichtenstein admired Krushenick's work, regularly attended his exhibitions, and visited his Connecticut studio in the 1970s. D. Lichtenstein, e-mail message to the author, Sept. 26, 2011.

17. Lichtenstein knew Hinman slightly. Regarding Neil Williams, the Lichtensteins saw him on Long Island in the 1970s and 1980s for occasional dinners and at other social events with some regularity. D. Lichtenstein, e-mail message to the author, Sept. 26, 2011.

18. In the United States, Charles G. Shaw and Abraham Joel Tobias both experimented with shaped canvases in the 1930s; Uruguayan artists Rhod Rothfuss and Carmelo Arden Quin used rhombuses and irregular geometric figures in their paintings beginning in the mid-1940s.

19. Since many of Clark's shaped/collaged works of the late 1950s were lost in shipment from Paris to New York, *Untitled* is one of his only remaining shaped paintings. Former Art Institute of Chicago curator Daniel Schulman first brought this work to my attention.

20. Michael Fried, *Three American Painters: Kenneth Noland, Jules Olitski, Frank Stella*, exh. cat. (Fogg Art Museum, Cambridge, 1965), p. 40. For a thorough examination of Stella's Irregular Polygon series, see Brian P. Kennedy, *Frank Stella: Irregular Polygons, 1965-66*, exh. cat. (Hood Museum of Art, Hanover, 2010).

21. "He saw mostly all of Frank's exhibitions." D. Lichtenstein, e-mail message to the author, Sept. 26, 2011.

22. Lichtenstein, "A Review of My Work Since 1961," p. 66.

23. Bois argues that Lichtenstein's Modern paintings engaged Stella's work but did not take on its most salient characteristic: shape. "It is as if Lichtenstein had not been able to address the issue back then." Quoting the unnamed lecturer whose observations frame his essay, Bois conveys: "What Lichtenstein does in these [Imperfect] works . . . is to re-open a chapter that had been closed too fast by the expedient logic of the look-alike." Bois, "Roy Lichtenstein," p. 14. In a review of the 1987 Castelli exhibition, Schwabsky posed a further question: "And why, for that matter, is an artist of Lichtenstein's stature paying such close attention to the doings of his juniors that he felt it necessary to parody the bravura

brushstroke when Expressionism was the rage, and then revert to pure geometry now that this is the issue of the moment?" Schwabsky, "Roy Lichtenstein," p. 97.

24. Lichtenstein saw Halley's work at Sonnabend Gallery, met him on several occasions, and found his work "interesting." D. Lichtenstein, e-mail message to the author, Sept. 26, 2011.

25. Peter Halley, "The Crisis in Geometry," *Arts Magazine* (New York) 58, 10 (June 1984), pp. 111–15; quotation at p. 111.

26. Lichtenstein expunged representational images from this series on one other occasion. Two Greek columns appear in a Perfect study from 1985, *Perfect Painting (Study)* (private collection), but disappear in a later drawing and painting, *Perfect Painting #1 (Study)* (1985; Collection of Barbara Bertozzi Castelli, New York), and *Perfect Painting #1.*

27. Ernst Busche, *Roy Lichtenstein: Das Frühwerk, 1942–1960* (Gebr. Mann Verlag, 1988), p. 186.

28. Roy Harvey Pearce, from Roy and Marie Pearce, oral history, conducted by Avis Berman, Aug. 21, 2001, transcript, p. 101. The Roy Lichtenstein Foundation Archives.

29. "At a certain time in the 1960s, many announcements were done on graph paper. This amused Roy and he made some paintings of drips and splats on graphs he drew on the canvas. He discarded these for the most part but this may have been the germ for Perfect/Imperfect paintings." D. Lichtenstein, e-mail message to the author, Sept. 26, 2011.

30. Relevant works are *Interior* (1977; private collection), *Female Figure on Beach* (1977; private collection), *Figures* (1977; private collection), *Figures in Landscape* (1977; private collection), *Two Figures* (1977; Collection Simona and Jerome Chazen), *Reclining Nude* (1977; Frederick R. Weisman Art Foundation, Los Angeles), and *Female Head* (1977; private collection). In *Reclining Nude* the Imperfect form is difficult to discern but is quite evident in preparatory drawings. *Female Head*, while primarily a portrait, has elements of both interiors and landscapes. Other works, excluding Interiors (see note 34), that feature Imperfect compositions include four lithographs (*A Bright Night* [1978], *At the Beach* [1978], and *Figures with Rope* [1978], all editions of thirty-eight; and *Best Buddies* [1991; edition of one hundred]); seven paintings (*Cosmology* [1978; private collection], *Figures with Sunset* [1978; Doris and Donald Fisher Collection, San Francisco, and the San Francisco Museum of Modern Art], *Razzmatazz* [1978; Robert and Jane Meyerhoff Collection], *This Figure Is Pursued by That Figure* [1978; private collection], *Two Figures* [1978; private collection, Japan], *Woman with Neck Ribbon* [1978; private collection], and *Go for Baroque* [1979; private collection, New York]); one collage (*IX by XII [Rug Design]* [1978; Collection James and Katherine Goodman]); and one mural (*Greene Street Mural* [1983; destroyed]).

31. Jean-Claude Lebensztejn, "Eight Statements: Roy Lichtenstein," *Art in America* 63, 4 (July–Aug. 1975), p. 68.

32. *Artist's Studio* (1973; fig. 1, p. 72) references the following works or series: *Still Life after Picasso* (1964; fig. 5, p. 41), *Baseball Manager* (1963; private collection), Entablatures (1971–76), Mirrors (1969–72), Stretcher Frames (1968), and Ceramic Sculptures (1965–66).

Artist's Studio "Look Mickey" (1973; cat. 104) references the following works or series: *Look Mickey* (1961; cat. 8), *-R-R-R-Ring!!* (1962; fig. 3, p. 74), *Couch* (1961; Sonnabend Collection), *Drawing for Landscape* (1973; private collection), Entablatures (1971–76), Mirrors (1969–72), Stretcher Frames (1968), and *Bananas and Grapefruit I* (1972; private collection). The painting containing the dialogue bubble hanging above *Couch* relates to a broad spectrum of paintings, prints, and drawings produced from 1961 to 1966.

Artist's Studio "The Dance" (1974; cat. 106) references the following works or series: *Sound of Music* (1964; Collection Richard and Barbara Lane), Mirrors (1969–72), and Still Lifes (1972–74).

Artist's Studio "Foot Medication" (1974; cat. 107) references the following works or series: *Drawing for Foot Medication* (1962; Menil Collection, Houston), *Couch, Temple of Apollo* (1964; fig. 4, p. 63), *Grapes* (1972; cat. 70), and Still Lifes (1972–74). Piano imagery is used in *Piano* (1964; private collection) and *Girl at Piano* (1963; private collection). The female portrait could be the reversed image of the woman in *Portrait Triptych* or *Still Life with Portrait* (1974; edition of one hundred).

Artist's Studio with Model (1974; cat. 105) references the following works or series: Entablatures (1971–76) and Explosions (1963–68). The image of the man smoking a pipe, an exception, seemingly surfaces only later in *Large Interior with Three Reflections* (1993; private collection) and *Reflections of "Large Interior" (Panel 3 of 3)* (1993; private collection).

33. Bois wonders whether Lichtenstein, with the Perfect/Imperfects, is asking his audience whether art "has become, at best, random décor?" He continues: "Haven't we already heard that, most forcefully from Gerhard Richter, who always professed the greatest admiration for Lichtenstein?" Bois, "Roy Lichtenstein," p. 14.

34. The inventory of Perfect/Imperfect imagery, as painting and sculpture, in the Interior series is as follows: *Bedroom* (1990; edition of sixty), *Bedroom Unique State* (1990; private collection), *Interior with Mirrored Wall* (fig. 16), *Collage for the Waldo Times Cover* (1992; private collection), *Interior with Perfect Painting* (1992; private collection), *Interior with Skyline* (1992; private collection), *Interior with T'aime* (1993; Collection Simonyi), *Large Interior with Three Reflections, Reflections of "Large Interior" (Panel 1 of 3), Nude with Yellow Pillow* (1994; fig. 12, p. 34), and *Interior with Painting of Bather* (1997; Eli and Edythe L. Broad Collection, Los Angeles).

35. An example of a representation of a work of art preceding its realization is the sculpture *Cityscape* (1995; edition of six), which appears on the coffee table of *Large Interior with Three Reflections.*

36. Quoted in Bois, "Roy Lichtenstein," p. 20 n. 15. Tomkins and Adelman, *Roy Lichtenstein*, p. 80.

37. Lichtenstein, quoted in Deborah Solomon, "The Art behind the Dots," *New York Times Magazine*, Mar. 8, 1987, pp. 42–46, 107, 112; quotation at p. 44. He continued to use this language in specific relation to the Imperfect paintings: "These paintings seemed to me like the dumbest abstraction you could think of, an abstract painting by someone without any motivation. It's about setting up rules and not obeying them. It's very simple minded but I loved the idea of being so literal."

Lichtenstein quoted in Ann Hindry, "Conversation with Roy Lichtenstein," *Art Studio* 20 (Spring 1991), p. 16.

Relative to Lichtenstein's mention of the "background of a sitcom," one is reminded of the Julie Lazar–curated show *Uncommon Sense: Six Projects Explore Social Interactions and Art* at the Museum of Contemporary Art, Los Angeles, in 1997, in which artist Mel Chin's collaborative GALA made works of art for background shots for the TV program *Melrose Place.*

38. Robert Hughes, cited in an obituary of Larry Zox, *Los Angeles Times*, Dec. 18, 2006, p. B9. James Monte describes little-known early work by Larry Zox potentially relevant to a consideration of Imperfect paintings: "Zox, in his quest for an increasingly clear, lucid pictorial format during the years 1962 to 1965, turned to constructing plywood and plexiglas reliefs. Generally the reliefs were about two feet square with the painted plywood rectangle next to the wall and each side of it containing shallow triangular jigsaw cuts which reshaped it into a dynamic polygon. One and a half inches in front of the painted wood, a rectangular sheet of transparent plexiglas was held in place by bolts. Narrow stripes of color painted on the plexiglas conformed visually to the various painted shapes on the notched-wood panel." See James Monte, *Larry Zox*, exh. cat. (Whitney Museum of American Art, New York, 1973), p. 9. These pieces were never publicly shown.

39. Michael Fried elaborates: "[A]t the same time that the spectator may have gained the ability to see a length of fabric as a potential painting, he may have also have acquired the tendency to regard a modernist painting of the highest quality as nothing more than a length of colored fabric." Fried, *Three American Painters*, p. 47. Lichtenstein made a silk-screen on silk satin shirt: *Untitled Shirt* (1979; edition of one hundred).

40. See Hilary Spurling et al., *Matisse, His Art and His Textiles*, exh. cat. (Royal Academy of Arts, London, 2004).

41. The woven fabric was bought at a bazaar, the printed fabric may have been silk-screen printed or hand printed for Lichtenstein, and the monochrome fabrics, including the black used for outline, are probably cotton. Clare Bell, e-mail message to the author, Jan. 3, 2012.

42. John Coplans, "An Interview with Roy Lichtenstein," *Artforum* 2, 4 (Oct. 1963), p. 31.

43. Numerous art historians, among them Michael Lobel (*Image Duplicator: Roy Lichtenstein and the Emergence of Pop Art* [Yale University Press, 2002]) have focused on the influence of Hoyt Sherman; Bois regards the focus on Sherman and the issue of pictorial unity as banal. "Roy Lichtenstein," p. 17.

44. This integrity was celebrated in the ten Stretcher Frames (see fig. 14, p. 68) that Lichtenstein made in 1968, which pictured the verso of square and rectangular canvases.

45. Lichtenstein famously pronounced that he was "anti-contemplative, anti-nuance, *anti-getting-away-from-the-tyranny-of-the-rectangle*, anti-movement-and-light, anti-mystery, anti-paint-quality, anti-Zen, and anti all of those brilliant ideas of preceding movements which everyone understands so thoroughly." G. R. Swenson, "What Is Pop Art? Answers from Eight Painters, Part I: Jim Dine, Robert Indiana, Roy Lichtenstein, Andy Warhol," *Artnews* 62, 7 (Nov. 1963), pp. 24–27, 60–64; quotation at p. 25; emphasis added.

LANDSCAPES IN THE CHINESE STYLE
STEPHEN LITTLE

Roy Lichtenstein explored the landscape genre throughout his career, recomposing topographic vistas to reflect his personal vision. In the last three years of his life, he honed this motif, creating a powerful series of over twenty works inspired by Song dynasty (960–1279) painting. His earlier landscapes already point to a long-standing fascination with sky, water, and light, key elements of the Chinese aesthetic. Lichtenstein's profound grasp of this rich tradition and its underlying worldview is visible in this series, which stands as a simultaneously grand and subtle statement at the end of the artist's life.[1]

Lichtenstein was exposed to Chinese art while a student at Ohio State University in the late 1940s, if not earlier. His knowledge of the field also derived from books he owned, many of which he acquired early in his career.[2] These volumes contained reproductions of works that are strikingly reminiscent of the Chinese landscapes that he would create decades later. Lichtenstein also viewed East Asian art in person. His very first group exhibition, in 1949, was at the Chinese Gallery in New York, which showed Chinese ceramics and other classical art forms in addition to American art.[3] Lichtenstein owned the exhibition catalogue for *Chinese Landscape Painting*, a seminal show at the Cleveland Museum of Art, organized in 1954 by Sherman Lee, the legendary director and chief curator of Asian art.[4] Throughout his later career Lichtenstein regularly visited museums and had many opportunities to see traditional Chinese landscapes dating to the Song and subsequent Yuan (1260–1368) dynasties in museums in New York, Boston, Washington, D.C., and elsewhere in the United States.

The painting of the Song dynasty, and especially that of the Southern Song dynasty (1127–1279), had the most significant impact on Lichtenstein. The great thirteenth-century artists Ma Yuan, Xia Gui, Liang

Fig. 1. Muqi. *Evening Glow on a Fishing Village*, Southern Song dynasty (1127–1279), 13th century. Hanging scroll, ink on paper; 33 × 112.6 cm (13 × 44 ⁵⁄₁₆ in.). Nezu Museum, Tokyo.

Kai, and Muqi, a Buddhist monk (see fig. 1), explored the effects of atmosphere with brush and ink in an astonishingly sophisticated and subtle manner, pushing the real and the visible to the edge of abstraction in a way that resonated deeply with Lichtenstein's own artistic goals.

Key aspects of the genre that fascinated Lichtenstein included the successful projection of atmosphere as a simplifying and unifying element that reduces the visible world to near-abstraction, embodying a striking philosophical and metaphysical detachment in the contemplation of emptiness.[5] The broad vistas, the renderings of mist-laden sky, and the minute scale of the figures featured in these landscapes convey an immediate and palpable sense of the grandeur of nature. Created at the end of the artist's endlessly creative career, these landscapes convey a distinct sense of timelessness.

Perhaps the aspect of Song dynasty landscape painting that most enthralled Lichtenstein was its spare technique: the ability to suggest a vision of a vast and harmonious universe in a highly economical manner. The origins of this vision lie in Daoism, which focuses on the pursuit of balance, simplicity, harmony, humility, and mindfulness. Lichtenstein's paintings achieve these goals to a remarkable degree and demonstrate that he had grasped much of the underlying conceptual framework that informed the traditional Chinese approach to landscape.

The series was influenced by the three major formats of traditional Chinese painting: the hanging scroll, the handscroll, and the album leaf. Although Lichtenstein's finished paintings are generally much larger than most traditional Chinese paintings, they nonetheless conform in their visual orientation to the ways in which Chinese landscapes were usually presented. The hanging scroll is a vertical image, usually bounded by strips of silk brocade on all sides (see *Landscape in Scroll* [fig. 2], in which Lichtenstein included a painted "mounting"). The handscroll presents a horizontal image, traditionally unrolled from right to left on a table, at one's leisure, and then rolled up and put away. Chinese handscroll paintings were often relatively short in length, but most comprised multiple sheets of paper or lengths of silk and were many meters long. Finally, the album leaf, which was usually mounted in a book or album, could be either square or round in shape. As album leaves are considerably smaller in size than most hanging scrolls or handscrolls, viewing one tended to be a more intimate experience, much like viewing an Indian miniature painting. Lichtenstein's Chinese-style landscapes include several examples derived from the round (or oblate) album leaf type, yet ironically they are close to (or over) two meters in height. Regardless of their format, however, the works in this series evoke the grandeur of traditional Chinese landscape paintings in their tremendous dignity coupled with an astonishing economy of technique, aspects a traditional Chinese audience would have deeply admired.

In many of his vertically structured Chinese Landscapes, the artist also incorporated wonderful spatial ambiguities in the compositions, of the type often seen, for example, in landscapes by the Buddhist monk-painter Hongren (1610–1663). In *Landscape with Philosopher* (1996; cat. 124), it is nearly impossible to tell whether the narrow white V-shaped cleft at the painting's lower center is to be read as in front of, or behind, the area of graduated dots on a blue ground to the immediate right of the cleft. Does the white cleft represent the sheer face of a cliff, or mist in a recessed valley or defile (i.e., is it a positive or negative space)? Traditional Chinese painters, especially of the late Ming and early Qing dynasties, delighted in this type of visual ambiguity, spatially challenging the viewer and creating an unsettling tension within the landscape.

Wu Tung, former Curator of Asiatic Art at the Museum of Fine Arts, Boston, recalls Lichtenstein's enthusiasm for Song dynasty painting. The artist and his wife twice visited the museum's storerooms, once prior to 1996, and again during his 1997 exhibition at the museum. Wu recounts one episode:

> **The first time, he and his wife and friends all came to the Asiatic Department after visiting our painting galleries. He complained [about] not seeing any Tang and/or Song works shown to the public. Having realized he's the real Lichtenstein, I promised to take him to our painting storage for a special treat . . . We then went to view quite a number of Southern Song album leaves. He obviously was very excited, and thanked me repeatedly. During his 1997 show . . . Roy asked to see more Song works. This time I took out many hanging and hand scrolls for him.[6]**

Lichtenstein was also influenced by traditional Japanese painting that followed Southern Song prototypes, particularly ink paintings (*suibokuga*) of the Muromachi period (1392–1573) and Kanô School paintings of the Edo period (1615–1868), which he would have known from art history books, museum visits, and private collections like that of John and Kimiko Powers. The Powerses were collectors of Lichtenstein and Pop art in general and also of traditional Japanese painting.[7] Lichtenstein acknowledged this shared interest in Japanese art in his preparatory drawing for *Landscape in Scroll* (figs. 2, 3), which he dedicated to the couple.

Lichtenstein took several trips in the two years before he began the series that could well have spurred him to turn to Chinese landscapes. In 1994 and 1995, Lichtenstein traveled to Japan (on the latter trip to accept the Inamori Foundation's Kyoto Prize). There he would have had firsthand access to superb Song dynasty landscape paintings in Japanese collections. Meanwhile, in 1995 Lichtenstein was inspired by the monotype and pastel landscapes of Edgar Degas on view at the Metropolitan Museum of Art; this has also been identified as an impetus behind the series.[8]

Lichtenstein's understanding of the Song aesthetic and its philosophical underpinnings is on display in the magnificent *Vista with Bridge* (fig. 4). It depicts a sweeping view of a broad river or lake, with distant mountains disappearing in mist and a single, tiny figure — almost an afterthought — crossing a bridge at the lower left. The gessoed canvas ground is painted with solid areas of white, light blue, light turquoise, and yellow pigments. This ground is covered with grids of graduated black and blue dots, together forming distant mountains at the upper right and left and a band of sky. The bridge projects a sharp, chiseled appearance, while the single figure is painted with a brush. Areas of yellow, orange, and pink were applied with a sponge in the ground to the left of the bridge. The rocks that jut out of the water's edge along the riverbank at the upper right consist of bold, starkly graduated Benday dots on a white ground. Stenciled onto the surface, the dots successfully convey an illusion of atmosphere similar to those of the Song dynasty originals Lichtenstein had studied — remarkable, given their mechanical appearance and application technique. In large measure this was a consequence of both their range of sizes and their unique spacing on the canvas (*Treetops through the Fog* [1996; cat. 122], for example, utilizes at least fifteen different sizes of dots).[9] The artist's use of variably sized dots can be traced back to the 1970s, specifically to the Mirrors (1969–72); works in the series employ this technique in a sophisticated manner to create the illusion of mountains, water, and atmosphere.

Almost all of the Chinese Landscapes began with a drawing, usually on a small or modest scale (in contrast to the much larger scale of the

Fig. 2. Roy Lichtenstein. *Landscape in Scroll*, 1996. Oil and Magna on canvas; 263.5 × 125.7 cm (103 ¾ × 49 ½ in.). Arthur M. Sackler Gallery, Smithsonian Institution, Washington, D.C.

Fig. 3. Roy Lichtenstein. *Flower with Bamboo and Landscape in Scroll (Studies)*, 1996. Graphite pencil and colored pencil on paper; 24.1 × 30.8 cm (9 ½ × 12 ⅛ in.). Private collection.

90

finished paintings). Lichtenstein's 1995 Sketchbook G, for example, contains eight small, beautifully contained drawings, each bounded by a rectangular outline (see fig. 5). Visually succinct renderings of preparatory collages and finished paintings, these drawings showcase Lichtenstein's own calligraphic line at work, which does not remain in the final versions. This was to be expected, given Lichtenstein's oft-stated desire to achieve a mechanically rendered appearance in the finished work: "Chinese landscapes with mountains a million miles high, and a tiny fishing boat—something scroll-like, and horizontal with graduated dots making these mountains, and dissolving into mist and haze. It will look like Chinese scroll paintings, but all mechanical."[10] It is noteworthy that Lichtenstein's first two works in the series were not paintings but prints, created in 1996 at the Gemini G.E.L. Studio in Los Angeles, for which he also made preparatory collages (see fig. 6).[11]

One of the most mysterious works in the exhibition is Lichtenstein's cast and painted stainless steel sculpture *Scholar's Rock* (1996–97; cat. 123). Lichtenstein most likely saw several displays of Chinese scholar's stones (also known as "spirit stones" [*lingshi*] or "strange stones" [*guaishi*]) in American museums, and it is noteworthy that he owned the important 1997 exhibition catalogue *Worlds within Worlds*.[12] Lichtenstein's fascination with these strangely shaped stones can be directly tied to his interest in traditional Chinese landscapes and their philosophical and cosmological underpinnings.[13] For collectors and poets in traditional China, such stones, placed both in interiors and in gardens, represented the universe in miniature—or more precisely, the inchoate energies that created the universe. By the late Bronze Age the Chinese had intuitively recognized that matter and energy are interchangeable (a fundamental concept of modern nuclear physics), and this understanding led the Chinese to view such things as mountains and rocks as made up of primordial energies, momentarily frozen in the seemingly (but deceptively) solid form of a stone. In John Hay's words, scholar's stones were thought to reflect the organic structure that characterizes the world, flowing with and energized by *qi* (breath, vital energy, or spirit).[14] The odd caverns and perforations that penetrated such spirit stones were understood in traditional China as gateways to Daoist paradises, where inside became outside and vice versa. It is typical of Lichtenstein's genius that he manifested this sensibility in the guise of a steel "stone," at once solid, fluid, and utterly mechanical. Like so many Chinese representations of stones (both in other materials and in paintings), Lichtenstein's painted steel version beautifully embodies a distinctly Asian sensibility in its shimmering, enigmatic, and foraminate surfaces, beautifully conveying the essentially multivalent (e.g., simultaneously solid and fluid) nature of stones as they were perceived in traditional Chinese culture.

An unusual and provocative work in the series is *Landscape in Fog* (1996; cat. 126), for which both a preparatory drawing and a collage (fig. 7) exist. Here actual brushstrokes are visible—as they are in many instances early in the artist's career. In rendering the eponymous fog, the bold gestural strokes in both the collage and the finished work seem to violate the austerity and the sense of detachment and isolation conveyed by the mechanically applied, graduated grid of dots that provide the illusion of materiality in the water, mountains, and sky. From the traditional Chinese point of view, both works display a tremendous

91

irony. Since the early 1980s Lichtenstein had been combining dots that mimicked printing processes with powerful gestural brushwork, and this continued through eight consecutively numbered canvases beginning with *Brushstroke with Still Life I* (1996).[15] In Chinese painting, the primary criterion for judging quality and authenticity was the brushstroke—the individual, calligraphic mark left by the artist on paper or silk. Seen through this lens, the spontaneous, painterly brushstrokes in Lichtenstein's paintings of the 1980s–90s comprise unique signs of the artist's character and persona.

Chinese painting and calligraphy share a bond through their materials: brush, ink, ink stone, and paper or silk. These arenas shared a theoretical foundation as well: the earliest theoretical texts on Chinese painting derive from the theory of calligraphy.[16] Likewise, the oldest extant Chinese text on connoisseurship concerns calligraphy, not painting. Dating to the sixth century AD, this text comprises a series of letters between the Liang dynasty emperor Wudi and the Daoist alchemist Tao Hongjing. Their correspondence concerns the authenticity of records of visions experienced by Daoist adepts, which included recipes for elixirs that they had received directly from deities and transcribed while in trances. So popular were these accounts of visionary transmission that they were frequently forged. Tao Hongjing was able to determine the authenticity of the texts on the basis of his knowledge of brushwork and calligraphy.

At first glance, the lack of brushwork per se in Lichtenstein's work might suggest it does not share an affinity with traditional Chinese painting, given the latter's overriding emphasis on brushwork. On the other hand, it is likely (and ironic) that the traditional Chinese viewpoint would assess the bold, gestural brushwork in Lichtenstein's *Landscape in Fog* as a reflection of the artist's character and, consequently, as a criterion for judging the quality of the painting's artistry.

A key point of confluence between Lichtenstein and traditional Chinese painters is admiration for images that appear naïve but are in fact technically brilliant, understated, and imbued with subtlety—images in which the artist's true mastery is masked. In China the achievement of these seemingly disparate goals was held in the highest esteem. As in Lichtenstein's work, in Chinese art it is often the case that what does not appear is as—or more—important than what does. This is a key element of Lichtenstein's artistic achievement. In much classical Chinese painting, what is seemingly bland, detached, and understated (the artistic quality known in Chinese as *pingdan*, literally, "plain and even") masks intense intellectual depth. In Lichtenstein's work, this accounts for the viewer's seduction as much as the droll ironies lurking in his brilliant celebrations of the mundane and timeless aspects of human life.

When asked what attracted him to Chinese landscape painting, Lichtenstein's responses were characteristically brief: for example, "It's just a style that I like."[17] Elsewhere, he reflected on the intention behind the series: "[I]n my mind it's a sort of pseudo-contemplative or mechanical subtlety . . . I'm not seriously doing a kind of Zen-like salute to the beauty of nature. It's really supposed to look like a printed version."[18] While appearing mechanically produced, Lichtenstein's landscapes do project the illusion of a transcendent realm that conveys the same philosophical resonance and subtlety as the Chinese originals he so admired. His virtuosity is especially impressive as this creative transformation relied on a technical approach radically different from traditional Chinese brushwork.

While multivalent ironies are present in Lichtenstein's art and resonate throughout the works in the series, he believed that "irony alone never makes a painting."

Fig. 7. Roy Lichtenstein. *Landscape in Fog (Study)*, 1996. Paint, cut-and-pasted painted and printed paper on board; 101.3 × 113.7 cm (39 ⅞ × 44 ¾ in.). Private collection.

92

To draw outlines and color them in is about as dumb a way of painting as you can imagine, and you can look at my work and say that's how it's done. And up to a point it is. Partly that's supposed to be ironic. For example, when I did paintings based on Monets I realized everyone would think that Monet was someone I could never do because his work has no outlines and it's so Impressionistic. It's laden with incredible nuance and a sense of the different times of day and it's just completely different from my art. So, I don't know, I smiled at the idea of making a mechanical Monet. But irony alone never makes a painting. I'm always trying to get at something having to do with color, too. I'm trying to make paintings like giant musical chords, with a polyphony of colors that is nuts but works. Like Thelonious Monk or Stravinsky. It's tough to make a painting succeed in terms of color and drawing within the constraints I insist on for myself. And I think it takes appreciation of another sort of art—Fragonard, Rembrandt—to pull it off.[19]

The supreme irony is that despite the artist's insistence on achieving a purely mechanical version of traditional Chinese landscape and not trying to present a "Zen-like salute to the beauty of nature," the Landscapes in the Chinese Style, simultaneously rooted in tradition and thoroughly contemporary, present a cosmic vision true to the Song dynasty masters Lichtenstein so admired. Gone are the familiar touchstones of modern Western culture, be they Mickey Mouse, heroic men and tragic women, classical entablatures, or Art Deco mirrors. In their place are the numinous, mist-enshrouded hills and rivers of ancient China. As the final act of his brilliant career, Lichtenstein invited the viewer to engage with an alien world in which he was completely at home.

NOTES

I would like to acknowledge the research of Karen Bandlow, in particular her book *Roy Lichtenstein und Ostasien* (Michael Imhof Verlag, 2007), which provided invaluable background material for this essay, as well as the kind assistance of the Roy Lichtenstein Foundation, the Estate of Roy Lichtenstein, and Stephanie Barron, Curator of Modern Art at the Los Angeles County Museum of Art.

1. The series was first shown at Leo Castelli in New York in the autumn of 1996, with subsequent exhibitions over the next two years at the Museum of Fine Arts, Boston; the Singapore Museum of Art; the Hong Kong Museum of Art; and the Arthur M. Sackler Gallery, Smithsonian Institution, Washington, D.C.
2. The earliest of these he acquired in the mid-1940s. Karen Bandlow, *Roy Lichtenstein und Ostasien* (Michael Imhof Verlag, 2007), pp. 11, 157; and Clare Bell, chronology in this catalogue, p. 342. In particular, Osvald Sirén's *The Chinese on the Art of Painting* (1964) contained translations of key texts on the theoretical and technical principles of Chinese art.
3. Bell, chronology, p. 343.
4. At least one of Lichtenstein's drawings was included in a 1954 exhibition of "spontaneous and unrehearsed drawings" at the same museum. Bandlow, *Roy Lichtenstein und Ostasien*, p. 54; and Bell, chronology, p. 344.
5. Bandlow, *Roy Lichtenstein und Ostasien*, pp. 58–80.
6. Wu Tung, e-mail message to the author, Sept. 24, 2011.

7. *Pop Art: The John and Kimiko Powers Collection*, exh. cat. (Gagosian Gallery, New York, 2001).
8. Bell, chronology, p. 360.
9. Published in *Roy Lichtenstein: Landscapes in Chinese Style*, exh. cat. (Hong Kong Museum of Art, 1998), cat. 10.
10. Bandlow, *Roy Lichtenstein und Ostasien*, p. 54.
11. I am grateful to Taras Matla of the Los Angeles County Museum of Art Prints and Drawings Department for giving me first-hand access to both prints, impressions of which were donated to LACMA by Lichtenstein and Gemini G.E.L.
12. Robert Mowry et al., *Worlds within Worlds: The Richard Rosenblum Collection of Chinese Scholars' Rocks*, exh. cat. (Harvard University Art Museums, Cambridge, 1997). See also Bandlow, *Roy Lichtenstein und Ostasien.*
13. See Stephen Little, *Spirit Stones of China: The Ian and Susan Wilson Collection of Chinese Stones, Paintings, and Related Scholar's Objects*, exh. cat. (Art Institute of Chicago, 1999).
14. John Hay, *Kernels of Energy, Bones of Earth: The Rock in Chinese Art*, exh. cat. (China Institute, New York, 1985), pp. 42, 100.
15. For the works from the 1980s, see Diane Waldman, *Roy Lichtenstein*, exh. cat. (Solomon R. Guggenheim Museum, New York, 1993), pp. 263–97.
16. See Chang Ch'ung-ho and Hans H. Frankel, trans., *Two Chinese Texts on Calligraphy* (Yale University Press, 1995).
17. Quoted in "Roy Lichtenstein: Landscapes in the Chinese Style," in *Brockton Enterprise* (Mass.), Mar. 23, 1997.

18. Quoted in Barbara Stern Shapiro, *Roy Lichtenstein: Landscapes in the Chinese Style*, exh. brochure, Museum of Fine Arts, Boston, Mar. 19–July 6, 1997. Reprinted in *Roy Lichtenstein* (Hong Kong Museum of Art); see also Bandlow, *Roy Lichtenstein und Ostasien*, p. 58.
19. Michael Kimmelman, *Portraits: Talking with Artists at the Met, the Modern, the Louvre and Elsewhere* (Modern Library, 1999), p. 93.

LATE NUDES

SHEENA WAGSTAFF

"I have to tell you a funny story. The *Two Nudes* collage [fig. 1] [was] up against the wall, not facing out. It was the last one he showed me, and he had this funny smirk on his face. He said, 'Now I want to introduce you to—', as if he was going to introduce me to the two models. But it was that other, unsaid thing. 'I want to introduce you to the first print you're going to have some trouble explaining.'" So Kenneth Tyler of Tyler Graphics described his first sight in 1993 of a collage by Roy Lichtenstein of two full-scale nude figures intended as the basis for a series of prints. As he warmed to his anecdote, Tyler added, "*Two Nudes* was the least popular . . . in the beginning a lot of people didn't like it. 'What's this lesbian crap?' . . . Roy was still trying to subvert something. Even though he pretended that it wasn't subject matter, it was."[1]

Lichtenstein explored the motif of the female nude extensively in a series of prints and then huge paintings beginning that same year and curtailed by his death in 1997. This was the first series he undertook following his exhaustive 1993 Guggenheim retrospective, the scope of which had extended to 1993. While some of the Nudes were exhibited in gallery shows of lithographs and prints, as well as in a Leo Castelli exhibition in 1994 that included eight Nudes, Tyler's comments are borne out by subsequent critical reaction, which has been cursory, nonplussed, or entirely silent regarding the Nudes.

Yet an examination of Lichtenstein's great Nudes reveals a fascinating story: a spiral return not just to the comic-book sources that from the 1960s defined him as a major painter of the twentieth century, but also to the 1970s, to two of his artistic mentors, Pablo Picasso and, to a lesser extent, Henri Matisse. In particular, following Picasso's death in 1973, Lichtenstein revisited with increasing verve a period of great pictorial

Fig. 1. Roy Lichtenstein. *Two Nudes (Study)*, 1993. Tape, cut-and-pasted painted and printed paper on board; 105.4 × 88.9 cm (41 ½ × 35 in.). Private collection.

significance in the artist's work—the so-called Marie-Thérèse Walter years. The Nude series of the 1990s, a notable parallel to and strange echo of Picasso, was the culmination of this artistic engagement. The 1994 exhibition *Picasso and the Weeping Women: Marie-Thérèse Walter and Dora Maar* at the Metropolitan Museum of Art in New York and the early 1996 exhibition *Picasso and Portraiture* at the Museum of Modern Art in New York would have renewed his interest in this period of Picasso's work.[2] In the Nudes, not only did Lichtenstein alter the equation in the compositional tension between motif and formal concerns, but also, crucially, he seized upon a new pictorial language. He deduced and acknowledged the nude as a form through which a new syntax could emerge by means of an understated narrative that implies a relationship between the artist-creator and the nude—a contemporary rendition of the Pygmalion-artist conjuring a plausible painterly version of his Galatean muse. Both the artistic and the perceptual tension between form and content, most especially in those paintings that intensified this balance through a mirroring device, were to occupy Lichtenstein in the last years of his life.

The nude is an accomplished symbol of desire whose appeal, from antiquity to the present day, also lies in its potential for formal perfection. It represents perfect design material, reduced to simplified forms ready for inclusion in artistic compositions. Two key nudes in 1907 marked the revolutionary starting point of twentieth-century art as an intellectual activity: Matisse's *Blue Nude (Memory of Biskra)* (fig. 2) and Picasso's *Demoiselles d'Avignon* (1907; Museum of Modern Art, New York). Matisse painted *Blue Nude* after the sculpture he was then working on shattered. He later finished the sculpture, *Reclining Nude I (Aurore)* (1906–07; Nasher Sculpture Center, Dallas), which is represented within several of his still-life paintings, such as *Goldfish and Sculpture* (1912; Museum of Modern Art, New York).

Fig. 2. Henri Matisse. *Blue Nude (Memory of Biskra)*, 1907. Oil on canvas; 92.1 × 140.3 cm (36 ¼ × 55 ¼ in.). The Baltimore Museum of Art.

Lichtenstein's homage to Matisse's seminal nude began with a hard-edged comic-ized approximation of the painting entitled *Still Life with Sculpture (Study)* (fig. 3)—and ended over two decades later with *Still Life with Reclining Nude (Study)* (1997; cat. 171). In the later work, the Matissean sculpture lounges precariously on a small table, nestled in a still-life grouping amid an open book and potted plant, equidistant from a window opening onto a landscape and, within the room, an oval mirror reflecting a self-portrait of the artist rendered in classic cartoon style. A metaphorical equivalent of Edvard Munch's last great painting, *Self-Portrait between Clock and Bed* (1940–42; Munch Museum, Oslo), Lichtenstein's painting evokes a tone of mortal destiny.[3]

Given the Matisse sculpture's significance for Lichtenstein throughout his artistic life, it is unsurprising that he created his own version of *Blue Nude* (1995; cat. 113), discussed further below. Both the title and pose of Lichtenstein's *Blue Nude* bring to mind Matisse's own final body of work, his paper-cutout Blue Nudes (1952–54), in which representation of the human form reaches its most extreme abstraction. But whereas the Blue Nude series crowned a lifetime of aesthetic endeavor and marked a final period of creative serenity for Matisse, Lichtenstein hit upon deliberately provocative subject matter in his Nudes, begun in earnest when the artist turned seventy years old. Their undeniable frisson of pictorial eroticism both problematizes the compositional architecture's integrity and highlights Lichtenstein's supreme mastery of form, distilled over a lifetime of pursuing technical perfection.

Fig. 3. Roy Lichtenstein. *Still Life with Sculpture (Study)*, 1973. Graphite pencil and colored pencil on paper; 17.9 × 22.7 cm (7 ¹/₁₆ × 8 ¹⁵/₁₆ in.). Private collection.

Lichtenstein's dalliance with the nude began early. As Dorothy Lichtenstein recalled, "He grew up studying [the Venus de Milo], but I think he felt more challenged by what we would call the early Modernists—Picasso, Cézanne, and Matisse. He felt that they had restructured the

painting and they were actually part of his time. He grew up in New York, and so these were really the first works he saw in the Museum of Modern Art."[4] The nude as artist's model debuts in Lichtenstein's major work *Artist's Studio with Model* (1974; cat. 105). He took inspiration from Matisse's 1920s series of odalisques and Moorish women; as a result the meaning of "model" oscillates ambiguously between a diaphanously clad living woman and a maquette. In addition, tucked into the lower right corner is a graphic sketch of a girl, the artist's hand with pencil poised in the act of drawing, playfully complicating further the identification of the "model" and the artist's relationship to the pictures within the overall picture—not least because the sketch is not a likeness of the odalisque "model" posing before him, but instead resembles a drawing by Picasso of his young muse Marie-Thérèse Walter.

The previous year, in a widely published eulogy to Picasso written on the occasion of his death in 1973, Lichtenstein reflected on the intense artistic dialogue he had carried on with the Modernist painter since his student days in the 1940s: "I don't think there is any question that Picasso is the greatest figure of the twentieth century."[5] Lichtenstein's earlier meditations on Picasso's work had been based on paintings from various periods and styles, but after 1973 he began to draw specifically from the formal innovations of 1927–37, the period of Picasso's astonishing creative fecundity known as the Marie-Thérèse years.[6]

In January 1927, Picasso had encountered the seventeen-year-old Marie-Thérèse, who for the next decade was his lover as well as the catalyst for some of his most exceptional paintings and for his inspired return to sculpture.[7] Picasso scholars consider this decade to have been a period of unprecedented creativity, in which his consort's athletic body, healthy physiognomy, and celebrated "Greek" nose had aroused an irresistible urge in him to become ever more erotically and formally inventive. In these most fruitful years, Picasso rendered Marie-Thérèse's form in a powerfully volumetric style, creating great lyrical paintings, monumental busts, assemblage sculptures, and a suite of etchings of Ovid's *Metamorphoses*.

Lichtenstein dug deep into Picasso's erotic mythology/vocabulary by engaging with all these bodies of work, beginning in 1977 with paintings that hark back to his iconic *Girl With Ball* (1961; fig. 9, p. 32) but which are obviously filtered through the narrative lens of Picasso. In his update of the art historical genre of "bathers" in paintings such as *Frolic* (1977; cat. 77) and *Girl with Beach Ball II* (fig. 4), Lichtenstein drew on a variety of other sources, from Paul Cézanne's lifelong fascination with the theme, to Salvador Dalí's biomorphic nude or seminude female forms with etiolated flipper limbs and overtly molded sexual attributes. Most notably, Lichtenstein alluded directly to paintings by Picasso made at the time of his clandestine affair with Marie-Thérèse, in which he stealthily encrypted her identity into his pneumatic *Bather with Beach Ball* (1932; Museum of Modern Art, New York) or the earlier 1928 series that included *Baigneuses au ballon* (fig. 5) and *Joueurs de ballon sur la plage* (Musée Picasso, Paris).[8] (The affair was necessarily clandestine because Picasso was then married and Marie-Thérèse was still a teenager.) Lichtenstein's 1977 riff on Picasso's "bathers" goes so far as to replicate the priapic beach cabana symbolizing the secret love nest that Picasso himself depicted as the place in which he and his young lover consummated their mutual ardor.

Twenty years later, Lichtenstein again picked up his artistic dialogue with Picasso on the theme of bathers, echoing within his own remarkable series of Nudes the latter's artistic experimentation and discovery of the late

Fig. 4. Roy Lichtenstein. *Girl with Beach Ball II*, 1977. Oil and Magna on canvas; 152.4 × 127 cm (60 × 50 in.). Private collection.

Fig. 5. Pablo Picasso. *Baigneuses au ballon*, 1928. Oil on canvas; 19 × 33 cm (7 ½ × 13 in.). Collection George L. K. Morris.

Fig. 6. Roy Lichtenstein. *Beach Scene with Starfish*, 1995. Oil and Magna on canvas; 299.7 × 603.3 cm (118 × 237 ½ in.). Fondation Beyeler, Riehen/Basel.

96

1920s and early 1930s. In his monumental twelve-foot canvas *Beach Scene with Starfish* (fig. 6), Lichtenstein demonstrated an ingenious interweaving of Modernist invention and pulp fiction in his frieze of energetic, innocent sexuality. The poses of his female ballplayers are similar to those of Picasso's painting *Baigneuses au ballon*, but in divesting his female bathers of their striped bathing suits, Lichtenstein identified them as latter-day Three Graces, the attendants to the goddess of love, Aphrodite. Their proximity to the cabana, which Lichtenstein once again depicted as the site of Picasso's sexual tryst, serves to heighten a symbolism already indicated by the suggestively round opening in a large rocky outcrop in the sea beyond, holding the exact center of the mural-sized work.

The figural sources for the painting are found in Lichtenstein's clippings archive: comic-book blondes from DC Comics's *Girls' Romances* of 1963 and 1965. Lichtenstein must have perused his entire comic-book collection at length to find the exact characters; once found, he "stripped bare" each one of them — in a late twentieth-century version of Picasso's innovative allegory for sexual subterfuge and arcadian animation. Notwithstanding Lichtenstein's deliberately iconographic encoding of his sources, it is his use of compositional devices, particularly the strips and planes of graduated red Benday dots that stain, amalgamate, and differentiate zones of the composition, that distinguishes his 1990s Nude series as markedly different from his previous work.

The drawings for both *Beach Scene with Starfish* (1995; Fondation Beyeler, Riehen/Basel) and *Nudes with Beach Ball* (fig. 7; and see cat. 117) from the previous year reveal the underlying graphic logic of Lichtenstein's adaptation of Benday dots as pattern: a frenzy of vertical red pencil scribbles follows the inflections of the body to bifurcate each nude, with crosshatching to darken certain areas.[9] When translated into dots, the most intensely colored areas become filled with those of the largest diameter. Just to the right of center, an oval zone of dots appears to overlay another— a compositional device reminiscent of a fractured reflection from Lichtenstein's extensive Mirror series (1969–72), employed to create a spatial conundrum that simultaneously evokes and flattens depth of field.

Although *Nudes with Beach Ball* (cat. 117) and its smaller pendant from the same year, *Nude with Beach Ball* (Collection Simonyi), are obvious references to his 1961 *Girl With Ball* (fig. 9, p. 32), the pictorial structure of the later works marks a radical new point along the trajectory of the nude motif in Lichtenstein's oeuvre. It also moves beyond his earlier embrace of Picasso's synthetic cubism in, for instance, the double-faceted face of *Girl with Beach Ball III* (1977; National Gallery of Art, Washington), which in turn relates to *Female Head* (1977; private collection), in which a similar binary portrait using the same restricted three-color palette is juxtaposed with a depicted mirror that appears to reflect the woman's tresses.

The mirror and depicted mirroring are familiar art historical tropes that historically have been used to represent mortality, the transience of life, and the ephemerality of beauty (see fig. 8). Lichtenstein's fascination with positioning a reflection on the same plane as the object being reflected occurred early in *Girl in Mirror* (1964; edition of eight), which appears to relate stylistically to Picasso's epic work *Girl before a Mirror* (fig. 9), reputedly the first painting by the modern master that he encountered, and with which he had subsequently been familiar in the collection of the Museum of Modern Art. Mirrors are generally located in places where we are naked, in the bathroom and bedroom and at the vanity, the last of these an eponymous setting for a latter-day vanitas. These are the environments for most of Lichtenstein's late Nudes. As monumental celebrations of domesticated eroticism, a number of them involve mirrors, which,

97

Fig. 7. Roy Lichtenstein. *Nudes with Beach Ball (Study)*, 1994. Graphite pencil and colored pencil on paper; 39.4 × 47.6 cm (15 ½ × 18 ¾ in.). Private collection.

in their function as reflections of narcissism, can also extend to the related theme of the artist and model.

The mirror's reflection in *Nude at Vanity* (1994; Doris and Donald Fisher Collection, San Francisco) is denoted by diagonal lines and graduated slices of dot fields that Lichtenstein took from commercial and comic-book graphic shorthand to signify a mirror, and which he had explored extensively in his Mirrors. Deploying the same mirroring technique in *Nudes in Mirror* (1994; fig. 10, p. 33), Lichtenstein introduced the mischievous narrative element suggested by two nude women together, to which Ken Tyler referred above. Adapted from a frame in the 1964 romance comic book *Secret Hearts*, the scene now includes an open window (a hackneyed symbol for sexual availability), nude women instead of clothed characters, and the entire scenario "reflected" as the picture itself, the edges of the "mirror" fitting just within the borders of the painting. Less a phenomenological aspect of the viewer as a kind of reflected substitute for the main nude's self-portrait, the painting is more a meditation on the idea of reflection, playing with erotic innuendo to the extent that the nudes have no defining personal characteristics and thus are reflections of one another. As Lichtenstein said in an interview that year, "It's kind of amusing that you just paint them and leave the clothes off and it means something much different. It's more riveting."[10]

Blue Nude epitomizes the importance that Lichtenstein attributed to Picasso's *Girl before a Mirror* twenty years earlier and from which he had learned and assimilated by the 1990s. In acknowledging his debt to Picasso at his death in 1973, Lichtenstein was more expressively forthright than usual: "*Girl before a Mirror* has a special meaning for me. Its strength and color relationships are extraordinary . . . [it] reaches a level of discord and intensity that has few parallels."[11] *Girl before a Mirror* had marked a moment of pictorial revelation for Picasso, who had drawn extensively on then-contemporary Matissean sources and mirror motifs in his own quest to hold in tension rather than resolve through fusion the dichotomy between color plane and contour/line. Indeed, it was Matisse's intention to deflect visual attention from the principal figural motif through vividly contrasted colors to which Picasso responded, heightening his own use of dissonant color and patterned form in his portrait of a young girl confronting her own sexuality. While Picasso's *Girl before a Mirror* is innovative in its rendering of both stance and reflection on the same planar surface, like a hinged panel joining recto and verso, it is simultaneously the subject's erotic body—semiclad in a striped maillot revealing her breasts and pulled up raunchily between her buttocks as she peers deep into the pool of her mirror—that has memorably been described as offering "an object lesson of the depth of psychological complexity."[12]

By 1974, in his considered appreciation of Picasso's *Girl before a Mirror*, Lichtenstein had registered both theme and pictorial innovation, but was less engaged with the potential of color per se for desired discord and intensity. By the 1990s, however, he had discovered a new way to render color plane and contour, filtered through his profound understanding of mutual influence—an artistic process of call-and-response that defined the innovations of both Picasso and Matisse in the 1930s in holding the pictorial framework in tension. At the same time, he was equally aware that the beguiling intimations of his subject matter—the odalisque as "calendar girl" (a contemporary version of the traditional nude/mirror trope)—were explicit enough to threaten to destabilize the work's formal tension.

Lichtenstein described his encounter with the nude thus: "It started out as my idea of mixing chiaroscuro—done with dots and shading—with flat areas of color, which is a complete inconsistency. Nobody I know has

Fig. 8. Hans Memling. *Vanitas*, c. 1490. From *Polyptych of Earthly Vanities and Heavenly Redemption*. Oil on wood; 20 × 13 cm (7 ⁷/₈ × 5 ⅛ in.). Musée des Beaux Arts de Strasbourg.

Fig. 9. Pablo Picasso. *Girl before a Mirror*, 1932. Oil on canvas; 162.3 × 130.2 cm (64 × 51 ¼ in.). Museum of Modern Art, New York, gift of Mrs. Simon Guggenheim.

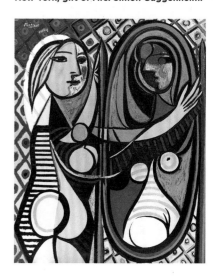

used it . . . With a nude the surface is curvilinear. You can put any kind of a shadow on it and it takes its place somewhere. But I found that it doesn't really make any difference whether it's a nude or a jar of something. So it originated with an art problem rather than with the nude."[13] After repeating his mantra about subject matter being simply grist for his formal interests, he made an admission: "But then I also thought that the nudes would disappear because this idea I had in my head was so strong. It isn't that way at all. If you draw three lines that look like a nude, people see a nude."[14] Coming to terms with the fact that his nudes were not only identifiable as traditional carriers of historic meaning but were also invested with implications of "something much different," he used the motif increasingly inventively until the end of his life.

In the Nudes, Lichtenstein employed his version of Benday dots to create strong contrasts in illumination to achieve the effect of chiaroscuro long used by artists to evoke volume and modeling of three-dimensional objects. Thus in *Blue Nude*, vertical swaths of dots, their size waxing steadily to an intense blue cluster, extend from the Blue Nude's calf to stretch methodically across the white field of midthigh, flank, and shoulder up to the vertical stem of her neck. Instead of observing the limits of the nude's curvilinear torso, the dots ebb over her contours (working around the opaque yellow of her blonde bob), spreading unfettered across the painting's space, intensifying to a dense blue, curved vertical plane that fills a third of the right side of the picture. Accordingly, the latter's spatial position becomes supremely ambiguous, simultaneously suggesting a mirror plane, a perspectival reflection, and the picture plane itself.

Thus Lichtenstein arrived at a way of incongruously mixing his form of chiaroscuro with planes of bright color. He described this in a 1995 interview: "With my nudes I wanted to mix artistic conventions that you would think incompatible, namely chiaroscuro and local color, and see what happened. I'd seen something similar in Léger's work. My nudes are part light and shade, and so are the backgrounds, with dots to indicate the shade. The dots are also graduated from large to small, which usually suggests modeling in people's mind, but that's not what you get with these figures."[15] His solution distinguishes the Nude series as formally groundbreaking, relying equally on its pictorial subject matter for its impact.

Central to Lichtenstein's *Blue Nude*—and before that, to Picasso's *Girl before a Mirror* or a line drawing by Matisse from the period such as *Artist and Model Reflected in a Mirror* (fig. 10)—is the familiar Romantic motif of the mirror as proscenium. In a recent interview, Dorothy Lichtenstein mentioned that Lichtenstein "usually worked with a mirror in the background to get as much distance from the canvas as possible, so he could try to see it as a whole and in reverse. He was very interested in form and style."[16] Like his predecessors, Lichtenstein no longer represented the surface of the mirror: the two images of his *Blue Nude* press together like Siamese twins in a proximate space between two rooms. In general, his paintings of nudes are monumental in size and are among the biggest in his oeuvre. Larger than life size, they fill the canvas and our field of vision, like in a cinema screen close-up of sheer image. We are inescapably confronted with the orchestration of corporeal surface, in which the female body deprived of clothes becomes the nude, the body re-formed, within the painting's architecture.

It is notable that Lichtenstein's work often connotes his elliptical presence as artist in relation to the nude-model. Matisse showed himself explicitly in the mirror's reflection as the artist gazing at his model, her body duplicated and reversed in reflection with a sketch of her on the studio wall behind him. Alternately, Picasso's identity is embodied within the character—his young muse Marie-Thérèse. Lichtenstein's presence in

99

Fig. 10. Henri Matisse. *Artist and Model Reflected in a Mirror*, 1937. Pen and black ink; 61.2 × 41.5 cm (24 ⅛ × 16 ⁵⁄₁₆ in.). The Baltimore Museum of Art, the Cone Collection, formed by Dr. Claribel Cone and Miss Etta Cone of Baltimore, Maryland, BMA.

Blue Nude can be implied by an oval mirror on the wall of the reflected room, whose surface is opaquely—even obdurately—indicated by his signature graphic signs for light refraction. Among a handful of self-portraits made in his lifetime, the most well-known work (1978; cat. 101) is a painting of a rectangular mirror hanging in place of a head atop a T-shirt. In response to the question, "What do you see in a mirror?" Lichtenstein's near contemporary and admirer Gerhard Richter, whose own series of mirrors began in 1967 with the work *4 Panes of Glass* (Anton and Annick Herbert Collection, Ghent), answered, "Myself. But then I immediately see that it functions like a painting. Just more perfectly." The interviewer pressed the point: "So the mirror would be the perfect artist?" As if in Lichtenstein's shoes, Richter answered, "Exactly."[17]

At the inception of his thinking about the 1990s Nudes, Lichtenstein adopted the theme of artist and model that had obsessed Picasso throughout the Marie-Thérèse years. To this end he engaged in concerted artistic dialogue with Picasso on two major paintings with which he was fascinated: *The Studio* (1927–28; Museum of Modern Art, New York) and *Painter and Model* (fig. 11). Lichtenstein's reworking of the motif in his respondent paintings, *Reflections on "The Artist's Studio"* (1989; Hamburger Bahnhof, Museum für Gegenwart, Berlin) and *Reflections on "Painter and Model"* (fig. 12), is both a metaphorical and a literal reflection on the nature of the painting and its origins, topically and historically. He overlaid Picasso's *Painter and Model* (now slightly altered in details of color and form) with slanting graphic notations that stand for "reflection," as if the entire image were being seen by us in a mirror, mediated at a further remove via another artist's perception.

The many-layered visual riddle of what constitutes origin and reality within the hall of mirrors was distilled in Lichtenstein's first depicted nude of the 1990s, *Reflections on Jessica Helms* (fig. 13). In ironic riposte to then U.S. Senator Jesse Helms, the stridently conservative politician of the post-1960 era whose Helms Amendment during the "culture wars" of 1989–90 prohibited the use of federal funding for art deemed "obscene" or "indecent," Lichtenstein's painting ensures that Jessica's modesty is maintained by mirrored reflections prudishly obscuring and consciously flattening the voluptuous womanliness of the upper and lower parts of her anatomy.

A sculptural equivalent to the painting's bodily depiction, *Galatea* (1990; cat. 114) makes visible the censored sexuality of a female nude by reducing her to abstracted female attributes, crowned by a hank of flowing yellow hair. While a windblown blonde bob is closely identified with Picasso's portraits of Marie-Thérèse, Galatea's tresses can be interpreted equally as a depiction of a brushstroke. Indeed, three years later, coincident with his first nude collage *Two Nudes*, Lichtenstein developed huge sculptural renditions of this elemental aspect of painting in *Brushstroke Nude* (fig. 14); torqued along its height to present both the front and rear sides of its two-dimensional plane, in simultaneous amalgam of image and reflection.

Galatea derives from the mythological story of Galatea, the exquisite ivory statue of Venus carved by the young sculptor Pygmalion. The perfection and beauty of his sculptural creation kindled his imagination so intensely that he fell in love with it as though it were a real woman. Indeed, he willed her into existence through the life-giving magic of his desire. By referring simultaneously to Picasso's Pygmalion-like relationship to his muse Marie-Thérèse and to the statuesque sweep of his own "brushstroke," which had by the 1990s become a leitmotif in his oeuvre, Lichtenstein was making a wry but powerfully evident association between the dualities of the myth/reality of artistic creation and the

Fig. 11. Pablo Picasso. *Painter and Model*, 1928. Oil on canvas; 129.8 × 163 cm (51 ⅛ × 64 ¼ in.). The Sidney and Harriet Janis Collection.

Fig. 12. Roy Lichtenstein. *Reflections on "Painter and Model,"* 1990. Oil and Magna on canvas; 198.1 × 243.8 cm (78 × 96 in.). Private collection.

Fig. 13. Roy Lichtenstein. *Reflections on Jessica Helms*, 1990. Oil and Magna on canvas; 160.0 × 124.5 cm (63 × 49 in.). Private collection.

"authentic" essence of its expression. It is reasonable to assume that Lichtenstein was acutely aware of Picasso's obsessive preoccupation with the notion of metamorphosis, given that he owned at least four books devoted to a seminal group of etchings by Picasso known as the Vollard Suite, in which the majority of works explore the artist-and-model theme.

Invited in 1931 by art dealer Ambroise Vollard to illustrate Ovid's *Metamorphoses*, Picasso focused mainly on two stories within the lyric series of fifteen chapters: Narcissus and Pygmalion.[18] It was a serendipitous commission, coincident with his affair with Marie-Thérèse, for it gave Picasso greater impetus to explore his innate interest in the symbolic subject of the artist's studio.[19] This became the principal narrative thread of the Vollard Suite, which consists of variations on the scene of the classical sculptor contemplating a sculpted head while the model looks on. In his vividly erotic graphic of the artist-muse-model triad, Picasso secured a choreographed interplay of glances between creator and creation, a metaphorical dialectic born of the eternal circuit of the arousal of desire and the disillusion of its fulfillment.

At this time, inspired by his lover's classical looks and athletic body, Picasso had returned to sculpture, creating a group of large white plaster busts and hieratic heads. In the Vollard etchings of the sculptor and model, these larger-than-life heroic busts feature extensively, presented on classical columns, plinths, and tables. Recalling a visit in mid-1933 to his friend Picasso's studio, the photographer Brassaï immediately associated the sculptures he was seeing with the woman who inspired them: "He adored the golden light in her hair . . . her sculpted body . . . Sculpture . . . lay dormant in the very heart of his painting, betraying his nostalgia for full-bodied relief."[20] Not only had Picasso found in Marie-Thérèse the reality of the neoclassical type he had already been painting in the 1920s; in his sculpture, he also created her as a contemporary embodiment of the Pygmalion muse, the physical animation of Venusian perfection (Picasso, *Model and Sculptor with His Sculpture* [fig. 15]).

While situating *Nude with Bust* (1995; cat. 119) within the intimacy of an interior, Lichtenstein was at the same time making drawings and collages for a bust entitled *Woman: Sunlight, Moonlight* (1996; cat. 118), recalling a small group of heads from thirty years earlier, including *Head of Girl* (1964; Roy Lichtenstein Foundation Collection) and *Blonde* (Museum Ludwig Köln), which were cast volumetrically from a milliner's mannequin head and surface-painted like a two-dimensional painting.

In contrast to her older sisters, *Woman: Sunlight, Moonlight* in fact occupies a single plane, in which each face, with regularly sized dots denoting shadow and volume from the woman's temple to the foot of the support, evokes a fully rounded depiction of a female head in both the sulfurous light of day and the blue shadows of its nocturnal end, playing at the same time with the meaning of chiaroscuro ("light-dark") traditionally used in art to suggest strong contrasts of light and shadow. In a short step from the two-dimensionality of his sculpture to that of his painting, the same volumetric form is suggested by Lichtenstein's representation of *Woman: Sunlight, Moonlight* as a sculptural "bust" in *Nude with Bust*. With the closed eyes and open lips of a woman in ecstasy, the bust (as well as the nude), like all Lichtenstein's 1990s Nudes, emerged from in his archive of romance comic books.

Lichtenstein's late Nudes do not open up explicit stories about the artist-model relationship as Picasso's works do, nor do they replicate the emotional intensity and trauma of Lichtenstein's comic-strip girls from the 1960s embroiled in romantic or life-and-death incidents. They do, however, enter the domain of narrative through the glimmer of their implied sexuality. Inspired by single frames in the comic books *Secret Hearts*

(Apr. 1964) and *Young Romance* (Jan. 1964), respectively, Lichtenstein removed the bathing suit from the comic-book character as she sits on the beach. Thus the naked girl, like a modern Aphrodite, is metamorphosed in the painting *Nude with Bust* into an expectant, winsome playmate, her "bust" a witty double entendre. Juxtaposed with a replica of her head, whose blissful expression suggests postcoital exultation, *Nude with Bust* might be seen as the two faces of "before and after." Jeff Koons, who shared a 1995 two-man show with Lichtenstein at the Broad Foundation in Santa Monica the same year as *Nude with Bust* was painted, commented, "The later women paintings and nudes that Roy did are just absolutely gorgeous. The women playing with the beach ball are, I think, equal to the girl with the beach ball, the original one. I know the first one has the history, but in terms of beauty and engaging imagery—interesting, viral imagery—the women are fantastic."[21] Dorothy Lichtenstein concurred: "He really got interested in that theme again—the paintings with two women, one modeling a bust of the other . . . That was certainly a theme that Roy always returned to."[22]

In reproducing the essentials of nude iconography in the languid sensuality and sometimes resigned pathos of each nude, the sinuous curves and unblemished skin constitute a perfect ground for design. In *Nude with Bust*, graduated lines of chiaroscuro dots flow vertically in graduated progression across both the character and sculptural bust, extending across the room and what appears to be a large painting behind her, formally pinning all to the same picture plane.

Yet the notion persists in this painting that Lichtenstein was depicting a contemporary version of his Galatea, brought to life through the artist's passion. Moreover, by his inclusion of a painted version of the other sculpture Lichtenstein made in 1995, *Endless Drip* (fig. 16) (the dribbly byproduct of an actual brushstroke—the DNA of painting that Lichtenstein strove to emblematize throughout his career), he added a sly note of "self" or self-consciousness, like a kitsch attribute of the artist's persona more traditionally represented by a palette or drawing board.

A further distinctive stage in Lichtenstein's late odyssey with the nude occurred in 1997 in an explicit and complex artistic dialogue within *Interior with Painting of Nude (Study)* (fig. 17), and its horizontal pendant, *Still Life with Reclining Nude (Study)*, mentioned above. In the former, a large vertical canvas occupies nearly half the picture, depicting a smiling nude whose truncated body fills the canvas, her scale larger than life size in relation to that of the studio interior. The canvas nude has one arm raised behind her head in classic odalisque pose, the volume of her form faintly evoked by a scattered shading of chiaroscuro dots, while a continuous thick umber outline, broken momentarily by the frame, transfixes her to the same plane as the tablecloth edge before her. On this improbably draped studio table lie a color-daubed palette, a tin of color-flecked brushes, and two other vessels, clustered together like a votive still life, with the artist's stool sitting empty as if he had just been interrupted. Beyond, the view from the window is a line of twisted oaks, their mature branches intertwined with one another, a variation on a similar view through the open door of the other collage. In both, the rendering of trees derives from a small clutch of drawings Lichtenstein was beginning to work up in conscious reference to Cézanne, whose late Bathers series he was inspired by in 1997.[23]

In the 1990s, not only had Lichtenstein discovered a unique rendering of chiaroscuro, but it led him in his very final year to the beginning of an even more radical pictorial language.[24] "I'm trying to make paintings like giant musical chords, with a polyphony of colors that is nuts but works . . . It's tough to make a painting succeed in terms of color and

102

Fig. 16. Roy Lichtenstein. *Endless Drip*, 1995. Painted and fabricated aluminium; 374 × 34.3 × 11.4 cm (147 ¼ × 13 ½ × 4 ½ in.), including base; edition of three. Private collection.

Fig. 17. Roy Lichtenstein. *Interior with Painting of Nude (Study)*, 1997. Cut-and-pasted painted and printed paper, tape, and felt-tip marker on board; 153 × 101.9 cm (60 ¼ × 40 ⅛ in.). Private collection, New York.

Fig. 18. Roy Lichtenstein. *Nude*, 1997. Oil and Magna on canvas; 209.6 × 114.3 cm (82 ½ × 45 in.). Private collection.

Fig. 19. Pablo Picasso. *Standing Nude*, 1922. Oil on canvas; 26 × 21.6 cm (10 ¼ × 8 ½ in.). Private collection, New York.

Fig. 20. Roy Lichtenstein. *Nude (Study)*, 1997. Graphite pencil on tracing paper; 13.3 × 7 cm (5 ¼ × 2 ¾ in.), irregular. Private collection.

drawing within the constraints I insist on for myself."[25] Using contour strands of prismatic color weighed carefully against and in complement to his use of chiaroscuro, he spread collage elements episodically over the surface to create a dissonant dazzle of color. His emphasis was on the quantity and balance of colors, a rainbow mesh of interpenetrated forms whose rhythmic structure seals the integrity of the picture plane.

These are paintings about the act of painting. Crucially, the late Nudes can also be seen as allegories of the potency of the artist's creativity. At the age of seventy in 1993, it is not inconceivable that, like Picasso, Lichtenstein was taking account of his personal drive to yoke artistic motivation and desire by invoking past influences within his current preoccupations in order to reinvigorate and reinvent his art with a new pictorial idiom. Echoing his predecessor's preoccupation in his late years with the theme of "the painter and his model," Lichtenstein tackled the topic with gusto, and this endeavor found its apotheosis in the 1997 collages and paintings. Lichtenstein's self-portrait as painter is depicted metaphorically in both *Interior with Painting of Nude (Study)* and *Still Life with Reclining Nude (Study)*, in which the nudes make tangible contact with the symbolic embodiment of the creator of their images. In this case, the "mirrored image" of artist-and-muse reflects a potent facet of Lichtenstein's lifelong preoccupation with the reflected image. In the process, Lichtenstein devised a new formal vocabulary, apposite to but separate from his subject matter, whose enactment equals the power of Picasso's *Girl before a Mirror* in "help(ing) to realise the theme of change which this painting of a visual, temporal, biological, sexual and emotional transformation unfolds."[26]

Throughout his career, Lichtenstein's notion of "change" lay in his quest for innovation within tradition. In the motif of the nude, he found a perfect vehicle with which to contribute anew to her two-thousand-year art historical lineage. It is particularly poignant that he was completing a monumental standing nude at the time he was taken to the hospital. Sources for *Nude* (fig. 18) are said to include reproductions of Picasso's classical nudes of the 1920s, with the latter's *Standing Nude* (fig. 19), in which the subject leans against a pedestal draped with fabric, being of special relevance.[27] Lichtenstein's preliminary drawing on tracing paper for *Nude* (fig. 20) reveals the figure juxtaposed with a plinthlike structure, evidently clutching a piece of flowing fabric.

However, it is to the famous *Aphrodite of Knidos* (fig. 21), one of the few extant copies of the renowned fourth-century B.C. sculptor Praxiteles, the first artist to sculpt the nude female form in a life-size statue, to which both Picasso and Lichtenstein must refer. Her animated form in contraposto stance, the rhythmic swing of the hip, and the implication of being newly unclothed have defined her for eons as a vivid symbol of desire. Through their work, both Picasso and Lichtenstein acknowledged eroticism as a key means of holding a painting in tension, highlighting and dramatizing what Edward Said has called the "irreconcilabilities" in the work of artists in their mature years.[28]

Lichtenstein's serial development of the Nudes dazzles with new "stories" about pictorial representation, an important aspect of which pertains to duplication, usually through figurative or symbolic "reflections." In its powerful iconicity, the nude as an evocative embodiment of the creative process itself is reticulated through serial reiteration of the subject matter. It is the discovery and convulsive act of formal genesis—and Lichtenstein's symbolic transfiguration of pictorial skin and gristle—that signal its real pictorial metamorphosis, and thus become the means of simultaneously overcoming yet emphasising its narrative associations. Lichtenstein's Nudes, created in the last four years of his life, are a

profoundly innovative and active meditation on the relationship of creation and perception. As if designed specifically to corroborate Said's characterization of "late style," Lichtenstein's Nudes signal "the tension between what is represented and what isn't represented, between the articulate and the silent."[29]

Fig. 21. Praxiteles. *Aphrodite of Knidos.* Roman copy of an original, c. 364–61 B.C. 203.2 cm (80 in.) high. Musei Vaticani, Vatican City.

104 **NOTES**

1. Kenneth Tyler, oral history, conducted by Avis Berman, Apr. 29, 2008, transcript, pp. 71–72. The Roy Lichtenstein Foundation Archives.
2. *Picasso and Portraiture: Representation and Transformation*, Museum of Modern Art, New York, Apr. 28–Sept. 27, 1996. The exhibition catalogue of the same title (Museum of Modern Art, New York, 1996) included an insightful essay by Robert Rosenblum, "Picasso's Blond Muse: The Reign of Marie-Thérèse Walter," pp. 336–83.
3. While Munch scholar Elizabeth Prelinger has attributed the nude depicted in Munch's last painting as a reference to his lover Kotkaia, the painting bears closer resemblance to a figure in Matisse's *Bathers by a River* (1916–17; the Art Institute of Chicago). See Prelinger, *After the Scream: The Late Paintings of Edvard Munch* (High Museum of Art, Atlanta/Yale University Press, 2011), p. 156.
4. Conversation with Dorothy Lichtenstein and Jeff Koons, Apr. 11, 2008, in *Lichtenstein Girls*, exh. cat. (Gagosian Gallery, New York, 2008), p. 11.
5. Lichtenstein, quoted in Barbaralee Diamondstein, "Caro, de Kooning, Indiana, Lichtenstein, Motherwell, and Nevelson on Picasso's Influence," *Artnews* 73, 4 (Apr. 1974), p. 46.
6. Lichtenstein owned a prodigious sixty-one books devoted to the art of Picasso, along with twenty-four Matisse volumes, which contain several sources for Lichtenstein's interpretations of the work of both his predecessors.

7. Rosenblum suggested that Picasso may have met Marie-Thérèse as early as January or February 1925. "Picasso's Blond Muse," p. 339.
8. Featured in several books in Lichtenstein's library. Another source is the classical gigantism of Picasso's *Women Running on the Beach* (1922; Musée Picasso, Paris) and earlier works such as *The Bathers* (1918; Musée Picasso, Paris).
9. The drawings for *Nudes in Mirror* demonstrate the same graphic key—colored pencil sketched roughly and rapidly in linear planes across the entire picture plane—as that for *Nudes with Beach Ball* of the same year, scribbled across subject, background, and mirrored slash alike, to indicate clearly the corresponding spread and degrees of intensity of the Benday dots in the final painting.
10. Robert Enright, "Pop Goes the Tradition: An Interview with Roy Lichtenstein," *Border Crossings* 13, 3 (Aug. 1994), p. 27.
11. Lichtenstein, quoted in Diamondstein, "Caro, de Kooning," p. 46.
12. John Elderfield, *Matisse Picasso* (Tate Modern, 2003), p. 233.
13. Enright, "Pop Goes the Tradition," p. 27.
14. Ibid.
15. Lichtenstein, quoted in Michael Kimmelman, *Portraits: Talking with Artists at the Met, the Modern, the Louvre and Elsewhere* (Random House, 1998), p. 89.
16. D. Lichtenstein, quoted in *Lichtenstein Girls*, p. 10.

17. Dietmar Elger and Hans Ulrich Obrist, eds., *Gerhard Richter TEXT: Writings, Interviews and Letters, 1961–2007* (Thames & Hudson, 2004), p. 479.
18. Books 3 and 10, respectively.
19. For instance, Picasso, *La statuaire* (1925; private collection).
20. Brassaï, quoted in Picasso, *Vollard Suite*, Instituto de Credito Oficial Collection (Turespaña, 1993), p. 26.
21. Jeff Koons, quoted *Lichtenstein Girls*, p. 16. Koons's group of paintings and sculptures constituting his installation *Made in Heaven* (1990) was created in explicit interplay between art and *Playboy*-like soft pornography.
22. D. Lichtenstein, quoted in *Lichtenstein Girls*, p. 16.
23. D. Lichtenstein, conversation with the author, May 2011.
24. For further elaboration, please see the essay in this catalogue by Harry Cooper.
25. Michael Kimmelman, "At the Met with: Roy Lichtenstein; Disciple of Color and Line, Master of Irony," *New York Times*, Mar. 31, 1995, p. C27.
26. Elderfield, *Matisse Picasso*, p. 235.
27. Images of which are in several Picasso books in Lichtenstein's library. See Alfred Barr, *Picasso: 75th Anniversary Exhibition Catalogue* (New York, 1957).
28. Edward W. Said, quoted by Michael Wood in Said, *On Late Style: Music and Literature against the Grain* (Pantheon, 2006), p. xix.
29. Ibid.

PLATES

PLATES

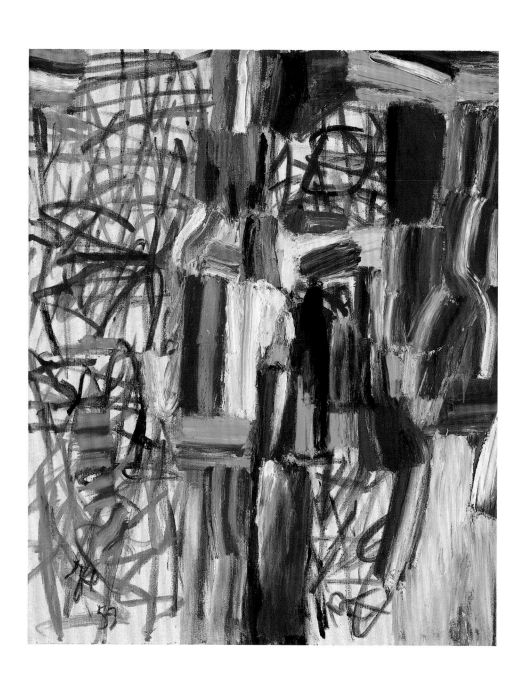

1.
Untitled, 1959
Oil on canvas
86.5 × 71.3 cm (34 ¹⁄₁₆ × 28 ¹⁄₁₆ in.)
Private collection

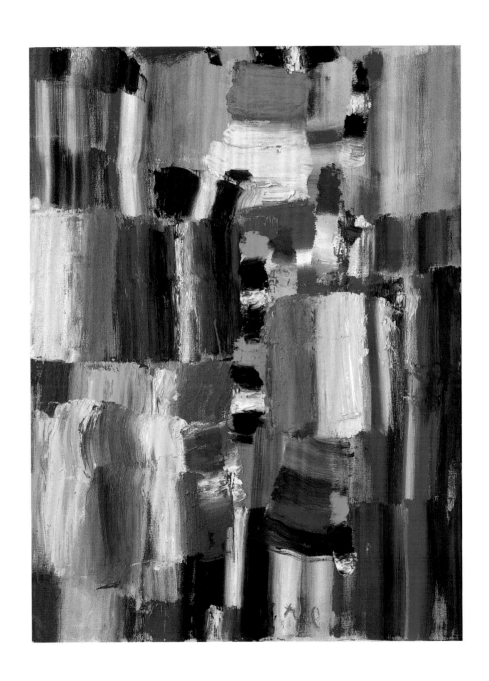

2.
Untitled, c. 1959
Oil on canvas
81.5 × 61.3 cm (32 ¹⁄₁₆ × 24 ⅛ in.)
Private collection

3.
Untitled, c. 1960
Oil on canvas
60.3 × 50.8 cm (23 ¾ × 20 in.)
Private collection

4.
Brushstroke with Still Life IV, 1996
Oil and Magna on canvas
86.4 × 71.1 cm (34 × 28 in.)
Private collection

5.
Brushstroke Abstraction I, 1996
Oil and Magna on canvas
66 × 81.3 cm (26 × 32 in.)
Private collection

6.
Brushstroke Abstraction II, 1996
Oil and Magna on canvas
76.2 × 68.6 cm (30 × 27 in.)
Private collection

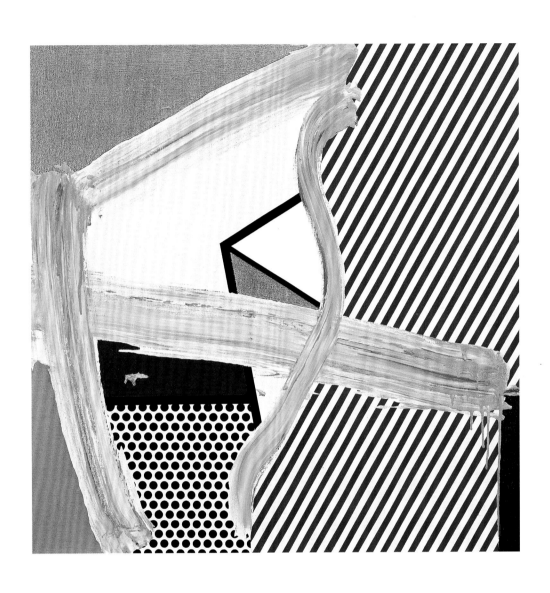

7.
Brushstroke with Still Life VII, 1996
Oil and Magna on canvas
76.2 × 76.2 cm (30 × 30 in.)
Lenhardt Collection, Arizona

EARLY POP

1961–1963

8.
Look Mickey, 1961
Oil on canvas
121.9 × 175.3 cm (48 × 69 in.)
National Gallery of Art, Washington,
Dorothy and Roy Lichtenstein,
Gift of the Artist, in Honor of the Fiftieth
Anniversary of the National Gallery of Art

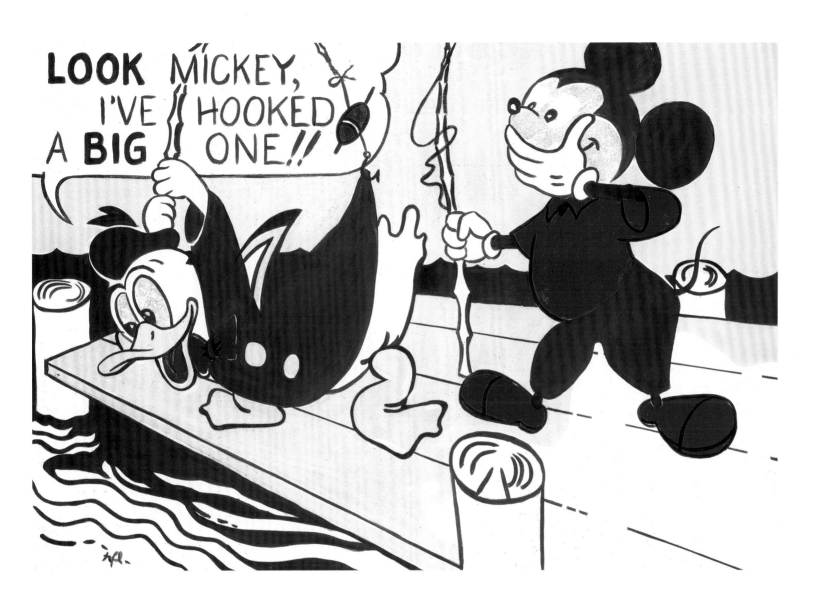

9.
Washing Machine, 1961
Oil on canvas
141.6 × 172.7 cm (55 ¾ × 68 in.)
Yale University Art Gallery,
Gift of Richard Brown Baker, B.A. 1935

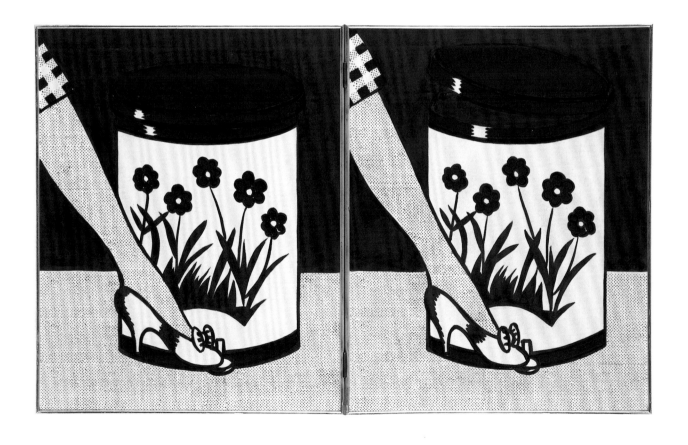

10.
Step-on Can with Leg, 1961
Oil on canvas
Two panels; each 82.6 × 67.3 cm (32 ½ × 26 ½ in.)
Fondation Louis Vuitton pour la Création

11.
Keds, 1961
Oil on canvas
123.2 × 88.3 cm (48 ½ × 34 ¾ in.)
The Robert B. Mayer Family Collection,
Chicago, Illinois, USA

12.
The Ring (Engagement), 1962
Oil on canvas
121.9 × 177.8 cm (48 × 70 in.)
Stefan T. Edlis Collection

13.
Sponge, 1962
Oil on canvas
172.7 × 142.2 cm (68 × 56 in.)
Private collection

14.
Spray, 1962
Oil on canvas
91.5 × 173.5 cm (36 × 68 in.)
Staatsgalerie Stuttgart

15.
Cup of Coffee, 1961
Oil on canvas
51.1 × 40.6 cm (20 ⅛ × 16 in.)
The Roy Lichtenstein Foundation Collection

16.
Hot Dog with Mustard, 1963
Oil and Magna on canvas
45.7 × 121.9 cm (18 × 48 in.)
Aaron I. Fleischman

17.
Mustard on White, 1963
Magna on Plexiglas
80 × 94 × 5.1 cm (31 ½ × 37 × 2 in.)
Tate. Lent from a private collection, 1993

BLACK AND WHITE

1961–1966

BLACK AND WHITE

1961–1966

18.
Portable Radio, 1962
Oil on canvas, aluminum, and leather
43.8 × 50.8 cm (17 ¼ × 20 in.)
The Doris and Donald Fisher Collection,
San Francisco

19.
The Ring, 1962
Oil on canvas
45.7 × 45.7 cm (18 × 18 in.)
Collection Anstiss and Ronald Krueck,
promised gift to the Art Institute of Chicago

20.
Golf Ball, 1962
Oil on canvas
81.3 × 81.3 cm (32 × 32 in.)
Private collection

21.
Tire, 1962
Oil on canvas
172.7 × 142.2 cm (68 × 56 in.)
The Doris and Donald Fisher Collection,
San Francisco, and the Museum of
Modern Art, New York

22.
Desk Calendar, 1962
Oil on canvas
123.2 × 173.4 cm (48 ½ × 68 ¼ in.)
Museum of Contemporary Art,
Los Angeles, The Panza Collection

23.
Large Jewels, 1963
Oil and Magna on canvas
172.7 × 91.4 cm (68 × 36 in.)
Museum Ludwig Köln /Schenkung Ludwig

24.
Ball of Twine, 1963
Oil and Magna on canvas
101.6 × 91.4 cm (40 × 36 in.)
Courtesy Christie's

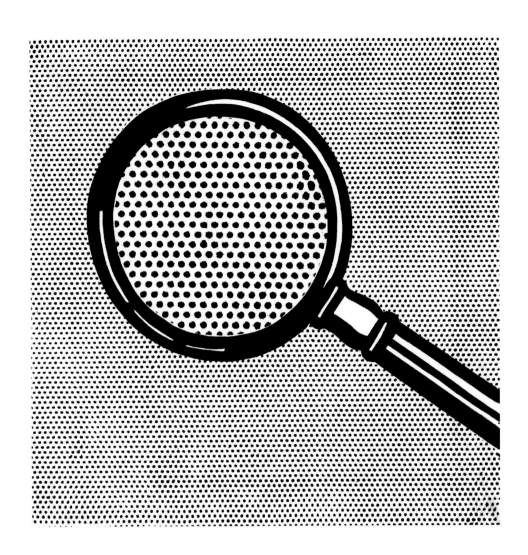

25.
Magnifying Glass, 1963
Oil on canvas
40.6 × 40.6 cm (16 × 16 in.)
Private collection

26.
Compositions I, 1964
Magna on canvas
172.7 × 147.3 cm (68 × 58 in.)
MMK Museum für Moderne Kunst,
Frankfurt am Main. Former Karl
Ströher Collection, Darmstadt

27.
Ceramic Sculpture 7, 1965
Glazed ceramic
24.1 × 22.9 × 17.8 cm (9 ½ × 9 × 7 in.)
Courtesy Mitchell-Innes & Nash

28.
Black and White Head, 1966
Glazed ceramic
38.1 × 19.1 × 20.3 cm (15 × 7 ½ × 8 in.)
Saint Louis Art Museum, Eliza McMillan Trust
and partial gift of Gerhard J. Petzall

29.
Masterpiece, 1962
Oil on canvas
137.2 × 137.2 cm (54 × 54 in.)
Agnes Gund Collection, New York

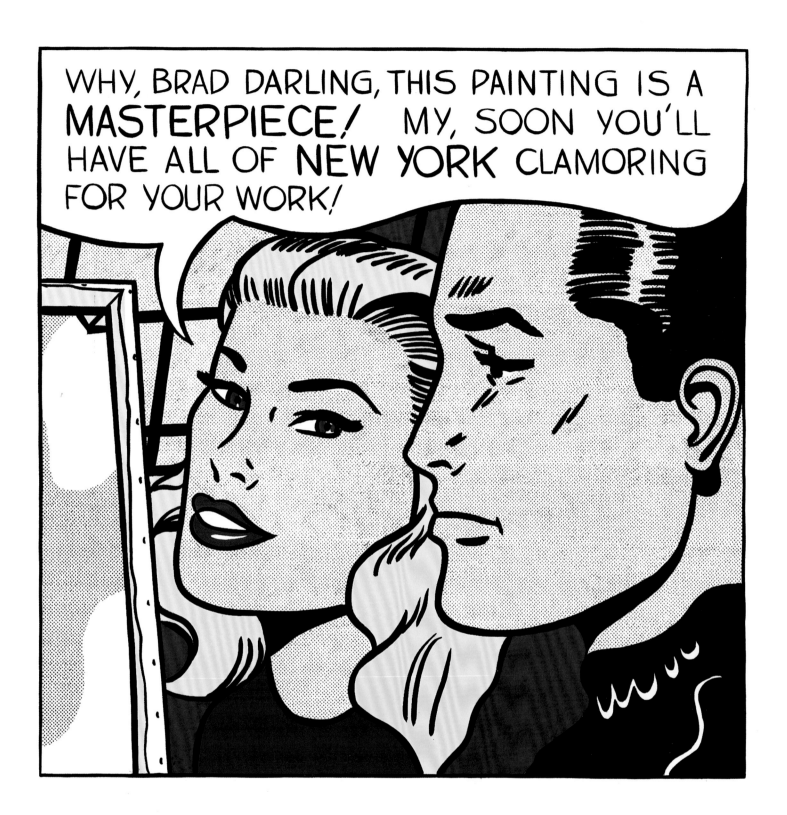

30.
Takka Takka, 1962
Oil and Magna on canvas
142.7 × 172.7 cm (56 × 68 in.)
Museum Ludwig Köln /Schenkung Ludwig

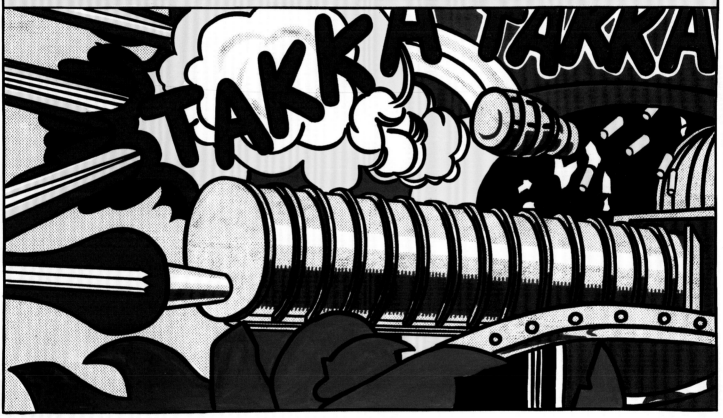

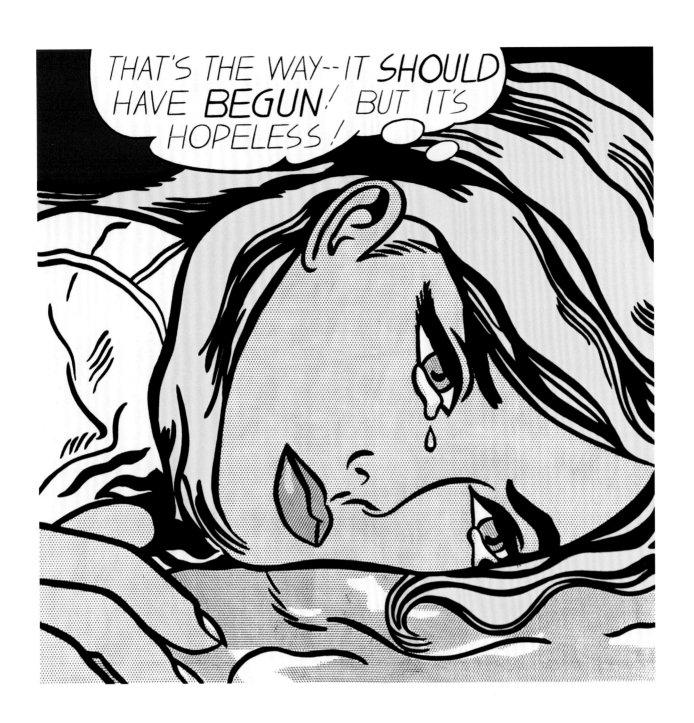

31.
Hopeless, 1963
Oil and Magna on canvas
111.8 × 111.8 cm (44 × 44 in.)
Kunstmuseum Basel, Depositum der Peter
und Irene Ludwig Stiftung, Aachen

32.
Drowning Girl, 1963
Oil and Magna on canvas
171.6 × 169.5 cm (67 ⅝ × 66 ¾ in.)
The Museum of Modern Art, New York,
Philip Johnson Fund (by exchange) and
gift of Mr. and Mrs. Bagley Wright, 1971

33.
Cold Shoulder, 1963
Oil and Magna on canvas
173.99 × 121.9 cm (68 ½ × 48 in.)
Los Angeles County Museum of Art,
gift of Robert H. Halff through the
Modern and Contemporary Art Council

34.
Torpedo . . . LOS!, 1963
Oil and Magna on canvas
172.7 × 203.2 cm (68 × 80 in.)
Collection Simonyi

35.
Bratatat!, 1962
Oil on canvas
116.8 × 86.4 cm (46 × 34 in.)
Collection Simonyi

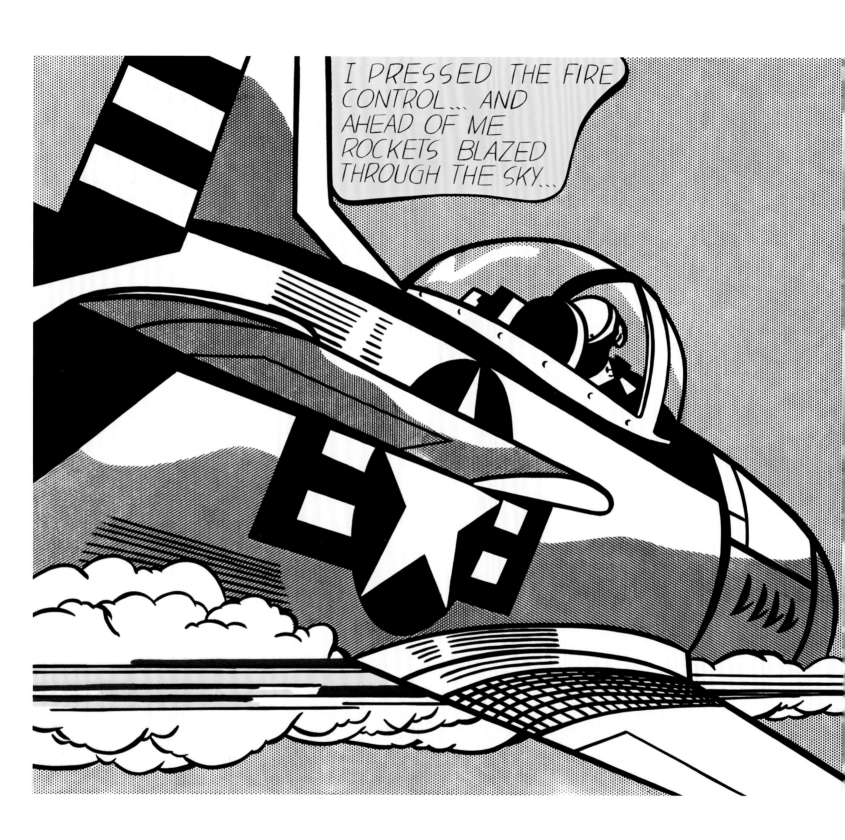

36.
Whaam!, 1963
Oil and Magna on canvas
Two panels; each 172.7 × 203.2 cm
(68 × 80 in.)
Tate. Purchased 1966

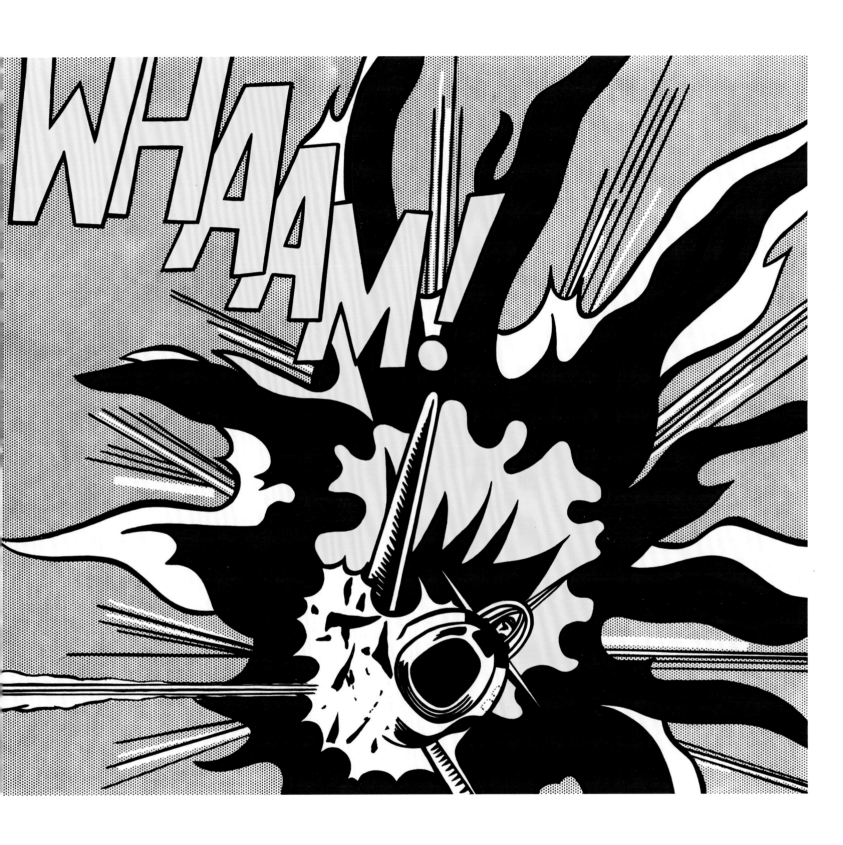

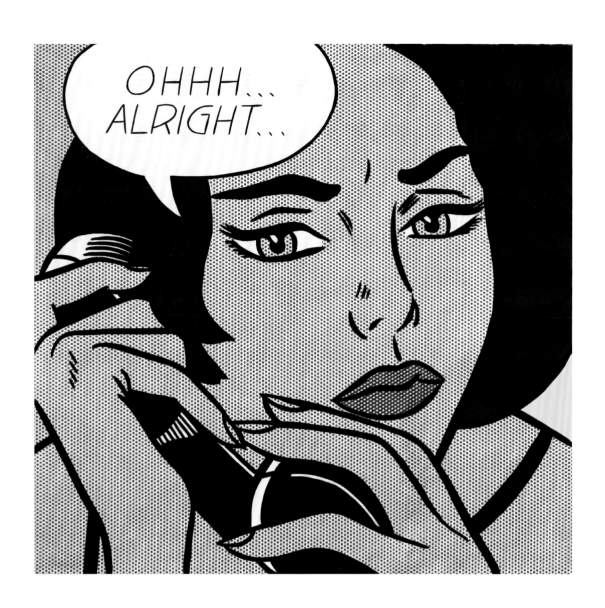

37.
Ohhh . . . Alright . . . , 1964
Oil and Magna on canvas
91.4 × 96.5 cm (36 × 38 in.)
Private collection

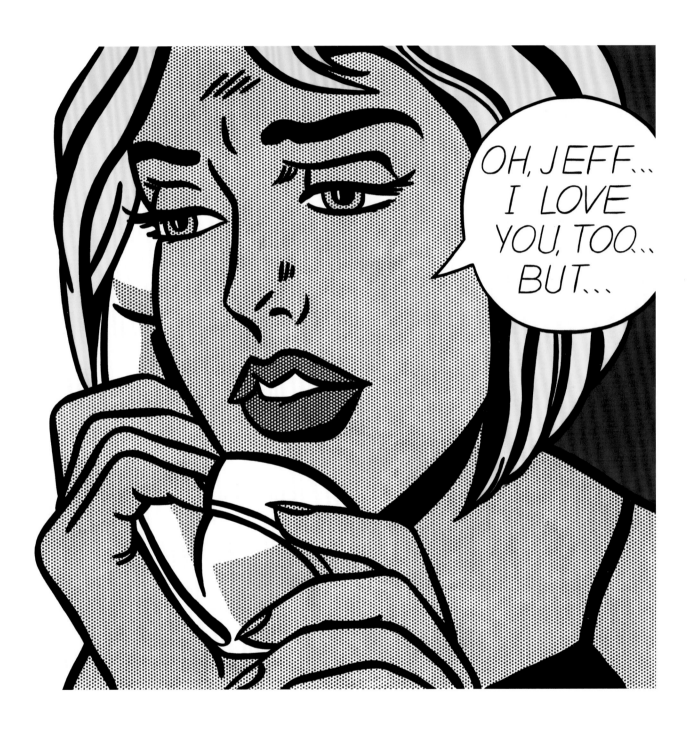

38.
Oh, Jeff . . . I Love You, Too . . .
But . . . , 1964
Oil and Magna on canvas
121.9 × 121.9 cm (48 × 48 in.)
Collection Simonyi

39.
We Rose Up Slowly, 1964
Oil and Magna on canvas
Two panels; 174.5 × 62.3 cm (69 × 25 in.);
174.5 × 234.5 cm (69 × 92 in.);
MMK Museum für Moderne Kunst, Frankfurt am
Main. Former Karl Ströher Collection, Darmstadt

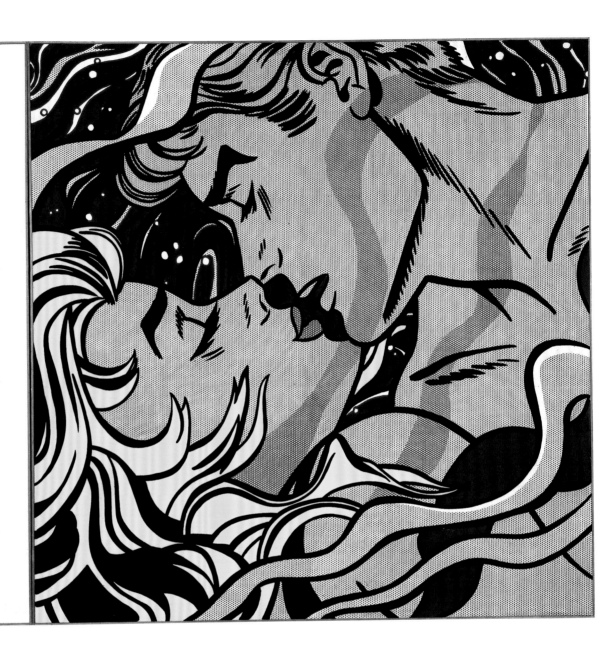

40.
As I Opened Fire, **1964**
Oil and Magna on canvas
Three panels; each 172.7 × 142.2 cm
(68 × 56 in.)
Stedelijk Museum, Amsterdam

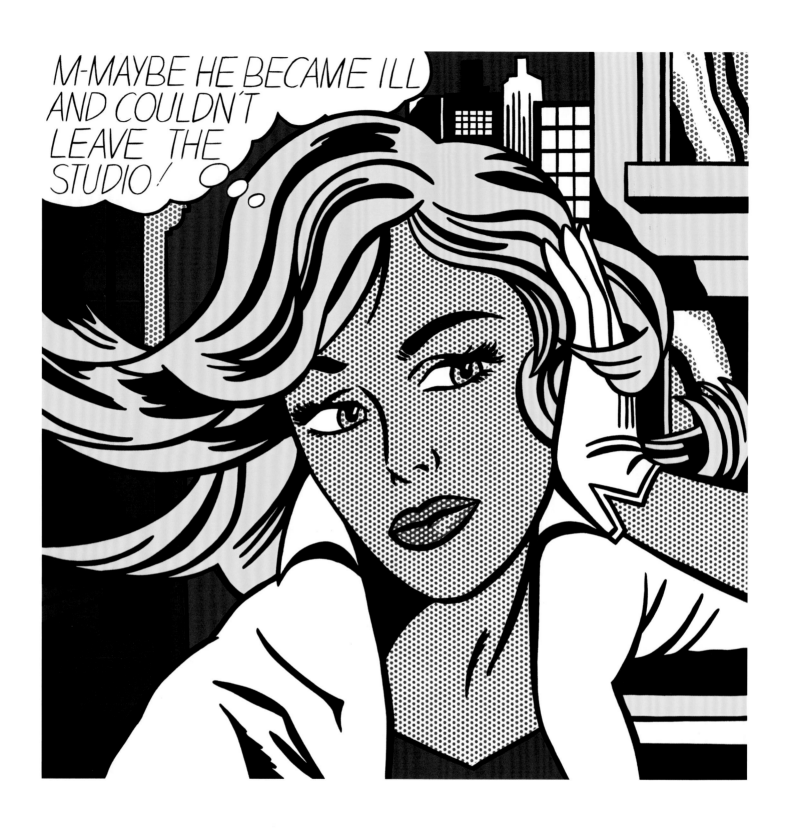

41.
M-Maybe, 1965
Oil and Magna on canvas
152.4 × 152.4 cm (60 × 60 in.)
Museum Ludwig Köln / Schenkung Ludwig

42.
Head with Blue Shadow, 1965
Glazed ceramic
38.1 × 21 × 20.3 cm (15 × 8 ¼ × 8 in.)
Raymond and Patsy Nasher Collection,
Nasher Sculpture Center, Dallas

BRUSHSTROKES

1965 – 1971

EXPLOSIONS

1963 – 1968

43.
Explosion, 1965
Oil and Magna on canvas
142.2 × 121.9 cm (56 × 48 in.)
Private collection

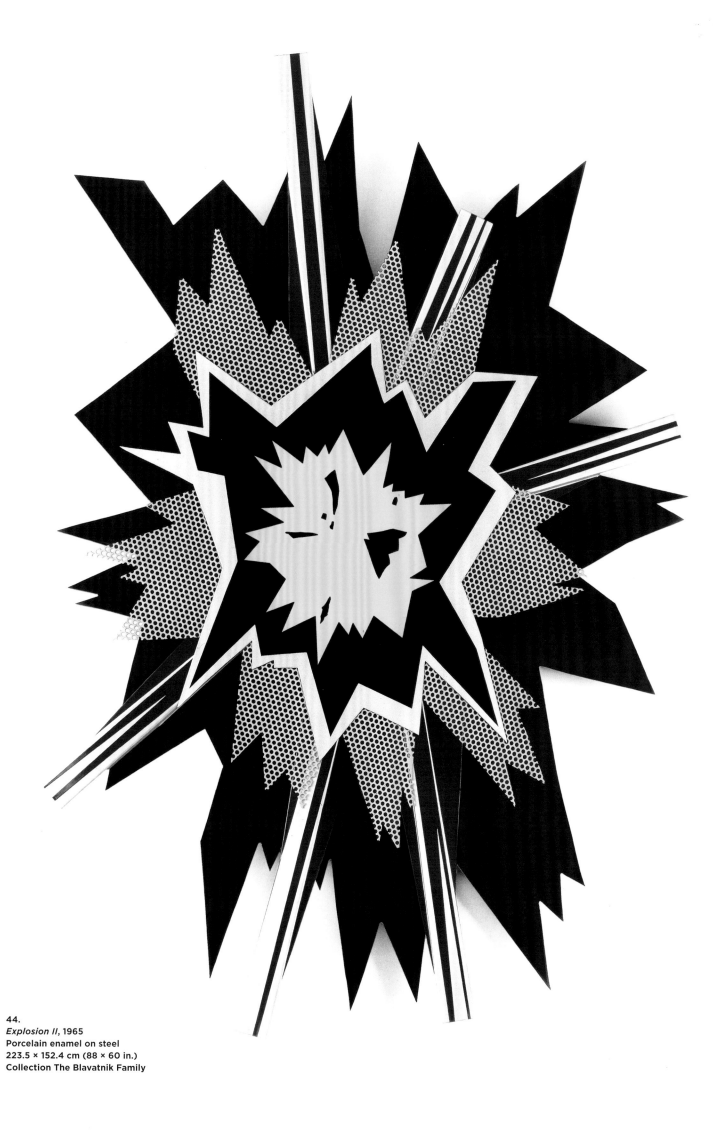

44.
Explosion II, 1965
Porcelain enamel on steel
223.5 × 152.4 cm (88 × 60 in.)
Collection The Blavatnik Family

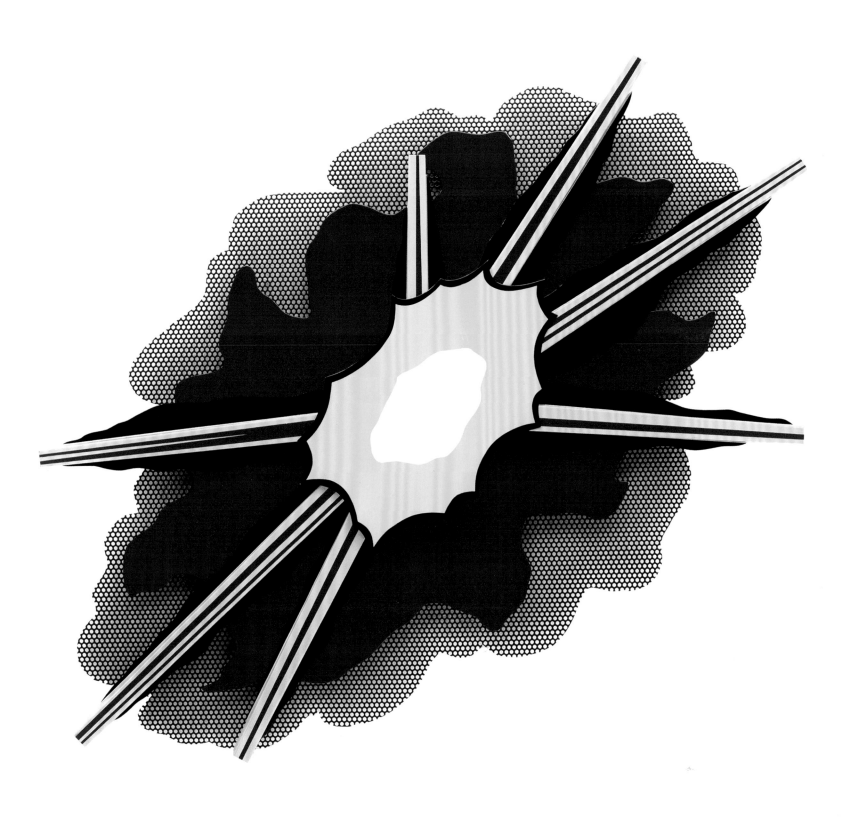

45.
Wall Explosion II, 1965
Porcelain enamel on steel
170.2 × 188 × 10.2 cm (67 × 74 × 4 in.)
Tate. Purchased 1980

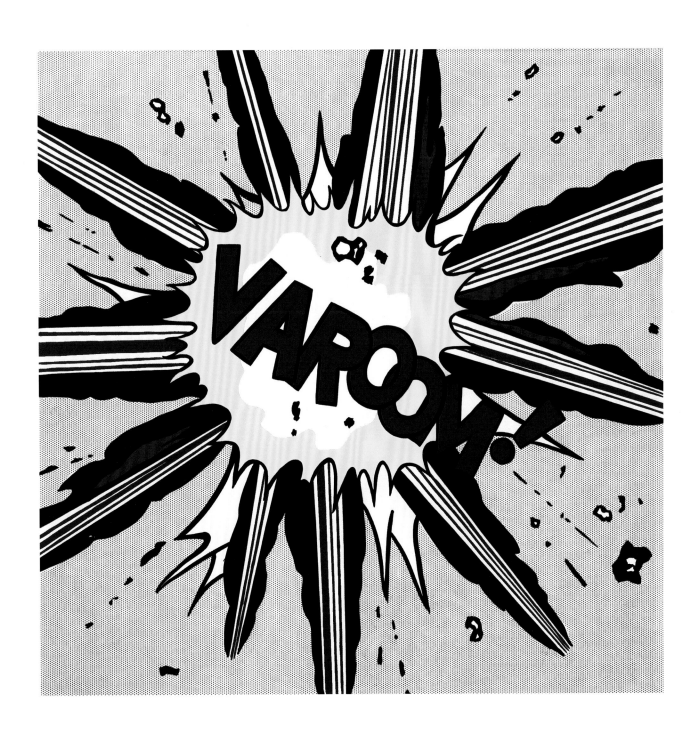

46.
Varoom!, 1963
Oil and Magna on canvas
142.2 × 142.2 cm (56 × 56 in.)
Ryobi Foundation

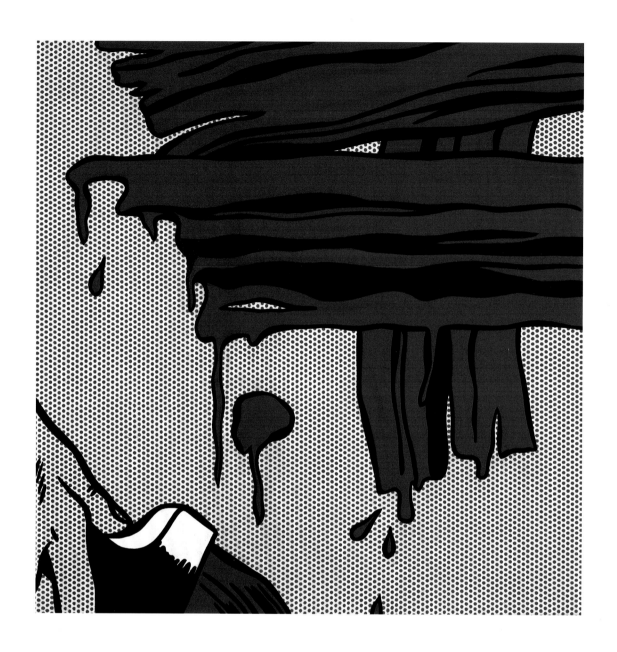

47.
Brushstrokes, 1965
Oil and Magna on canvas
122.5 × 122.5 cm (48 ¼ × 48 ¼ in.)
Private collection

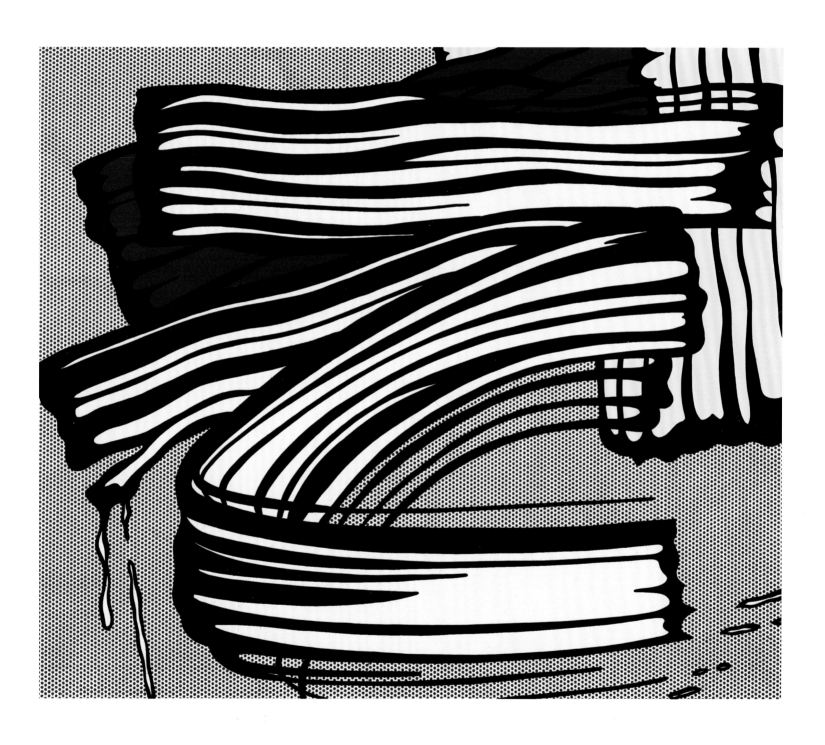

48.
Little Big Painting, 1965
Oil and Magna on canvas
172.7 × 203.2 cm (68 × 80 in.)
Whitney Museum of American Art,
New York, purchase, with funds from
the Friends of the Whitney Museum
of American Art

49.
Brushstroke with Spatter, 1966
Oil and Magna on canvas
172.7 × 203.2 cm (68 × 80 in.)
The Art Institute of Chicago,
Barbara Neff Smith and Solomon
Byron Smith Purchase Fund

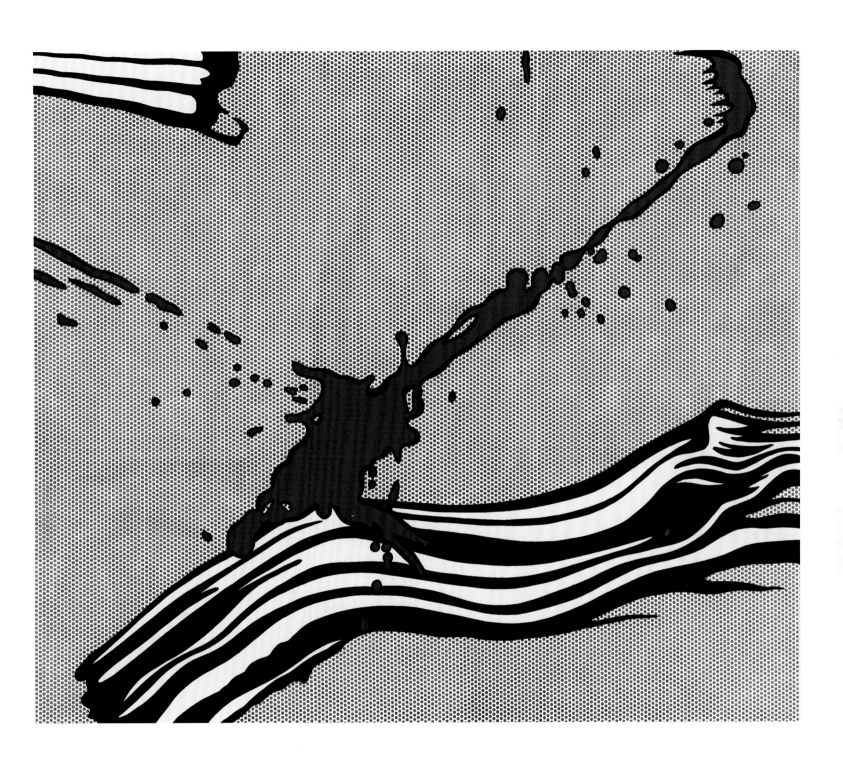

LANDSCAPES

1964 – 1967

50.
Sunrise, 1965
Oil and Magna on canvas
91.4 × 172.7 cm (36 × 68 in.)
Private collection

51.
Seascape, 1964
Oil on canvas
76.2 × 91.4 cm (30 × 36 in.)
Private collection

52.
White Cloud, 1964
Oil and Magna on canvas
172.7 × 203.2 cm (68 × 80 in.)
Irving Blum

53.
Perforated Seascape #1 (Blue), 1965
Porcelain enamel on steel
72.4 × 107.7 cm (28 ½ × 42 in.)
Aaron I. Fleischman

54.
Sunset, 1964
Oil and Magna on canvas
50.8 × 61 cm (20 × 24 in.)
Private collection, courtesy
Mitchell-Innes & Nash

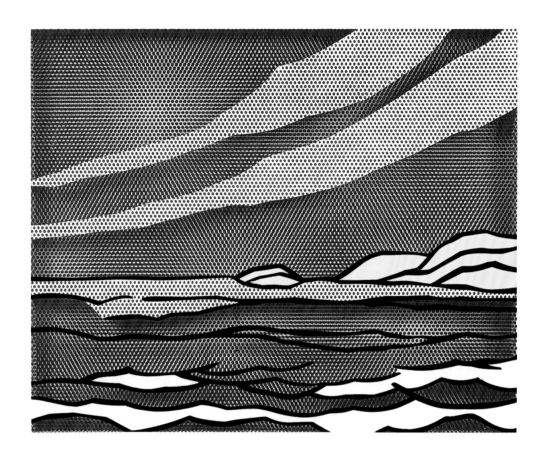

55.
Sea Shore, 1964
Oil and Magna on Plexiglas
61 × 76.2 cm (24 × 30 in.)
Private collection

56.
Seascape, c. 1965
Oil and Magna on canvas
172.7 × 121.9 cm (68 × 48 in.)
Private collection

57.
Seascape, 1965
Rowlux and cut-and-pasted
painted paper on board
75.1 × 55.6 cm (29 ⁹⁄₁₆ × 21 ⅞ in.)
Private collection

58.
Pink Seascape, 1965
Rowlux and cut-and-pasted
painted paper on board
71.1 × 54.6 cm (28 × 21 ½ in.)
Private collection, courtesy
Matthew Marks Gallery, New York

59.
Seascape, 1964
Oil and Magna on canvas
121.9 × 172.7 cm (48 × 68 in.)
Collection Viktor and Marianne Langen

60.
Three Landscapes, c. 1970–71, detail
Three-screen 35 mm film installation
transferred to video, color, silent;
one minute looped
Private collection

61.
Washington Crossing the Delaware I, c. 1951
Oil on canvas
66 × 81.3 cm (26 × 32 in.)
The Roy Lichtenstein Foundation Collection

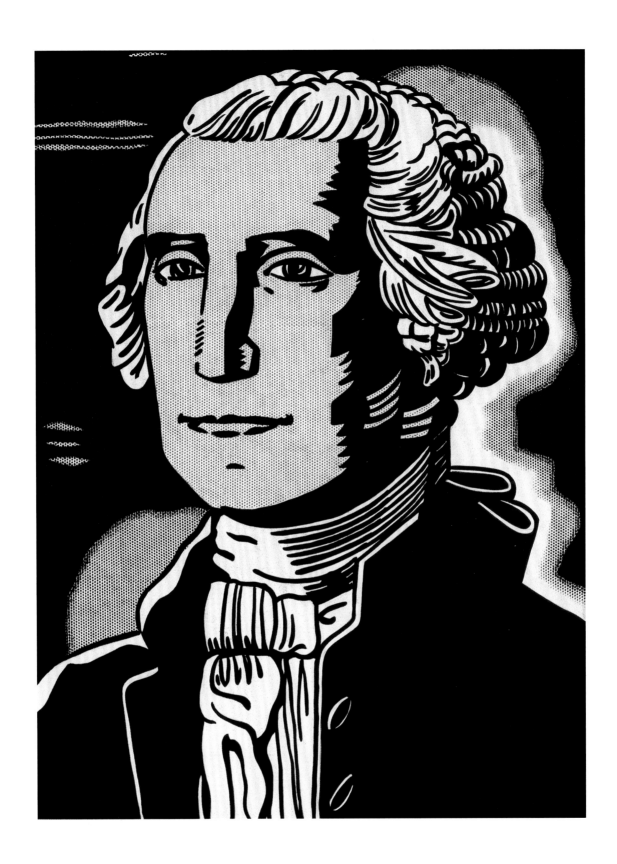

62.
George Washington, 1962
Oil and Magna on canvas
129.5 × 96.5 cm (51 × 38 in.)
Private collection

63.
Portrait of Madame Cézanne, 1962
Magna on canvas
172.7 × 142.2 cm (68 × 56 in.)
Jason Blum

64.
Femme d'Alger, 1963
Oil on canvas
203.2 × 172.7 cm (80 × 68 in.)
The Eli and Edythe L. Broad Collection,
Los Angeles

65.
Non-Objective I, 1964
Oil and Magna on canvas
142.9 × 121.9 cm (56 ¼ × 48 in.)
The Eli and Edythe L. Broad Collection,
Los Angeles

66.
Still Life with Goldfish, 1972
Oil and Magna on canvas
132.1 × 106.7 cm (52 × 42 in.)
Private collection

67.
Haystack, 1969
Oil and Magna on canvas
45.7 × 61 cm (18 × 24 in.)
The Ruben Family

68.
Haystacks, 1969
Oil and Magna on canvas
40.6 × 61 cm (16 × 24 in.)
The Ruben Family

69.
Rouen Cathedral, Set 5, 1969
Oil and Magna on canvas
Three panels; each 160 × 106.7 cm (63 × 42 in.);
overall 160 × 355.6 cm (63 × 140 in.)
San Francisco Museum of Modern Art,
Gift of Harry W. and Mary Margaret Anderson

70.
Grapes, 1972
Oil and Magna on canvas
55.9 × 71.1 cm (22 × 28 in.)
Aaron I. Fleischman

71.
Still Life with Glass and Peeled Lemon, 1972
Oil and Magna on canvas
106.7 × 121.9 cm (42 × 48 in.)
The Helman Collection

72.
Unfurled (after Morris Louis), 1973
Magna on canvas
76.2 × 91.4 cm (30 × 36 in.)
Private collection

73.
The Atom, 1975
Oil and Magna on canvas
106.7 × 91.4 cm (42 × 36 in.)
Private collection

74.
Purist Painting with Pitcher,
Glass and Classical Column, 1975
Oil and Magna on canvas
152.4 × 101.6 cm (60 × 40 in.)
Private collection

76.
Little Landscape, 1979
Oil and Magna on canvas
91.4 × 121.9 cm (36 × 48 in.)
Private collection

77.
Frolic, 1977
Oil and Magna on canvas
203.2 × 167.6 cm (80 × 66 in.)
Courtesy Gagosian Gallery

78.
Landscape with Figures and Rainbow, 1980
Oil and Magna on canvas
213.4 × 304.8 cm (84 × 120 in.)
Museum Ludwig Köln /Schenkung Ludwig

79.
Amerind Figure, 1981
Patinated bronze
166.4 × 52.1 × 34.3 cm (65 ½ × 20 ½ × 13 ½ in.)
Edition three of three
Private collection

80.
Archaic Head VI, 1988
Patinated bronze
148.6 × 47.6 × 25.4 cm (58 ½ × 18 ¾ × 10 in.)
Artist's proof from edition of six
Private collection

81.
Woman III, 1982
Oil and Magna on canvas
203.2 × 142.2 cm (80 × 56 in.)
Stefan T. Edlis Collection

82.
Sleeping Muse, 1983
Patinated bronze
64.8 × 87 × 10.2 cm (25 ½ × 34 ¼ × 4 in.)
Edition three of six
Private collection

83.
Plus and Minus VI, 1988
Oil and Magna on canvas
127 × 96.5 cm (50 × 38 in.)
Private collection

84.
Laocoön, 1988
Oil and Magna on canvas
304.8 × 259.1 cm (120 × 102 in.)
Private collection

85.
Reflections on "Interior with Girl Drawing," 1990
Oil and Magna on canvas
191 × 274.3 cm (75 × 108 in.)
The Eli and Edythe L. Broad Collection,
Los Angeles

MODERN

1966 – 1971

87.
Modern Sculpture, 1967
Brass and mirror
182.9 × 78.7 × 52.1 cm (72 × 31 × 20 ½ in.)
San Francisco Museum of Modern Art,
Bequest of Marcia Simon Weisman

88.
Modern Painting Triptych, 1967
Oil and Magna on canvas
91.4 × 274.3 cm (36 × 108 in.)
Collection Neil G. Bluhm

89.
Modern Painting with Division, 1967
Oil and Magna on canvas
106.7 × 213.4 cm (42 × 84 in.)
Cari and Michael J. Sacks

90.
Modern Sculpture with Glass Wave, 1967
Brass and glass
231.8 × 73.8 × 70.1 cm (91 ¼ × 29 × 28 in.)
Edition one of three
The Museum of Modern Art, New York,
Gift of Mr. and Mrs. Richard L. Selle, 1976

91.
Modern Painting with Bolt, 1967
Oil and Magna on canvas
173.2 × 173.5 cm (68 ¼ × 68 ⅜ in.)
The Museum of Modern Art, New York,
The Sidney and Harriet Janis Collection, 1967

92.
Modern Sculpture (Maquette), c. 1968
Brass
72.4 × 135.9 × 24.1 cm (28 ½ × 53 ½ × 9 ½ in.)
Detroit Institute of Arts, Gift of the artist

93.
Modern Sculpture with Velvet Rope, 1968
Brass and velvet rope
Two parts, 211.5 × 66 × 38.1 and 149.9 × 63.5 ×
38.1 cm (83 ¼ × 26 × 15 and 59 × 25 × 15 in.)
Edition three of three
Private collection

MIRRORS

1969 – 1972

94.
Mirror #1 (Oval 60″ × 48″), 1969
Oil and Magna on canvas
152.4 × 123.2 cm (60 × 48 ½ in.)
The Eli and Edythe L. Broad Collection,
Los Angeles

95.
Mirror #1 (Oval 48" × 32"), 1970
Oil and Magna on canvas
121.9 × 81.3 cm (48 × 32 in.)
Private collection

96.
Mirror #1 (48" Diameter), 1970
Oil and Magna on canvas
122.6 cm (48 ¼ in.) diameter
Nancy and Robert Magoon

97.
Mirror #2 (Six Panels), 1970
Oil and Magna on canvas
243.8 × 274.3 cm (96 × 108 in.)
San Francisco Museum of Modern Art.
Gift of Harry W. and Mary Margaret Anderson

98.
Mirror #3 (Six Panels), 1971
Oil and Magna on canvas
304.8 × 335.3 cm (120 × 132 in.)
The Art Institute of Chicago, Anstiss
and Ronald Krueck Fund for
Contemporary Art, facilitated by the
Roy Lichtenstein Foundation

99.
Mirror #5 (36″ Diameter), 1971
Magna on canvas
91.4 cm (36 in.) diameter
Private collection

100.
Mirror #6 (36" Diameter), 1971
Oil and Magna on canvas
91.4 cm (36 in.) diameter
Private collection

101.
Self-Portrait, 1978
Oil and Magna on canvas
177.8 × 137.2 cm (70 × 54 in.)
Kravis Collection

ENTABLATURES

1971 – 1976

102.
Entablature #8, 1972
Oil and Magna on canvas
76.2 × 609.6 cm (30 × 240 in.)
Private collection

103.
Entablature, 1975
Oil, Magna, and sand with aluminum
powder and Magna medium on canvas
137.2 × 548.6 cm (54 × 216 in.)
Private collection

ARTIST'S STUDIOS
1973 – 1974

ARTIST'S STUDIOS
1973 – 1974

104.
Artist's Studio "Look Mickey," 1973
Oil, Magna, and sand with aluminum
powder and Magna medium on canvas
243.8 × 325.1 cm (96 × 128 in.)
Walker Art Center, Minneapolis,
Gift of Judy and Kenneth Dayton and
the T. B. Walker Foundation, 1981

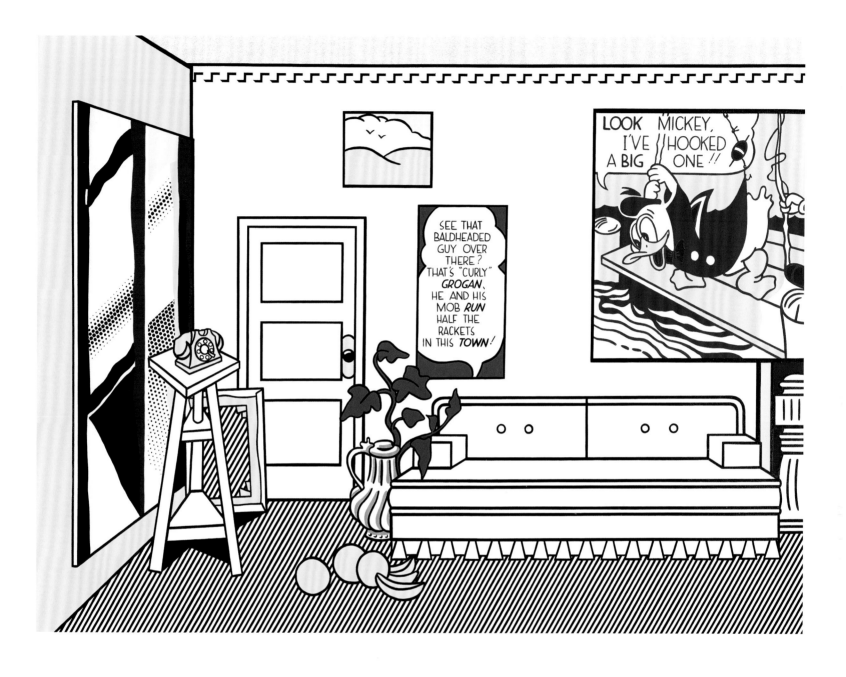

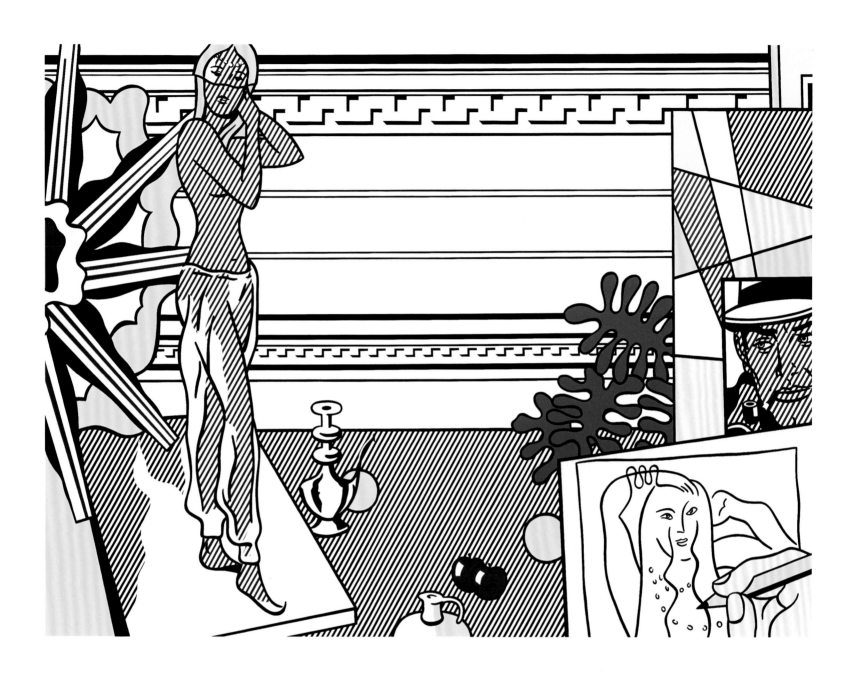

105.
Artist's Studio with Model, 1974
Oil and Magna on canvas
243.8 × 325.1 cm (96 × 128 in.)
Collection Irma and Norman Braman,
Miami, Florida

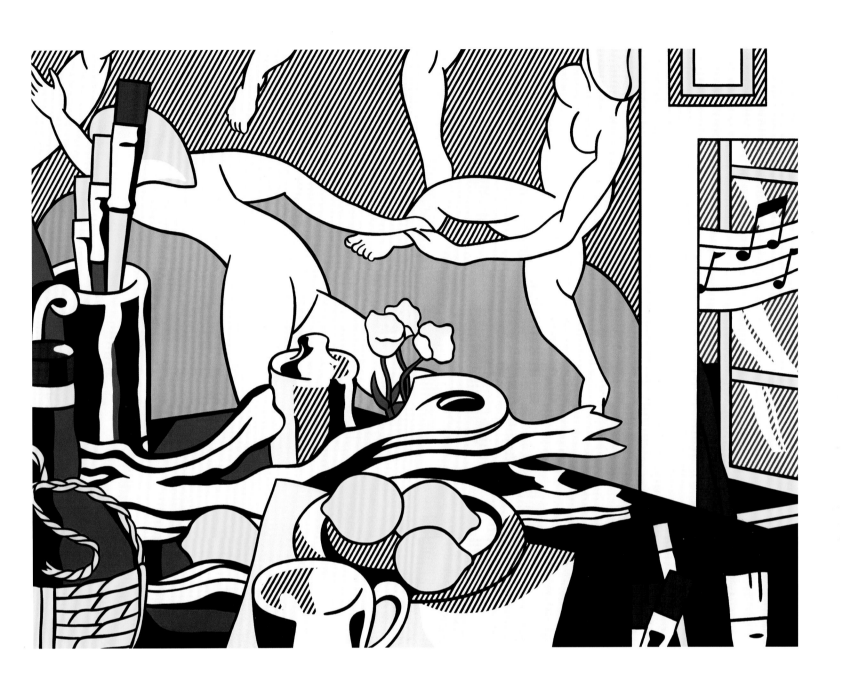

106.
Artist's Studio "The Dance," 1974
Oil and Magna on canvas
244.3 × 325.5 cm (96 ³/₁₆ × 128 ⅛ in.)
The Museum of Modern Art, New York,
Gift of Mr. and Mrs. S. I. Newhouse, Jr., 1990

107.
Artist's Studio "Foot Medication," 1974
Oil and Magna on canvas
243.8 × 325.1 (96 × 128 in.)
Stefan T. Edlis Collection

PERFECT / IMPERFECT

1978 – 1989

108.
Perfect Painting, 1978
Oil and Magna on canvas
101.6 × 127 cm (40 × 50 in.)
Private collection

109.
Perfect Painting, 1986
Oil and Magna on canvas
178.8 × 254.3 cm (70 ⅜ × 100 ⅛ in.)
The Broad Art Foundation, Santa Monica

110.
Imperfect Sculpture, 1995
Stained cast iron and painted stainless steel plates
78.1 × 88.3 × 12.7 cm (30 ¾ × 34 ¾ × 5 in.)
Edition three of six
Private collection

111.
Imperfect Painting, 1986
Oil and Magna on canvas,
228.6 × 157.5 cm (90 × 62 in.), irregular
Collection Kenneth and Judy Dayton

112.
Imperfect Painting (Gold), 1987
Oil and Magna on canvas
Two panels; overall 161.6 × 275 cm
(63 ⅝ × 108 ¼ in.), irregular
Private collection

NUDES

1994 – 1997

113.
Blue Nude, 1995
Oil and Magna on canvas
205.7 × 152.4 cm (81 × 60 in.)
Private collection

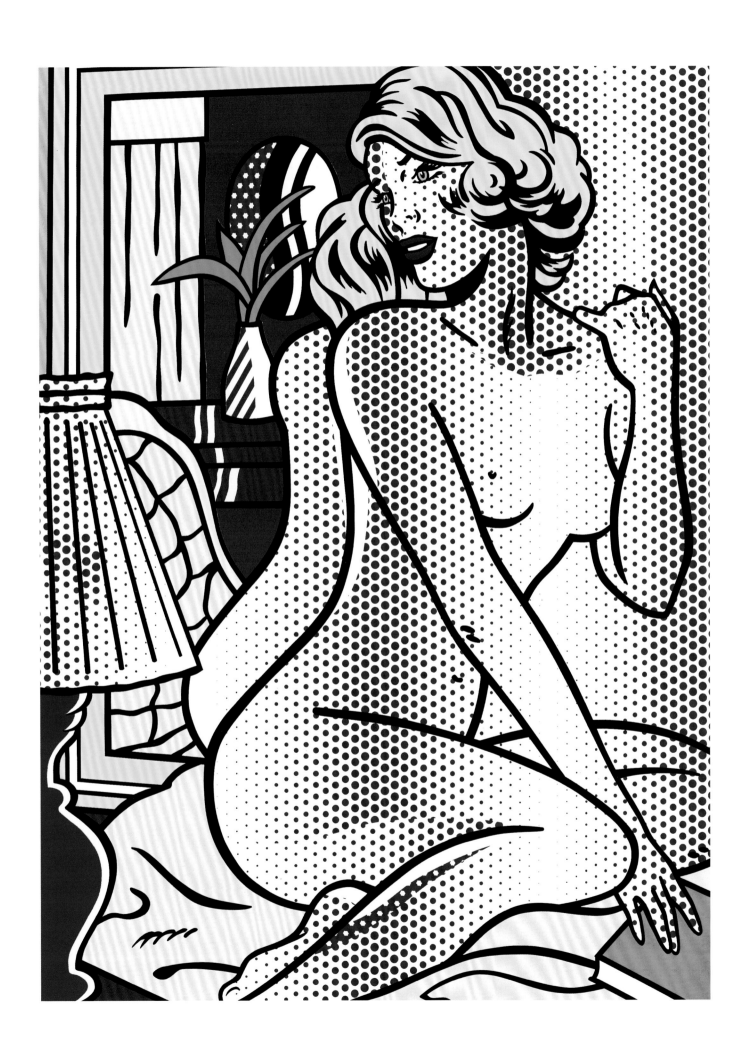

114.
Galatea, 1990
Painted and patinated bronze
226.1 × 81.3 × 48.3 cm (89 × 32 × 19 in.)
Edition one of six
Private collection

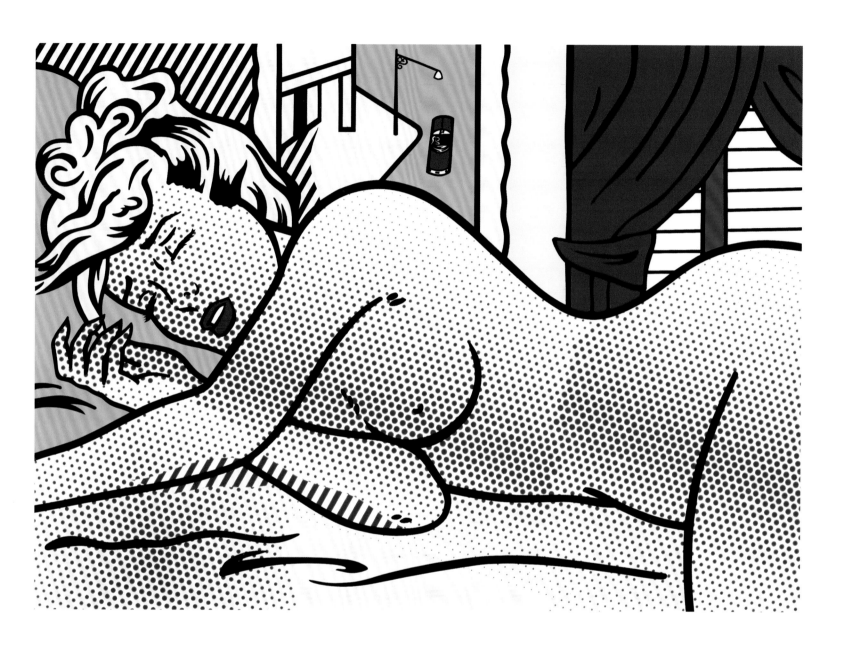

115.
Nude with Street Scene, 1995
Oil on Magna on canvas
121.9 × 171.5 cm (48 × 67 ½ in.)
Collection Simonyi

116.
Two Nudes, 1995
Oil and Magna on canvas
205.7 × 302.3 cm (81 × 119 in.)
Collection Simonyi

117.
Nudes with Beach Ball, 1994
Oil and Magna on canvas
301 × 272.4 cm (118 ½ × 107 ¼ in.)
Private collection

118.
Woman: Sunlight, Moonlight, 1996
(recto and verso)
Painted and patinated bronze
104.1 × 64.1 × 34.9 cm (41 × 25 ¼ × 13 ¾ in.)
Edition one of six
Private collection

119.
Nude with Bust, 1995
Oil and Magna on canvas
274.3 × 228.6 cm (108 × 90 in.)
Private collection

120.
Interior with Nude Leaving, 1997
Oil and Mineral Spirits Acrylic (MSA)
on canvas
177.8 × 180.3 cm (70 × 71 in.)
Private collection

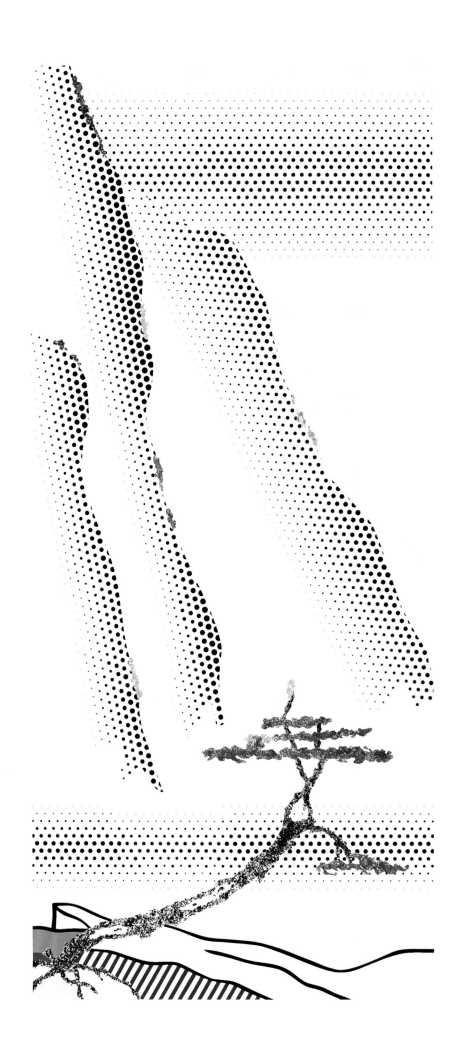

121.
Yellow Cliffs, 1996
Oil and Magna on canvas
276.2 × 123.8 cm (108 ¾ × 48 ¾ in.)
The Pace Gallery

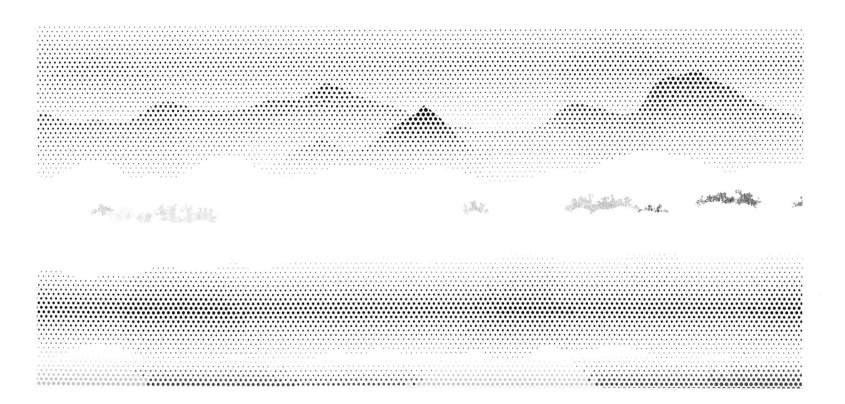

122.
Treetops through the Fog, 1996
Oil and Magna on canvas
177.8 × 391.2 cm (70 × 154 in.)
Private collection

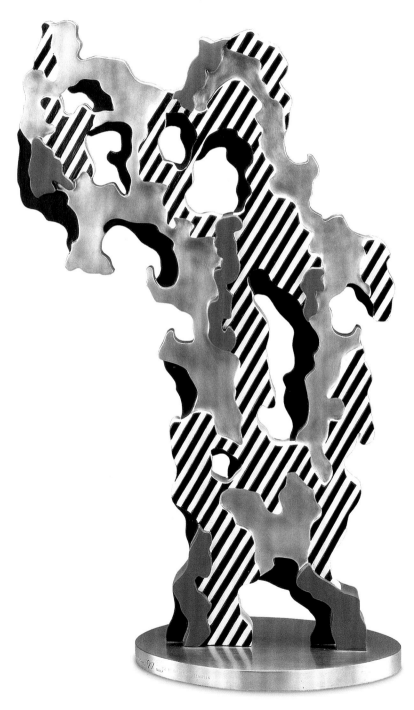

123.
Scholar's Rock, 1996–97
Cast and painted stainless steel
71.1 × 43.5 × 22.2 cm (28 × 17 ⅛ × 8 ¾ in.)
Artist's proof from edition of six
Private collection

124.
Landscape with Philosopher, 1996
Oil and Magna on canvas
264.2 × 121.3 cm (104 × 47 ¾ in.)
Private collection

125.
Landscape with Boat, 1996
Oil and Magna on canvas
149.2 × 244.5 cm (58 ¾ × 96 ¼ in.)
Private collection

126.
Landscape in Fog, 1996
Oil and Magna on canvas
180.3 × 207.6 cm (71 × 81 ¾ in.)
Private collection

127.
The Last of the Buffalo (Study), 1950
Brush and india ink on paper
48.3 × 63.5 cm (19 × 25 in.)
Private collection

The Death of General Wolfe

128.
The Death of the General (Study), c. 1951
Charcoal on paper
48.3 × 63.5 cm (19 × 25 in.)
Private collection

129.
Donald Duck, 1958
Brush and india ink on paper
51 × 66.2 cm (20 ¹⁄₁₆ × 26 ¹⁄₁₆ in.)
Private collection

130.
Mickey Mouse I, 1958
Pastel and india ink on paper
48.6 × 63.5 cm (19 ⅛ × 25 in.)
Private collection

131.
Untitled, c. 1959
Gouache and watercolor on paper
48.6 × 63.2 cm (19 ⅛ × 24 ⅞ in.)
Private collection

132.
Baseball Manager (Study), c. 1963
Graphite pencil on tracing paper
15.2 × 11 cm (6 × 4 ⁵⁄₁₆ in.)
Private collection

133.
Crying Girl (Study), 1964
Graphite pencil and colored pencil on paper
14 × 14.6 cm (5 ½ × 5 ¾ in.)
Collection Barbara Bluhm-Kaul and Don Kaul,
Chicago, Illinois, USA

134.
Ohhh . . . Alright . . . (Study), 1964
Graphite pencil and colored pencil on paper
14.9 × 14.9 cm (5 ⅞ × 5 ⅞ in.)
Janet and Craig Duchossois

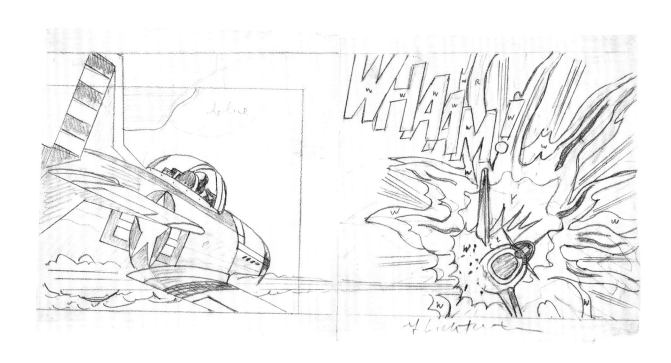

135.
Whaam! (Study), 1963
Graphite pencil on paper
14.9 × 30.5 cm (5 ¾ × 12 in.)
Tate. Presented by the artist 1969

136.
Untitled (Futurist Studies), c. 1975
Graphite pencil on paper
34.9 × 27.9 cm (13 ¾ × 11 in.)
Private collection

137.
Desk Explosion (Study), c. 1965
Graphite pencil on paper
27 × 21 cm (10 ⅝ × 8 ¼ in.)
Private collection

138.
Seascape with Clouds (Study), 1964
India ink and colored pencil on paper
9.2 × 14.1 cm (3 ⅝ × 5 ⁹⁄₁₆ in.), irregular
Private collection

139.
Alka Seltzer, 1966
Graphite pencil, pochoir, and
lithographic rubbing crayon on paper
76.2 × 55.9 cm (30 × 22 in.)
The Art Institute of Chicago,
Margaret Fisher Endowment

$8 \frac{3}{8} \times 14 \frac{7}{8}$ $38 \frac{1}{2}'' \times 68''$

140.
Pyramids II (Study), 1969
Graphite pencil and colored pencil on paper
26.7 × 41.9 cm (10 ½ × 16 ½ in.), irregular
Private collection

141.
Haystack and Haystacks (Studies), c. 1968
Graphite pencil, india ink, and
colored pencil on paper
152.5 × 112.7 cm (60 × 44 in.)
The Art Institute of Chicago,
Margaret Fisher Endowment

142.
Mirrors (Studies), 1970
Graphite pencil on paper
20.3 × 25.1 cm (8 × 9 ⅞ in.)
The Art Institute of Chicago,
gift of Dorothy Lichtenstein

143.
Mirror #3 (Six Panels) (Study), 1970
Graphite pencil and colored pencil on paper
29.1 × 40 cm (15 ⅜ × 15 ¾ in.)
The Art Institute of Chicago,
Margaret Fisher Endowment

144.
Portrait Triptych (Study), 1974
Two sheets, graphite pencil and colored pencil
on paper; one sheet, graphite pencil, colored
pencil, and cut-and-pasted paper on paper
Each sheet, 56.2 × 38.1 cm (23 ⅜ × 16 ⅜ in.)
Private collection

145.
Cape Cod Still Life (Study), 1972
Graphite pencil and colored pencil on paper
14.9 × 23 cm (5 ⅞ × 9 ¹⁄₁₆ in.)
Courtesy Mitchell-Innes & Nash

146.
The Red Horseman (Study), 1974
Graphite pencil and colored pencil on paper
52.4 × 60 cm (20 ⅝ × 23 ⅝ in.)
Courtesy Gagosian Gallery

Carlo Carrà "The Red Horseman" 1913

147.
Abstraction (Studies), 1975
Graphite pencil and colored pencil on paper
29.5 × 22.9 cm (11 ⅝ × 9 in.)
Private collection

148.
Entablatures (Studies), 1972
Graphite pencil on paper
19.1 × 27 cm (7 ½ × 10 ⅝ in.)
Private collection

149.
Entablatures (Studies), 1976
Graphite pencil, colored pencil,
and cut-and-pasted paper on paper
35.4 × 27.9 cm (13 ¹⁵⁄₁₆ × 11 in.)
Private collection

150.
Still Life with Attache Case (Studies), 1976 (recto)
Still Life with Coffee Pot (Studies), 1976 (verso)
Graphite pencil, ink, india ink, felt-tip marker,
colored pencil, and cut-and-pasted paper on paper
33.5 × 27.6 cm (13 ³⁄₁₆ × 10 ⁷⁄₈ in.)
Private collection

151.
Still Life with Locker, Bottle and Tray (Study), 1976
Felt-tip marker, ink, india ink, graphite pencil,
and colored pencil on paper
30.5 × 24.8 cm (12 × 9 ¾ in.)
Private collection

152.
Airplane (Study), 1977
Magna, india ink, and graphite pencil on board
37.6 × 76.7 cm (14 ¹³⁄₁₆ × 30 in.)
Private collection

153.
Art About Art Cover (Studies), 1978
Graphite pencil and colored pencil on paper
27 × 21.9 cm (10 ⅝ × 8 ⅝ in.)
Private collection

154.
Study of Hands (Study), 1980
Graphite pencil, colored pencil,
and cut-and-pasted paper on paper
26 × 17.9 cm (10 ¼ × 7 ¹⁄₁₆ in.), irregular
Private collection

155.
The Prisoner (Study), 1980
Graphite pencil and colored pencil on paper
26 × 17.8 cm (10 ¼ × 7 in.)
Private collection

156.
Forest Scene with Temple (Study), 1985
Graphite pencil and colored pencil on paper
23.5 × 29.7 cm (9 ¼ × 11 ¹¹⁄₁₆ in.)
Private collection

157.
Forest Scene (Study), 1980
Graphite pencil, colored pencil,
and gouache on paper
52.7 × 64.5 cm (20 ¾ × 25 ⅜ in.)
Jeffrey H. Loria, New York

158.
Mural with Blue Brushstroke (Study), c. 1984
Graphite pencil and colored pencil on
tracing paper
101.6 × 45.7 cm (40 × 18 in.), irregular
The Roy Lichtenstein Foundation Collection

159.
Reclining Nude in Brushstroke
Landscape (Study), 1986
Watercolor and graphite pencil on paper
27.6 × 35.6 cm (10 ⅞ × 14 in.)
Private collection

160.
Imperfect Paintings (Studies), 1987
Graphite pencil and colored pencil on
graph paper
27.8 × 21.6 cm (10 ¹⁵⁄₁₆ × 8 ½ in.)
Private collection

161.
Airplane (Study), 1989
Graphite pencil and colored pencil on paper
22.7 × 15.2 cm (8 ¹⁵⁄₁₆ × 6 in.), irregular
Private collection

162.
Virtual Flowers (Study), c. 1989
Ink pen on paper
15.2 × 10.2 cm (6 × 4 in.)
Private collection

163.
Reflections on Nancy (Study), 1989
Graphite pencil and colored pencil on paper
18.9 × 28.4 cm (7 ⁷⁄₁₆ × 11 ³⁄₁₆ in.)
Private collection

164.
Reflections on Brushstrokes (Study), 1989
Graphite pencil and colored pencil on paper
28.4 × 19.1 cm (11 ³⁄₁₆ × 7 ½ in.)
Private collection

165.
Interior with Bathroom (Study), 1992
Graphite pencil and colored pencil on paper
17.1 × 25.1 cm (6 ¾ × 9 ⅞ in.)
Private collection

166.
*Interior with House out the Window
(Study)*, 1997
Graphite pencil and colored pencil on paper
20.2 × 22.4 cm (7 ¹⁵⁄₁₆ × 8 ¹³⁄₁₆ in.)
Private collection

167.
Interior with Nude Leaving (Study), 1997
Graphite pencil and colored pencil on paper
20.3 × 22.2 cm (8 × 8 ¾ in.)
Janet and Craig Duchossois

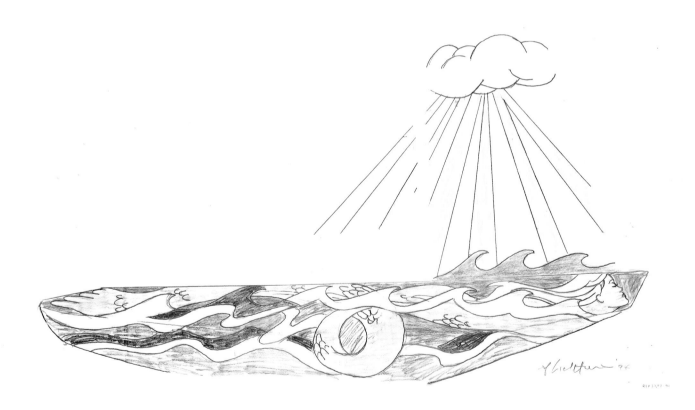

168.
Landscape with Rock and Chinese Style
Landscapes (Studies), 1996
Graphite pencil and colored pencil on paper
24.8 × 33.8 cm (9 ¾ × 13 ⁵⁄₁₆ in.)
Private collection

169.
Mermaid Sailboat (Study), 1994
Graphite pencil and colored pencil on vellum
33 × 66 cm (13 × 26 in.), irregular
Private collection

170.
*Interior with Painting of Reclining Nude
(Study)*, 1997
Magna and cut-and-pasted printed and
painted paper on board
101.9 × 153 cm (40 ⅛ × 60 ¼ in.)
The Roy Lichtenstein Foundation Collection

171.
Still Life with Reclining Nude (Study), 1997
Cut-and-pasted printed and painted paper
on board
101.9 × 153 cm (40 ⅛ × 60 ¼ in.)
The Roy Lichtenstein Foundation Collection

172.
Interior with Ajax (Study), 1997
**Cut-and-pasted painted and printed paper
on board
68.6 × 63.5 cm (27 × 25 in.)
Private collection**

CHRONOLOGY

CLARE BELL

CHRONOLOGY

CLARE BELL

Lichtenstein, age eleven, at Lake Buel, in Massachusetts, 1933. Photographer unknown. The Roy Lichtenstein Foundation Archives.

1923

OCT. 27 Roy Fox Lichtenstein is born in Manhattan to Milton (1893–1946) and Beatrice (née Werner; 1896–1991). Milton, a real-estate broker for Lichtenstein & Loeb and co-owner of Garage Realty, is a first-generation German Jewish American. Beatrice, a homemaker and gifted piano player, is of German Jewish descent. The family resides on the Upper West Side in New York.

1927

DEC. 17 Sister Renée is born.

1928

FALL Attends kindergarten near 104th Street and West End Avenue.

1931

FALL Begins first grade at P.S. 9. Develops a strong interest in drawing and science and later recalled spending time designing model airplanes. Frequently visits the American Museum of Natural History. Favorite radio shows include *The Shadow*, *Jack Armstrong*, *Flash Gordon*, and *Mandrake the Magician*.

1935

OCT. 10 George Gershwin's *Porgy and Bess* debuts at the Alvin Theater. Later makes pen-and-ink sketches of the show.

1936

FALL Starts eighth grade at Franklin School for Boys, a private school in Manhattan. Interest in art is piqued because Franklin offers no such instruction. During high school, studies French.

1937

Enrolls in Saturday morning watercolor classes at the New York School of Fine and Applied Art (now Parsons The New School for Design). Paints still lifes and flower arrangements using watercolor and opaque watercolor; also works directly from the model.

During high school, studies the clarinet and can play piano. With friend Don Wolf, visits jazz clubs. Forms a small band.

SUMMER Makes "romantic watercolors" of the forest trees and lake while at camp in Maine.

Receives first art book, Thomas Craven's *Modern Art: The Men, the Movements, the Meaning* (Simon and Schuster, 1934).

1938

JAN. 16 Attends Benny Goodman's first concert at Carnegie Hall. Begins doing renditions of jazz musicians.

1939

APR. 30 Opening of the 1939–40 World's Fair in Flushing Meadows, New York, whose theme is "Building the World of Tomorrow." Is a frequent visitor.

1940

JUNE Graduates from Franklin.

Lichtenstein with his sister, Renée, and his mother, Beatrice, in New York, c. 1939. Photographer unknown. The Roy Lichtenstein Foundation Archives.

JULY 1 – AUG. 9 Attends Reginald Marsh's painting class at the Art Students League. Learns to paint directly from the model. Studies anatomical drawing and Renaissance techniques such as glazing and underpainting, which he is encouraged to apply to quotidian subjects. Later recalls Marsh adding musculature and the like to his paintings. Feeling that Marsh's paintings have a "very brassy, commercial quality," is ultimately dissatisfied with the course's insistence on technique over process. In most paintings from the time, strives for exact representation of model.

SEPT. 23 Begins undergraduate degree at Ohio State University (OSU) in the College of Education. First art classes are Art Appreciation, taught by Frank Roos, and Advanced Freehand Drawing. Other classes include Education Survey, Field Artillery, and Botany. Pledges Phi Sigma Delta and moves into the fraternity house at 1968 Iuka Avenue in Columbus.

NOV. 7 – DEC. 8 Sees Picasso's masterwork *Guernica* (1937; Museo Nacional Centro de Arte Reina Sofía, Madrid) at the Cleveland Museum of Art, which is a venue for *Picasso: His Forty Years of Art*, organized by the Museum of Modern Art, New York (MoMA).

Paintings of the period include abstract works based on landscapes, still lifes, and figure studies.

1941

WINTER Classes include Elementary Design and Elementary Freehand Drawing, along with Field Artillery and Comprehension and Reading.

SPRING Takes Drawing from the Head, taught by Robert Gattrell, and Introduction to Literature, as well as continued classes in field artillery.

FALL Enrolls in History through the Ages, taught by Robert Fanning, a yearlong survey course of Western, Asian, and Indian art history. Textbook is *Art through the Ages* (Harcourt, Brace, 1926) by Helen Gardner.

Takes first drawing class taught by Hoyt Sherman, Drawing from Life. Learns about the concept of kinesthetic drawing, which is based on psychological optics. In 1945, Sherman realizes his "flash lab," a totally darkened room in which a tachistoscope projects slides of objects in quick succession. Students draw what they see based on the automatic recall of afterimages formed on their retinas. Does not experience Sherman's flash lab, but his idea of art—reflected in statements such as "Organized perception is what art is all about"—is deeply influenced by Sherman.

Moves to North High Street.

Picasso's Blue Period is a significant influence despite pervasiveness of Regionalism at OSU.

1942

WINTER Attends Intermediate Design with Roos, and Sculpture with Erwin Frey, where he works with Plasticine. Later recalls making a blue ceramic water buffalo sculpture. Other classes include Mechanical Drawing, economics, humanities, and the natural sciences.

Moves to student housing; creates oil painting of roommate's feet soaking in a basin. Among works admired at the time are Pablo Picasso's *Guernica* and Honoré Daumier's *The Third-Class Carriage* (c. 1862–64; the Metropolitan Museum of Art, New York).

SPRING Takes first class in oil painting, with James Grimes. Also takes Evolution of Design with Wayne Anderla.

SUMMER Enrolls in Portrait Painting with Grimes, Principles of Drawing, and Principles of Economics.

FALL Completes classes in drawing with Carolyn Bradley, as well as Principles of Advertising and Technical Problems.

Paintings are done primarily on paper or inexpensive chipboard. Uses big cans of soybean-based paint similar to water-based house paint. Begins to stretch own canvases.

1943

Paints *Untitled (Portrait of a Man)* (1943; private collection).

FEB. 6 Inducted into the U.S. Army. Enters active service three days later.

MAR. Begins basic training at Camp Hulen, Texas, an antiaircraft training base.

DEC. Enters Army Specialized Training Program in engineering at DePaul University, Chicago. Takes classes in math, chemistry, physics, geography, speech, and history; twenty-four weeks in, Army cancels program.

1944

APR. Arrives at Camp Shelby, Mississippi, and reports to 69th Infantry Division, Ninth Army headquarters. Serves as orderly to a two-star major general. Duties include enlarging William H. Mauldin cartoons in *Stars and Stripes* for commanding officer.

JUNE Works as draftsman and artist in G-3 (Plans and Training).

AUG. Draws maps in the Intelligence Section of the Engineers Battalion, 69th Infantry Division, Ninth Army.

Works from this period include black watercolor or charcoal drawings of the rugged terrain of Mississippi swamps.

DEC. Division is shipped to Europe. Boat has a library; there reads Edgar Allan Poe and philosophers such as Søren Kierkegaard and John Locke.

DEC. 14 In London, sees Paul Cézanne and Henri de Toulouse-Lautrec exhibitions. Buys a book on Chinese painting and sends it home in a duffle along with a collection of African masks.

Continues to draw in conté crayon, black ink, and ink wash on paper. Subjects include trees in London parks.

1945

JAN. Begins combat operations in France, working in an office a mile from the front. Does quite a bit of drawing in between Army tasks, which are related to maintaining roads and bridges. On a furlough to Paris, buys three portfolios of reproductions of Rembrandt etchings.

FEB. Arrives in Belgium.

APR. Writes home reporting only fair results with drawings and paintings in black and white tempera.

MAY 69th Infantry Division is the first to meet up with the Soviet Army. Awarded a battle-star ribbon although not directly involved in the fighting. Transferred to the Ninth Army. Continues combat operations in Germany.

Receives oil paints from home.

Sent to Oberammergau, a picturesque German town in the Bavarian Alps. There works at the Army's Information and Education School.

JULY Paints in gouache.

SEPT. Travels by rail to Paris on a three-day pass and visits the Louvre Museum. Remarks on El Greco's *Christ on the Cross Adored by Two Donors* (c. 1590; Musée du Louvre, Paris), Cézanne's *The Card Players* (1890–92; the Metropolitan Museum of Art, New York), and Daumier's *La blanchisseuse* (1863; Musée d'Orsay, Paris). At the Louvre bookshop, buys a small book on Fauvist Georges Rouault. In a letter home, writes of doing stacks of drawings and of intention to study painting, citing Picasso, Rouault, and Henri Matisse. Buys books on Francisco Goya's etching and Georges Seurat's paintings, even though he later remarked that he was not that inspired by latter's work.

Lichtenstein in Paris, Oct. 1945. Photographer unknown. The Roy Lichtenstein Foundation Archives.

OCT. 29 – DEC. 22 Accepted to Cité Universitaire, Paris, and begins French Language and Civilization course. Visits Chartres Cathedral. Contemplates studying with Fernand Léger, then teaching in Paris. Passes Picasso's studio on Rue des Grands-Augustins but decides not to intrude.

DEC. Reports home to Fort Dix, New Jersey, after learning that his father is very ill.

1946

JAN. Milton Lichtenstein dies on January 11. Is discharged from the Army and returns home. Regularly visits the Metropolitan Museum of Art and MoMA with mother and sister.

MAR. Returns to OSU to complete degree. Courses include History of Renaissance Art and Watercolor Painting.

JUNE Receives B.F.A. degree from OSU, College of Education, School of Fine and Applied Arts. Lives and works in a small room in a converted mess hall off campus.

SEPT. Joins OSU School of Fine and Applied Arts faculty as an instructor.

OCT. Teaches drawing and design courses. Creates own version of a flash lab, stacking boxes in a darkened room and asking students to draw the afterimage using charcoal or crayon on paper.

Creates stonelike sculptures from Hydrocal, a castable plaster product. Figures have Picassoesque features but seem almost pre-Columbian in style. Begins to paint abstractly in the style of Piet Mondrian, using similar shapes but a different palette; the paintings are later destroyed.

1947

JAN. Enrolls in the Graduate School of Fine and Applied Arts at OSU. Travels with Charles Csuri to see various art exhibitions in New York.

SPRING Classes include Technical Problems and Water Color Painting with Bradley.

Occasionally returns to New York with friends Stanley Twardowicz and Csuri to visit galleries, especially Charles Egan and Betty Parsons Galleries.

Paintings of this period depict bulbous figures with animated features. Continues to work in ceramic; details emulate Joan Miró. Found object pieces have a Paul Klee–like quality.

Buys a centrifuge casting machine to create silver jewelry using lost wax process. Buys a small electrical kiln for enameling.

FALL Enrolls in Advanced Research Problems and Research in Art History: Criticism and Philosophy of Art.

1948

FALL Classes include Art History Research and Criticism.

Produces pastels, oils, and drawings. Subjects include musicians, landscapes, and fairy tales.

Begins showing work at Ten-Thirty Gallery, located on the third floor of the State Theater Building in Cleveland. Algesa O'Sickey is one of the directors and is the wife of faculty colleague Joseph O'Sickey.

1949

JUNE 12 Marries Isabel Wilson (b. July 26, 1921; d. Sept. 25, 1980), a volunteer and then gallery assistant at Ten-Thirty Gallery whom he meets through the O'Sickeys earlier that year. She begins to paint after meeting him.

AUG. 1–31 Firs t group exhibition in New York, at Chinese Gallery (38 E. 57th St.), which shows American art along with classical Chinese art forms, including ceramics.

FALL Takes painting classes with Sherman and Grimes. Completes M.F.A. thesis, "Paintings, Drawings, and Pastels," which includes a series of poems celebrating various artists.

DEC. 12–30 Ten-Thirty Gallery exhibits twenty oils and pastels along with work by ceramists Harry Schulke and Charles Lakosky. Works are described as "flat abstracts with objects like animals, plants and faces being faintly recognizable."

Borrows book on nineteenth-century American painter George Catlin from colleague Roy Harvey Pearce. North American Indian themes begin to appear in paintings and drawings.

1950

Rents a two-story house at 1496 Perry Street in Columbus with Isabel, which doubles as a studio. Begins to use paint cans full of sand to counterbalance an old easel in order to rotate canvases. Uses a mirror to see paintings upside down to abstract the subject matter and concentrate on compositional unity.

SUMMER Takes Mural Painting; Research: Oil and Watercolor Painting; and final Technical Problems class.

JULY 28 Denied tenure at OSU due to lack of "substantial growth."

Giant beetles, flowers, and birds along with medieval imagery account for much of subject matter. Influenced by a friend's book on the Bayeux Tapestry.

Woodcut *To Battle* (1950; edition of ten) takes first prize at the Ohio State Fair.

Isabel finds work at Arts and Crafts, the interior design department of Tibbals-Crumley-Musson Architects; coordinates exhibitions of artisan jewelry and ceramics.

Regularly attends jazz to Philharmonic performances in Columbus. Teaches himself to play the flute.

1951

Starts to bring paintings to galleries in New York, such as M. Knoedler and Sidney Janis, transporting them on top of car.

MAR. 21–MAY 20 *To Battle* is exhibited in a Brooklyn Museum juried show, *Fifth National Print Annual Exhibition*, and receives a museum purchase award.

APR. 30–MAY 12 First solo exhibition in New York, at Carlebach Gallery (937 Third Ave.), which includes twenty oils and pastels; five prints rendered in muted pinks, blues, and mauves; and four assemblages made from wood found from packing crates, metal pieces, and found objects such as screws and drill buffers.

JUNE Moves to Cleveland and sets up home and studio on the second floor of the Music Center Building at 1150 Prospect Avenue, across from Gray's Armory. Isabel finds work as an assistant interior decorator at Jane L. Hanson, Inc. Paints an "early Renaissance"–style self-portrait.

Notebook is filled with cartoonlike drawings of things such as bananas.

AUG. *Knight on Horseback* (1951; private collection) takes first prize in sculpture at the Ohio State Fair.

In Columbus, Ohio, c. 1949.
Photographer unknown. The Roy Lichtenstein Foundation Archives.

Roy Lichtenstein. *To Battle,* 1950. Woodcut on brown kraft paper; sheet, 32.9 × 64.2 cm (12 ¹⁵⁄₁₆ × 25 ¼ in.); image, 28.3 × 58.5 cm (11 ⅛ × 23 ¹⁄₁₆ in.); edition of ten.

RECENT PAINTINGS BY

ROY F.

LICHTENSTEIN

January 26 – February 7, 1953

j o h n h e l l e r g a l l e r y
108 east 57 street · new york 22

Checklist announcement featuring *Emigrant Train—after William Ranney* (1951; private collection) for *Recent Paintings by Roy F. Lichtenstein, January 26–February 7, 1953*, John Heller Gallery, New York. The Roy Lichtenstein Foundation Archives.

Draws clowns and other fairground scenes in sketchbooks.

DEC. 2 Exhibits "colorful" silk-screen prints for the *Craftsman* Christmas exhibition of the Art Colony Galleries in Cleveland.

DEC. 31 – JAN. 12, 1952 Solo exhibition at John Heller Gallery in New York (108 E. 57th St.), consisting of sixteen paintings based on American frontier themes and several self-portraits as a knight. Sherman contributes a brief preface to the show's brochure. One painting in the show, *Death of the General* (1951; private collection, New Jersey), is reproduced in *Artnews* and *Art Digest*.

Shows jewelry at the Bertha Schaefer Gallery in New York (32 E. 57th St.).

Begins to incorporate titles and advertising copy in woodcut compositions and paintings such as *Emigrant Train—after William Ranney* (1951; private collection).

1952

MAR. 2 – 22 Solo exhibition of seventeen works (paintings, drawings, and prints) at the Art Colony Galleries. One pencil drawing, which includes a photo of a castle taped onto it, is described by a *Cleveland News* art critic as "truly like the doodling of a five-year-old." Is referred to as an "odd talent"; show elicits mixed responses.

FALL Contributes work to juried exhibitions, including Denver City Building (*Insect with Man* [1950; private collection]), the Pennsylvania Academy of the Fine Arts (*Hunter with Dog* [1951; edition of ten]), and the University of Nebraska (*A Cherokee Brave* [1952; edition of seventeen]). A charcoal of that year, study for *Two Indians* (1952; location unknown) is included in a show at the Metropolitan Museum of Art.

Decorates display windows and floors part-time at a Halle Brothers' Shaker Square department store.

1953

JAN. 26 – FEB. 7 Second solo exhibition at John Heller Gallery, consisting of oils and watercolors based on Americana themes. *The Statesman* (1951; private collection) is reproduced in *Artnews* (titled *The Diplomat*) in black-and-white and reviewed by Fairfield Porter.

SEPT. 20 – OCT. 5 Contributes work to the third season opening exhibition of the Art Colony Galleries.

NOV. Receives an award for woodcut *A Cherokee Brave* in the Contemporary Printmaking Exhibition at OSU.

Works from his apartment at 11483 Hessler Road in Cleveland. Audits classes at the Cleveland Institute of Art.

1954

Teaches drawing at the Cooper School, a commercial-art school in Cleveland.

MAR. 8 – 27 Third solo exhibition at John Heller Gallery, consisting of paintings on American folklore themes and others that feature depictions of clock and gear parts, based on engineering blueprints that echo *French's Engineering Drawing*, illustrated by Sherman. Some works include toys. Critics Robert Rosenblum and Porter review the show for *Art Digest* and *Artnews*, respectively.

OCT. 7 – 24 Included in Cleveland Museum of Art's show of "spontaneous and unrehearsed" drawings by local artists, although his works are consistently rejected for the museum's coveted invitational May show.

OCT. 9 Son David Hoyt Lichtenstein is born.

MID-1950s Creates mosaic tables for clients of Isabel, with welding done by a friend.

1955

JAN. 1 *Weatherford Surrenders to Jackson* (1953; private collection) is purchased by collectors and donated to the Butler Museum of American Art in Youngstown, Ohio.

JAN. 9 The Art Colony Galleries exhibits thirteen paintings in a three-person show that also includes Christine Miller and Louis Penfield. One critic describes paintings in the show as "Klee-like and surprising."

OCT. – NOV. Displays jewelry at the Brooklyn Museum Gallery Shop.

Creates several wall-mounted assemblages of painted wood.

Works on the "before" models of a low-income Cleveland neighborhood for a proposed renovation project designed by Robert Little and photographed by Margaret Bourke-White for *Life* magazine. One contribution is to paint graffiti in the miniature alley.

1956

Creates first proto-Pop work, a lithograph called *Ten Dollar Bill (Ten Dollars)* (1956; edition of twenty-five).

Returns to imagery of the Wild West.

MAR. 10 Son Mitchell Wilson Lichtenstein is born.

Exhibits works at the Wilbur Avenue Gallery in Cleveland, run by Jerry Weiss, which features crafts, graphics, and paintings.

Mechanism, Cross Section (1954; Flint Institute of Arts) is purchased by the same collectors who bought *Weatherford Surrenders to Jackson* and is donated to the Flint Institute of Arts.

1951 – 57

Works at various jobs in Cleveland, most lasting about six months each. Hand-paints black-and-white dial markings on volt and amp meters for Hickok Electrical Instrument Co. Teaches drawing to Dr. Karl Salus, a psychologist and friend, and to his young daughter Carol. Commissioned by Salus to paint Carol's portrait but is reluctant to sign the finished canvas. Travels frequently to New York. Introduced by Stanley Landesman to Herman Cherry and Warren Brandt.

1957

Buys first home at 2421 Edgehill Road in Cleveland Heights and sets up a studio there.

Works as an engineering draftsman making furniture in the Product and Process Department at Republic Steel Company.

JAN. 8 – 26 Solo exhibition at John Heller Gallery, consisting of paintings on Americana themes. Works described by critics as "acrid in color," "flatly patterned . . . spontaneously felt depictions of a grown-up's child-world."

FEB. Invited to exhibit with Group 5, an association of Cleveland artists who banded together in defiance of their omissions from the May show at the Cleveland Museum of Art. Lichtenstein shows several paintings and constructions.

MAY Shows lithographs at Karamu House, Cleveland, where different races, religions, and creeds practice dance, printmaking, theater, and writing.

SUMMER Accepts assistant professorship of art at State University of New York (SUNY) at Oswego to teach industrial design. Hoping to get closer to New York, accepts the position.

Moves home and studio to 11 W. Sixth Street in Oswego, where his family shares a two-family house.

Uses an opaque projector to trace a large image of Mickey Mouse on son Mitchell's bedroom wall.

Abstract Expressionist style appears in paintings, which include renderings of cartoon characters such as Mickey Mouse, Donald Duck, and Bugs Bunny. Later recalls that these canvases were used as drop cloths for first Pop-inspired works.

Lichtenstein with wife Isabel and sons David (left) and Mitchell (right) at their home on 52 Church Street in Oswego, New York, c. 1959. Photographer unknown.

1958

MAY Six oil paintings are among those Heller sends for an exhibition in Los Angeles.

JUNE Approaches Csuri's dealer in New York, Harry Salpeter, whose gallery is across from Heller's on 57th Street, about representation. Salpeter turns him down.

AUG. Teaches Industrial Art Design summer course at SUNY Oswego and graduate course in painting. Hosts salon-style open-house evenings for students.

Creates drawings based on Mickey Mouse and Donald Duck using brush and india ink.

1959

Moves with family to 52 Church Street in Oswego. Continues to teach Industrial Arts during the summer and graduate courses in painting.

MAR. – MID APR. Exhibits oil painting in *Sixth Annual Central Art Exhibition* at the Syracuse Museum of Fine Arts.

JUNE 2 – 27 Untitled abstractions are shown for the first time in a solo exhibition at Condon Riley Gallery in New York (24 E. 67th St.). Paintings feature scant traces of bright color on an unprimed background; some contain heavy impasto. Described as washy, waterish, abstract, thinly painted.

345

Beth Ann Simon, Lichtenstein, and Robert Watts at Douglass College art gallery, c. 1961.

1960

SPRING Resigns from SUNY Oswego after accepting assistant professorship of art at Douglass College, Rutgers, State University of New Jersey. Teaches Art Structure and Design and Advanced Design. Shares an office with Geoffrey Hendricks. Robert Miller, a future dealer, serves as his studio assistant.

Moves into a house at 66 S. Adelaide Avenue, Highland Park, New Jersey, where he sets up his studio in the bedroom. Bolts a two-by-four to the ceiling, to which he attaches clip-on lights. Paintings are hung throughout the house.

JUNE 6 – 24 Sees works by Jim Dine and Claes Oldenburg at the Martha Jackson Gallery, New York, in *New Form—New Media I*, organized by Steve Joy.

FALL Is introduced by colleague Allan Kaprow to Oldenburg, Lucas Samaras, George Segal (then completing his M.F.A.), and Robert Whitman. Through Robert Watts, another professor in the department, meets George Brecht, Dick and Allison Higgins, and George Maciunas, all artists who will be involved with Fluxus.

Attends some of Kaprow's informal happenings.

Leaves John Heller Gallery.

1961

JAN. Shows Kaprow the semiabstract paintings with cartoon figures embedded in paint.

JAN. 11–27 At Douglass College, exhibits twelve abstract ribbon paintings made by putting three or four colors onto plate glass, saturating a rag or torn-up bedsheet with them, and then dragging it across the surface. One work is painted on several pieces of refrigerator-crate plywood nailed together.

FEB. Meets Art Department secretary Letty Lou Eisenhauer.

JUNE Tells Eisenhauer about his new painting *Look Mickey* (1961; cat. 8) (based on an image in one of his children's Little Golden Books). First Pop works demonstrate what the artist refers to as paintings without any expressionism in them. Uses a plastic-bristle dog-grooming brush dipped in oil paint to create dot effect. Works features blown-up versions of advertised consumer goods and other well-known characters including Popeye and Wimpy, as well as panels from the comic strips *Buck Rogers*, *Steve Roper*, and *Winnie Winkle*. Experiments with other ways to apply dots, from using a lightly loaded paint brush, which he drags over the canvas, to employing a small, square, handmade stencil made from thin aluminum with holes he drills himself. Uses pre-primed white canvas. Flat areas are done in primary colors and outlined with black. Some paintings are done exclusively in black-and-white or blue-and-white. Creates several diptychs joined with hinges.

Works on a series of finished black-and-white drawings in pen, felt-tip marker, brush, and india ink. Some feature *pochoir*, a stenciling technique of pushing india ink through a small metal grid. Three-color drawings entitled *Baked Potato* (1961; private collection) feature synthetic polymer paint.

FALL Kaprow arranges a meeting with Ivan Karp, director of Leo Castelli. Brings *The Engagement Ring* (1961; private collection), *Girl With Ball* (1961; fig. 9, p. 32), *Look Mickey*, and *Step-on Can with Leg* (1961; cat. 10). Castelli contacts the artist several weeks later and agrees to represent him. In the meantime, Ileana Sonnabend visits the Highland Park studio together with Billy Klüver. Irving Blum also visits. Sonnabend and Blum offer to represent him.

Separates from Isabel and moves into a studio on Broad Street near Coenties Slip.

SEPT. 22–OCT. 14 *Girl With Ball* is added to Castelli's show *An Exhibition in Progress* (Bontecou, Chamberlain, Daphnis, Higgins, Johns, Langlais, Moskowitz, Rauschenberg, Scarpitta, Stella, Twombly, Tworkov). Is the first public showing of one of his Pop works. The show's concept is to start with a group of works and slowly replace them with Robert Rauschenberg's works until it becomes a full Rauschenberg show, and then begin to slowly replace Rauschenberg's works with others' until it turns back into a group show by the end of its run.

OCT. Consigns first works for sale to Castelli, including *Washing Machine* (1961; Yale University Art Gallery, New Haven), *Emeralds* (1961; private collection), *Roto Broil* (1961; Museum of Contemporary Art, Teheran), and *Keds* (1961; cat. 11).

NOV. *Mr. Bellamy* (1961; Modern Art Museum of Fort Worth), *Yellow Garbage Can* (1961; private collection), *Red Flowers* (1961; private collection), *Step-on Can with Leg, Black Flowers* (1961; Eli and Edythe L. Broad Collection), *I Can See the Whole Room! . . . And There's Nobody in It!* (1961; fig. 11, p. 33), *Girl and Rope Ladder* (1961; lost/presumed destroyed), *Cup of Coffee* (1961; Roy Lichtenstein Foundation Collection), and *Bread with Bag* (1961; Städtisches Museum Abteiberg, Mönchengladbach) are sent to Castelli for sale.

NOV. 9 Castelli sells his first work *I Can See the Whole Room! . . . And There's Nobody in It!* to Burton and Emily Hall Tremaine of Meriden, Connecticut.

NOV. 30 New York collector Richard Brown Baker buys *Washing Machine*.

DEC. A third wave of works is consigned to Castelli, including *Turkey* (1961; private collection), *Roller Skates* (1961; private collection), *Electric Cord* (1961; location unknown/ presumed stolen), *Bathroom* (1961; private collection), and *Transistor Radio (with Metal Antenna)* (1961; private collection), which includes an actual aerial antenna.

DEC. 12 Chicago collector Walter Netsch buys *Black Flowers*.

Meets Rauschenberg and Jasper Johns.

Warhol takes his own paintings to Leo Castelli and shows them to Karp. Karp shows Warhol *Girl With Ball*.

With Karp, visits Warhol's studio at 1342 Lexington Avenue in New York and sees Warhol's comic-strip and consumer-goods paintings.

Lichtenstein and Leo Castelli at the latter's gallery in New York with (from left to right) *Mr. Bellamy* (Modern Art Museum of Fort Worth), *Girl With Ball* (fig. 9, p. 32), *Step-on Can with Leg* (cat. 10), and (back) *Roto Broil* (Museum of Contemporary Art, Teheran) (all 1961). Photographed by Paul Berg for *St. Louis Post-Dispatch: Sunday Pictures*, Dec. 31, 1961.

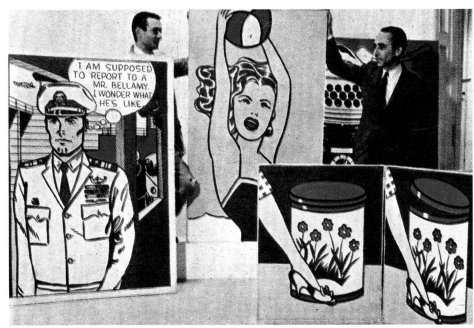

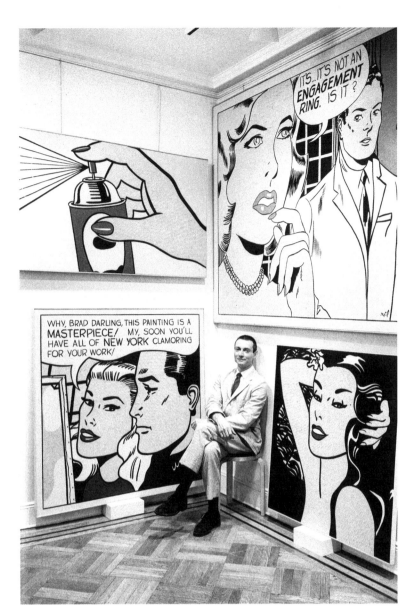

Lichtenstein at Leo Castelli in 1962 with (clockwise from top left) *Spray* (1962; cat. 14), *The Engagement Ring* (1961), *Aloha* (1962; The Helman Collection), and *Masterpiece* (1962; cat. 29). Photograph by Bill Ray.

1962

Returns to live and work in Highland Park.

Experiments with acrylic emulsion paint, in particular, Liquitex, but quickly abandons it for Magna, a polymer-based paint manufactured by Leonard Bocour that is soluble in turpentine but without the "yolky" or "milky" quality of Liquitex. Uses a Magna-based varnish between coats. Because Magna dries too quickly, continues to use oil paint for simulated Benday dots and later diagonals. Begins to use an industrial perforated metal screen, which he finds through the Beckley Perforating Co., in Garwood, N.J., for his Benday dots.

Close cropping of imagery appears.

First paintings based on panels from All-American Men of War comics, such as *Blam* (1962; Yale University Art Gallery, New Haven) and *Takka Takka* (1962; cat. 30). The five-panel work *Live Ammo* features one diptych and three other panels; the painting is later broken up and sold as four individual works. Most works begin with drawings to organize the material, done either sitting in a chair or at the drafting table. Starts drawings with colored pencils. Next, redraws lines onto the canvas using a Postoscope opaque projector. Many of these drawings are then discarded. Pencil marks unerased in earlier works begin to disappear entirely from compositions.

First paintings based on reproductions of works by Picasso and Cézanne, including *Portrait of Madame Cézanne* (1962; cat. 63), an enlarged version of a black-and-white outline diagram by Cézanne scholar Erle Loran.

Isolates the words *Art* (1962; private collection) and *In* (1962; Solomon R. Guggenheim Museum, New York) on canvas. Late recalls wanting to make one with the word "Flat" but soon abandons the idea.

Switches from ink to pencil for finished drawings. Develops a frottage technique for black-and-white drawings by placing a sheet of paper on a window screen and rubbing it with graphite to achieve the look of machine-applied dots. Finished drawings often depict subjects different from those in paintings and do not require preliminary sketches. Simultaneously works on paintings and these drawings in no clear chronological order.

FEB. 10 – MAR. 3 First solo show of paintings at Leo Castelli, featuring works such as *Turkey*, *Washing Machine*, *The Engagement Ring*, *The Kiss* (1961; private collection), *The Refrigerator*, *Blam*, and *The Grip* (1962; Museum of Contemporary Art, Los Angeles).

FEB. 26 *Newsweek* magazine reviews Leo Castelli show and reproduces *Girl With Ball*.

MAR. Is linked for the first time with Dine, Oldenburg, and James Rosenquist as a cohesive group (together with Peter Saul and Watts) in Max Kozloff's article, "'Pop' Culture, Metaphysical Disgust, and the New Vulgarians," in *Art International*.

APR. Donald Judd reviews Leo Castelli show for *Arts* magazine.

APR. 3 – MAY 13 *The Kiss* is included in *1961*, a group exhibition at the Dallas Museum for Contemporary Arts curated by Douglas MacAgy.

MAY Consigns a number of black-and-white pencil drawings to Castelli.

MAY 26 – JUNE 30 Black-and-white drawings are shown for the first time in *Drawings: Lee Bontecou, Jasper Johns, Roy Lichtenstein, Robert Moskowitz, Robert Rauschenberg, Jack Tworkov* at Leo Castelli.

JUNE 15 Among several artists featured in "Something New Is Cooking" in *Life* magazine.

AUG. 6 – 31 *Art of Two Ages: The Hudson River School and Roy Lichtenstein* at Mi Chou Gallery in New York (801 Madison Ave.) features *Golf Ball* (1962; cat. 20), *Electric Cord*, drawing *Zipper* (1962; private collection), *Bratatat!* (1962; cat. 35), *The Refrigerator, Ice Cream Soda* (1962; private collection), and *Takka Takka*, along with paintings by Albert Bierstadt, John William Casilear, Frederic Edwin Church, Jasper Cropsey, and Asher B. Durand. Chou borrowed the nineteenth-century works from Kennedy Galleries in New York.

SEPT. Included in *Artnews* essay, "The New American 'Sign Painters,'" by Gene R. Swenson, along with Dine, Stephen Durkee, Robert Indiana, Rosenquist, Richard Smith, and Warhol.

SEPT. 25 – OCT. 19 Comic-strip and consumer-goods paintings are shown on the West Coast for the first time in the group exhibition *New Painting of Common Objects* at the Pasadena Art Museum, curated by Walter Hopps.

OCT. 25 – NOV. 7 Included in *Art 1963—A New Vocabulary*, organized by Joan Kron and Audrey Sabol for the Art Council of the YM/YWHA in Philadelphia, which features paintings, collages, assemblages, combines, and machines by Brecht, Dine, Johns, Kaprow, Marisol, Oldenburg, Rauschenberg, Rosenquist, Segal, Jean Tinguely, and Watts. Exhibition brochure includes statements by the artists and a dictionary of terms written by Klüver to describe the new art. Contributes a handwritten word balloon with the words "DYNAMIC: KPOW! WHUMP! TAKKA TAKKA!! VAROOM!"

OCT. 31 – DEC. 1 Included in Sidney Janis Gallery exhibition *International Exhibition of the New Realists*, featuring "factual paintings and sculpture" by American and European artists, along with Dine, Klein, Oldenburg, Rosenquist, Mimmo Rotella, Segal, Tinguely, and Warhol.

NOV. Swenson publishes "What Is Pop Art? Answers from Eight Painters, Part I: Jim Dine, Robert Indiana, Roy Lichtenstein, Andy Warhol," in *Artnews*. Featured speaker for a session entitled "'Sign' Painters" for the eighteenth annual design conference of the American Society of Industrial Designers at the Waldorf Astoria.

Work is included for the first time as part of the MoMA's Art Lending Service.

NOV. 18 – DEC. 15 *Takka Takka* is included in *My Country 'Tis of Thee* at the Dwan Gallery in Los Angeles, along with works by Indiana, Johns, Edward Kienholz, Marisol, Oldenburg, Rauschenberg, Larry Rivers, Rosenquist, Warhol, and Tom Wesselmann.

Head—Red and Yellow (1962; Albright-Knox Art Gallery, Buffalo) is acquired by the Albright-Knox Art Gallery.

DEC. 4 On "The Unpopular Artist in a Popular Society" panel held in New York.

DEC. 13 Attends symposium on Pop art at MoMA. Speakers include Dore Ashton, Henry Geldzahler, Hilton Kramer, Stanley Kutz, and Leo Steinberg, with Peter Selz as moderator. "Pop" art is chosen as name for the new movement. Other artists in the audience include Duchamp, Maciunas, Rosenquist, and Warhol.

DEC. 26 Among eleven artists chosen to collaborate on the New York State exhibit at the World's Fair in Flushing Meadows, 1964–65.

Sock Announcement (1963), for *Roy Lichtenstein, April 1–20, 1963*, Ferus Gallery, Los Angeles. Offset lithograph in blue and black, on white wove paper; sheet, 33.1 × 25.3 cm (13 1/16 × 9 15/16 in.); image, 26.7 × 19.1 cm (11 1/4 × 7 1/2 in.) .

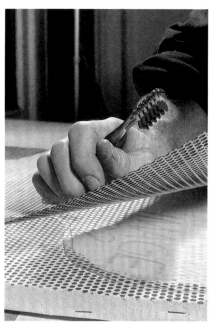

Working with perforated metal screen and toothbrush on *Image Duplicator* (1963; Collection Simonyi). Photograph by John Loengard.

1963

Begins series of canvases depicting women from the DC Comics's Girls' Romances and Secret Hearts series. Benday dots are doubled in areas such as lips by shifting the screen. Some are done in red and blue to create the effect of purple. Several canvases feature mad scientists from science fiction comic books.

Hires assistant to paint in Benday dots.

Begins to use lithographic rubbing crayon in his finished black-and-white drawings to achieve larger, more uniform, machine-looking dots.

MAR. 14 – JUNE 12 Included in *Six Painters and the Object* at the Solomon R. Guggenheim Museum, organized by Lawrence Alloway, along with Dine, Johns, Rauschenberg, Rosenquist, and Warhol. The show travels throughout the United States.

APR. Three paintings are included in *Pop! Goes the Easel* at the Contemporary Arts Museum, Houston, organized by MacAgy.

APR. 1 – 20 First exhibition at Ferus Gallery in Los Angeles, featuring *Sock* (1962; private collection), *Masterpiece* (1962; cat. 29), *Sponge* (1962; cat. 13), *Sponge II* (1962; private collection), *Portrait of Madame Cézanne*, and *Drowning Girl* (1963; cat. 32), as well as other works from 1962–63.

APR. 18 – JUNE 2 *Electric Cord, Handshake* (1961; private collection), *George Washington* (1962; cat. 62), *Aloha* (1962; The Helman Collection), *The Refrigerator*, and *Femme d'Alger* (1963; cat. 64) are included in *The Popular Image* at the Washington Gallery of Modern Art, organized by Alice Denney.

APR. 28 – MAY 26 Leo Castelli lends *Girl at Piano* (1963; private collection) and *Magnifying Glass* (1963; cat. 25) for *Popular Art: Artistic Projections of Common American Symbols* at the William Rockhill Nelson Gallery of Art and Atkins Museum of Fine Arts, Kansas City.

MAY 10 – JUNE 20 Included in first European group show, *De A à Z: 31 Peintures américains choisis par the Art Institute of Chicago*, at the American Cultural Center in Paris. *The Ring (Engagement)* (1962; cat. 12) is included.

MAY 17 *Time* magazine publishes a letter by William Overgard stating that *I Can See the Whole Room! . . . And There's Nobody in It!* is taken from the last panel of his August 6, 1961, comic strip *Steve Roper*. Overgard's panel and the painting are reproduced side by side.

JUNE Commissioned by poet Walasse Ting to contribute a piece for the cover of his collection of writing entitled *1¢ Life*.

JUNE 5 – 30 First solo exhibition in Europe, at Galerie Sonnabend in Paris (37, quai des Grands-Augustins). Trip to Paris for the opening is first time back since the war.

SUMMER – WINTER Works are included in shows in Lausanne, Toronto, London, Turin, Stockholm, and Gstaad.

Takes leave of absence from Douglass College.

SEPT. 28 – OCT. 24 Second solo exhibition at Leo Castelli includes *Drowning Girl, Baseball Manager* (1963, private collection), *Torpedo . . . LOS!* (1963; cat. 34), and *Whaam!* (1963; cat. 36).

OCT. First of a series of major interviews conducted by John Coplans appears in *Artforum*.

Lichtenstein working on his ceramic pieces at the W. 26th Street studio, 1965. Photograph by Ugo Mulas.

Lichtenstein with Leo Castelli at his third one-person Castelli show, *Roy Lichtenstein: Landscapes, Oct. 24–Nov. 19, 1964*. Pictured in background (from left to right) are *Sinking Sun* (1964; private collection) and *Temple of Apollo* (1964; fig. 4, p. 63). Photograph by Ugo Mulas.

OCT. 1 Sells Highland Park home. Separates from Isabel, who moves with the children to Princeton.

Moves with Eisenhauer to the second floor of 36 W. 26th Street, which doubles as a studio.

OCT. 24 – NOV. 23 Pop works are shown for the first time in Britain in *The Popular Image* at the Institute of Contemporary Art, London, organized by Alan Solomon.

NOV. 19 – DEC. 15 Included in *Mixed Media and Pop Art* at the Albright-Knox Art Gallery, organized by Gordon M. Smith, along with Dine, Johns, Oldenburg, Rauschenberg, Rosenquist, and Warhol, as well as lesser-known artists in the museum's collection.

Completes first work in Magna on Plexiglas. Makes several more on plastic, which appeals to interest in achieving an "antiseptical industrial look."

1964

JAN. 31 *Life* magazine publishes article entitled "Is He the Worst Artist in the U.S.?" The idea comes from author Dorothy Sieberling, then married to Leo Steinberg.
Both are supporters of the artist, who approves of the idea for the title.

Begins to prime own canvases by wiping them with tape to remove lint and applying two thin coats of gesso and one thin coat of white underpainting.

Makes full-scale canvases of composition notebooks and works that bear close resemblance to Mondrian's abstractions.

Begins to make Benday dots larger, in proportion to size of canvases.

Creates a series of frightened and crying women in close-up views.

Dialogue balloons begin to disappear from paintings.

Employs an airbrush for the first and only time to create *Duridium* (1964; private collection), which depicts a razor blade.

Begins series of cartoon-style landscapes and seascapes inspired by cartoon backgrounds. Creates first sunrise and sunset works.

Buys several mannequin heads and paints one like a cartoon girl.

APR. Invited by National Cartoonist Society in New York to talk about work.

Art in America cover features commissioned "pop panorama" drawing of the New York World's Fair.

APR. 22 *World's Fair Mural* (1964; University Art Museum, Minneapolis) of a girl in a window is among the murals featured at the New York State Pavilion at the New York State Fair.

SPRING Meets Dorothy Herzka at Paul Bianchini Gallery in New York (16 E. 78th St.) during preparations for *American Supermarket*, organized by Ben Birillo.

Introduced to a polycarbonate optical paper, Rowlux, by Jerry Foyster, and soon experiments with it in collages.

Increasingly invents own subject matter.

With help from Birillo, fabricates first enamel pieces on butcher trays featuring a red and white image of a hot dog. Creates first enamel edition *Hot Dog* (1964; edition of ten), inspired by the enameled look of a Good Humor truck and subway signs.

Seeks out ARPOR (Architectural Porcelain Fabricators, Inc.), in Orangeburg, New York, to create enameled works featuring cloudscapes, sunsets, and scenes of girls based on comic-book panels.

JUNE Included in Bruce Glaser round table radio discussion on New York WBAI that includes Oldenburg and Warhol. The transcript is published in *Artforum* (Feb. 1966).

JUNE 30 Resigns from Douglass College.

OCT. 6 Grand opening of *American Supermarket*, which includes works by a number of artists. Visitors can buy items and put them in shopping bags with his image of a Thanksgiving turkey or one by Warhol featuring Campbell's tomato soup. The show eventually travels to Rome and Venice, where it also features his enamel edition *Hot Dog*.

OCT. 24 – NOV. 19 *Temple of Apollo* (1964; fig. 4, p. 63), employing a classical art reference, is shown at Leo Castelli, along with several landscapes and enamel works.

OCT. 31 Attends Idelle Weber's Halloween party on Livingston Street in Brooklyn Heights dressed as Warhol with Herzka dressed as Edie Sedgwick.

NOV. 24 Solo exhibition of landscapes and girls at Ferus Gallery, Los Angeles. Dennis Hopper takes photographs of him at the gallery.

DEC. 7 Makes "Spear-Bearer" costume in which he performs with Eisenhauer and others in Dick Higgins's restaging of Dzhoneš's opera *Hrusalk* at the Café au Go Go in New York.

Klüver and noted Dada and Surrealist expert Arturo Schwartz publish *The International Anthology of Contemporary Engravings: The International Avant-Garde: America Discovered, Volume* 5 (Galleria Schwartz, Milan). Along with etching *On* (1962, published 1964; edition of sixty), it also contains Warhol's first print.

Rosa Esman begins Tanglewood Press with the portfolio *New York Ten*, which includes *Seascape* (1964, published 1965; edition of 200), his first color screen print on Rowlux.

1965

Officially separates from Isabel.

Begins collaboration with Rutgers colleague and potter Hui Ka Kwong to create a series of ceramic heads and another of stacked cups and saucers. Employs decals of ceramic material and uses punched-out tape so he can apply the dots evenly to the contours.

Look Mickey is shown in a photograph for the first time in John Rublowsky's *Pop Art*, the first book devoted to the movement.

Experiments with Modern motifs in poster of the World's Fair for the Cartoonists Association entitled *This Must Be the Place* (1965; edition size unknown).

Dealers Marian Goodman, Ursula Kalish, and Sunny Sloane, along with art consultant and framer Barbara Kulicke, establish Multiples, Inc., for editioned pieces of art. They had already opened the Betsy Ross Flag and Banner Company in 1962 with Robert Graham of New York's Graham Gallery to produce banners by artists. *Pistol* (1964; edition of twenty) is the most popular and sells out.

JAN. The Stedelijk Museum purchases *As I Opened Fire* (1964; cat. 40).

MAR. 13 Contributes to the Artist's Key Club, a happening orchestrated by Arman, where 104 keys to 104 Penn Station lockers are sold at the Chelsea Hotel in New York. Each locker has one signed work or one small gift by the participating artists. Contributes four signed drawings and four anonymous toys.

APR. Creates three screen prints, *Moonscape, Reverie*, and *Sweet Dreams Baby!* (all 1965; each in an edition of two hundred), commissioned by Philip Morris, for *11 Pop Artists, Volume 1, II–III*.

MAY 22 – 23 Participates in the planned group swim with other artists at the conclusion of Oldenburg's happening, Washes, at Al Roon's health club in New York.

JUNE 1 Second solo show at Galerie Sonnabend in Paris. Eisenhauer wears a dress designed by Lee Rudd based on one of his Sunrises for the opening reception.

FALL First Brushstroke painting (1965; cat. 47) is inspired by an image of a painted brushstroke from a science fiction comic-strip panel. Other invented Brushstroke works follow.

NOV. 20 – DEC. 11 Castelli presents the Brushstrokes along with recent ceramic pieces.

DEC. 7 – 31 Teardrop cloisonné pendant of a crying girl (1965) published in an edition of six is shown at Multiples Inc.

Roy Lichtenstein. *Turkey Shopping Bag*, 1964. Screenprint on white, wove paper bag with handles; 49 × 43.4 cm (19 ⁵⁄₁₆ × 17 ¹⁄₁₆ in.), slightly variable; height without handles; edition of approximately 125.

Roy Lichtenstein. *Pistol*, 1964. Felt; 208.3 × 124.5 cm (82 × 49 in.); edition of twenty. Betsy Ross Flag and Banner Co.

Lichtenstein working on *Big Painting VI* (1965; Kunstsammlung Nordrhein-Westfalen, Düsseldorf) at the W. 26th Street studio. Photograph by Ugo Mulas.

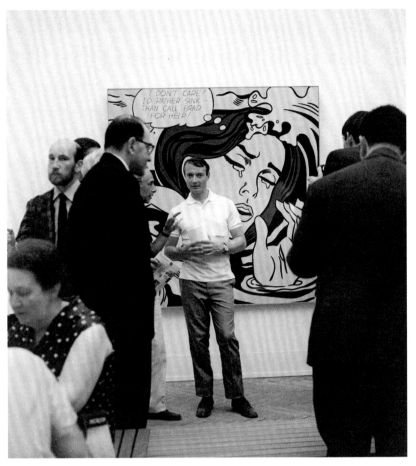

Lichtenstein in front of *Drowning Girl* (1963; cat. 32) at the 33rd Venice Biennale, U.S. Pavilion, in 1966. The Roy Lichtenstein Foundation Archives.

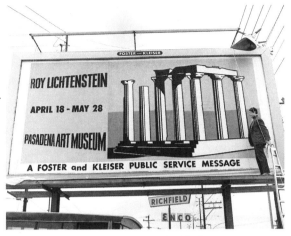

Lichtenstein with billboard announcing his show at the Pasadena Art Museum, April 18–May 28, 1967. Photograph by Frank J. Thomas.

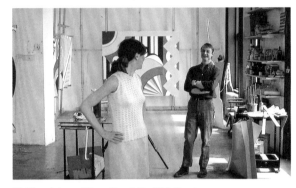

Lichtenstein and Dorothy at the 190 Bowery studio. Pictured (left to right) are *Modern Painting with Target*, *Modern Painting*, and *Modern Painting with Zigzag* (all 1967; all private collection). Photograph by Leta Ramos.

351

Enameled works feature sunrises and other cartoon-inspired imagery, including first large-scale group of 16-gauge porcelain enamel on steel wall and standing sculptures based on cartoon explosions in various primary colors, which also evidence perforated metal screens.

1966

Dialogue balloons disappear from canvases.

Creates paintings featuring drips and blots of paint against a graph-paper grid background.

Begins to create Landscapes that move using Rowlux and concealed surplus Hansen Synchron motors found on Canal Street. Designs some with specially made light fixtures, fabricated by Grand Lighting in Brooklyn, whose painted bulb casings rotate through a spectrum of color gels to simulate different times of day.

FEB. Contributes work to Los Angeles Peace Tower, a monument designed by Mark di Suvero.

MAR. 6 – APR. 2 In Caracas, Venezuela, promoting Jacinto Quirarte's show *Pop Art: La Nueva Imagen*, sponsored by Tabacalera Nacional/ Philip Morris International.

APR. 15 On Pop art symposium panel with Larry Rivers and Frank Stella, sponsored by the San Francisco Art Institute.

APR. 27 Gala opening of the fifth annual exhibition and sale to benefit the Congress of Racial Equality (CORE) at Grippi & Waddell Gallery, New York, which includes his limited-edition button featuring an apple core inside a painter's palette.

SUMMER Designs a limited-edition deluxe print on silver foil (1966; edition of one hundred) along with a larger commercial run of posters, based on 1930s Hollywood motifs, for Lincoln Center's fourth New York Film Festival.

JUNE 18 – OCT. 16 Together with Helen Frankenthaler, Ellsworth Kelly, and Jules Olitski, represents the United States at the 33rd Venice Biennale in an exhibition organized by Henry Geldzahler. Travels to Venice for the opening.

OCT. 1 Six-piece table setting of signed black-and-white china pieces produced by Jackson China Co. for Durable Dish Company sold at Leo Castelli.

NOV. 4 – DEC. 1 The Cleveland Museum of Art presents first solo museum exhibition, *Works by Roy Lichtenstein*, organized by Ed Henning.

Photographer Ugo Mulas's images of the artist appear in Alan Solomon's book *New York: The New Art Scene.*

Interviewed by British art critic David Sylvester for a broadcast of BBC's Third Programme.

Moves to 190 Bowery at Spring Street. Sets up a residence and studio on the fourth floor of the former German bank built in 1917. The studio is better lit, thanks to two large walls of windows that looks out onto Bowery. Adolph Gottlieb lives on the second floor, and Malcolm Morley, Louise Nevelson, and Mark Rothko live in the neighborhood. Paul Potash assists at the studio one day a week and learns how to construct the floor-to-ceiling easels.

Hires Jerry Simon as assistant.

The Tate Gallery, London, purchases *Whaam!*

The Art Institute of Chicago purchases *Brushstroke with Spatter* (1966; cat. 49).

1967

The Modern series emphasizes double-density dots more than in the lips or eyes of Pop-based work, where dots touch tangentially to create a white star in the middle.

ROY LICHTENSTEIN
Commissioned by Multiples, Inc.
Enameled jewel with sterling silver base,
to be worn as pendant or brooch.
Red, yellow, blue and white.
3 x 3 inches (outside dimensions)
Unlimited edition: $50.

MULTIPLES
929 MADISON AVENUE

Multiples, Inc., announcement for *Modern Head Pendant* (1968).

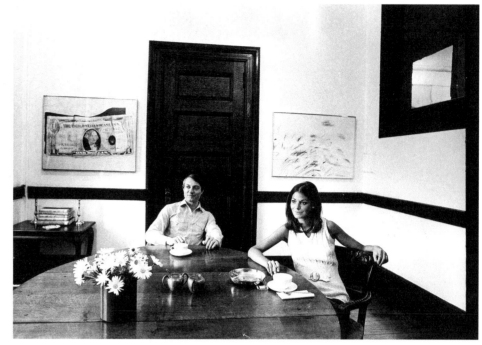

Lichtenstein with Dorothy.

1968

MAR. 23 Divorce from Isabel is finalized.

APR. "How an Elvis Presley Becomes a Roy Lichtenstein" by Salvador Dalí appears in *Arts Magazine*.

APR. 13 *Temple of Apollo Billboard* is unveiled at the corner of Melrose and La Cienega Boulevards in Los Angeles, announcing a show at the Pasadena Art Museum. The billboard is one of five donated to the museum by the advertising firm Foster and Kleiser.

APR. 18 – MAY 28 The Pasadena Art Museum, in collaboration with the Walker Art Center, Minneapolis, presents first traveling retrospective, organized by Coplans. The first solo exhibition catalogue is published.

Commissions Beckley to make a metal screen with graduated dots for use in his mural for Expo '67.

APR. 28 – OCT. 29 Mural *Modern Painting for Expo '67* (1967; Norton Simon Museum, Pasadena) in *American Painting Now* at the Expo '67 U.S. Pavilion in Montreal, which features graduated Benday dots.

SUMMER Rents Rivers's house in Southampton, New York, with friends. Meets Carlene Meeker and hires her as assistant; she stays on for twelve years. Often works on fifteen to twenty paintings at a time.

AUG. 17 – 20 Artist-in-residence under the auspices of the Aspen Center for Contemporary Art, along with Allan D'Arcangelo, Les Levine, Robert Morris, Oldenburg, and DeWain Valentine. They conceive of a weeklong "Culture-In" series of events that includes a black-and-white taped and painted environment entitled *Room* in studio space on the second floor of the Brand Building at the corner of Galena and Hopkins Streets. The installation is meant for destruction, although a door with the words "Nok!! Nok!!" (1967; private collection) is dismantled and saved with the artist's permission.

FALL Collaborates with Guild Hall in Paramus, New Jersey, to fabricate sculptures made of brass, mirror, tinted glass, marble, aluminum, and wood.

Billboard *Super Sunset* is installed on Sabol's handball court in Villanova, Pennsylvania. Covering six plywood panels and painted by hand, it measures eleven by twenty-eight feet.

SEPT. Submits *Illustration for "Romanze, or The Music Students" (I) and (II)* for *In Memory of My Feelings: A Selection of Poems by Frank O'Hara*, an unbound book (2,500 numbered on colophon page) of two musically derived Modern images drawn on a plastic surface. Edited by Bill Berkson, the works are done in honor of O'Hara, an assistant curator at MoMA who had died tragically.

NOV. 4 – DEC. 17 The Stedelijk Museum presents first European retrospective. The show travels to three other museums, including the Tate in 1968. It is the Tate's first show dedicated to a living American artist.

Appointed Regents Professor, University of California, Irvine.

Begins first Stretcher Frame paintings.

JAN. 4 Arrives in London for opening of Tate retrospective. Travels to Morocco with family after opening festivities.

Makes first Modular paintings featuring repeated design imagery, inspired by an art project completed in third or fourth grade.

MAY 24 Commissioned image of Robert F. Kennedy appears on cover of *Time* magazine.

JUNE Invited by Los Angeles County Museum of Art (LACMA) curator Maurice Tuchman to participate in forthcoming *Art and Technology* exhibition. Is paired with Universal Studios in Los Angeles.

Creates *Modern Head Pendant*, an enamel brooch in an edition of 250, which is sold by Multiples, Inc.

JUNE 21 *Time* magazine features his rendering of a gun for its cover story, "The Gun in America."

SUMMER Visits the Pasadena Art Museum with Coplans and sees Constructivist paintings of heads by German Expressionist artist Alexei Jawlensky. Coplans discusses his ideas for an exhibition on serial paintings. Creates first paintings on the theme of Claude Monet's Haystacks. Continues making works featuring Art Deco and stretcher bar imagery.

Shares house on Wooley Street in Southampton with friends.

AUG. Paper boat *Hat* (1968; edition of approximately two thousand) is included in *S.M.S.*, issue 4, a portfolio of artists' works edited by William Copley and Dimitri Petrov.

ROY LICHTENSTEIN

IRVING BLUM GALLERY
LOS ANGELES, CALIFORNIA
FROM TUESDAY, APRIL 9, 1968

Exhibition poster featuring *Stretcher Frame* (1968; private collection) for *Roy Lichtenstein, February 4–March 4, 1969*, Irving Blum Gallery, Los Angeles.

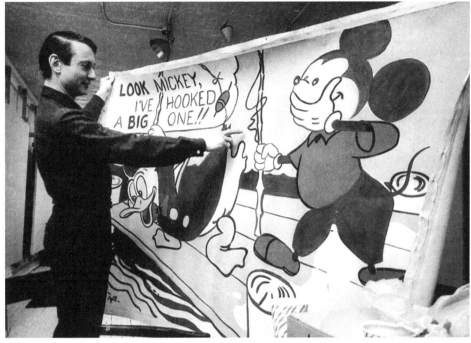

Lichtenstein in his studio on W. 26th Street with *Look Mickey* (1961, cat. 8). Photograph by Ken Heyman.

1969

SEPT. Joins artists' boycott of Chicago museums over the police action during the Democratic National Convention.

SEPT. 10 Appointed Fellow for Life at the Metropolitan Museum of Art.

SEPT. 12 Tours Universal City Studios.

SEPT. 17 – OCT. 27 Sees Coplans's exhibition *Serial Imagery* at the Pasadena Art Museum. Begins series of Rouen Cathedrals.

OCT. 22 – NOV. 23 Charles E. Slatkin Inc. Galleries debuts wool tapestry fabricated by modern masters, featuring a Modern version of a classical Greek head.

OCT. 23 Invited by prominent Chicago dealer Richard Feigen to contribute a work to month-long protest exhibition *Richard J. Daley*.

NOV. 1 Marries Dorothy Herzka at City Hall.

NOV. 24 Commissioned to make movie poster for *Joanna* (1968; edition unknown); it is reproduced in black-and-white newspaper ads but never distributed.

Commissioned to create an editioned sculpture to commemorate the fiftieth anniversary of both the U.S. Postal Service and international airmail service, *Salute to Airmail* (1968; edition of fifty each in silver, gold-plated bronze, and chromium-plated copper).

Designed *Wrapping Paper* sold at On 1st; *Paper Plate* sold following year is one of first using the reflective motif.

Executes several studies for *New York State Mural (Town and Country)* (1968), an unrealized mural for the New York State Legislature Building commissioned by the Empire State Plaza Art Commission.

Richard Kalina begins as studio assistant.

WINTER/SPRING Abandons metal screens and begins to use red oilboard perforated sheets he orders from Beckley, which are easier to manipulate. Haystack and Rouen Cathedral canvases are aided by assistants who must meticulously cut out wax paper stencils using a single-edge razor blade and lay them onto the canvases with double-sided tape. Directs the dotting process, which is painstaking. Next, a brayer is used to apply paint. Then applies a standard three coats of Magna paint, the black, to finish up a line, working from thin to thick. If unhappy with the result, can wipe away the Magna with turpentine, since the alcohol-based varnish protects the layer underneath, which allows for a very flexible system.

JAN. – JULY Issues first serial prints (seven Haystack and six Rouen Cathedral lithographs) through Gemini G.E.L. in Los Angeles, collaborating with master printer Kenneth Tyler.

Kalina leaves, and Richard Dimmler begins as studio assistant.

FEB. 3 Returns for a two-week stay at Universal City Studios, after which decides to make "moving pictures." Sketches fifteen landscape pictures in total, which would combine filmed sequences with other synthetic material separated by a heavy black horizontal line that would rock back and forth

Photographed by Lord Snowdon in his Southampton studio with Pyramid paintings and several Modern works; photographs appear in *Vogue* magazine in September.

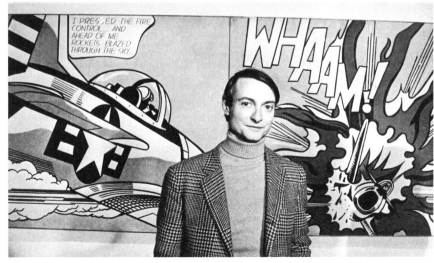

Lichtenstein in front of *Whaam!* (1963; cat. 36), Tate Gallery, London, Jan. 1968. Photographer Keystone-France/Contributor.

354

Roy Lichtenstein. *The Solomon R. Guggenheim Museum (Poster)*, 1969. Screen print in yellow, red, green, and black on smooth, white wove paper; sheet, 73 × 73 cm (28 ¾ × 28 ¾ in.); edition of 3,000–5,000. For *Roy Lichtenstein, September 19–November 16, 1969*, the Solomon R. Guggenheim Museum, New York.

SUMMER Stays on Wooley Street in Southampton again with friends. With the assistance of filmmaker Joel L. Freedman of Cinnamon Productions Inc., shoots 35 mm film of the sunrise and sunset in Montauk using a high-powered telescope attached to a Bolex camera. The resulting footage is too shaky to use. Over the course of the year, they experiment with shooting footage of rippling ocean water under Benday dot props. Not satisfied with the results, plans are altered to create three completely filmed vignettes that mirror the precision and clarity of his paintings. With Freedman, seeks out special-effects expert Hugo Casolaro, who collaborates on animating both the color and imagery of the final product, entitled *Three Landscapes*.

FALL Creates first Mirror paintings, inspired by the air-brushed quality of mirror sales catalogues. Begins to photograph own source material, such as magnifying mirrors that produce abstract shadows and shapes.

SEPT. 23 Buys carriage house on Gin Lane in Southampton.

SEPT. 19–NOV. 16 First New York retrospective of paintings and sculptures, at the Solomon R. Guggenheim Museum, organized by Diane Waldman. The show travels to four other U.S. museums.

1970

MAR. 15–SEPT. Two landscape films are shown on seven-by-eleven-foot screens using 35 mm film loop rear-screen projectors at the Expo '70 U.S. Pavilion in Osaka, Japan. The artist does not travel to Japan to see the installation.

SUMMER Moves into Gin Lane house with plans for a studio on the third floor, but ceilings turn out to be substantially lower than expected.

Creates first brass relief in an edition of one hundred of a *Modern Head* (1970) for sale by Gemini G.E.L.

OCT. Signs first realized large Brushstrokes mural—12 × 245 feet on four continuous walls—at the University of Düsseldorf School of Medicine.

Bianchini publishes the first monograph cataloguing most of his drawings and prints.

Elected to American Academy of Arts and Sciences.

1971

Begins Entablature series in black-and-white using own photographs of Wall Street's neoclassical buildings as sources, which are inspired by the background decorative dividers in works by Cubist painters such as Picasso and Georges Braque.

MAR. 13–APR. 3 Mirrors exhibited publicly for the first time at Leo Castelli.

MAY 10–AUG. 29 *Three Landscapes* (1970–71), which features an additional film loop along with the two shown in Osaka, is shown in 16 mm format in *Art and Technology* at LACMA. Once again, the artist does not see the final installation.

MAY 12 Inducted as a fellow into the American Academy of Arts and Sciences (Boston).

SEPT. Castelli opens a new gallery at 420 W. Broadway in SoHo.

Designs a poster for UNICEF child-welfare programs, *Save Our Planet Save Our Water* (1971), to raise ecological awareness. It references fish in an aquarium similar to his third and final film loop shown at LACMA.

Lithograph *Mao* (1971) accompanies Frederic Tuten's *The Adventures of Mao on the Long March*. The lithograph is packed in a specially designed container that acts as its frame and includes Tuten's signed and numbered book on the reverse.

Designs his studio in Southampton as a classic saltbox, with skylights across the lawn from the house. Replicates easel walls of wooden racks and clamps.

Harry N. Abrams publishes first monograph of his paintings and sculpture written by Waldman. Italian and German editions are also published that same year.

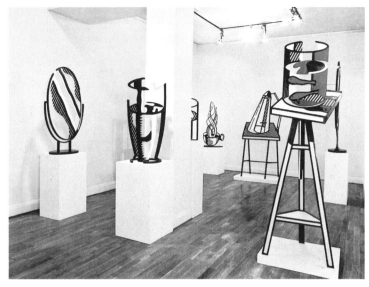

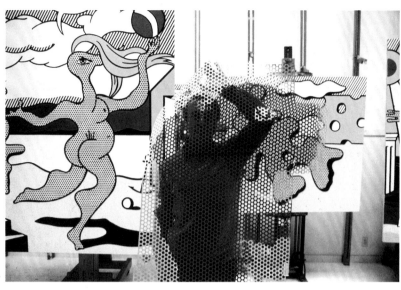

Roy Lichtenstein Sculpture, Nov. 16–Dec. 20, 1977, Mayor Gallery, London, 1977. Pictured (left to right) are *Mirror I* (1976), *Glass II* (1976), *Cup and Saucer II* (1977), *Lamp on Table* (1977), and *Goldfish Bowl* (1977), all editions of three.

Lichtenstein holding one of his red oilboard dot screens in Southampton, April 1977. Pictured (left to right) are *Frolic* (1977; cat. 77) and *Nude on Beach* (1977; Sammlung Würth, Künzelau). Photographer unknown. The Roy Lichtenstein Foundation Archives.

1972

Documentary Monographs in Modern Art publishes monograph edited by John Coplans.

Begins Still Life series.

Increasingly uses diagonal stripes in place of Benday dots.

Begins to quote own work in Still Life paintings.

References to Matisse appear in works.

OCT. Serves as visual consultant to Frank Perry's film *Play It as It Lays*, based on a novel by Joan Didion.

James de Pasquale begins as studio assistant in Southampton; Dimmler leaves.

1973

Begins series of trompe-l'oeil and Cubist still lifes, which includes his take on their use of faux-bois, but which also mimics Rowlux.

Channels the work of Morris Louis in a collage and then a painting *Untitled (Morris Louis Unfurled)* (1973; private collection).

FALL Begins Artist's Studio series, incorporating self-quotations of early 1960s paintings and drawings. Includes references to abstract-style paintings, precursors to a series of Perfect/Imperfect works.

Creates paintings showing the influence of De Stijl and Russian Constructivism.

Picasso's Bulls become a particular theme in graphic work.

1974

Paints first works influenced by Italian Futurism.

Begins new series of Entablatures using metallic and pastel colors. Mixes sand with paint to highlight surface texture.

SEPT. *Modern Head*, the first large-scale sculpture in metal, wood, and polyurethane, is assembled on a site in the Santa Anita Fashion Park in Arcadia, California.

1975

JAN. 10 – FEB. 1 Centre Beaubourg in Paris organizes first traveling retrospective of drawings.

Begins series of paintings based on works by Le Corbusier and Amédée Ozenfant.

1976

Paints Office Still Lifes based on newspaper illustrations of office items and business furniture.

Completes final series of Entablature paintings.

Creates several self-portraits in Futurist style.

Warhol creates a silk-screen portrait of him.

Makes first painted sculptures in bronze of mirrors, coffee cups, and drinking glasses. Uses the lost wax process, in which rubber molds encased in ceramic are made from his wooden maquettes, and wax is then steamed out and bronze poured into the mold. Bronze is patinated black, and colored areas are created using a brand of polyurethane anti-aircraft paint called Bostic, often in combination with Magna.

Produces bicentennial poster for the American Revolution Bicentennial Administration.

1977

Begins series of paintings based on works by Surrealist artists (including Dalí, Max Ernst, and Joan Miró) and Surrealist works by Picasso, some featuring a dialogue balloon.

MAR. Commissioned by BMW to create an exterior design for their 3201 race car, driven later in the year at Le Mans. They send a plastic mold, which he returns in April with a design of a sunrise.

APR. 26 Receives Skowhegan Medal for Painting and Sculpture.

MAY 13 Is awarded doctorate of fine arts from California Institute of the Arts in Valencia.

1978

North American Indian motifs reappear.

JUNE 5 First large-scale outdoor sculpture, *Lamp* (1978; private collection), in welded painted bronze with painted brass light rays fabricated by Tallix, is commissioned by Gilman Paper Company, St. Mary's, Georgia, and installed in front of its main administrative building (later deinstalled).

JULY 19 – SEPT. 24 Contributes cover design for the Whitney Museum of American Art's exhibition *Art about Art*, organized by Jean Lipman and Richard Marshall.

Visits Los Angeles. Sees the Robert Gore Rifkind collection of German Expressionist graphic art.

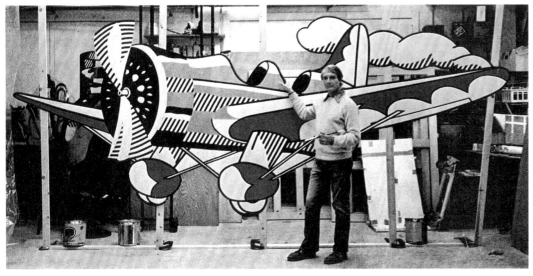

Lichtenstein in his studio with *Airplane* (1978; private collection) created for the set of Kenneth Koch's play *The Red Robins* (1977). Published in *L'Espresso*, May 30, 1982.

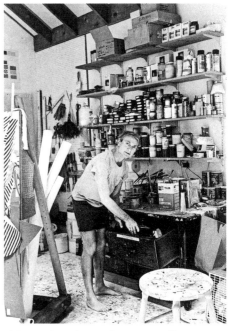

Lichtenstein at the Southampton studio working with his paints, late 1970s. Photographer unknown.

NOV. 12 – 26 Invited by Anand Sarabhai to visit his home in Ahmedabad, India, designed by Le Corbusier for Anand's mother, Manorama Sarabhai. There, makes several textile works on canvas and Mirrors in sandstone and marble. Prepares teakwood blocks for *Goldfish Bowl*, *Lamp*, and *Picture and Pitcher* (each, edition of thirty) but is unable to print them because blocks are warped. Prints them the following spring after Tyler Graphics fixes them.

1979

JAN. 12 Stage prop of an airplane (1978; private collection), made from Magna and tape on foam core mounted on wood, for American poet Kenneth Koch's novel-turned-play *The Red Robins* (1975) debuts at Saint Clement's Church on W. 46th Street. Made from tape, Magic Marker, and collaged elements, a replica by artist Vanessa James is used in the show to avoid wear and tear.

Makes last Surrealist-inspired works.

Begins German Expressionist–inspired works based on paintings and woodcuts by artists such as Erich Heckel, Franz Marc, and Karl Schmidt-Rottluff.

MAY Awarded honorary doctorate of fine arts from Southampton College in New York.

MAY 23 Elected to the American Academy of Arts and Sciences, New York.

JULY First outdoor public sculpture commission, *Mermaid* (1979; Miami Beach Theater for the Performing Arts), is installed. The twenty-four-foot-high painted steel work fabricated by Tallix is poised on three concrete waves in a fountain pool. A live palm tree planted near the head of the sculpture completes the ensemble.

JULY 11 London premiere of BBC profile re-creates Bowery studio, and films him at work in the Southampton studio.

OCT. 25 Designs *Untitled Shirt* using mirror motif in an edition of 150 in collaboration with the Fabric Workshop, Philadelphia, for Artists Spaces's sixth-anniversary fund-raising party at the Mudd Club.

1980

Makes numerous Expressionist Heads in sculpture and on canvas, along with Expressionist-inspired Nudes in Landscape paintings.

Combines loosely painted brushstrokes with constructed Abstract Expressionist brushstrokes in series of single and grouped apple drawings and several canvases based on the conceit of cartoon-style brushwork.

Creates an *American Flag* canvas, which he later destroys.

MAY Sketches some designs for a tea set commissioned by Rosenthal Glas und Porzellan AG; the edition of one hundred is completed in late 1984.

SEPT. 25 Isabel Lichtenstein (1921–1980) dies.

1981

MAY 8 – JUNE 28 Exhibition of paintings and sculptures from the period 1970–80 at Saint Louis Art Museum, organized by Jack Cowart; the show travels to museums in the United States, Europe, and Japan.

OCT. 4 – NOV. 25 The Whitney Museum's downtown branch on Wall Street showcases graphic work from the period 1971–81.

OCT. 17 – NOV. 7 Leo Castelli presents new works, featuring renditions of apples on canvas.

Painting a small sketch on acetate projected onto canvas, creates four Woman paintings using modified Abstract Expressionist brushstrokes based on Willem de Kooning's third Woman series from the late 1950s. Other subjects include apples, sailboats, and forest scenes. Before Magna is applied, uses collaged cutouts of painted brushstrokes to determine the final composition and palette.

1982

JAN. – FEB. Travels to Egypt.

APR. 1 Participates in round table discussion for exhibition *Roy Lichtenstein at Colorado State University*, April 1–30.

JUNE Submits three-dimensional maquette for tallest sculpture to date, *Brushstrokes in Flight*, to a national competition sponsored by the City of Columbus for an international airport.

Sets up studio at 105 E. 29th Street between Lexington and Park Avenues, next to the Hotel Deauville, on the seventh floor.

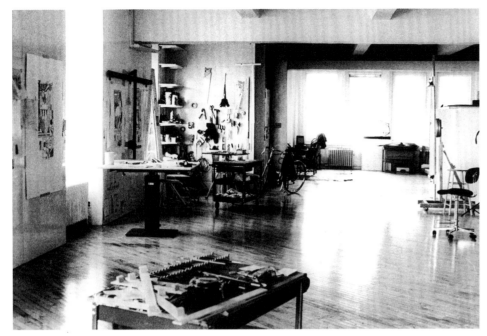

Lichtenstein's studio at 105 E. 29th Street, 1984.
Photographer unknown. The Roy Lichtenstein
Foundation Archives.

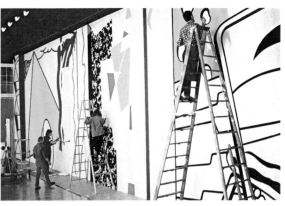

Lichtenstein working on the *Greene Street Mural*,
Dec. 1983–Jan. 1984.

Begins series of paintings incorporating a frame motif, and Paintings and Two Paintings series, in which two contrasting images are ambiguously linked by a single or hybrid frame motif. Reference to Johns's flagstones appears in one canvas.

AUG. 8 – SEPT. 19 *Look Mickey*, *Popeye* (fig. 3, p. 28), and *Wimpy (Tweet)* (1961; private collection) are exhibited for the first time at the Parrish Art Museum in Southampton. Carey Clark helps to put early pre-Pop drawings in early American frames, and becomes full-time framer.

1983

WINTER Petersburg Press publishes Seven Apples, a series of seven-color woodcuts in an edition of sixty each.

MAR. Selected to design, execute, and install *Brushstrokes in Flight* (1984; Collection of the Columbus Regional Airport Authority) near the central courtyard at the airport entrance. In June 1985, it is moved indoors for better visibility.

MAR. 21 Poster for UN Special Committee Against Apartheid is published by Galerie Maeght-Lelong in Paris.

OCT. 4 – DEC. 4 Contributes design to Brooklyn Academy of Music Next Wave Festival.

Publication of monograph by Alloway. Includes "Notes on Technique."

DEC. 3 – 11 Creates ninety-foot-long mural on the wall of Castelli's Greene Street gallery space, a compilation of many motifs from earlier works. It is on view until January 14, 1984, then covered with sheet rock and destroyed. Robert McKeever works on *Greene Street Mural* and eventually becomes part-time studio assistant in New York.

Designs logo for the Visual Arts Center at OSU, a yellow brushstroke on a blue grid background.

1984

Returns to New York part-time to live and work on E. 29th Street. The east wall has a Formica surface that he can draw on or tape things to, and it has windows along the north and south. Big paintings are difficult to fit in the elevator. Paints an image of Swiss cheese on elevator doors. Olivia Motch is administrative assistant. McKeever works part-time as studio assistant until the end of 1985 and thereafter full-time.

SPRING Joins board of directors of the Studio in a School Association, a not-for-profit organization that brings art experiences and artists to New York City public elementary schools.

MAY 3 Commissioned to create a mural for the lobby of the Equitable Tower (now AXA Equitable Center) in midtown Manhattan. The skyscraper, designed by Edward Larrabee Barnes and developed by Tishman Speyer Properties, is completed in early 1986 and features a five-story sky-lit atrium. In December, submits maquette for *Mural with Blue Brushstroke* (1984–86) out of preparatory drawings collaged together. References to Léger, Entablatures, and early Pop imagery as well as other art historical motifs feature prominently in the final design.

SEPT. Castelli arranges the commission for a large-scale outdoor sculpture for the Walker Art Center.

SEPT. 20 – DEC. 2 The Whitney Museum presents *Blam! The Explosion of Pop, Minimalism, and Performance*, organized by Barbara Haskell.

1985

NOV. 21 Sketching for *Mural with Blue Brushstroke* begins on the wall of the Equitable Tower, and painting begins December 7.

Sketches out a logo on a cocktail napkin for the Hampton Jitney Company for their "Riding the Wave" campaign. Logo appears on its buses beginning in 1989.

1986

JAN. *Mural with Blue Brushstroke* completed.

FEB. 15 Made from painted and fabricated aluminum and standing over twenty-five feet high, *Salute to Painting* (1986; Walker Art Center, Minneapolis) is dedicated at the Walker Art Center.

SPRING Perfect and Imperfect paintings, featuring compositions of generic geometric abstraction that feature a single line that bounces from one edge of the canvas to the other, sometimes breaking the boundary of the canvas.

Approached by Taittinger to design a bottle for their champagne. Result is introduced on October 16, 1990, in Paris. Some one thousand wine glasses with the same image are distributed with the bottle.

1987

MAR. 15 – JUNE 2 MoMA mounts a major drawings retrospective, organized by Bernice Rose, the first show of drawings by a living artist ever presented by the museum. The show travels to museums in the United States and Europe.

SUMMER Designs the exterior of a mirrored glass labyrinth funhouse for André Heller's traveling amusement park *Luna Luna* in Hamburg, with piped-in music by Philip Glass.

NOV. Visits Israel for the first time for opening of drawings show at the Tel Aviv Museum of Art. Discusses the possibility of a permanent mural for the museum with director Marc Scheps.

Creates diptychs *Painting with Detail (Blue)* (1987; private collection) and *Painting with Detail (Black)* (1987; Robert and Jane Meyerhoff Collection), in which a full field of blue and black Benday dots, respectively, appear alongside a much smaller counterpart.

Creates several American flaglike compositions from diagonals and Benday dots called *Forms in Space* in a variety of media.

1988

Begins Reflections series in Southampton, incorporating quotations of both previously depicted and new comic strips, a motif not fully used since the 1960s. Comes upon the idea while trying to photograph a Rauschenberg print under glass.

Creates sculptures of heads in patinated bronze on the themes of the archaic and the surreal and those of Constantin Brancusi.

Returns to the idea of creating drawings in black-and-white.

Coups de Pinceau (1988; Caisse des Dépôts, Paris), a thirty-one-foot-high aluminum Brushstroke sculpture, is installed at the Caisse des Dépôts et Consignations in Paris.

First German-language monograph devoted to pre-Pop works is written by Ernst A. Busche.

Begins Plus and Minus series based on works by Mondrian.

Commissioned to design a poster for the California campaign of Democratic presidential candidate Michael Dukakis. A black border added by the campaign is not part of the original design.

SPRING Patricia Koch replaces Motch as administrative assistant.

MAY Sets up a studio and residence in a 1912 building at 745 Washington Street. A former steel fabricating business, it is renovated by architect David Piscuskas of the firm 1100 Architect. Reestablishes easel walls around the perimeter. Divides time between Southampton and Manhattan. Robert McKeever becomes New York studio assistant.

JUNE Receives honorary doctorate of humanities from OSU.

NOV. 16 – MAY 1989 *Brushstroke Group* (1987; private collection), a thirty-foot-high painted aluminum sculpture, is installed in Central Park's Doris C. Freedman Plaza in Manhattan as part of the Public Art Fund's project to install temporary installations on public sites in New York.

Designs second shopping bag, produced by Dayton Hudson Department Store Company, to celebrate the inauguration of the Minneapolis Sculpture Garden in cooperation with the Walker Art Center and the Minneapolis Park and Recreation Board. The bag features Brushstrokes on a field of Plus and Minus imagery.

1989

MAR. 15 – MAY 15 Artist-in-residence at the American Academy in Rome. Sees highway sign advertising furniture, which spurs him to look through the Rome yellow pages for similar imagery. Begins thinking about doing a series of Interiors based on findings.

APR. 8 – 14 Travels with studio assistants to Tel Aviv to begin work on a large mural for the entrance hall of the Tel Aviv Museum of Art. Signs the completed mural on May 7.

SUMMER Begins work on *Bauhaus Stairway: The Large Version*, a mural for a building designed by I. M. Pei for Creative Artists Agency in Beverly Hills and commissioned by collector and agency founder Michael Ovitz.

JUNE Commissioned by the Metropolitan Transportation Authority of the State of New York (MTA) to create *Times Square Mural* (1990, fabricated 1994; MTA, New York) at the subway station at 42nd Street and Times Square. Plan is scrapped, but decides to fabricate the sixteen panels of porcelain enamel on steel. In 2002, they are posthumously installed by Polich ArtWorks for the MTA Arts for Transit program. They feature science fiction themes in a *Buck Rogers* futuristic style similar in feel to the 1964 *Art in America* panorama cover illustration and the 1965 print *This Must Be the Place*.

1990

WINTER Begins Interiors series, involving painting with sponges. Many feature paintings hanging on walls that the artist wanted to try out but not paint as full-fledged works. Uses the conceit of a room corner in most compositions.

JAN. Commissioned by composer Steve Reich to create a cover design for recording called *The Four Sections*. The cover and accompanying promotional poster are published by Elektra Entertainment, New York, the following year.

Sherrie Levine appropriates several of his comic-strip paintings and prints in her 1990 mixed-media work *Collage/Cartoon*.

SUMMER Laurie Lambrecht begins to work part-time in New York and Southampton, replacing Koch.

SEPT. Cassandra Lozano joins the New York studio full-time, and Lambrecht begins to work in the summers only until 1992.

Roy Lichtenstein. *Barcelona Head*, 1992. Concrete and ceramic; 1956 × 664 × 465 cm (770 × 261 ½ × 180 in.) overall. City of Barcelona.

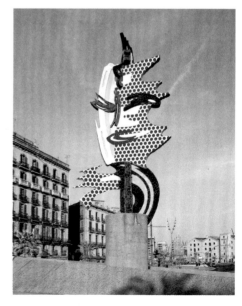

OCT. 7 – JAN. 15, 1991 Some comic-book sources are researched and shown for the first time in MoMA's *High and Low: Modern Art and Popular Culture*, an exhibition of twentieth-century art that includes source materials and related ephemera.

Creates costume designs for André Heller's unrealized *Pyramid Opera*, which was to star soprano Jessye Norman. The headdress is later made and worn by Maria Bill for Heller's opera *Sein und Schein*, which debuts in Salzburg, Vienna, at the Burgtheater on January 19, 1993. Also participating in the opera project are Mimmo Palladino, Keith Haring, and Andy Warhol.

1991

APR. 2 – JUNE 16 Two Interior paintings are included in Whitney Museum's Biennale.

APR. 25 Receives Brandeis University's Creative Arts Award.

MAY 15 – OCT. 31 *Modern Head* (1974/1989; Smithsonian American Art Museum, Washington, D.C.), based on a 1974 metal, wood, and polyurethane sculpture at the Santa Anita Fashion Park in Arcadia, California, is installed in Battery Park City in Lower Manhattan. The work is later recovered after the September 11, 2001, attacks on the World Trade Center.

FALL In collaboration with Saff Tech Arts, located in Oxford, Maryland, begins making enamel prints (on stainless steel with wooden frames) based on Monet's late Water Lilies.

OCT. Creates a sculpture based on the image of an African mask in *Interior with African Mask* (1991; Eli and Edythe L. Broad Collection, Los Angeles). It is fabricated at Tallix in versions of galvanized steel, tin-plated bronze, zinc-plated bronze, and pewter, in editions of six.

Creates ten collage studies for screen prints to be illustrated in *Nouvelle chute de l'Amérique*, a limited-edition unbound book published in 1992 by Les Éditions du Solstice to accompany eleven Allen Ginsberg poems under the title *Fall of America*. Etchings and aquatints are pulled on a handpress at Atelier Dupont in Visat, Paris. Each edition is signed and numbered by both.

Creates landscape mobiles in porcelain and cast resin.

1992

JUNE Approached by dealer Ronald Feldman to help fund-raise on behalf of the Democratic National Committee and Democratic senatorial campaigns. Creates a print of the Oval Office to benefit ten female senatorial candidates. A poster is also created.

JUNE 12 Made Commandeur de l'Ordre des Arts et des Lettres by the French Republic.

JULY Inspired by the work of Catalan artist Antoni Gaudí, creates *Barcelona Head* (1992; Ajuntament de Barcelona), a sixty-four-foot-high sculpture made of colored ceramic tiles, commissioned for the summer Olympics in Barcelona, Spain. It is installed on the site of the former naval yard where Christopher Columbus docked his ships.

Creates an interior inspired by Vincent van Gogh's *The Bedroom* (1889; the Art Institute of Chicago).

DEC. 6 – MAR. 7 The Museum of Contemporary Art, Los Angeles, presents *Hand-Painted Pop: American Art in Transition, 1955–62*, organized by Paul Schimmel and Donna De Salvo, devoted exclusively to the early years of the Pop art movement in the United States. Pre-1960s works such as *Washington Crossing the Delaware I* (c. 1951; cat. 61) and several semiabstract drawings of cartoon characters from 1958 are included. The show travels to two other U.S. museums.

1993

JAN. Painting *Oval Office* (1993; Roy Lichtenstein Foundation Collection) is finished.

MAY Produces cover and frontispiece for Tuten's book, *Tintin in the New World: A Romance* (William Morrow), which features Tintin, a character created by Belgian artist Hergé.

JULY 9 Receives honorary doctorate from the Royal College of Art, London.

JULY – AUG. Creates *Large Interior with Three Reflections* (1993; private collection), a mural consisting of a thirty-foot-long triptych and three additional panels, for the Revlon Corporation in New York.

OCT. Completes *Brushstroke Nude* (1993; fig. 14, p. 101), a twelve-foot-high painted aluminum sculpture fabricated at Tallix.

OCT. 8 – JAN. 16, 1994 The Solomon R. Guggenheim Museum presents *Roy Lichtenstein*, a retrospective survey of paintings and sculpture. Designs cover for museum's magazine. The exhibition travels to the Museum of Contemporary Art, Los Angeles; and Museé des Beaux-Arts, Montreal; pre-Pop works are added to the venues at the Haus der Kunst, Munich; Deichtorhallen, Hamburg; and the Palais des Beaux-Arts, Brussels. The tour concludes with a smaller exhibition at the Wexner Center for the Arts, Ohio.

OCT. 23 – NOV. 27 New series of paintings, including one of Tintin, premieres at Leo Castelli.

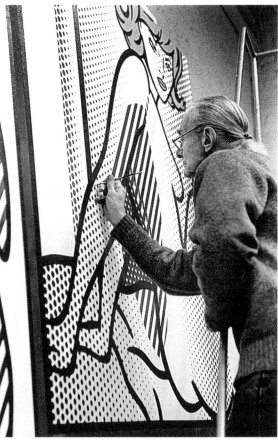

Lichtenstein working on *Interior: Perfect Pitcher* (1994; private collection) at the 745 Washington Street studio. Photograph by Gianfranco Gorgoni.

DEC. 23 Receives Amici de Barcelona award from Mayor Pasqual Maragall, L'Alcalde de Barcelona.

Begins a series featuring the female nude.

1994

JAN. *Roy Lichtenstein: The Artist at Work* (Lodestar) by Lou Ann Walker is published. Designed to teach children eight to twelve years old about art, it includes photos by Michael Abramson of the artist at work in his studio.

MAY Unveils designs for the hull and sails for PACT 95's yacht, *Young America*, featuring an image of a mermaid on the hull.

OCT. *The Prints of Roy Lichtenstein: A Catalogue Raisonné* (Hudson Hills Press, in association with the National Gallery of Art, Washington), by Mary Lee Corlett is published. The book appears in conjunction with the prints retrospective that opens that month at the National Gallery of Art. The show later travels to LACMA and to the Dallas Museum of Art.

NOV. 19 – DEC. 17 First series of Nudes is shown at Leo Castelli, inspired by Picasso's 1928 beach series. Graduated dots represent chiaroscuro.

Exhibition poster for *Roy Lichtenstein: Landscapes in the Chinese Style*, Museum of Fine Arts, Boston, Mar. 19, 1997–July 6, 1997.

Lichtenstein in his studio.
Photograph by Zubin Shroff.

360

1995

Continues to create Interiors, some of which he refers to as "virtual paintings," which feature colored, instead of black-only, outlining.

MAR. 31 The *New York Times* publishes "At the Met with: Roy Lichtenstein," an interview conducted by chief staff art critic Michael Kimmelman on the artist's favorite pieces at the museum.

JUNE 8 Donates *Composition III* (1995; edition of 186), based on the motif of musical notes, to the Friends of Art and Preservation in Embassies; 175 copies of the print hang in U.S. embassies.

OCT. Selected by Capuchin monks to design and execute two murals for Chapel of the Eucharist, the Padre Pio Pilgrimage located in San Giovanni Rotondo in Apulia, which is to be designed by Renzo Piano. The site centers on the tomb of Saint Pio of Pietrelcina, a Capuchin friar, priest, and mystic, and is the second-most-visited Roman Catholic shrine in the world.

OCT. 5 Receives the National Medal of Arts at a gala ceremony in Washington, D.C., presented by President and Mrs. Clinton.

NOV. 10 Receives Kyoto Prize from Inamori Foundation, Kyoto, Japan. Travels to Kyoto to accept the award and deliver a lecture on his work.

Inspired by monotype and pastel landscapes of Edgar Degas at the Metropolitan Museum of Art in 1994, begins a large series of Song Dynasty–inspired mountain views that he refers to as Landscapes in the Chinese Style. First makes a series of sketches and creates collages using shapes cut from sheets of printed Benday dot paper in graduated sizes to create monochromatic tonalities that simulate atmospheric effects.

Creates self-portrait, entitled *Coup de chapeau (Self-Portrait)* (1996; private collection).

1996

MAY 19 Awarded honorary doctorate of fine arts from George Washington University in Washington, D.C.

AUG. Designs logo for DreamWorks Records, a subsidiary of the film company DreamWorks SKG, founded by David Geffen, Steven Spielberg, and Jeffrey Katzenberg. It features a musical note within a dialogue balloon.

SEPT. 21–OCT. 26 *Roy Lichtenstein: Landscapes in the Chinese Style* is presented at Leo Castelli.

DEC. Donates 154 of his prints and two books spanning his career to the National Gallery of Art, Washington, making it the largest repository of his prints.

MAY Creates a foam core maquette and a collage for a hologram of a domestic interior commissioned by the C-Project based in Miami Beach. Unhappy with the results, abandons the idea. Concurrently begins work on maquettes of sculptures of a Pyramid and several Houses that rely on inverted angles to create the illusion of three-dimensionality.

Embarks on a series of sculptures based on brushstrokes and drips.

Sculptures of Houses play with the idea of perspective similar in feel to diagrams in Sherman's book *Drawing by Seeing* (Hinds, Hayden & Eldredge, 1947).

Creates a collage and two drawings called *Mickasso* (1996; fig. 8, p. 44), which play on the Disney character Mickey Mouse and Picasso's Cubist style.

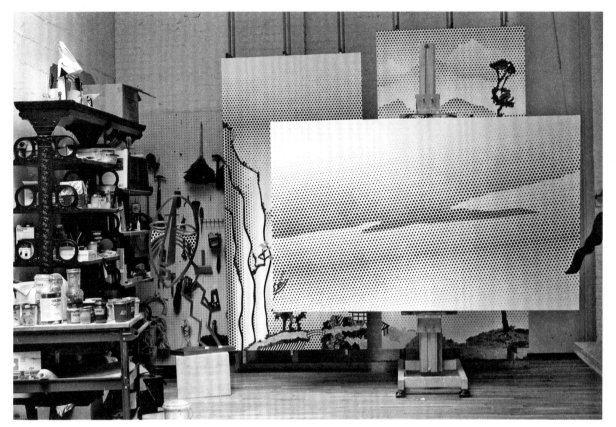

The Washington Street studio, summer 1996. Pictured are (front) *Landscape with Boat* (cat. 125), (behind, left to right) *Landscape with Bridge* (private collection) and *Landscape with Tall Tree* (private collection) (all 1996). Photograph by Cassandra Lozano.

Approached by NARAL to design a button to promote choice, creates a design featuring a hanger within a red circle with a diagonal line through it. The design is never produced.

1997

No longer able to find Bocour Magna paints, begins using Mineral Spirit Acrylics (MSA) by Golden Artist Colors, Inc., instead.

Completes over one hundred drawing and collage studies and a number of paintings of various virtual-style Interiors that feature tableaux of tables and chairs combined with female figures, still lifes, and other classical references.

Works on a number of prints, including one for Leo Castelli's *90th Birthday Portfolio* (edition of ninety) along with *Cubist Cello* (1997; edition of seventy-five) which features references to Marc Chagall in support of the Roy Lichtenstein Study Center for Contemporary Art at the Tel Aviv Museum of Art.

Embarks on a series of prints with Saff and Company that are meant to feature hand-painted brushstrokes; only one of the three prints (edition of twenty-four) is completed by the artist before his death.

Sketchbooks evidence drawings after Cézanne's Bather series.

APR. 9 Dedication of the Roy Lichtenstein Study Center for Contemporary Art by the American Friends of the Tel Aviv Museum of Art, Israel.

APR. 30 Interviewed by David Sylvester. The interview is one of the last ever given by the artist.

MAY Last major outdoor sculpture, comprising six large pieces, *Singapore Brushstroke* (1996; Millenia Pte Ltd.), is installed at the Pontiac Marina in Singapore.

JUNE 15 – NOV. 9 The 47th Venice Biennale opens. *House II* (1997; edition of one), a composite construction with fiberglass of a house exterior, is shown at the Italian Pavilion in the exhibition *Future, Present, Past*, curated by Biennale commissioner Germano Celant.

SEPT. 5 – OCT. 7 Galerie Lawrence Rubin in Zurich presents an exhibition of new Interior paintings. Sylvester's interview is published in the catalogue.

SEPT. 29 Dies unexpectedly at New York University Medical Center in Manhattan from complications due to pneumonia.

The oral histories conducted by Avis Berman for the Roy Lichtenstein Foundation have provided invaluable insight into Lichtenstein's life and work. Other invaluable sources include Lichtenstein's Ohio State University (OSU) transcripts; Richard Brown Baker's interview with the artist conducted in New York for the Archives of American Art, Smithsonian Institution, Washington, D.C., on November 15 and December 6, 1963, and January 15, 1964. Lichtenstein's letters home from 1942–45 provided specifics pertaining to, among other things, artworks he was then working on. Other facts have been culled from catalogue raisonné research conducted for the Roy Lichtenstein Foundation and from *The Prints of Roy Lichtenstein: A Catalogue Raisonné, 1948–1993* (Hudson Hills Press, in association with the National Gallery of Art, Washington, 1994), as well as from numerous published and unpublished interviews with and statements by the artist.

INDEX

Illustrations are in italic.

À Pablo Picasso (Éluard, 1944), 44n11
Abstract Expressionism, 24, 27, 38, 42,
 49–50, 83, 345, 356
Abstraction (Fabric) (Lichtenstein, 1978),
 79, 86n3–4
Abstraction (Studies) (1975; cat. 147), *322*
abstraction, Lichtenstein's use of, 68, 71n31,
 78, 80–85, *108–11*
Académie des Beaux-Arts, 64–65
adequation, 31–32, 35n33
Airplane (Lichtenstein, 1978), *356*
Airplane (Study) (1977; cat. 152), *326*
Airplane (Study) (1989; cat. 161), *333*
album leaf format, Chinese, 89
Alka Seltzer (1966; cat. 139), *312–13*
Alloway, Lawrence, 63, 64, 70n7, 86n15,
 348, 357
Aloha (Lichtenstein, 1962), *347,* 348
American Flag (Lichtenstein, 1980;
 destroyed), 71n31, 356
American Indian themes in Lichtenstein's
 art, 38, *82, 83, 218,* 343, 344, 355
American Revolution Bicentennial
 Administration poster (Lichtenstein,
 1976), 355
Amerind Figure (1981; cat. 79), *218*
Anderla, Wayne, 342
Andre, Carl, 70–71n19
Aphrodite of Knidos (Praxiteles, c. 4th
 century B.C.), 103, *104*
Archaic Head VI (1988; cat. 80), *219*
*Architecture of the École des Beaux-Arts,
 The* (MoMA exhibit and Drexler
 catalogue), 64, 65
Aristotle, 52
Art (Lichtenstein, 1962), 347
Art About Art Cover (Studies) (1978; cat.
 153), *326,* 355
Art and Technology (LACMA, 1971), 53, 56,
 57, 354
Art and Technology Program (LACMA), 53,
 55–57, 61, 352, 354
Art Deco, 41, 49, 66, 71n20, 80, 352
Art in America cover (Lichtenstein, 1964),
 349, 358
Art Institute of Chicago, Lichtenstein at,
 13, 14
Artist and Model Reflected in a Mirror
 (Matisse, 1937), *99*
Artist's Key Club, 350
Artist's Studios (Lichtenstein, 1973–74)
 (cats. 105–08), 31, 50, 72–77, 83–84,
 85, 87n32, *262–67,* 355
Artist's Studio (Lichtenstein, 1973), 45n44,
 72, 72–73, 87n32
Artist's Studio "Foot Medication" (1974; cat.
 107), 73, 75, 77, 83, 87n32, *266–67*
Artist's Studio "Look Mickey" (1973; cat.
 104), 50, 73–74, *74,* 87n32, *262–63*
Artist's Studio "The Dance" (1974; cat. 106),
 74, 76, *77,* 77n7, 87n32, *265*
Artist's Studio with Model (1974; cat. 105),
 75–76, 83, 87n32, 96, *264*
As I Opened Fire (Lichtenstein; 1964; cat.
 40), *166–67,* 350
Ashton, Dore, 22, 44n26, 348
At the Beach (Lichtenstein, 1978), 87n30
Atom, The (1975; cat. 73), *210*
Avant-garde, 47–51, 60, 67
"Avant-Garde and Kitsch" (Greenberg,
 1939), 47

Bader, Graham, 26–27, 32–33, 34n8, 35n40,
 53–54
Bærtling, Olle, *80,* 81, 86n14
Baigneuses au ballon (Picasso, 1928), *96,* 97
Baked Potato (Lichtenstein, 1961), 346
Baker, Richard B., 37, 39
Baldus, Edouard, 63
Ball of Twine (Lichtenstein, 1963; cat. 24),
 142
Balzac, Honoré de, 27
Bananas and Grapefruit (Lichtenstein, 1972),
 87n32
Barcelona Head (Lichtenstein, 1992), 359
Barozzi da Vignola, Giacomo, 70n8
Barthes, Roland, 27, 40, 43, 45n52
Baseball Manager (Lichtenstein, 1963), 72,
 73, 87n32, 349
Baseball Manager (Study) (c. 1963; cat. 132),
 306
Baselitz, Georg, 84
Basquiat, Jean-Michel, 84
Bathers (Cézanne), 96, 102, 361
Bather with Beach Ball (Picasso, 1932), 96
Bathers, The (Picasso, 1918), 104n8
Bathers by a River (Matisse, 1916–17), 104n3
Bathroom (Lichtenstein, 1961), 346
Baudrillard, Jean, 82
Bauhaus Stairway: The Large Version
 (Lichtenstein, 1989), 358
Beach Scene with Starfish (Lichtenstein,
 1995), *96,* 97
Beauty and the Beast I and *II* (Lichtenstein,
 1949), 38
Beaux-Arts, 64–65, 66
Beckley Perforating Company, *28,* 35n18–19,
 347, 352, 353
Bedroom, The (Lichtenstein, 1990), 87n34
Bedroom, The (van Gogh, 1889), 359
Bedroom Unique State (Lichtenstein, 1990),
 87n34
Bell, Clare, 54, 86n11
Benday dots. *See* dots and dot-making
Benny, Jack, 55
Berman, Avis, 83, 361
Best Buddies (Lichtenstein, 1991), 87n30
Bickerton, Ashley, 82
Birillo, Ben, 349
Black and White series (Lichtenstein,
 1961–66), *134–47*
Black and White Head (1966; cat. 28), *147*
Black Flowers (Lichtenstein, 1961), 346
Blam (Lichtenstein, 1962), 347
La blanchisseuse (Daumier, 1863), 342
Blonde (Lichtenstein, 1964–65), 101
Blue Nude (1995; cat. 113), 95, 98, 99, 100,
 278–79
Blue Nude (Matisse, 1907), *95*
Blue Nude paper cutouts (Matisse,
 1952–54), 95
blushing in Lichtenstein's art, *26,* 26–28, 33,
 34, 34n3
Bofill, Ricardo, 65
Bois, Yve-Alain, 62, 79, 80, 86n23, 87n33,
 87n43
Bradley, Carolyn, 342, 343
Brakhage, Stan, 59
Brancusi, Constantine, 358
Braque, Georges, 38, 80, 354
Brassaï (Gyula Halász), 101
Brata Gallery (New York), 81
Bratatat! (1962; cat. 35), *159,* 347
Bread with Bag (Lichtenstein, 1961), 346
Brecht, George, 346
Breer, Robert, 59
Bright Night, A (Lichtenstein, 1978), 87n30
Brushstrokes (Lichtenstein, 1965–71), 21, 50,
 68, 83, *176–79, 350,* 351, 354
Brushstroke Abstraction I (1996; cat. 5), *113*
Brushstroke Abstraction II (1996; cat. 6), *114*
Brushstroke Group (Lichtenstein, 1987), 358
Brushstroke Nude (Lichtenstein, 1993), 100,
 101, 359
Brushstroke with Still Life I (Lichtenstein,
 1996), 92
Brushstroke with Still Life IV (1996; cat. 4),
 112
Brushstroke with Still Life VII (1996; cat.
 7), *115*
Brushstrokes (1965; cat. 47), 50, 75, *176*
Brushstrokes in Flight (Lichtenstein, 1984),
 356, 357
Brushstroke with Spatter (1966; cat. 49), 13,
 50, *178–79*
Burnham, Jack, 57
Bute, Mary Ellen, 52

Catlin, George, 343
calligraphy, in Chinese aesthetic, 92
Cape Cod Still Life (Study) (1972; cat. 145),
 319
Captive, The (Proust), 27
Card Players, The (Cézanne, 1890–92), 342
cartoon/comic-book style and sources, 21,
 22, 25n17, *27, 29, 29,* 31, 33, 35n21,
 46–48, *48,* 64, 68, 71n34, 74–75, 79,
 79, 94, 97, 98, 101–02, 345, 348, 358
Casolaro, Hugo, 354
Castelli, Leo, 13, 23, 39, *346,* 348, *349,* 354,
 356, 361
Ceramic Sculptures (Lichtenstein, 1965–66),
 72, 87n32, *349,* 350, 351
Ceramic Sculpture 7 (1965; cat. 27), *146*
Cézanne, Paul, 46, 48, 52, 64, 95, 96, 102,
 342, 347, 361
Cézanne's Composition (Loran), 48. See
 also Loran, Erle
Chagall, Marc, 361
Chapel of the Eucharist, Apulia,
 Lichtenstein's murals for (1995), 360
Chaplin, Charlie, 59
Chardin, Jean-Baptiste-Siméon, 22
Cherokee Brave, A (Lichtenstein, 1952), 344
Chin, Mel, 87n37
Chinese aesthetics of landscape, 88–93,
 89–92, 292–97, 342, *360*
Chinese Gallery (New York), 88, 343
Christ on the Cross Adored by Two Donors
 (El Greco, ca. 1590), 342
chronology, 340–61
cinema. *See* film, Lichtenstein's use of
Cityscape (Lichtenstein, 1995), 87n35
Clark, Carey, 356
Clark, Edward, *81,* 86n19
Claude Lorraine glass, 61
cliché, Lichtenstein's use of, 20, 22, 25n15,
 33, 42, 54, 64, 67, 70n9, 71n21, 75, 77
Cold Shoulder (1963; cat. 33), *156–57*
Collage/Cartoon (Levine, 1990), 358
Collage for Landscape in Fog (Lichtenstein,
 1996), 91–92, *92*
Collage for the Waldo Times Cover
 (Lichtenstein, 1992), 87n34
Colosseum, Rome, Duc's restoration of
 (1830), 64–65, *65*
Columbus, Christopher, 359
comic book/cartoon style and sources. See
 cartoon/comic book style and sources
Composition (Lichtenstein, 1959), 38
Composition (No. 1) Gray-Red (Mondrian,
 1935), *49*
Composition III (Lichtenstein, 1995), 359
Compositions (Lichtenstein, 1964–65), 32,
 49, 68
Compositions I (1964; cat. 26), 32, 49,
 144–45
Conceptualism, 81–82

362

Constructivism, 352, 355
Cooper, Harry, 71n34
Coplans, John, 34, 352, 354
Cosmology (Lichtenstein, 1978), 87n30
Couch (Lichtenstein, 1961), 73, 87n32
Counter-Reliefs (Tatlin, 1913-14), 81
Coup de Chapeau (Self-Portrait)
 (Lichtenstein, 1996), 25n29, 360
Coup de Chapeau I (Lichtenstein, 1996),
 25n30
Coup de Chapeau II (Lichtenstein, 1996),
 25n30
Coups de Pinceau (Lichtenstein, 1988), *358*
Cow Triptych (Cow Going Abstract)
 (Lichtenstein, 1974), *82*
Craven, Thomas, 37, 341
cropping, 30-32, 71n34, 347
Crow, Thomas, 43
Crying Girl (Study) (1964; cat. 133), *307*
Cubism: Artist's Studios and, 73, 77n8;
 Entablatures and, 65, 66, 71n20, 354;
 Modernism, Lichtenstein's relationship
 to, 49; Nudes and, 97; Perfect/
 Imperfects and, 80, 81; Picasso,
 Lichtenstein, and, 37, 38, 39, 41, 44, 49
Cubist Cello (Lichtenstein, 1997), 361
Cubist Still Life (1974; cat. 75), *212-13*
Cubist Still Lifes (Lichtenstein, 1973-75), 73,
 212-13, 355
Cup of Coffee (1961; cat. 15), *128*, 346
Cybernetic Serendipity (Institute of
 Contemporary Art, London, 1968),
 61n16

Dalí, Salvador, 52-53, 96, 351
Daly, César, 63
Dance, The (Matisse, 1909-10), 74
Daoism, 89, 91, 92
D'Arcangelo, Allan, 352
Darwin, Charles, 26, 34n2-3
Daumier, Honoré, 342
David and Bathsheba lithograph series
 (Picasso, 1947), 38
Day, Benjamin, Jr., 29
Dayton Hudson Department Store Company
 shopping bag (Lichtenstein 1988), 358
de Kooning, Willem, 34n15, 38, 60, 356
de Pasquale, James, 86n4, 86n11, 355
De Stijl, 49, 355
Death of the General (c. 1951; cat. 128), *301*,
 344
Degas, Edgar, 360
Delacroix, Eugène, 40, 44n24, 48
Deleuze, Gilles, 32
Demoiselles d'Avignon (Picasso, 1907), 95
Desk Calendar (1962; cat. 22), *138-39*
Desk Explosion (Study) (c. 1965; cat. 137),
 310
Deux femmes (Two Women) (Picasso,
 1935), 43
dialogue balloons, 51n26, 349, 350, 355,
 360
Diamond Cut Series (Zox, 1966), *84*
Didion, Joan, 355
Dietcher, David, 60
Dine, Jim, 345, 347, 348, 349
Disney Corporation, 27
Disney, Walt, 27
Divisionism, 29
Donald Duck, 26-27, *27*, 34n8, 345
Donald Duck (1958; cat. 129), *302*
Donald Duck Lost and Found (Buettner,
 1960), as source for Lichtenstein's
 Look Mickey, *27*
dots and dot-making, 26-34; evolution
 of Lichtenstein's technique, 25n4,
 28-30, 28-34, *32-34*, 35n20, 347,
 348, 350, 352, 353, 355, 358, 360; and
 use of film, 53, 54, 55, 58, 59, 354;
 historical background, 29; in Chinese
 Landscapes, 90-91; *Look Mickey*
 (1961; cat. 8), *26*, 26-29, *27*, 31, 35n24;
 Modernism, Lichtenstein's relationship
 to, 49, 50; in Nudes, 33, 97, 98, 99, 101,
 102, 359

Drawing by Seeing (Sherman, Mooney, and
 Fry, 1947), *58*, 360
Drawing for Foot Medication (Lichtenstein,
 1962), 87n32
Drawing for Landscape (Lichtenstein, 1973),
 87n32
Nude (Study) (Lichtenstein, 1997), *103*
DreamWorks Records logo (Lichtenstein,
 1996), 360
Drexler, Arthur, 64, 65
Drowning Girl (1963; cat. 32), 32, 39, 48,
 155, 348, *351*
Duc, Louis, 64-65, *65*
Duchamp, Marcel, 24, 24n31, 52, 68, 348
Dukakis, Michael, 358
Duridium (Lichtenstein, 1964), 349
Durkee, Stephen, 348
Dutch angle in film-making, 59

early Pop paintings (Lichtenstein, 1961-63),
 30, 68, 82, *118-31*
École des Beaux-Arts, 64-65
Edo period (1615-1868) painting, *48*, 90
Eisenhauer, Letty Lou, 346, 349, 350, 351
El Greco (Domenikos Theotokopoulos), 41,
 342
Electric Cord (Lichtenstein, 1961), 346, 347,
 348
Electric Seascapes (Lichtenstein, 1966-67),
 54-55, 60
Éluard, Paul, 44n11
Emeralds (Lichtenstein, 1961), 346
Emigrant Train—after William Ranney
 (Lichtenstein, 1951), 344, *344*
Empire (Warhol film, 1964), 60
Endless Drip (Lichtenstein, 1995), *102*
Engagement Ring, The (Lichtenstein, 1961),
 346, *347*
Entablatures (Lichtenstein, 1971-76), 62-69,
 63-68, 72, 82, 87n26, 87n32, *256-59*,
 354, 355, 357
Entablature (Lichtenstein, 1975 [Art
 Institute of Chicago]), 67
Entablature (Lichtenstein, 1975 [Musée
 d'art moderne de Saint-Étienne
 Métropole]), *66*
Entablature (1975 [private collection]; cat.
 103), *67*, 70n4, *258-59*
Entablature #4 (Lichtenstein, 1971), *66*,
 70n4
Entablature #8 (1972, cat. 102), 66, *256-57*
Entablatures (Studies) (1972; cat. 148), *323*
Entablatures (Studies) (1976; cat. 148), *323*
Equitable Tower project, 23, 86n5, *329*, 357
Ernst, Max, 355
Evening Glow on a Fishing Village (Muqi,
 thirteenth century), 89
Experiments in Art and Technology
 program (E.A.T.), 57, 61n16
Explosions (1963-68; cats. 44-46), 76, 82,
 87n32, *172-75*
Explosion (1965; cat. 43), *172*
Explosion II (1965; cat. 44), *173*
Expo '67 Montreal, Lichtenstein's mural at,
 33, 352
Expo '70 Osaka, Lichtenstein's film
 installation at, 56, 60, 61, 354
Expressionism, 38, 41, 49-50, 81, 83, 86n22,
 356

fabric, Lichtenstein's use of, 79, 84, *85*,
 86n4, 87n39-41, 356
Fantasia (film, 1940), 26
Fauvism, 342
Feldman, Ronald, 359
Female Figure on Beach (Lichtenstein,
 1977), 87n30
Female Head (Lichtenstein, 1977), 87n30, 97
Femme au chapeau (Lichtenstein, 1962), *39*,
 39-40, 42
Femme d'Alger (1963; cat. 64), 40, 48-49,
 82, *201*, 348
Femme d'Alger (Picasso, 1955), 48, *49*
Femme dans un fauteuil (Lichtenstein,
 1963), 40

Fénéon, Félix, 30, 31
Figures (Lichtenstein, 1977), 83, *84*, 87n30
Figures in Landscape (Lichtenstein, 1977),
 87n30
Figures with Rope (Lichtenstein, 1978),
 87n30
Figures with Sunset (Lichtenstein, 1978),
 87n30
film, Lichtenstein's use of, 52-61; flash lab at
 Ohio State University and, *58*, 58-59,
 61; landscape as focus of, 53-55, *54*;
 Three Landscapes (c. 1970-71; cat. 60),
 52, 53, 54, 55-61, *56*, *195*, 354
Fiore, Bob, 55
Fischinger, Oscar, 52
Fish and Sky (Lichtenstein, 1964), *54*
Flag (Johns), 68
Flame, The (comic), *29*
Flash, The (comic), 75, *79*, 86n8-9
flash lab, 34n8, *58*, 58-59, 60
Flaubert, Gustave, 27
Flavin, Dan, 70n19
*Flower with Bamboo and Landscape in
 Scroll (Studies)* (Lichtenstein, 1996),
 90
Flowers (Lichtenstein, 1973), 41
Fluxus, 346
Forest Scene (Study) (1980; cat. 157), *328*
Forest Scene with Temple (Study) (1985;
 cat. 156), *328*
Forms in Space series (Lichtenstein, 1985
 and 1987), 71n31-32, 358
Foster, Hal, 42, 47, 71n21, 71n30
Foucault, Michel, 40
Four Sections, The (Lichtenstein, 1990), 358
4 Panes of Glass (Richter, 1967), 100
*Fragmented Painting of Lemons and
 a Melon on a Table, Trompe l'oeil
 with Leger Head and Paintbrush*
 (Lichtenstein, 1973), *354*
framing, 30-31, 41-42, 59, 71n34
Freedman, Joel, 55, 56, 354
French Impressionism, 49
Frey, Erwin, 342
Fried, Michael, 71n30, 81, 87n39
Frolic (1977; cat. 76), 96, *215*, 355
Fry, Roger, 63, 70n7
Futurism, 41, 71n20, 76, 80, 81, 355

Galatea (1990; cat. 114), 100-01, 102, *280*
Gaudí, Antoni, 359
Gaugin, Paul, 38,
Geldzahler, Henry, 40, 348, 351
Géométrie descriptive (Monge, 1799/1820),
 70n14
George Washington (1962; cat. 62), *28*,
 35n19, *199*, 348
George Washington (Study) (Lichtenstein,
 1962), *28*
German Expressionism, 41, 353, 356
Gertrude Stein (Picasso, 1905-06), 37
Gilot, Françoise, 44n10
Ginsberg, Allen, 359
Girl and Rope Ladder (Lichtenstein, 1961),
 346
Girl at Piano (Lichtenstein, 1963), 87n32,
 348
Girl before a Mirror (Picasso, 1932), 37, 97,
 98, 99, 103
Girl in Mirror (Lichtenstein, 1964), 97
Girl With Ball (Lichtenstein, 1961), *32*, 39,
 96, 97, *346*, 347
Girl with Beach Ball II (Lichtenstein, 1977),
 96
Girl with Beach Ball III (Lichtenstein, 1977),
 97
Girls' Romances (DC Comics), 97, 348
Glaser, Bruce, 20
Go for Baroque (Lichtenstein, 1979), 87n30
Goldberg, Mike, 85
Goldfish and Sculpture (Matisse, 1912), 73,
 95
Goldfish Bowl (Lichtenstein, 1978), 356, *367*
Golf Ball (1962; cat. 20), 68, 69, *136*, 347
Gottlieb, Adolph, 351

Goya, Francisco, 342
Grapes (1972; cat. 70), 87n32, *206*
Graves, Michael, 65, 66
Great Wave off Kanagawa, The (Hokusai, c. 1830-32), *48*
Grecian Dream (Noland, 1969), *67*
Greco-Roman tradition in Lichtenstein's Entablatures, 62-69, *63-68*
Greek Slave (Power), 70n19
Greenberg, Clement, 44n26, 47, 48, 51n12, 53, 60, 71n30, 86n12
Greene Street Mural (Lichtenstein, 1983), 42, 87n30, *357*
Grimes, James, 342, 343
Grip, The (Lichtenstein, 1962), 347
Group 5, 345
guaishi, 91
Guattari, Félix, 32
Guernica (Picasso, 1937), 37, 341, 342
Guitar, Glass, Fruit Dish with Fruit (Picasso, 1924), 40-41

"hackneyed," Lichtenstein's use of, 64, 70n9
Halley, Peter, 81-82, 87n24
Hamilton, Richard, 20, 22, 71n30
handscrolls, 89
hanging scrolls, 89, *90*
Haring, Keith, 84, 358
Harlequin with a Guitar (Picasso, 1918), 44
Hat (Lichtenstein, 1968), 352
Hay, John, 91
Haystacks (Lichtenstein, 1968-69), *204*, 352, 353, 354
Haystack (1969; cat. 67), *204*
Haystack and Haystacks (Studies) (c. 1968; cat. 141), *315*
Haystacks (1969; cat. 68), *204*
Head of a Bull (Picasso, 1942), 38
Head of Girl (Lichtenstein, 1964), 101
Head with Blue Shadow (1965; cat. 42), *169*
Head—Red and Yellow (Lichtenstein, 1962), 348
Heller, André, 84, 358, 359
Helms, Jesse, 100
Henri Matisse: A Novel (Aragon, 1972), 73-74
Hergé, 359
Hidden Persuaders (Packard, 1957), 35n40
Higgins, Dick and Allison, 346
Hinman, Charles, 81, 86n17
Hockney, David, 84
Hokusai, Katsushika, 48
Hongren, 89
Hopeless (1963; cat. 31), 32, *154*
Hot Dog (Lichtenstein, 1964), 350
Hot Dog with Mustard (1963; cat. 16), *129*
House II (Lichtenstein, 1997), 361
Hughes, Robert, 84, 87n38
humor in Lichtenstein's work, 62
Hunter with Dog (Lichtenstein, 1951), 344

I . . . I'll Think about It (Lichtenstein, 1965), 35n24
I Can See the Whole Room! . . . And There's Nobody in It! (Lichtenstein, 1961), *33*, 346, 348
Ice Cream Soda (Lichtenstein, 1962), 347
Illustration for "Romanze, or the Music Students" (I) and (II) (Lichtenstein, 1967), 352
Imperfect Painting (1986; cat. 111), *272-73*
Imperfect Painting (Lichtenstein, 1987), *80*
Imperfect Painting (Gold) (1987; cat. 112), *274-75*
Imperfect Paintings (Studies) (1987; cat. 160), *332*
Imperfect Sculpture (1995; cat. 109), *272*
Impressionism, 49, 54, 64
In (Lichtenstein, 1962), 347
Indian (Lichtenstein, 1951), *82*
Indian (American Indian) themes in Lichtenstein's art, 38, *82, 83, 218*, 343, 344, 345
Indian with Pipe (Lichtenstein, 1953), 38
Indiana, Robert, 49, 348

Information (MoMA, New York), 1970, 57, 61n16
Insect with Man (Lichtenstein, 1950), 344
Interiors (Lichtenstein, 1990-97), *84*, 358, 359, 360, 361
Interior (Lichtenstein, 1977), 87n30
Interior with African Mask (Lichtenstein, 1991), 359
Interior with Ajax (Study) (1997; cat. 172), *339*
Interior with Bathroom (Study) (1992; cat. 165), *335*
Interior with House out the Window (Study) (1997; cat. 166), *336*
Interior with Mirrored Wall (Lichtenstein, 1991), *84*, 87n34
Interior with Nude Leaving (1997; cat. 120), *288-89*
Interior with Nude Leaving (Study) (1997; cat. 167), *336*
Interior with Painting of Bather (Lichtenstein, 1997), 84, 87n34
Interior with Painting of Nude (Study) (Lichtenstein, 1997), 102
Interior with Painting of Reclining Nude (Study) (1997; cat. 170), 102, 103, *338*
Interior with Perfect Painting (Lichtenstein, 1992), 87n34
Interior with Skyline (Lichtenstein, 1992), 87n34
Interior with T'aime (Lichtenstein, 1993), 87n34
Iras (Bærtling, 1959), *80*
Irregular Polygons (Stella, 1965-66), 81
Irving Blum Gallery (Los Angeles), *353*
islanding, 31-32, 69, 71n36

Japanese painting, Lichtenstein's interest in, *48, 90*
Jawlensky, Alexei, 353
Jericho Compositions Notebook (Lichtenstein), 63-64, *64*, 70n8, 77n12, 77n14
Joanna movie poster (Lichtenstein, 1968), 353
John Heller Gallery (New York), 81, *344*, 346
Johns, Jasper, 41, 68, 346, 348, 349, 357
Jones, John, 36, 64
Joueurs de ballon sur la plage (Picasso, 1928), 96
Le journal (Lichtenstein, 1975), 41
Judd, Donald, 67, 71n26, 71n28, 86n14

Kanô School painting (1615-1868), 90
Keds (1961; cat. 11), 82, *122-23*
Kelly, Ellsworth, *68*, 81
Kienholz, Edward, 348
Kimbell, Ward, 34
Kimmelman, Michael, 359
Kinetic Seascapes (Lichtenstein, 1960s), *54*, 56, 60, 351
Kinetic Seascape #3 (Lichtenstein, 1966), *54*
Kiss, The (Lichtenstein, 1961), 32, 347
Kitsch, 47-48, 51, 61
Klee, Paul, 343, 344
Klein, Yves, 348
Kline, Franz, 60
Knidian Aphrodite (Praxiteles, c. 4th century B.C.), 103, *104*
Knight on Horseback (Lichtenstein, 1951), 343
Koch, Kenneth, *356*
Kolsky, Peter, 55
Koons, Jeff, 82, 102, 104n21
Krauss, Rosalind, 71n26, 71n30
Krushenick, Nicholas, *80*, 81, 86n16
Kwong, Hui Ka, 350
Kyoto lecture (Lichtenstein, 1995), 62, 66, 67, 68, 70n2, 71n31, 360

La La La! (Lichtenstein, 1977), *355*
Labrouste, Henri, *64*, 65, 66
LACMA (Los Angeles County Museum of Art), 55-57, 61, 352, 354
Lakosky, Charles, 343

Lamp (Lichtenstein, 1978), 355, *356*
landscape: Chinese aesthetic and, 88-93, *89-92*; film, Lichtenstein's use of, 53-55, *54*; Landscapes (Lichtenstein, 1964-67), 21, 35n20, 80, *182-95*, 351; use of Rowlux in, 54-55
Landscape in Fog (1996; cat. 126), 91-92, *297*
Landscape in Fog (Study) (Lichtenstein, 1996), *92*
Landscape in Scroll (Lichtenstein, 1996), 89, *90*
Landscape with Boat (1996; cat. 125), *296, 361*
Landscape with Boats (Lichtenstein, 1996), *91*
Landscape with Boats (Study) (Lichtenstein, 1995), *91*
Landscape with Figures and Rainbow (1980; cat. 78), *216-17*
Landscape with Philosopher (1996; cat. 124), 89, *295*
Laocoön (1988; cat. 84), *224-25*
Large Interior with Three Reflections (Lichtenstein, 1993), 87n32, 87n34-35, 359
Large Jewels (1963; cat. 23), *140-41*
Larionov, Mikhail, 79, 80
Last of the Buffalo, The (1950; cat. 127), *300*
Late Brushstrokes (Lichtenstein, 1996), *112-15*
Le Gray, Gustave, 62-63
Learning from Las Vegas (Venturi), 65
Lebensztejn, Jean-Claude, 72, 74, 77n7
Lee, Sherman, 88
Léger, Fernand, 41, 52, 80, 99, 342, 357
Leo Castelli (New York), 39, 42, 79, 81, 93n1, 346, 347, *349*, 354
Levine, Les, 352
Levine, Neil, 65
Levine, Sherrie, 358
Levy, Chuck, 55
LeWitt, Sol, 71n31
Liang Kai, 88-89
Lichtenstein, Dorothy (née Herzka; wife), 14, 42, 86n10, 86n17, 87n29, 95-96, 99, 102, 350, *351, 352*, 353
Lichtenstein, Roy, 13; biographical information, 37-38, 84, 95-96, 340-61; and Chinese aesthetic regarding landscapes, 88-93, *89-92, 292-97*, 342, *360*; artistic self-representation of, 23-24, 25n30, *33*, 76, 100; content and subject matter of, 22-23; critical response to, 21, 22, 23, 44n26, 79, 94, 344, 349; death of, 13, 94, 361; dots used by, 26-34 (*see also* dots and dot-making); exhibitions, 18, 21, 22, 39, 40, 56-57, 74, 79, 81, 86n6-7, 88, 93n1, 93n4, 343-61; *344*; film installation, 52-61; high and low modes of art, 47-48; humor of, 62; Matisse and (*see* Matisse, Henri); Modernism and, 46-51 (*see also* Modernism); photographs of, *46, 77, 85, 341-43, 345-57, 359, 360*; Picasso and, 36-44 (*see also* Picasso, Pablo); as Pop artist, 19-22, 24, 85 (*see also* Pop art); significance of, 13, 18-24; and still life genre, 40-41, *41*, 73-74, 77n1, 102. *See also specific works and series by title*
Like New (Lichtenstein, 1962), *29*, 30, 31, 33
Lincoln Center Poster (Lichtenstein, 1966), 30, 351
lingshi, 91
Livingston, Jane, 25n12
Little Big Painting (1965; cat. 48), 50, *177*
Little Landscape (1979; cat. 76), *214*
Little, Stephen, 88
Live Ammo (Lichtenstein, 1962), 347
Lobel, Michael, 24, 33, 42, 45n31
logos, 357, 360
Look Mickey (1961; cat. 8), 21, *26*, 26-29, *27*, 31, 35n24, 39, 46, 50, 76, 87n32, *118-19*, 346, 350, *353*, 357

Loran, Erle, 48, 51n16, 51n20, 347
Los Angeles County Museum of Art, 55–57, 61, 352, 354
Los Angeles Peace Tower monument, 351
Louis, Morris, 208–09, 355
Luna Luna Pavilion (André Heller Project) (Lichtenstein, 1987), 84–85, 85, 358

Ma Yuan, 88
Machine, The (MoMA, New York), 1968, 57, 61n16
Maciunas, George, 346, 348
Made in Heaven (Koons, 1990), 104n21
Magna paints, 18, 21, 22, 347, 360, 361
Magnifying Glass (1963; cat. 25), 23, 29–30, 30, 33, 143, 348
Magritte, René, 76
Malevich, Kazimir, 52
Mallarmé, Stéphane, 27
Malraux, André, 43
Man Ray (Emmanuel Radenski), 52
Man with a Movie Camera (Vertov film), 59
Mao (Lichtenstein, 1971), 354
Marisol, 348
Marsh, Reginald, 341
Marx, Karl, 63, 70n6
Masterpiece (1962; cat. 29), 32, 75, 150–51, 347, 348
Matisse, Henri: Artist's Studios and, 73–74, 74, 76, 77; early interest of Lichtenstein in, 342; first references in Lichtenstein's work to, 355; Modernism and, 50; Munch and, 104n3; Nudes and, 94–97, 95, 98, 99, 100; Perfect/ Imperfects and, 84; Picasso's influence on Lichtenstein and, 41, 45n33. See also specific paintings
Mauldin, William H., 342
McKeever, Robert, 357, 358
Mechanism, Cross Section (Lichtenstein, 1954), 344
Meeker, Carlene, 22–23, 352
Memling, Hans, 98
Las Meninas (Velázquez, 1656), 43
Mermaid (Lichtenstein, 1979), 356
Mermaid Sailboat (Study) (1994; cat. 169), 337
Metamorphoses (Ovid), 96, 101
Mickasso (Study) (Lichtenstein, 1996), 44, 360
Mickey Mouse, 26, 26–28, 34n12–13, 44, 345, 360
Mickey Mouse (1958; cat. 130), 303
mimicking, 71n31
Minatauromachy (Picasso, 1935), 38
Minimalism, 62, 67, 83
Miró, Joan, 47, 343, 355
Mirrors (1969–72; cats. 94–101), 31, 33, 68, 72, 87n32, 97–98, 242–51, 354
Mirror #1 (1969; cat. 94), 242–43
Mirror #1 (48" Diameter) (1970; cat. 96), 245
Mirror #1 (Oval 48" × 32") (1970; cat. 95), 244
Mirror #5 (36" Diameter) (1971; cat. 99), 250
Mirror #6 (36" Diameter) (1971; cat. 100), 251
Mirror Six Panels #2 (1970; cat. 97), 246–47
Mirror Six Panels #3 (1971; cat. 98), 248–49
Mirror (Six Panels) (Study) (1970; cat. 143), 317
Mirrors (Studies) (1970; cat. 142), 316
Mission Héliographique, 62
M-Maybe (1965; cat. 41), 75, 168
Modern series (Lichtenstein, 1966–71), 23, 66, 80, 230–39, 351, 352, 354
Modern Head (Lichtenstein, 1970), 354
Modern Head (Lichtenstein, 1974), 355, 359
Modern Head (Lichtenstein, 1991), 359
Modern Head Pendant (Lichtenstein, 1967), 352
Modern Painting for Expo '67 (Lichtenstein, 1967), 352
Modern Painting I (1966; cat. 86), 230–31
Modern Painting Triptych (1967; cat. 88), 233

Modern Painting with Bolt (Lichtenstein; 1967; cat. 91), 237
Modern Painting with Division (Lichtenstein; 1967; cat. 89), 234–35
Modern Painting with Zigzag (Lichtenstein; 1967), 351
Modern Sculpture (1967; cat. 87), 232
Modern Sculpture (Maquette) (c. 1968; cat. 92), 238
Modern Sculpture with Glass Wave (1967; cat. 90), 236
Modern Sculpture with Velvet Rope (1968; cat. 93), 239
Modernism, 46–51; Artist's Studios and, 74; Entablatures and, 63, 65–66, 70n7; Three Landscapes and, 53, 60; Lichtenstein's relationship to, 20, 46–51, 48, 49; Lichtenstein's use of, 22, 34n8, 46–47; Look Mickey and, 27, 46; Nudes and, 95–96, 97; Perfect/ Imperfects and, 74, 79, 81–84, 87n39
Moholy-Nagy, László, 52, 79, 80
Mondrian, Piet, 21, 39, 49, 64, 68–69, 75, 86n6, 342, 349
Monet, Claude, 39, 353, 359
Monge, Gaspard, 70n14
Moonscape (Lichtenstein, 1965), 350
Morley, Malcolm, 352
Morris, Robert, 71n30, 352
Motherwell, Robert, 44n26
Mourlot, Fernand, 44n10
Moynihan, Brian T., 7
Mr. Bellamy (Lichtenstein, 1961), 346
Munch, Edvard, 95, 104n3
Muqi, 89
Mural with Blue Brushstroke (Equitable Tower project) (Lichtenstein, 1984–86), 23, 86n5, 357
Mural with Blue Brushstroke (Study) (Equitable Tower project) (1984–86; cat. 158), 329
Muromachi period (1392–1573) painting, 90
Musician, The (Lichtenstein, 1948), 37, 44
La musique (Music) (Matisse, 1939), 76
Musketeer (Lichtenstein, 1967), 41
Mustard on White (1963; cat. 17), 130–31

NARAL logo (Lichtenstein, 1996), 361
NASA, 55
Nasturtiums with the Painting "Dance" (Matisse, 1912), 74
Native American themes in Lichtenstein's art, 38, 82, 83, 218, 343, 344, 355
Neo-Geometric Conceptualism, 81–82, 85
neo-Kantian aesthetics, 71n30
neo-Neo architects, 66, 70n19
Nevelson, Louise, 352
New York State Mural (Town and Country) (Studies) (Lichtenstein, 1968), 353
IX by XII (Rug Design) (Lichtenstein, 1978), 87n30
Noland, Kenneth, 67, 67–68, 71n30
Non-Objective I (1964; cat. 65), 49, 202
North American Indian themes in Lichtenstein's art, 38, 82, 83, 218, 343, 344, 355
Nouvelle chute de l'Amérique (Ginsberg and Lichtenstein, 1992), 359
Nudes (Lichtenstein, 1993–97), 21, 94–104, 278–89, 359; comic-book sources, 94, 97, 98, 101–02; dot technique in, 33, 97, 98, 99, 101, 102, 359; Galatea, Pygmalion, and, 100–01, 102; and return to Picasso and Matisse, 94–97, 95, 96, 98, 99, 100–02, 103
Nude (Lichtenstein, 1997), 103
Nude at Vanity (Lichtenstein, 1994), 98
Nude on Beach (Lichtenstein, 1977), 355
Nude with Beach Ball (Lichtenstein, 1994), 97
Nude with Bust (1995; cat. 119), 101–02, 287
Nude with Street Scene (1994; cat. 115), 281
Nude with Yellow Pillow (Lichtenstein, 1994), 33, 34, 87n34

Nudes in Mirror (Lichtenstein, 1994), 33, 98
Nudes with Beach Ball (1994; cat. 117), 97, 284–85
Nudes with Beach Ball (Study) (Lichtenstein, 1994), 97, 98

"Object" series (Lichtenstein, 1962–63), 31–32, 135–46
Ocean Motion (Lichtenstein, 1966), 54
Oetterman, Stephan, 60, 61
Office Furniture series (Lichtenstein), 67
Oh, Jeff . . . I Love You, Too . . . But . . . (1964; cat. 38), 32, 163
O'Hara, Frank, 352
Ohhh . . . Alright . . . (1964; cat. 37), 32, 162
Ohhh . . . Alright . . . (Study) (1964; cat. 134), 307
Oldenburg, Claes, 61, 345, 346, 347, 348, 349, 352
On the Five Orders of Architecture (Barozzi da Vignola), 70n8
Oval Office (Lichtenstein, c. 1993), 359
Overgard, William, 348
Ovid, 96, 101

Packard, Vance, 35n40
Padre Pio Chapel of the Eucharist, Apulia, Lichtenstein's murals for (1995), 360
Paestum, Labrouste's restoration plan of (1828), 64, 65
Painter and Model (Picasso, 1928), 100
Painterly Architectonic (Popova, 1917), 80
Painting with Detail (Black) (Lichtenstein, 1987), 68, 358
Painting with Detail (Blue) (Lichtenstein, 1987), 68, 69, 258
Paintings and Two Paintings series (Lichtenstein, 1982), 357
Paintings: Picasso Head (Lichtenstein, 1984), 42
Palladino, Mimmo, 358
Paper Plate (Lichtenstein, 1968), 353
Pattern and Decoration movement, 84, 85
Peale, Charles Wilson, 38
Pearce, Roy Harvey, 83
Pei, I. M., 358
Le peintre et son modèle (Painter and Model) (Picasso, 1928), 45n54
Perfect/Imperfects (Lichtenstein, 1978–89), 21, 68, 71n31, 75, 78–85, 79–85, 270–75, 358
Perfect (1978; cat. 107), 78–79, 86n3–4
Perfect Painting (1978; cat. 108), 270
Perfect Painting (1986; cat. 109), 80, 271
Perfect Painting #1 (Lichtenstein, 1985), 79
Perforated Seascape #1 (Blue) (1965; cat. 53), 188
Perry, Frank, 355
photographs, Lichtenstein's use of, 63, 63–64, 72, 354
Piano (Lichtenstein, 1964), 87n32
Picabia, Francis, 52
Picasso and Portraiture (MoMA, New York), 1996, 95
Picasso and the Weeping Women: Marie-Thérèse Walter and Dora Maar (Metropolitan Museum of Art, New York), 1994, 95
Picasso, Pablo, 36–44; Artist's Studios (Lichtenstein) and, 73, 74; Entablatures (Lichtenstein) and, 64, 68–69, 354; Lichtenstein influenced by, 21, 36–44, 37, 39–42, 44, 341, 342, 347, 355; Mickasso (Study) (Lichtenstein, 1996), 44, 360; and Modernism, Lichtenstein's relationship with, 46, 47, 48–49, 49, 50; Nudes (Lichtenstein) and, 94–97, 98, 100, 100–02, 103; Perfect/Imperfects (Lichtenstein) and, 80, 82. See also specific paintings
Picture and Pitcher (Lichtenstein, 1978), 356
pingdan, 92
Pink Seascape (1965; cat. 58), 193
Pink Studio (Matisse, 1911), 73
Pistol (Lichtenstein, 1964), 350

365

Pitcher Triptych (Lichtenstein, 1972), 82
Plato, 52
Play It as It Lays (film, 1972), 355
Plus and Minus series (Lichtenstein, 1988), 35n42, 68, *223,* 358
Plus and Minus VI (1988; cat. 83), *223*
pointillism, 29, 81
Pollock, Jackson, 21, 27, 38, 46, 49, 86n12
Pop abstraction, 80
Pop art: Artist's Studios and, 74-75; Entablatures and, 68; Equitable Tower mural referencing, 357; *Three Landscapes* and, 51, 58; Lichtenstein as Pop artist, 19-22, 24, 85; MoMA symposium, 1963, 349; neo-Kantian aesthetics, deflation of, 71n30; Perfect/Imperfects and, 82; Picasso's influence on Lichtenstein and, 36, 39-41, 43, 45n42; and subject matter, 20, 21, 23, 25 nn21-22 30, 39, 47-47
Popeye (Lichtenstein, 1961), *28, 357*
Popova, Liubov', 80
Portable Radio (1962; cat. 18), 32, 35n35, *134*
Portrait of Jorge Manuel (El Greco, 1605), 41
Portrait of Madame Cézanne (1962; cat. 63), 48, *200,* 347, 348
Portrait of a Painter, after El Greco (Lichtenstein, 1950), 41
Portrait Triptych (Lichtenstein, 1974), 82, 83, 87n32
Portrait Triptych (Study) (1974; cat. 144), *318*
Postmodernism, 48, 50, 65-66
Potash, Paul, 352
Poussin, Nicolas, 21
Power, Hiram, 70n19
Powers, John and Kimiko, 90
Prisoner (Study), The (1980; cat. 155), *327*
Proust, Marcel, 27
Purism, 71n20, 73
Purist Painting with Pitcher, Glass and Classical Column (1975; cat. 74), *211*
Pyramids (1968-69; cat. 140), 63, 82, *314,* 354
Pyramids II (1969; cat. 140), *314*

Quatremère de Quincy, Antoine, 64
Quin, Carmelo Arden, 86n1

Rain Machine (Daisy Waterfall) (Warhol, 1971), 56, *57*
Rauschenberg, Robert, 346, 347, 348, 349, 358
Rayonism, 79
Razzmatazz (Lichtenstein, 1978), 87n30
Reclining Nude (Lichtenstein, 1977), 87n30
Reclining Nude (The Painter and His Model) (Matisse, 1935), *76*
Reclining Nude I (Aurore) (Matisse, 1906-07), 95
Reclining Nude in Brushstroke Landscape (Study) (1986; cat. 159), *330-31*
Reclining Woman (Lichtenstein, 1942), 37
Red Flowers (Lichtenstein, 1961), 346
Red Horseman (Study), The (1974; cat. 146), *320-21*
Red Robins, The (Koch play with Lichtenstein sets, 1977-78), *356*
Red Studio (Matisse, 1911), 73
Reflections (Lichtenstein, 1989-90), 31, 35n20, 358
Reflections of "Large Interior" (Panel 1 of 3) (Lichtenstein, 1993), 87n34
Reflections of "Large Interior" (Panel 3 of 3) (Lichtenstein, 1993), 87n32
Reflections on "The Artist's Studio" (Lichtenstein, 1989), 100
Reflections on Brushstrokes (Study) (1989; cat. 164), *334*
Reflections on "Interior with Girl Drawing" (1990; cat. 85), 31, 43, *226-27*
Reflections on Jessica Helms (Lichtenstein, 1990), *100*
Reflections on Nancy (Study) (1989; cat.

163), *334*
Reflections on "Painter and Model" (Lichtenstein, 1990), 45n54, *100*
Reflections: Whaam! (Lichtenstein, 1990), 35n20
Refrigerator, The (Lichtenstein, 1962), 346, 347, 348
Reich, Steve, 358
Rembrandt, 41
Remington, Frederic, 38
Resnick, Milton, 85
Reverie (Lichtenstein, 1965), 351
Richter, Gerhard, 87n33, 100
Richter, Hans, 52
Ring, The (Lichtenstein, 1962; cat. 19), *135,* 348
Ring (Engagement), The (1962; cat. 12), *124-25*
Ring-A-Ding II (Krushenick, 1970), *80*
Rivers, Larry, 348, 351
Roller Skates (Lichtenstein, 1961), 346
Rondeau, James, 13, 16, 18
Roos, Frank, 341, 342
Rose, Bernice, 86n6, 358
Rosenblum, Robert, 39, 344, 348, 349
Rosenquist, James, 347
Rosenthal Glas und Pozellan AG tea set (Lichtenstein, 1980), 356
Rothfuss, Rhod, 86n18
Rothko, Mark, 351
Roto Broil (Lichtenstein, 1961), *346*
Rouault, Georges, 342
Rouen Cathedral, Set 5 (Lichtenstein, 1969; cat. 69), *205*
Rouen Cathedrals (Lichtenstein, 1968-69), 22, 35n20, *205,* 353, 354
Rousseau, Henri, 38
Rowlux, 35, 54, *54, 55, 192, 193,* 349, 350, 351, 355
-R-R-R-R-Ring!! (Lichtenstein, 1962), 74, 87n32
"Run for Love!" (comic panel), *48*
Russian Constructivism, 355

Said, Edward, 103, 104
Sainte-Geneviève Library, 65
Salon des Indépendants, 30
Salute to Airmail (Lichtenstein, 1968), 353
Salute to Painting (Lichtenstein, 1986), 357
Samaras, Lucas, 346
Saul, Peter, 347
Save Our Planet Save Our Water (Lichtenstein, 1971), 354
Schlegel, August Wilhelm, 57
Scholar's Rock (1997; cat. 123), 91, *294*
School of Paris, 54
Schulke, Harry, 343
Schwabsky, Barry, 79, 86-87n23
Sculptor, Model and Sculpted Bust (Picasso, 1933), *101*
Sea Shore (1964; cat. 55), *190*
Seascape (1964; cat. 51), *183-84,* 350
Seascape (c. 1965; cat. 56), *191*
Seascape (1965; cat. 57), *192*
Seascape (1965; cat. 59), *194*
Seascape with Clouds (1964; cat. 138), *311*
Secret Hearts (comic book), 98, 102, 348
Segal, George, 346
Seiberling, Dorothy, 349
self-representation, Lichtenstein, 24, 25n29, 27, 33, 76, 77n13, 86n13, 100, 103, *252-53*
Self-Portrait (Lichtenstein, 1976), 25n30, 76, 86n13
Self-Portrait (1978; cat. 101), 25n30, 76, 100, *252-53*
Self-Portrait between Clock and Bed (Munch, 1940-42), 95, 104n3
Self-Portrait II (Lichtenstein, 1976), 25n30, 76, 86n13
Seurat, Georges, 29, 30, 31, 35n28, 53, 57, 342
Seven Apples (Lichtenstein, 1983), 357
Severini, Gino, 80, 81, 86n13
Sharp, Willoughby, 57, 60

Shaw, Charles G., 86n18
Sherman, Hoyt L., 25n13, 27, 31, 33, 34n8, 37, 51n20, *58,* 59, 85, 343, 344, 360
Sieberling, Dorothy, 25n21
Sigmund, Natasha, 86n3-4
Singapore Brushstroke (Lichtenstein, 1996), 361
Sinking Sun (Lichtenstein, 1964), *349*
Sketch for Artist's Studio "Look Mickey" (Lichtenstein, 1973), *74*
Sketchbook G (Lichtenstein, 1995), *91*
Sleeping Muse (1983; cat. 82), *222*
Smith, Richard, 348
Smithson, Robert, 71n30
Sock (Lichtenstein, 1962), 35n35, *348*
Software (Jewish Museum, New York), 1969, 57
Song dynasty painting, 88-89, 90, 360
Sound of Music (Lichtenstein, 1964), 74, 76, 87n32
Southern Song dynasty (1127-1279) painting, 88-89, *89,* 90
spirit stones, 91
Splinter series (Lichtenstein, 1954-55), 83, *83*
Sponge (1962; cat. 13), 23, *125-26,* 348
Sponge II (Lichtenstein, 1962), 23, 348
Spray (1962; cat. 14), *127,* 347
Standing Nude (Picasso, 1922), *103*
Steinbach, Haim, 82
Steinberg, Leo, 22, 25n20, 67, 349
Stella, Frank, 71n31, *81,* 82, 86n12, 86n23, 351
Step-on Can with Leg (1961; cat. 10), 29, 30, *121,* 346
Still Lifes (Lichtenstein, 1972-74), 73, 87n32, 355
Still Life after Picasso (Lichtenstein, 1964), 40-41, *41,* 45n44, 72, 87n32
Still Life with Attache Case (Studies) (1976; cat. 150), *324*
Still Life with Glass and Peeled Lemon (1972; cat. 71), *207*
Still Life with Goldfish (1972; cat. 66), 73, *203*
Still Life with Locker, Bottle and Tray (Study) (1976; cat. 151), *325*
Still Life with Panel of "The Dance" (Matisse, 1909), *74*
Still Life with Picasso (Lichtenstein, 1973), *41, 42*
Still Life with Portrait (Lichtenstein, 1974), 87n32
Still Life with Reclining Nude (Study) (1997; cat. 171), 31, 95, 102, 103, *338*
Still Life with Sculpture (Study) (Lichtenstein, 1973), *95*
Stretcher Frame (Lichtenstein, 1968), 35n34, *68,* 72-73
Stretcher Frame Revealed Beneath Painting of a Stretcher Frame (Lichtenstein, 1973), *354*
Stretcher Frames (Lichtenstein, 1968), 66, 87n32, 352
Studio, The (Picasso, 1927-28), 100
Studio Wall with Pocketwatch, Fly, and Sketch of Lemons (Lichtenstein, 1973), *354*
Study for White Relief Over Black (Kelly, 1955), 81
Study of Hands (Study) (1980; cat. 154), *327*
suibokuga, 90
Summerson, John, 63
Sunrise (1965; cat. 50), *182-83*
Sunset (1964; cat. 54), *189*
Super Sunset (Lichtenstein, 1967), 352
Sweet Dreams Baby! (Lichtenstein, 1965), 351
Sylvester, David, 20, 21, 62, 70, 351, 361

Taittinger logo (Lichtenstein, 1986), 358
Takka Takka (1962; cat. 30), *152-53,* 347, 348
Tao Hongjing, 92
Tate Modern, Lichtenstein at, 13, 14, 352

Tatlin, Vladimir, 81
technology and visual culture, artists
 exploring, 56–57, 61
Tel Aviv Mural (Lichtenstein, 1989), *42,* 79,
 84, 358
Temple of Apollo (Lichtenstein, 1964), *63,*
 64, 71n28, 87n32, *349,* 350, 352
Ten Dollar Bill (Ten Dollars) (Lichtenstein,
 1956), 344
Ten-Thirty Gallery (Cleveland), 343
Statesman, The (Lichtenstein, 1951), 344
Third-Class Carriage, The (Daumier, ca.
 1862–64), 342
Third Man, The (film), 59
This Figure Is Pursued By That Figure
 (Lichtenstein, 1978), 87n30
This Must Be the Place (Lichtenstein, 1965),
 350, 358
*A Thousand Plateaus: Capitalism and
 Schizophrenia* (Deleuze and Guattari),
 32
Three Landscapes (c. 1970–71; cat. 60), *52,*
 53, 54, 55–61, *56, 195,* 354
Three Landscapes (Studies) (Lichtenstein,
 1969), 55–56, *56*
Three Musicians (Picasso, 1921), 37
Three Pyramids (Lichtenstein, 1969), 63
Three Reflections (Lichtenstein, 1993),
 87n32
Time magazine covers, 352
Times Square Mural (Lichtenstein, 1990),
 358
Ting, Wallasse, 348
Tintin in the New World: A Romance,
 Lichtenstein's cover and frontispiece
 for (1993), 359
Tire (1962; cat. 21), *137*
To Battle (Lichtenstein, 1950), 37–38, *343*
Tobias, Abraham Joel, 86n18
Torpedo . . . LOS! (1963; cat. 34), *158,* 349
Toulouse-Lautrec, Henri de, 342
Transistor Radio (with Metal Antenna)
 (Lichtenstein, 1961), 346
Treetops through the Fog (1996; cat. 122),
 90, *293*
Tuchman, Maurice, 55, 56, 352
Tuftonboro III (Stella, 1966), *81*
Turkey (Lichtenstein, 1961), 346, 347
Turkey Shopping Bag (Lichtenstein, 1964),
 350
Tuten, Frederic, 19, 354, 359
Twelfth Copper Corner (Andre), 70–71n19
29th Copper Cardinal (Andre), 70–71n19
23 (Lichtenstein, 1959), 38
Two Figures (Lichtenstein, 1977), 87n30
Two Figures (Lichtenstein, 1978), 87n30
200 Years of American Sculpture (Whitney
 Museum of American Art, 1976),
 70–71n19
Two Indians (Lichtenstein, 1952), 344
Two Nudes (1993; cat. 116), *94,* 100, *282–83*
Two Nudes (Study) (Lichtenstein, 1993), *94*
Two Paintings (Alien) (Lichtenstein, 1983),
 86n9
Two Paintings with Dado (Lichtenstein,
 1983), 41
Tyler, Kenneth, and Tyler Graphics, 94, 98,
 353, 356

UN Special Committee Against Apartheid
 poster (Lichtenstein, 1983), 357
*Uncommon Sense: Six Projects Explore
 Social Interactions and Art* (Museum of
 Contemporary Art, Los Angeles, 1997),
 87n37
Unfurled (after Morris Louis) (1973; cat. 72),
 208–09, 355
UNICEF poster *Save Our Planet Save Our
 Water* (Lichtenstein, 1971), 354
Universal Exposition, Paris, 61
Universal Film Studios, 55, 352, 353, 354
Untitled (Clark, 1957), *81,* 86n19
Untitled (Progression) (Judd, 1979), *67*
Untitled (Lichtenstein, 1955), *83*
Untitled (1959; cat. 1), *108*

Untitled (1959; cat. 2), *109*
Untitled (1959; cat. 131), *304–05*
Untitled (1960; cat. 3), *110–11*
Untitled (Lichtenstein, 1975), 82, *83*
Untitled (Abstraction) (Lichtenstein, 1975),
 82
Untitled (Futurist Studies) (c. 1975; cat.
 136), *309*
Untitled (Portrait of a Man) (Lichtenstein,
 1943), 342
Untitled (Portrait of a Man) (Lichtenstein,
 1943), *37*
Untitled Shirt (Lichtenstein, 1979), 356
Untitled (Paris Series) (Williams, c. 1965), *81*
Untitled (Xmas Ornament) (Lichtenstein,
 1987), 84

Valentine, DeWain, 352
van Doesburg, Theo, 41, 82, 86n6
van Gogh, Vincent, 38, 359
Vanitas (Memling, c. 1490), 97, *98*
Varoom! (1963; cat. 46), *175*
Velázquez, Diego, 41, 43
Venetian Blinds (Lichtenstein, 1994),
 71n31–32
Venetian School I and *II* (Lichtenstein,
 1996), 71n31
Venturi, Robert, 65, 70n19
Vertoz, Dziga, 59
Viollet-le-Duc, Eugène, 64
Virtual Flowers (Study) (c. 1989; cat. 162),
 333
Vista with Bridge (Lichtenstein, 1996), 90,
 91
Visual Arts Center at OSU logo
 (Lichtenstein, 1983), 357
Vitruvius, 64
Vollard Suite (Picasso, 1931), 101
Vorticism, 71n20

Wagstaff, Sheena, 13, 16, 18
Waldman, Diane, 22, 25n15, 53
Wall Explosion II (1965; cat. 45), *174*
Walter, Marie-Thérèse, 94, 96, 100, 101
War and Romance series (Lichtenstein,
 1961–66), 24, 35n33, *150–69*
Warhol, Andy, 25, 56, *57,* 60, 61, 346, 348,
 349, 350, 355, 359
Warrior, The (Lichtenstein, 1951), 38
Washing Machine (1961; cat. 9), *120,* 346,
 347
Washington Crossing the Delaware I (c.
 1951; cat. 61), *198,* 359
Watts, Robert, *345,* 346, 347, 348
We Rose Up Slowly (1964; cat. 39), 32,
 164–65
Weatherford Surrenders to Jackson
 (Lichtenstein, 1953), 344
Wesselmann, Tom, 348
Whaam! (1963; cat. 36), 13, 39, *160–61,* 348,
 351
Whaam! (Study) (1963; cat. 135), *308*
White Cloud (1964; cat. 52), *186–87*
Whitman, Robert, 346
Williams, Neil, *81,* 86n17
Wilmerding, John, 25n4
Wilson, Isabel, 84, 343, *345,* 346, 349, 350,
 352, 356
Wimpy (Tweet) (Lichtenstein, 1961), 357
Window, Museum of Modern Art, Paris
 (Kelly, 1949), *68*
Woman III (1982; cat. 81), *220–21*
Woman in Gray (Picasso, 1942), 39
Woman Seated in an Armchair (Picasso,
 1941), 40
Woman: Sunlight, Moonlight (1995; cat. 118),
 101, *286*
Woman with Flowered Hat (Lichtenstein,
 1963), *40,* 41
Woman with Flowered Hat (Picasso,
 1939–40), *40*
Woman with Neck Ribbon (Lichtenstein,
 1978), 87n30
Women of Algiers in Their Apartment
 (Delacroix, 1834), 40

Women of Algiers series (Picasso, 1954–55),
 40
Women Running on the Beach (Picasso,
 1922), 104n8
World's Fair Mural (Lichtenstein, 1964), 350
*Worlds within Worlds: The Richard
 Rosenblum Collection of Chinese
 Scholars' Rocks* (Mowry, 1997), 91
Wrapping Paper (Lichtenstein, 1968), 353
Wu Tung, 90
Wudi (Liang dynasty emperor), 92

Xia Gui, 88

Yellow and White Drip on Graph
 (Lichtenstein, 1966), *83*
Yellow Cliffs (1996; cat. 121), *292*
Yellow Garbage Can (Lichtenstein, 1961),
 346
Young America yacht designs (1994; cat.
 169), *337,* 359
Young Romance (romance comic book,
 1964), 102
Yuan dynasty (1260–1368) painting, 88

Zipper (Lichtenstein, 1962), 348
Zola, Émile, 27
Zox, Larry, *84,* 87n38

PHOTOGRAPHY CREDITS

Artworks by Roy Lichtenstein © Estate of Roy Lichtenstein with the exception of *Look Mickey*, 1961 © National Gallery of Art; and *Drawing for Mural with Blue Brushstroke*, 1984 © Roy Lichtenstein Foundation.

Unless otherwise stated, all photographs of artworks appear by permission of the lenders mentioned in their captions. Every effort has been made to contact and acknowledge copyright holders for all reproductions; additional rights holders are encouraged to contact the Art Institute of Chicago.

Images of objects in the collection of the Art Institute of Chicago were produced by the Department of Imaging, Christopher Gallagher, director. The following credits apply to all images for which separate acknowledgment is due.

Front cover: Photograph by Joseph Coscia. **Back cover**: Photograph by Dennis Hopper. © The Dennis Hopper Trust. Courtesy of The Dennis Hopper Trust.

COOPER ESSAY
Fig. 2. © Disney.

DORIS ESSAY
Fig. 1. Time & Life Pictures/Getty Images. **Fig. 2.** © DC Comics. Used with permission. **Fig. 4.** Photograph © Christie's Images/ The Bridgeman Art Library. © 2012 Estate of Pablo Picasso/Artists Rights Society (ARS), N.Y. **Fig. 5.** © 2012 Mondrian/ Holtzman Trust c/o HCR International, Washington, D.C.

ILES ESSAY
Fig. 1. Photograph by Bill Orcutt. **Fig. 6.** © The Andy Warhol Foundation for the Visual Arts, Inc./Artists Rights Society (ARS), N.Y.

BOIS ESSAY
Figs. 6, 7. École nationale supérieure des beaux-arts, Paris. **Fig. 8.** Photograph by Eric Politzer. **Fig. 10.** © The Museum of Modern Art/Licensed by SCALA/Art Resource, N.Y. © Judd Foundation. Licensed by VAGA, N.Y. **Fig. 11.** © Estate of Kenneth Noland. Licensed by VAGA, N.Y. **Fig. 13.** Photograph by Robert McKeever. **Fig. 15.** © Ellsworth Kelly. Photograph courtesy of the artist.

LAWRENCE ESSAY
Fig. 4. © 2012 Succession H. Matisse/Artists Rights Society (ARS), N.Y. **Fig. 5.** © 2012 Succession H. Matisse/Artists Rights Society (ARS), N.Y. **Fig. 6.** © 2012 Vaughan Rachel/Artists Rights Society (ARS), N.Y.

RONDEAU ESSAY
Fig. 1. Courtesy Gagosian Gallery. Photography by Robert McKeever. **Fig. 2.** © DC Comics. Used with permission. **Fig. 4.** © 2012 Artists Rights Society (ARS), New York/BUS, Stockholm. **Fig. 5.** © Estate of Nicholas Krushenick, courtesy Gary Snyder Gallery, N.Y. **Fig. 6.** Courtesy of Spanierman Modern, N.Y. **Fig. 8.** © 2012 Frank Stella/ Artists Rights Society (ARS), N.Y. **Fig. 17.** Courtesy of Stephen Haller Gallery and Inson Dubois Wood LLC Interior Designer.

LITTLE ESSAY
Fig. 3. Photograph by Steve Mundinger. **Fig. 6.** Photograph © 2012 Museum Associates/Los Angeles County Museum of Art. Licensed by Art Resource, N.Y.

WAGSTAFF ESSAY
Fig. 2. Photograph by Mitro Hood courtesy of the Baltimore Museum of Art. © 2012 Succession H. Matisse/Artists Rights Society (ARS), N.Y. **Fig. 5.** © 2012 Estate of Pablo Picasso/Artists Rights Society (ARS), N.Y. **Fig. 8.** Photograph Bridgeman-Giraudon/Art Resource, N.Y. **Fig. 9.** Photograph © The Museum of Modern Art/ Licensed by SCALA/Art Resource, N.Y. © 2012 Estate of Pablo Picasso/Artists Rights Society (ARS), N.Y. **Fig. 10.** Photograph by Mitro Hood courtesy of the Baltimore Museum of Art. © 2012 Succession H. Matisse/Artists Rights Society (ARS), N.Y. **Fig. 11.** Photograph © The Museum of Modern Art/Licensed by SCALA/Art Resource, N.Y. © 2012 Estate of Pablo Picasso/Artists Rights Society (ARS), N.Y. **Fig. 15.** Réunion des Musées Nationaux/Art Resource, N.Y. Photograph: Thierry Le Mage. © 2012 Estate of Pablo Picasso/ Artists Rights Society (ARS), N.Y. **Fig. 19.** © 2012 Estate of Pablo Picasso/Artists Rights Society (ARS), N.Y. **Fig. 21.** akg-images/John Hios.

PLATES
Cat. 8. Image courtesy National Gallery of Art, Washington. **Cat. 12.** Photograph by Jamie Stukenberg, Professional Graphics, Inc. **Cat. 19.** Photograph by Jamie Stukenberg, Professional Graphics, Inc. **Cat. 28.** Photograph by Jean Paul Torno. **Cat. 30.** © Rheinisches Bildarchiv Köln, rba_c005087. **Cat. 32.** Digital Image © The Museum of Modern Art/Licensed by SCALA/Art Resource, N.Y. **Cat. 33.** © 2012 Museum Associates/LACMA. Licensed by Art Resource, N.Y. **Cat. 34.** © Timothy Aguero Photography. **Cat. 36.** © Tate, London 2011. **Cat. 38.** © Timothy Aguero Photography. **Cat. 41.** Photograph © Rheinisches Bildarchiv, Fotografennname, rba_c007153. **Cat. 42.** Raymond and Patsy Nasher Collection, Nasher Sculpture Center, Dallas. Photograph by Tom Jenkins. **Cat. 46.** Courtesy Gagosian Gallery. Photography by See Spot Run. **Cat. 53.** Photograph by Peter Harholdt. **Cat. 56.** Photograph by Joseph Coscia. **Cat. 58.** Photograph courtesy of Matthew Marks. **Cat. 59.** Courtesy of Collection Viktor and Marianne Langen. **Cat. 61.** Photograph by Robert McKeever. **Cat. 63.** Photograph courtesy of the Columbus Museum of Art, Ohio. **Cat. 65.** Photograph by Douglas M. Parker Studio. **Cat. 67.** Photograph by Jamie Stukenberg, Professional Graphics, Inc. **Cat. 68.** Photograph by Jamie Stukenberg, Professional Graphics, Inc. **Cat. 70.** Photograph courtesy Gagosian Gallery. **Cat. 71.** Courtesy Gagosian Gallery. Photography by Robert McKeever. **Cat. 75.** Image courtesy National Gallery of Art, Washington. **Cat. 77.** Courtesy Gagosian Gallery. Photography by Robert McKeever. **Cat. 78.** ©Rheinisches Bildarchiv Köln, rba_c002147. **Cat. 90.** © The Museum of Modern Art/Licensed by SCALA/Art Resource, N.Y. **Cat. 91.** © The Museum of Modern Art/Licensed by SCALA/Art Resource, N.Y. **Cat. 92.** Detroit Institute of Arts, USA/© DACS/The Bridgeman Art Library International. **Cat. 95.** Photograph by Robert McKeever. **Cat. 104.** Courtesy the Walker Art Center. **Cat. 106.** © The Museum of Modern Art/Licensed by SCALA/Art Resource, N.Y. **Cat. 121.** Photograph by Kerry Ryan McFate, courtesy The Pace Gallery, N.Y. **Cat. 133.** Photograph by Jamie Stukenberg, Professional Graphics, Inc. **Cat. 135.** © Tate, London 2011. **Cat. 145.** Courtesy Mitchell-Innes & Nash. **Cat. 146.** Photograph courtesy Gagosian Gallery.

CHRONOLOGY
P. 345, bottom. Special Collections and University Archives, Rutgers University Libraries. **P. 347.** © Bill Ray. **P. 348, top right.** Time & Life Pictures/Getty Images. **P. 349, left, right; p. 350, right.** © Estate of Ugo Mulas. **P. 351,** upper right. Photograph by Frank J. Thomas, Courtesy of the Frank J. Thomas Archives. **P. 351, lower right.** © Leta Ramos, courtesy Mel Ramos. **P. 353, top right.** Ken Heyman. **P. 353, bottom.** Gamma-Keystone via Getty Images. **P. 358.** © DACS/Photo © AISA/The Bridgeman Art Library International. **P. 361.** Cassandra Lozano.